ORIGINAL JAPANESE EDITION

Publisher
MASAHIKO SHIOYA

Supervising Editor
EIJI AONUMA (Nintendo)

Design & Editing
AKAHARU TSUCHIDA
YASUYUKI KATO
KAZUYA SAKAI (Ambit)
NAOYUKI KAYAMA
MIKA KANNO
GINKO TATSUMI
HIRONORI SAO
JUNKO FUKUDA
KUNIO TAKAYAMA (Shogakukan)
TADAHIKIO ABE

Coeditors
FLORENT GORGES • KEVIN DIE • CHIE MARUYAMA

Original Cover Design
AKEMI TOBE

ENGLISH LANGUAGE EDITION

Publisher
MIKE RICHARDSON

Editor
PATRICK THORPE

Assistant Editor
EVERETT PATTERSON

Translation Coordinator
MICHAEL GOMBOS

Digital Production
CARY GRAZZINI • CHRIS HORN • IAN TUCKER

Lead Designer
CARY GRAZZINI

Designers
TINA ALESSI • STEPHEN REICHERT

Cover Design
CARY GRAZZINI

Originally published by Shogakukan Co., Ltd. First edition: December 2011.

Special thanks to Shigeru Miyamoto, Akira Himekawa, Jeremy Krueger-Pack, Davey Estrada, Nick McWhorter, and Annie Gullion.

President and Publisher Mike Richardson · *Executive Vice President* Neil Hankerson · *Chief Financial Officer* Tom Weddle · *Vice President of Publishing* Randy Stradley · *Vice President of Book Trade Sales* Michael Martens · *Vice President of Business Affairs* Anita Nelson · *Editor in Chief* Scott Allie · *Vice President of Marketing* Matt Parkinson · *Vice President of Product Development* David Scroggy · *Vice President of Information Technology* Dale LaFountain · *Senior Director of Print, Design, and Production* Darlene Vogel · *General Counsel* Ken Lizzi · *Editorial Director* Davey Estrada · *Senior Books Editor* Chris Warner · *Executive Editor* Diana Schutz · *Director of Print and Development* Cary Grazzini · *Art Director* Lia Ribacchi · *Director of Scheduling* Cara Niece · *Director of International Licensing* Tim Wiesch · *Director of Digital Publishing* Mark Bernardi

Published by Dark Horse Books
A division of Dark Horse Comics, Inc.
10956 SE Main Street
Milwaukie, OR 97222

DarkHorse.com

International Licensing: (503) 905-2377

First English edition: January 2013
ISBN 978-1-61655-041-7

15 17 19 20 18 16 14
Printed in China

THE LEGEND OF ZELDA™

HYRULE HISTORIA

Translated by

MICHAEL GOMBOS • TAKAHIRO MORIKI
HEIDI PLECHL • KUMAR SIVASUBRAMANIAN
ARIA TANNER • JOHN THOMAS

All concept illustrations that originally
contained handwritten notes in Japanese have been translated
into English and updated for this version of the book.

DARK HORSE BOOKS

On the 25th Anniversary of The Legend of Zelda

Shigeru Miyamoto, senior executive director of Nintendo Corporation and general producer of the *Legend of Zelda* series

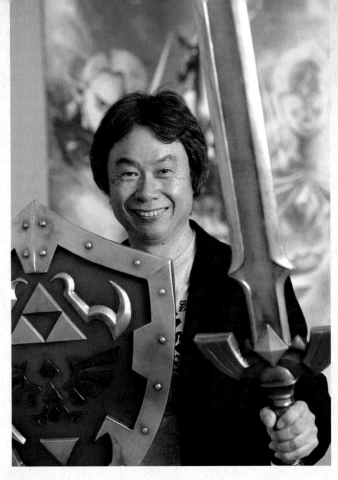

Photos: Shoji Nakamichi

I started working on the first *Legend of Zelda* project with a small staff in a corner of Nintendo's development office in Kyoto. It was the mideighties, and the Famicom *[Editor's note: Famicom is the Japanese name for the Nintendo Entertainment System or NES]* console had been out for about two years. At that time I was working on a *Super Mario Bros.* compilation for the Famicom, but the Disk System *[Editor's note: The Disk System was a peripheral for the Famicom that was not released in the United States]* was about to come out, and we needed to develop a launch title for it.

I thought that we should take advantage of the Disk System's ability to rewrite data by making a game that allowed two players to create dungeons and then explore each other's creations. We designed that game, and the

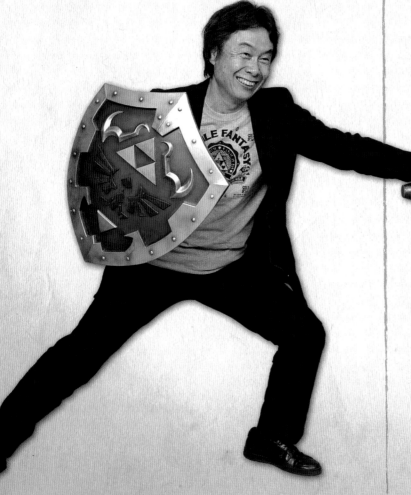

overall response was that playing through the dungeons was the best part. We made a one-player game with dungeons under mountains that surrounded Death Mountain, but we couldn't shake that "I want to play aboveground, too!" feeling, so we added forests and lakes, and eventually Hyrule Field.

Of course, the title of the game wasn't decided right at the beginning. I knew I wanted it to be *The Legend of* something, but I had a hard time figuring out what that "something" was going to be. That's when the PR planner said, "Why don't you make a storybook for this game?"

He suggested an illustrated story where Link rescues a princess who is a timeless beauty with classic appeal, and mentioned, "There's a famous American author whose wife's name is Zelda. How about giving that name to the eternal beauty?" I couldn't really get behind the book idea, but I really liked the name Zelda. I asked him if I could use it, and he said that would be fine. And that's where the title *The Legend of Zelda* was born.

We named the protagonist Link because he connects people together. He was supposed to spread the scattered energy of the world through the ages. The old female storyteller who feeds information to Zelda is named Impa;

her name comes from the word *impart*. Impa, Link, and Zelda were the guardians of the Triforce. Today, when you think of characters who are connected to the Triforce, you think of Link, Zelda, and Ganon, but that started in *Ocarina of Time*. Originally Ganon was only a villain in relentless pursuit of the Triforce.

So, twenty-five years have passed, and we have made a lot of *Zelda* titles. In the beginning, Link was just a bunch of pixelated dots, and now he is a hero who appears fearless, capable of realistic and free movement. Ganon has turned into a powerful archvillain, and Zelda, an incredibly beautiful woman.

With better hardware come richer and more elaborate production values. However, I feared that the game play might come to rely on, and ride solely upon, the benefits of improved technology. The most important aspects of a game are the game system, the action, the sensory experience, the creativity, the production values, and the performances. With each generation the production values evolve, but in certain respects my involvement has been that of a guardian, to ensure that game play doesn't suffer.

And in respect to game play elements, I feel that *Skyward Sword*, the most recent game, which came out at the turning point of the twenty-fifth anniversary, is very well balanced. Over these twenty-five years we have come up with new items, changed the way many items are used, made Link's controls more comfortable for solving puzzles, and adapted to, and improved, new controllers. We have even designed the controllers themselves with the *Zelda* games in mind, and I feel the Wii MotionPlus and the Nunchuck are ideal for *Skyward Sword*.

The year 2011 was also the thirtieth anniversary of *Donkey Kong*, where my life in video game design all started. I've been involved in countless titles these past thirty years, but *The Legend of Zelda* is the only game series where a player can input his or her own name. I said the name Link came from his role as a connector, but Link is you, the player. The series has been so successful because the player must solve puzzles and defeat tough enemies in order to ultimately save the world. I am so thankful this has allowed us to "link" with players all around the globe.

Even though Ganon is defeated time and time again, he is evil incarnate and will come back time and time again, with a vengeance. Each time, when the world is blanketed in evil, a young boy and girl will be born. Link's adventures will go on for as long as you continue to love his world. With new hardware will come new games in this series, and I emphatically ask you to please give them a shot.

25th Anniversary
Thank you!
Shigeru Miyamoto

Shigeru Miyamoto's HYRULE HISTORY

CONTENTS

SPECIAL COMIC
THE LEGEND OF ZELDA: SKYWARD SWORD
AKIRA HIMEKAWA
[This story reads from back to front]

THE LEGEND BEGINS

The World of *Skyward Sword*

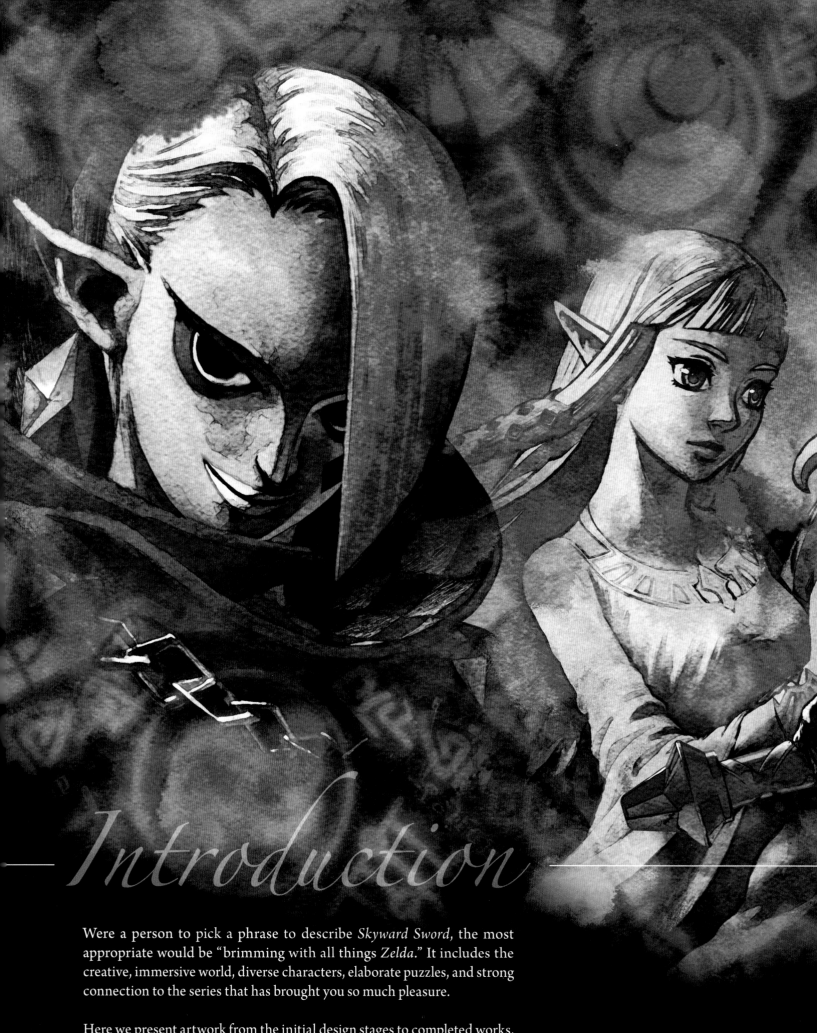

Introduction

Were a person to pick a phrase to describe *Skyward Sword*, the most appropriate would be "brimming with all things *Zelda*." It includes the creative, immersive world, diverse characters, elaborate puzzles, and strong connection to the series that has brought you so much pleasure.

Here we present artwork from the initial design stages to completed works, as well as comments from the development staff, and introduce items and elements connected with—and intrinsic to—*The Legend of Zelda*

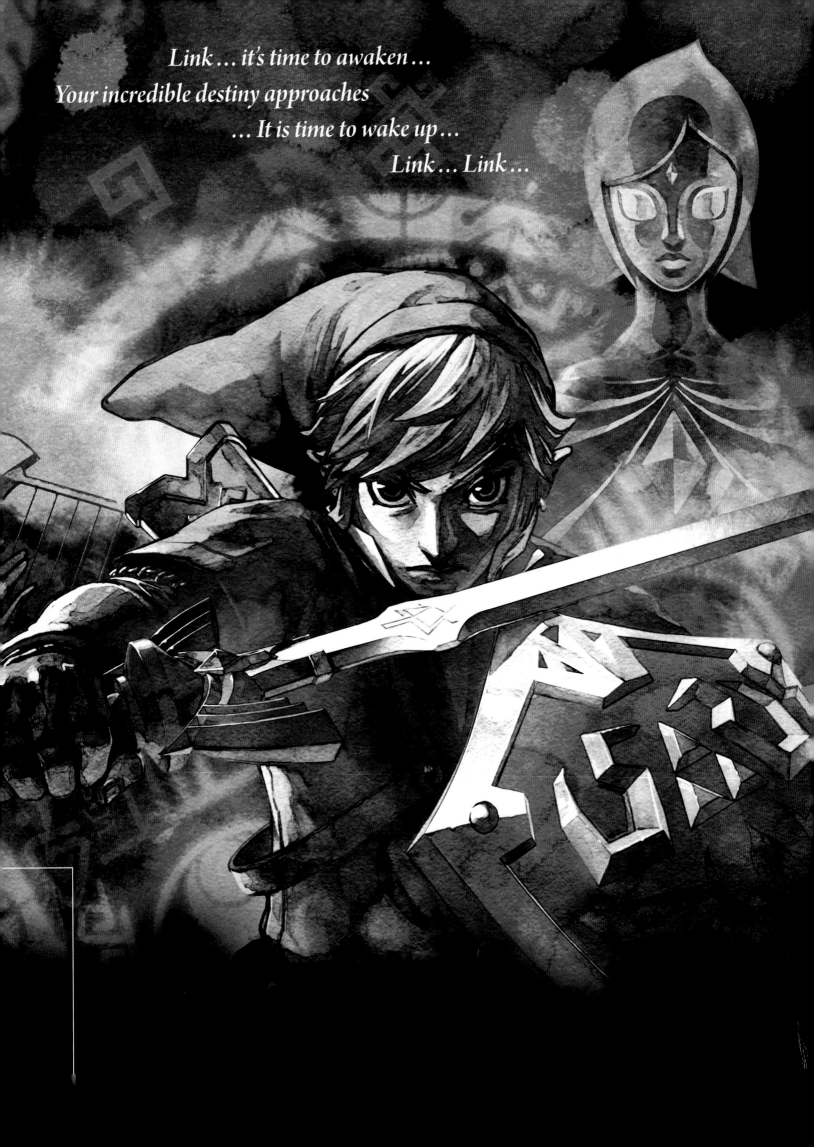

Link … it's time to awaken …
Your incredible destiny approaches
… It is time to wake up …
Link … Link …

THOSE WHO HOLD THE FATE OF THE WORLD IN THEIR HANDS

It was a time when people lived in the heavens, and a time far before the name Hyrule was even a thought. The followers of the goddess and those of evil gathered their numbers and battled it out.

The Link presented here is a mere seventeen and a half years old. He was designed as such—"halfway grown up, not fully matured"—in order to strike a thematic balance between this and *Twilight Princess*. His armament and attire remain mostly unchanged (with perhaps only the absence of arm guards). The expressions on his face are portrayed as slightly more comical and lighthearted than before, so that regardless of what expression he makes, the expressions themselves seem relatable. Additionally, there is a lot of interpersonal interaction in this installment, so the expressions became much richer.

— Kobayashi, designer

The Hero of the Skies raises his sword to the heavens.

LINK

A young boy who attends the knight academy at Skyloft. His search for Zelda will not only allow him to mature as a young man, but indeed, will introduce him to his destiny.

Design drafts

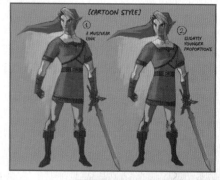

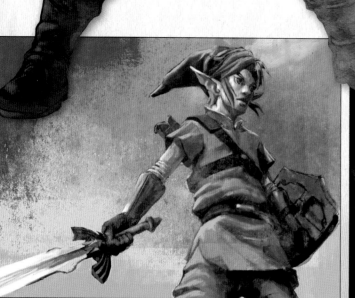

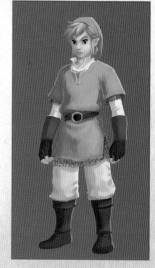

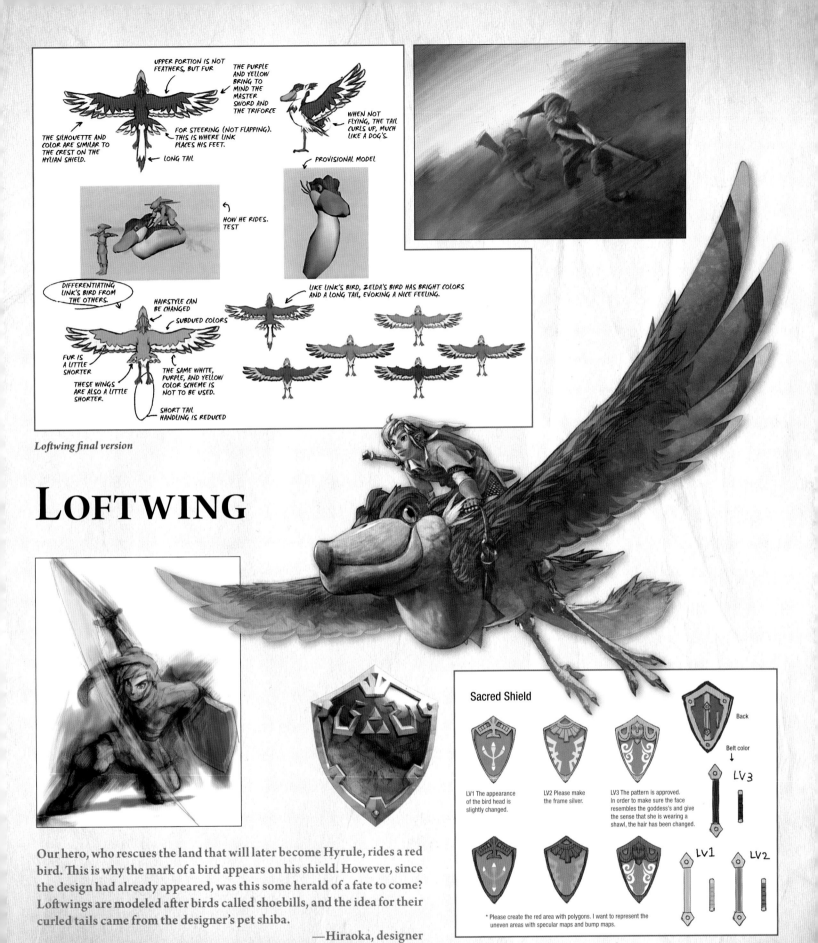

UPPER PORTION IS NOT FEATHERS, BUT FUR

THE PURPLE AND YELLOW BRING TO MIND THE MASTER SWORD AND THE TRIFORCE

THE SILHOUETTE AND COLOR ARE SIMILAR TO THE CREST ON THE HYLIAN SHIELD.

FOR STEERING (NOT FLAPPING). THIS IS WHERE LINK PLACES HIS FEET.

WHEN NOT FLYING, THE TAIL CURLS UP, MUCH LIKE A DOG'S.

LONG TAIL

PROVISIONAL MODEL

HOW HE RIDES. TEST

DIFFERENTIATING LINK'S BIRD FROM THE OTHERS.

LIKE LINK'S BIRD, ZELDA'S BIRD HAS BRIGHT COLORS AND A LONG TAIL, EVOKING A NICE FEELING.

HAIRSTYLE CAN BE CHANGED

SUBDUED COLORS

FUR IS A LITTLE SHORTER

THESE WINGS ARE ALSO A LITTLE SHORTER

THE SAME WHITE, PURPLE, AND YELLOW COLOR SCHEME IS NOT TO BE USED.

SHORT TAIL HANDLING IS REDUCED

Loftwing final version

LOFTWING

Our hero, who rescues the land that will later become Hyrule, rides a red bird. This is why the mark of a bird appears on his shield. However, since the design had already appeared, was this some herald of a fate to come? Loftwings are modeled after birds called shoebills, and the idea for their curled tails came from the designer's pet shiba.

—Hiraoka, designer

Sacred Shield

Back

Belt color

LV1 The appearance of the bird head is slightly changed.

LV2 Please make the frame silver.

LV3 The pattern is approved. In order to make sure the face resembles the goddess's and give the sense that she is wearing a shawl, the hair has been changed.

LV3

LV1 LV2

* Please create the red area with polygons. I want to represent the uneven areas with specular maps and bump maps.

Sacred Shield final version

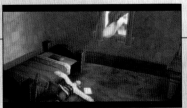

Skyward Sword

The Wind Waker

IS OUR HERO ALWAYS OVERSLEEPING?

The opening scenes of *Zelda* games often show Link sleeping. Is this a way of conveying the notion of a normal person waking up to the unknown and embarking on a hero's journey?

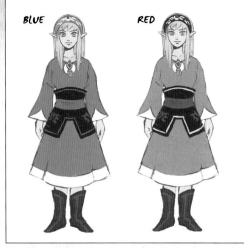

BLUE　　　RED

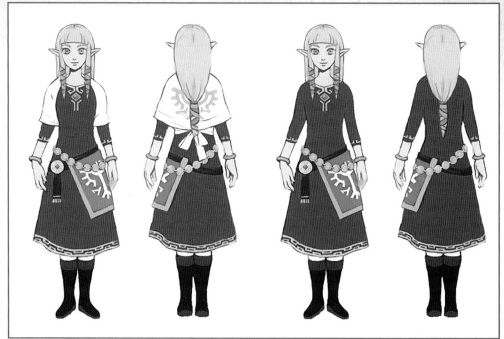

Rough illustration

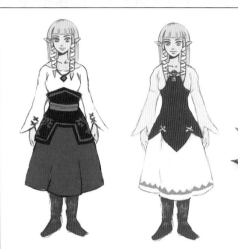

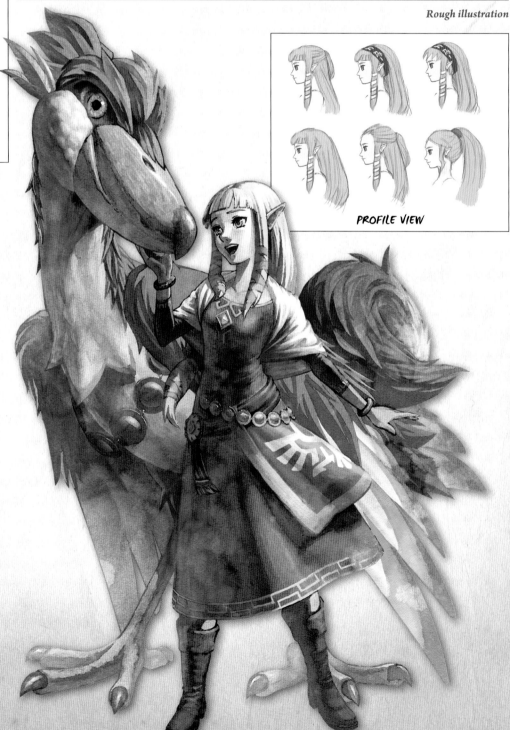

ZELDA

Much like Link, she is living a normal existence at the Knight Academy when she awakes to the destiny set in motion for her by the goddess. Joined by Impa on the surface world, they do what they must to ensure the safety of the land.

Zelda final version

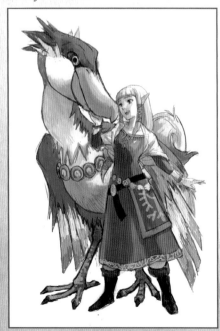

PROFILE VIEW

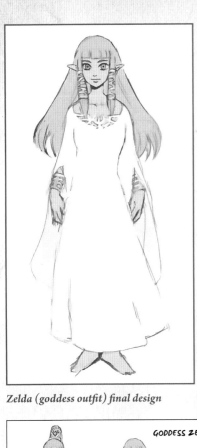

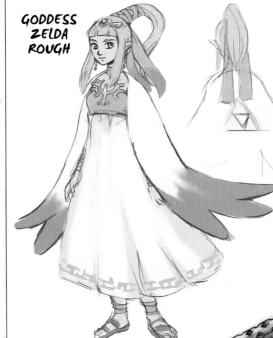

GODDESS
ZELDA
ROUGH

This time around she isn't a princess, so the first thing we did was remove any sort of regal ornamentation from her head. Afterward, her look was much too simple . . . We wanted her to look like a typical village girl, but we also wanted to establish her as a heroine at the same time, so this is what we decided upon. Her outfit is a pretty sky blue, and compared to previous iterations, we went with a dress that was more red than purple. We had a director who requested Goddess Zelda be dressed "simply, and in white."

—Hirono / Kobayashi, designers

Zelda (goddess outfit) final design

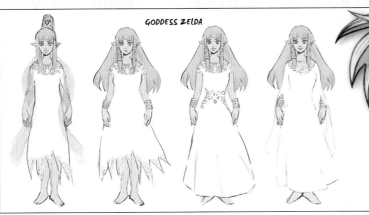

GODDESS ZELDA

When all this is over, will you come to wake me up?

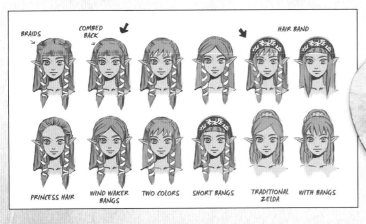

BRAIDS COMBED BACK HAIR BAND

PRINCESS HAIR WIND WAKER BANGS TWO COLORS SHORT BANGS TRADITIONAL ZELDA WITH BANGS

PRINCESS ZELDA AND THE GODDESS'S HARP
The harp in *Skyward Sword* looks a lot like Sheik's harp in *Ocarina of Time*. Could it be the same one . . . ?

Sheik, Ocarina of Time

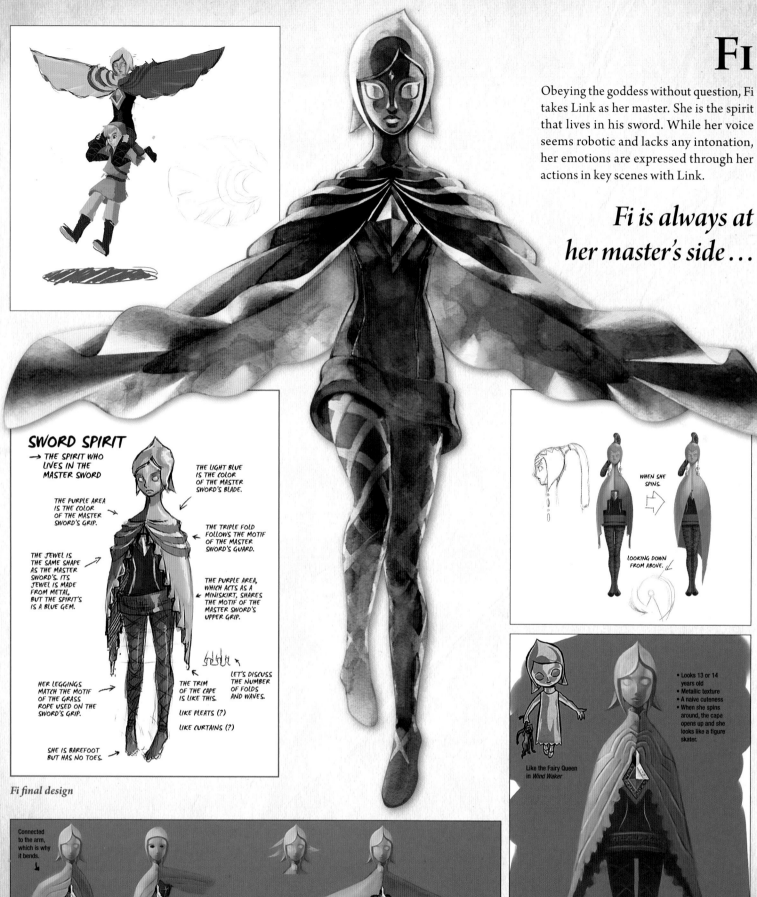

FI

Obeying the goddess without question, Fi takes Link as her master. She is the spirit that lives in his sword. While her voice seems robotic and lacks any intonation, her emotions are expressed through her actions in key scenes with Link.

Fi is always at her master's side...

SWORD SPIRIT

→ THE SPIRIT WHO LIVES IN THE MASTER SWORD

THE LIGHT BLUE IS THE COLOR OF THE MASTER SWORD'S BLADE.

THE PURPLE AREA IS THE COLOR OF THE MASTER SWORD'S GRIP.

THE TRIPLE FOLD FOLLOWS THE MOTIF OF THE MASTER SWORD'S GUARD.

THE JEWEL IS THE SAME SHAPE AS THE MASTER SWORD'S. ITS JEWEL IS MADE FROM METAL, BUT THE SPIRIT'S IS A BLUE GEM.

THE PURPLE AREA, WHICH ACTS AS A MINISKIRT, SHARES THE MOTIF OF THE MASTER SWORD'S UPPER GRIP.

HER LEGGINGS MATCH THE MOTIF OF THE GRASS ROPE USED ON THE SWORD'S GRIP.

THE TRIM OF THE CAPE IS LIKE THIS.

LET'S DISCUSS THE NUMBER OF FOLDS AND WAVES.

LIKE PLEATS (?)

LIKE CURTAINS (?)

SHE IS BAREFOOT BUT HAS NO TOES.

Fi final design

WHEN SHE SPINS.

LOOKING DOWN FROM ABOVE.

• Looks 13 or 14 years old
• Metallic texture
• A naive cuteness
• When she spins around, the cape opens up and she looks like a figure skater.

Like the Fairy Queen in *Wind Waker*

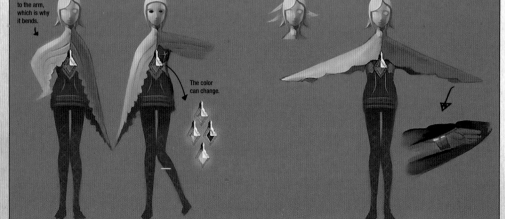

Connected to the arm, which is why it bends.

The color can change.

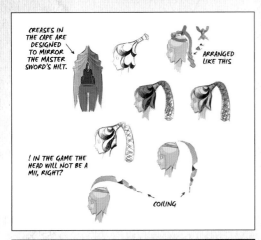

CREASES IN THE CAPE ARE DESIGNED TO MIRROR THE MASTER SWORD'S HILT.

ARRANGED LIKE THIS

! IN THE GAME THE HEAD WILL NOT BE A MII, RIGHT?

COILING

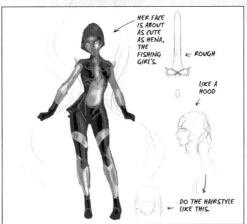

HER FACE IS ABOUT AS CUTE AS HENA, THE FISHING GIRL'S.

ROUGH

LIKE A HOOD

DO THE HAIRSTYLE LIKE THIS.

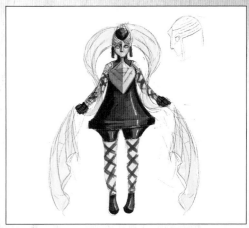

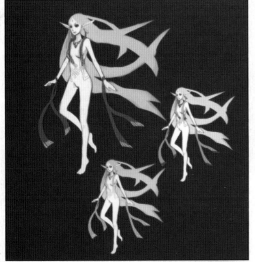

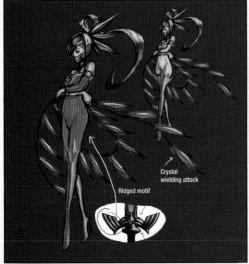

Ridged motif

Crystal wielding attack

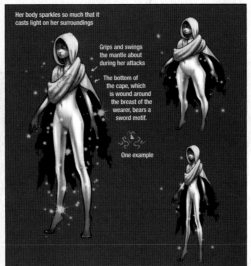

Her body sparkles so much that it casts light on her surroundings

Grips and swings the mantle about during her attacks

The bottom of the cape, which is wound around the breast of the wearer, bears a sword motif.

One example

Since the spirit of the Goddess Sword would eventually become the Master Sword, there were many design components taken from the Master Sword and implemented as motifs here. Additionally, at the beginning, we had imagined this à la 1980s anime, in which the main character was usually accompanied by a beautiful personal assistant. There were so many designs, from the robot to the lady cat burglar, but once we saw the *Wind Waker* inspired design, we came to a unanimous decision.

—Kobayashi, designer

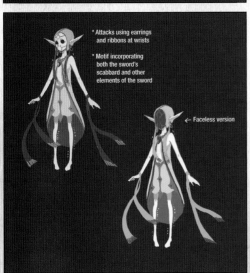

Attacks using earrings and ribbons at wrists

Motif incorporating both the sword's scabbard and other elements of the sword

← Faceless version

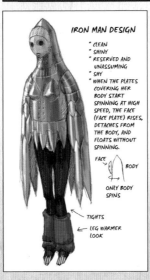

IRON MAN DESIGN

* CLEAN
* SHINY
* RESERVED AND UNASSUMING
* SHY
* WHEN THE PLATES COVERING HER BODY START SPINNING AT HIGH SPEED, THE FACE (FACE PLATE) RISES, DETACHES FROM THE BODY, AND FLOATS WITHOUT SPINNING.

FACE
BODY

ONLY BODY SPINS

TIGHTS

LEG WARMER LOOK

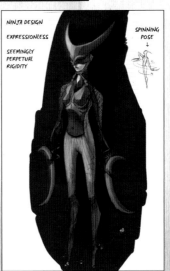

NINJA DESIGN

EXPRESSIONLESS

SEEMINGLY PERPETUAL RIGIDITY

SPINNING POSE

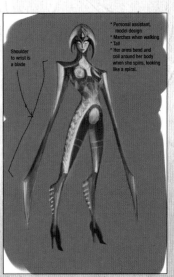

* Personal assistant, model design
* Marches when walking
* Tall
* Her arms bend and coil around her body when she spins, looking like a spiral.

Shoulder to wrist is a blade

Ghirahim sword design

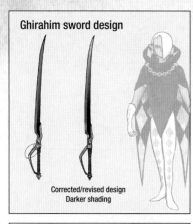

Corrected/revised design
Darker shading

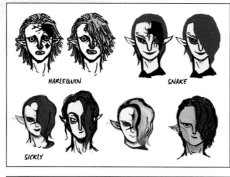

HARLEQUIN SNAKE

SICKLY

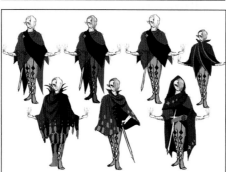

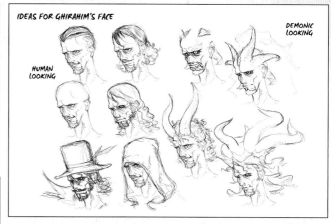

HUMAN LOOKING

DEMONIC LOOKING

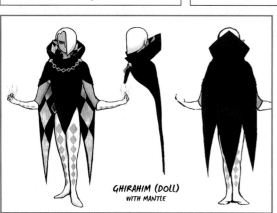

GHIRAHIM

A demonic being that relentlessly pursues Zelda for one reason: To use her spirit to resurrect his master, the Demon King Demise.

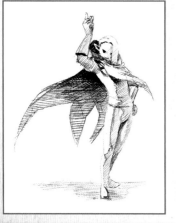

Ghirahim's weapon (knife) color

GHIRAHIM (DOLL)
WITH MANTLE

Ghirahim (cape) final version

Rough illustration

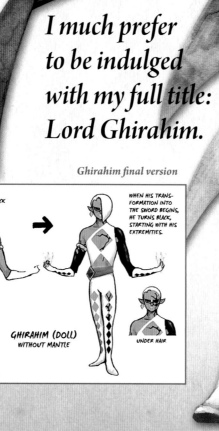

I much prefer to be indulged with my full title: Lord Ghirahim.

Ghirahim final version

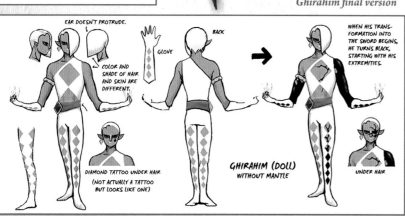

EAR DOESN'T PROTRUDE.

GLOVE

BACK

COLOR AND SHADE OF HAIR AND SKIN ARE DIFFERENT.

WHEN HIS TRANSFORMATION INTO THE SWORD BEGINS, HE TURNS BLACK, STARTING WITH HIS EXTREMITIES.

DIAMOND TATTOO UNDER HAIR
(NOT ACTUALLY A TATTOO BUT LOOKS LIKE ONE)

GHIRAHIM (DOLL)
WITHOUT MANTLE

UNDER HAIR

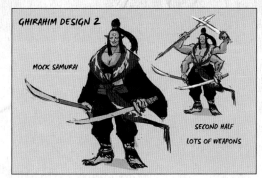

GHIRAHIM DESIGN 2

MOCK SAMURAI

SECOND HALF
LOTS OF WEAPONS

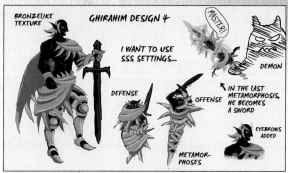

BRONZELIKE TEXTURE

GHIRAHIM DESIGN 4

MISTER!

I WANT TO USE SSS SETTINGS...

DEMON

DEFENSE

OFFENSE

IN THE LAST METAMORPHOSIS, HE BECOMES A SWORD

EYEBROWS ADDED

METAMOR-PHOSES

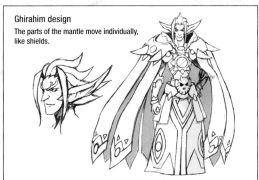

Ghirahim design

The parts of the mantle move individually, like shields.

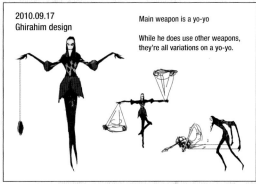

2010.09.17
Ghirahim design

Main weapon is a yo-yo

While he does use other weapons, they're all variations on a yo-yo.

2010.09.10
Ghirahim design

Not clothing, but body fur

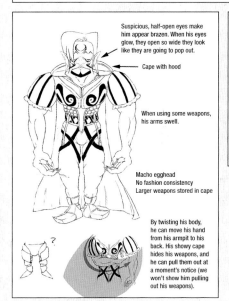

Suspicious, half-open eyes make him appear brazen. When his eyes glow, they open so wide they look like they are going to pop out.

Cape with hood

When using some weapons, his arms swell.

Macho egghead
No fashion consistency
Larger weapons stored in cape

By twisting his body, he can move his hand from his armpit to his back. His showy cape hides his weapons, and he can pull them out at a moment's notice (we won't show him pulling out his weapons).

Ghirahim design

* Suffers from lack of sleep due to perpetual worship of Demise. The bags under his eyes never go away.
* He always dresses up. He loves jewelry.
* The color changes depending on his mood, making it easy to see if he is angry, using hypnosis, etc.
* He summons his weapons from another dimension using black magic.
* His appearance is reminiscent of a magician

When hypnotizing

TA-DA!

Angry

Gentle version

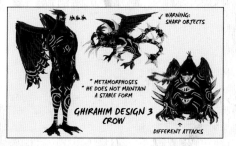

WARNING: SHARP OBJECTS

* METAMORPHOSES
* HE DOES NOT MAINTAIN A STABLE FORM

GHIRAHIM DESIGN 3
CROW

DIFFERENT ATTACKS

Upon the completion of design 4, we'd pretty much firmed up Ghirahim's look. First, we decided that we wanted him to be around the same age as Link and act as a contrasting counterpart to Fi, and through this, the design of the evil sword spirit gradually revealed itself. His third form had textured diamonds all over his body that would reflect light.
—Hirono / Kinouchi / Kaneko, designers

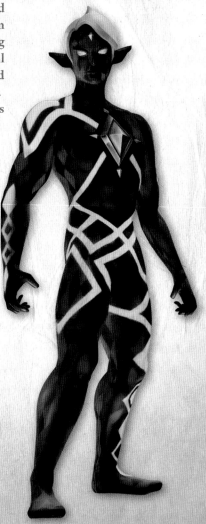

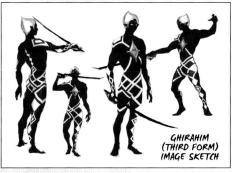

GHIRAHIM
(THIRD FORM)
IMAGE SKETCH

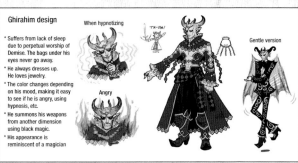

Ghirahim (third form) final version

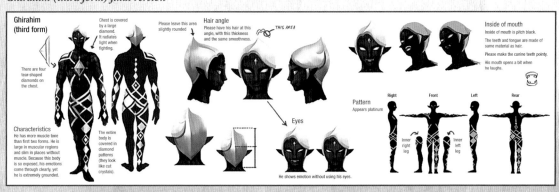

Ghirahim
(third form)

There are four tear-shaped diamonds on the chest.

Characteristics
He has more muscle tone than first two forms. He is large in muscular regions and slim in places without muscle. Because this body is so exposed, his emotions come through clearly, yet he is extremely grounded.

The entire body is covered in diamond patterns (they look like cut crystals).

Chest is covered by a large diamond. It radiates light when fighting.

Please leave this area slightly rounded

Hair angle
Please have his hair at this angle, with this thickness and the same smoothness.

THIS AREA

Eyes

He shows emotion without using his eyes.

Inside of mouth
Inside of mouth is pitch black.

The teeth and tongue are made of same material as hair.

Please make the canine teeth pointy.

His mouth opens a bit when he laughs.

Pattern
Appears platinum

Right

Front

Left

Rear

Inner right leg

Inner left leg

IMPA

Whether in the past or the present, she appears to do one thing only: protect Zelda. Sometimes, this requires fighting, and sometimes, merely watching and waiting.

For young Impa we referenced Impa and Sheik from *Ocarina of Time*. We also gave her an androgynous look, like a male role in an opera. The aging Impa's costume also follows the passage of time, and her entire body is dressed to reflect that. Her pendulum braid measures time, ticking away the seconds, and the entire triangular robe she wears becomes a sundial, with her age being measured by the braids in her hair.

—Kaneko, designer

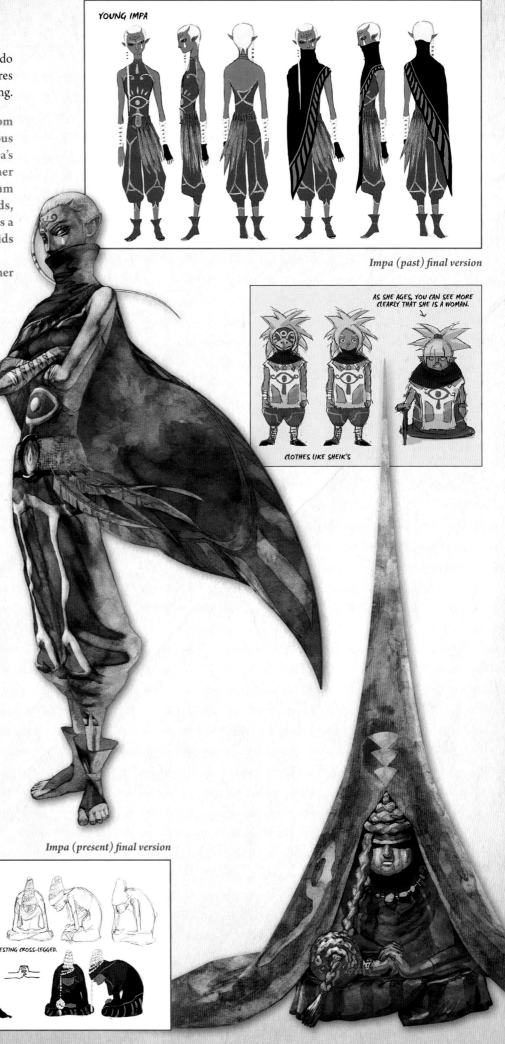

Impa (present) final version

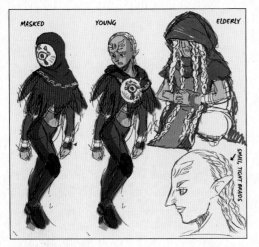

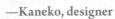

MASKED YOUNG ELDERLY

SMALL, TIGHT BRAIDS

OVERWEIGHT UNDERWEIGHT

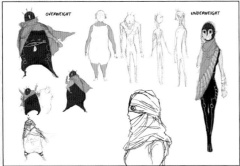

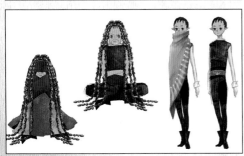

YOUNG IMPA

Impa (past) final version

AS SHE AGES, YOU CAN SEE MORE CLEARLY THAT SHE IS A WOMAN.

CLOTHES LIKE SHEIK'S

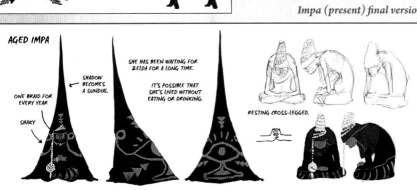

AGED IMPA

ONE BRAID FOR EVERY YEAR

SHADOW BECOMES A SUNDIAL.

SHE HAS BEEN WAITING FOR ZELDA FOR A LONG TIME.

IT'S POSSIBLE THAT SHE'S LIVED WITHOUT EATING OR DRINKING.

RESTING CROSS-LEGGED.

SHAKY

THE IMPRISONED AND DEMISE

The root of all evil. Wielding enough power to bring the world to ruin.

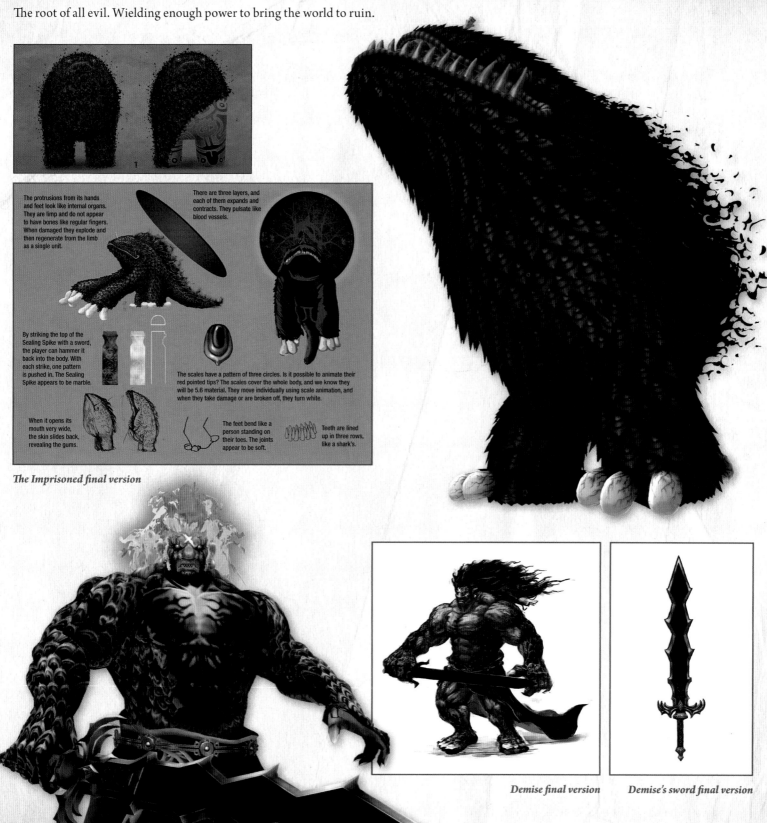

The protrusions from its hands and feet look like internal organs. They are limp and do not appear to have bones like regular fingers. When damaged they explode and then regenerate from the limb as a single unit.

There are three layers, and each of them expands and contracts. They pulsate like blood vessels.

By striking the top of the Sealing Spike with a sword, the player can hammer it back into the body. With each strike, one pattern is pushed in. The Sealing Spike appears to be marble.

The scales have a pattern of three circles. Is it possible to animate their red pointed tips? The scales cover the whole body, and we know they will be 5.6 material. They move individually using scale animation, and when they take damage or are broken off, they turn white.

When it opens its mouth very wide, the skin slides back, revealing the gums.

The feet bend like a person standing on their toes. The joints appear to be soft.

Teeth are lined up in three rows, like a shark's.

The Imprisoned final version

Demise final version

Demise's sword final version

With the only instructions that it should be enormous and that "its vulnerability is on its head," we were allowed to design the Imprisoned as we pleased. Its design looks more like a *kaiju* than a monster. Trying to show the impressive presence and the overwhelming power of Demise, we drew him again and again until we got it right. To give him some resemblance to Ganondorf, we didn't just make his hair red, but set it on fire. (*laughs*) His sword looks like a black Master Sword.

—Kinouchi, designer

HUMANS IN THE HEAVENS AND THE TRIBES BELOW

In the sky, where Link and the humans live, the surface world is only a legend. Similarly, amongst tribes like the Goron and the Kikwi on the Surface, there are legends of a great landmass that floats in the sky.

This time around, the game maps were kept relatively simple. We challenged ourselves to allow the player quick and easy access between each area. The planners also wanted to let the player jump from a high place and skydive into each area. There was a time when we considered placing a lake near the center of the land, too.

—Fujibayashi, director

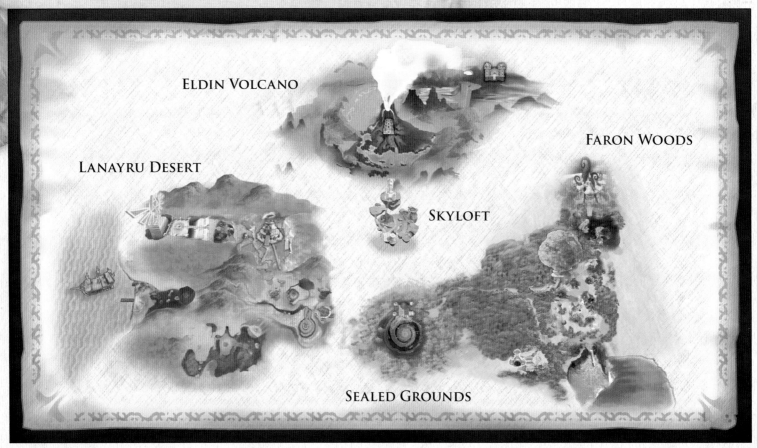

ELDIN VOLCANO

FARON WOODS

LANAYRU DESERT

SKYLOFT

SEALED GROUNDS

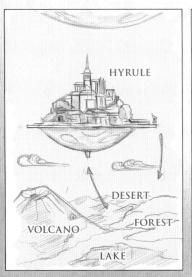

HYRULE

DESERT

VOLCANO

FOREST

LAKE

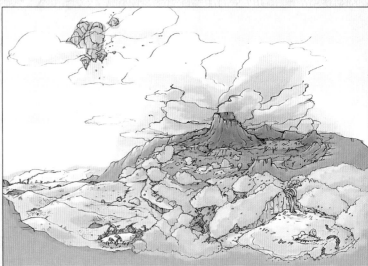

Illustrations and discarded plans

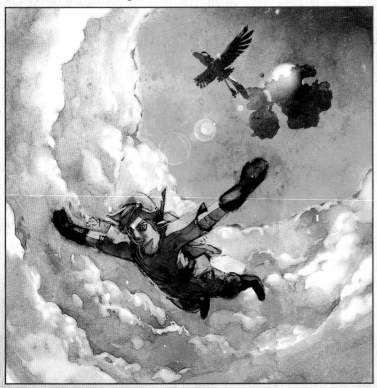

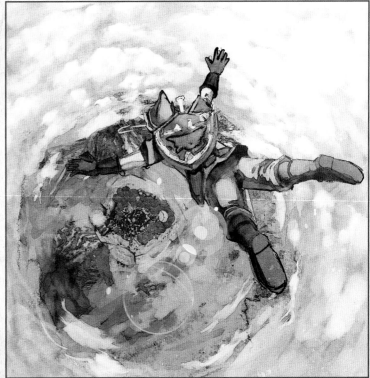

THE TWO SIDES OF THE WORLD

In the *Legend of Zelda* series, there are many titles where Link travels between two different worlds. There are worlds of light and dark, light and twilight, past and future, and, of course, sky and surface. Link is oftentimes responsible for connecting two very different worlds.

SKYLOFT AND THE ISLANDS IN THE SKY

All human beings live on floating islands in the sky. The islands are so high in the air that the only birds that can reach them are Loftwings. Their isolation allows the humans to worship their goddess and live in peace.

Having Skyloft floating in the air was such a fantastical idea that we didn't try to design the city realistically. The shading and ornamentation on the buildings were designed and created based on the keywords "sky, wind, and peace." Also, given the incredible altitude of the sky world, Loftwings are the only birds that exist there. That's why it is surprising to the humans to see smaller birds on the Surface.

—Hisada, designer

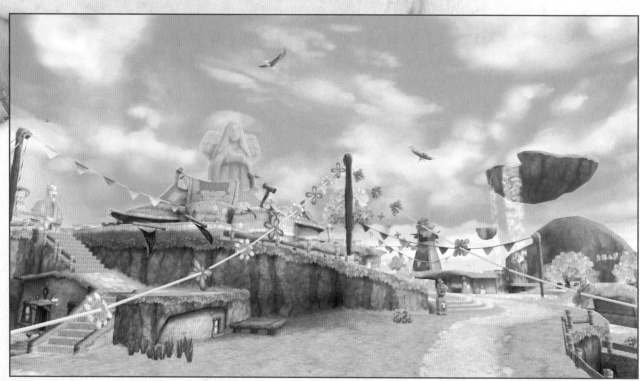

Skyloft official visual

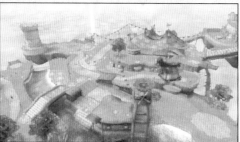

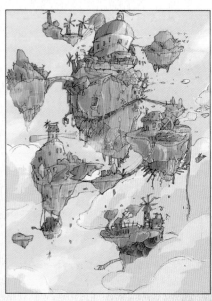

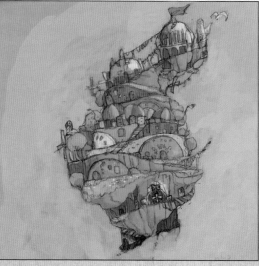

Smaller islands are connected to Skyloft by narrow bridges, and the difference in elevation between the islands can be rather extreme, so there were a lot of drafts in Skyloft's design. In the design on the far left, you can see a structure similar to a castle.

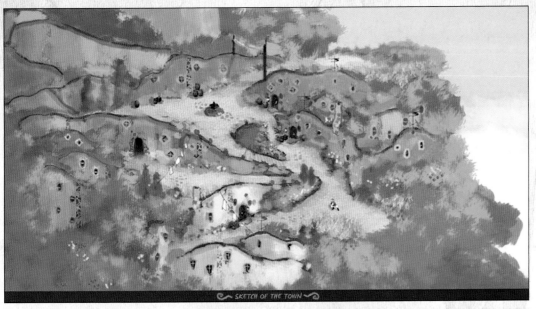

SKETCH OF THE TOWN

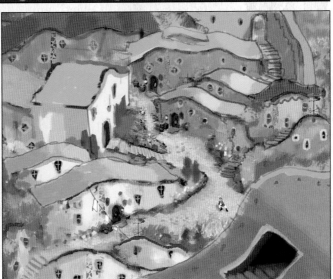

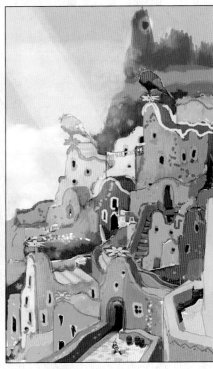

TOWNSCAPE

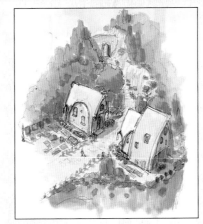

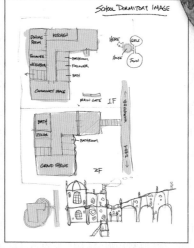

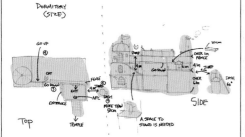

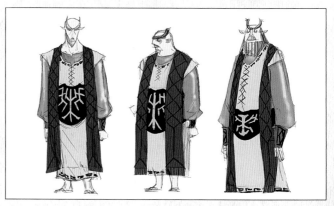

KNIGHT ACADEMY

When we were thinking about making a tutorial for the game (which later became the Wing Ceremony section), we wanted to create three rivals for Link. They eventually became the gang of three bullies, and that then expanded into the idea of a school. Gaepora is the wisest and most knowledgeable person in Skyloft, so naturally we made him the headmaster of the academy.

—Iwamoto, planner / Kaneko, designer

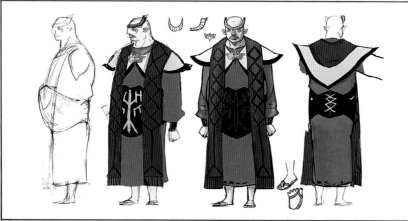

Headmaster Gaepora final version

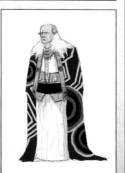

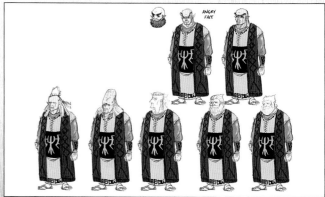

DORMITORY HOUSEMOTHER

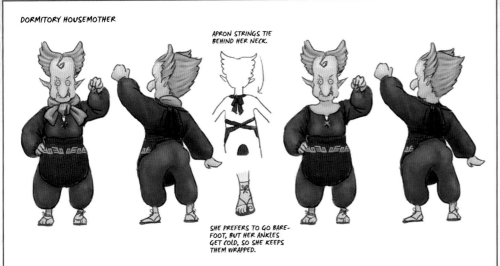

APRON STRINGS TIE BEHIND HER NECK.

SHE PREFERS TO GO BARE-FOOT, BUT HER ANKLES GET COLD, SO SHE KEEPS THEM WRAPPED.

ISLAND RESIDENT 4

LITTLE OLD LADY WHO IS KIND TO THE DORMITORY STUDENTS. (SISTER OF A STUDENT'S GRANDMOTHER)

SHE THINKS THE STUDENTS ARE CUTE, SO SHE MAKES IT A POINT TO SWING BY THE DORMITORY ON HER DAILY WALK TO CHECK IN ON THEM.

Dormitory housemother

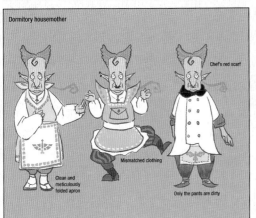

Dormitory housemother

Chef's red scarf

Clean and meticulously folded apron

Mismatched clothing

Only the pants are dirty

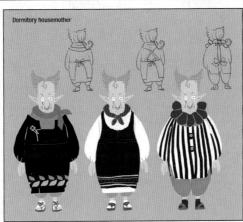

Dormitory housemother

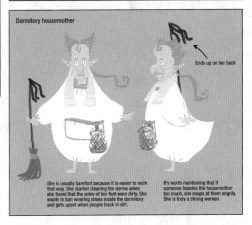

Dormitory housemother

Ends up on her back

She is usually barefoot because it is easier to work that way. She started cleaning the dorms when she found that the soles of her feet were dirty. She wants to ban wearing shoes inside the dormitory and gets upset when people track in dirt.

It's worth mentioning that if someone hassles the housemother too much, she snaps at them angrily. She is truly a strong woman.

In the beginning it was decided that all residents of Skyloft would be modeled after birds. That's where the idea to give Henya a rooster's body came from. Groose's pointy hairstyle was inspired by a rooster's comb. Owlan's and Horwell's designs were based on the Rito tribe from *The Wind Waker*.

—Hirono, designer

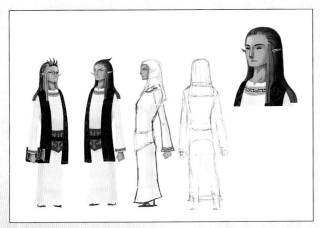

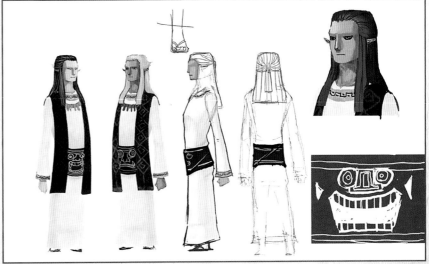

Horwell and Owlan final versions

The hand in the toilet from Oracle of Ages

I NEED PAPER...

It has been said that if you listen closely at the door of the Knight Academy at night, you can hear a woman's voice calling, "I need paper . . ." A similar story also plays out in *Majora's Mask* and *Oracle of Ages* and may have its roots in traditional ghost stories.

STUDENTS OF THE KNIGHT ACADEMY

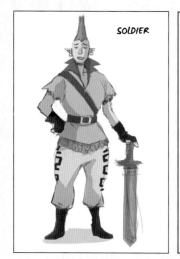

SOLDIER

Groose final version

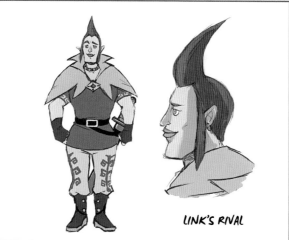

LINK'S RIVAL

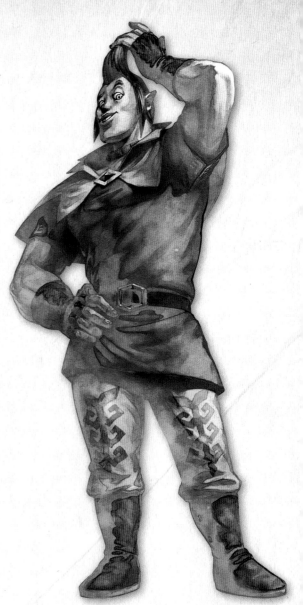

SNOBBY

HERE WE ARE!!

LINK IS ABOUT THIS TALL

HUNCHBACKED

Cawlin and Strich final versions

Rough illustration

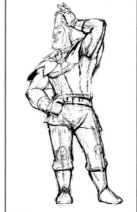

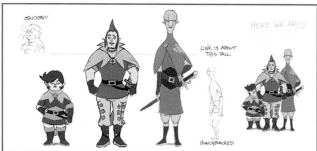

He may look a little rough around the edges, but Groose engineered a massive, railed weapon that was instrumental in helping Link defeat the Imprisoned and defend the Sealed Temple. Groose has a lot of training equipment in his room, and I think he's probably a hard-working and surprisingly skilled kid. He also acts like the leader of the kids in the dormitory, and has invaded Cawlin and Strich's room.

—Hirono, designer

Fledge final version

HONOR STUDENT

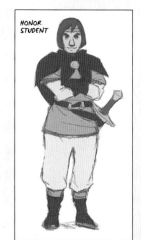

HIS MOST ATTRACTIVE FEATURE IS THE NAPE OF HIS NECK.

THE TIPS OF HIS FINGERS ARE A LITTLE RED.

LARGE REAR

DORMITORY STUDENTS

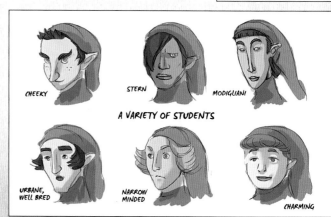

CHEEKY

STERN

MODIGLIANI

A VARIETY OF STUDENTS

URBANE, WELL BRED

NARROW MINDED

CHARMING

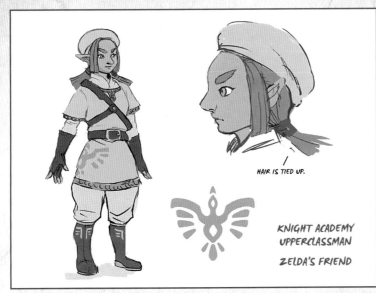

HAIR IS TIED UP.

KNIGHT ACADEMY
UPPERCLASSMAN

ZELDA'S FRIEND

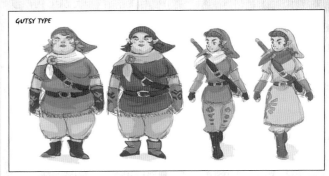

GUTSY TYPE

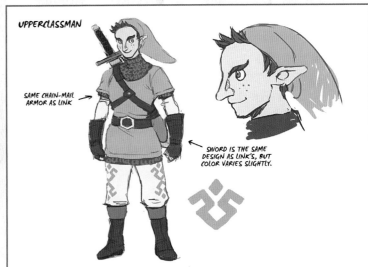

UPPERCLASSMAN

SAME CHAIN-MAIL
ARMOR AS LINK

SWORD IS THE SAME
DESIGN AS LINK'S, BUT
COLOR VARIES SLIGHTLY.

Pipit final version

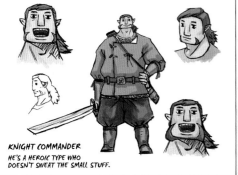

KNIGHT COMMANDER
HE'S A HEROIC TYPE WHO
DOESN'T SWEAT THE SMALL STUFF.

Eagus final version

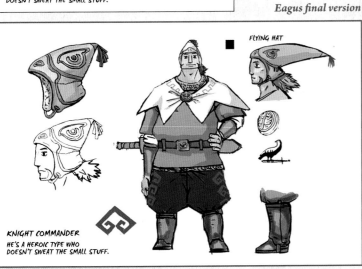

FLYING HAT

KNIGHT COMMANDER
HE'S A HEROIC TYPE WHO
DOESN'T SWEAT THE SMALL STUFF.

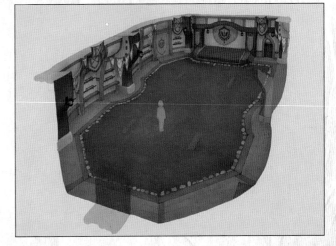

SPARRING HALL

Ocarina of Time 3D

SHEIKAH STONE AND GOSSIP STONE

One of the Sheikah Stones lives between the Sparring Hall and the Knight Academy. He is easy to dismiss, but his hints are very valuable. The Gossip Stones that dot the surface world hold rare information just like in *Ocarina of Time*.

Market Plan

Market Zoning

The plan is to combine convenience with mentally stimulating visual effects. Things like the width of the road and the elevation are varied to keep the Bazaar fun and interesting.

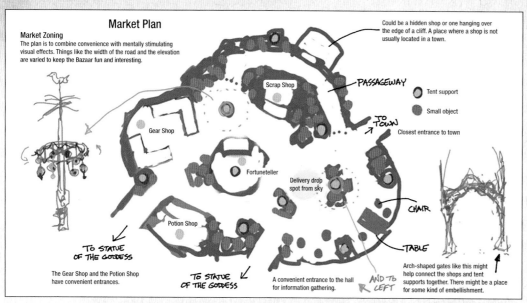

Could be a hidden shop or one hanging over the edge of a cliff. A place where a shop is not usually located in a town.

Scrap Shop

Gear Shop

PASSAGEWAY

TO TOWN

Closest entrance to town

● Tent support

● Small object

Fortuneteller

Delivery drop spot from sky

CHAIR

TABLE

TO STATUE OF THE GODDESS

TO STATUE OF THE GODDESS

AND TO R LEFT

Potion Shop

The Gear Shop and the Potion Shop have convenient entrances.

A convenient entrance to the hall for information gathering.

Arch-shaped gates like this might help connect the shops and tent supports together. There might be a place for some kind of embellishment.

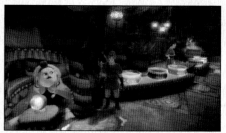

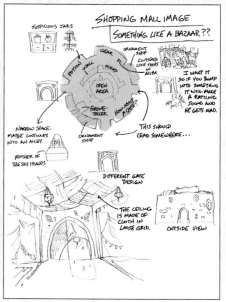

SUSPICIOUS JARS

SHOPPING MALL IMAGE
SOMETHING LIKE A BAZAAR??

ORNAMENT SHOP
CLUTTERED LIKE SHOPS IN ASIA

I WANT IT SO IF YOU BUMP INTO SOMETHING IT WILL MAKE A RATTLING SOUND AND HE GETS MAD.

NARROW SPACE. MAYBE CONTINUES INTO AN ALLEY.

MOTHER OF THE SKY ISLANDS

ORNAMENT SHOP

THIS SHOULD LEAD SOMEWHERE...

DIFFERENT GATE DESIGN

THE CEILING IS MADE OF CLOTH IN LOOSE GRID.

OUTSIDE VIEW

BAZAAR

When the player returns to Skyloft after an adventure and prepares for the next one, it's inconvenient if all the shops are in different locations, so we decided to design a centralized town-market model. Did you notice the different music in each shop?

—Fujibayashi, director
Hisada, designer

FORTUNETELLER

SINCE THERE IS NO OVERHEAD, HE IS VERY PROFITABLE.

IS COZY WITH THE GEAR SHOP OWNER.

IS ALWAYS KNEELING WITH TOP OF FEET FLAT ON FLOOR.

IT IS NOT BLACK BUT A BURNT BROWN

Sparrot (fortuneteller) final version

Scrap Shop design
Market's Scrap Shop design 01

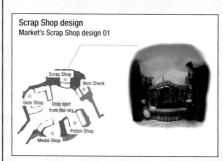

Scrap Shop

Item Check

Gear Shop

Drop spot from the sky

Potion Shop

Medal Shop

Gondo (Scrap Shop) final version

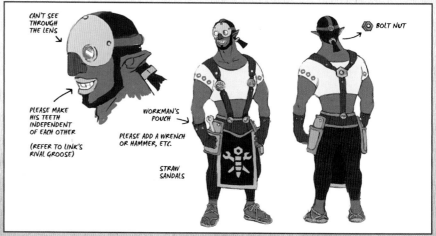

CAN'T SEE THROUGH THE LENS

BOLT NUT

PLEASE MAKE HIS TEETH INDEPENDENT OF EACH OTHER

(REFER TO LINK'S RIVAL GROOSE)

WORKMAN'S POUCH

PLEASE ADD A WRENCH OR HAMMER, ETC.

STRAW SANDALS

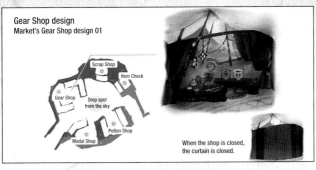

Gear Shop design
Market's Gear Shop design 01

Scrap Shop

Item Check

Gear Shop

Drop spot from the sky

Potion Shop

Medal Shop

When the shop is closed, the curtain is closed.

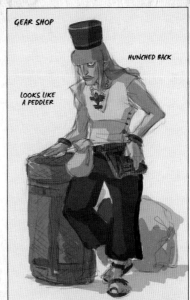

GEAR SHOP

LOOKS LIKE A PEDDLER

HUNCHED BACK

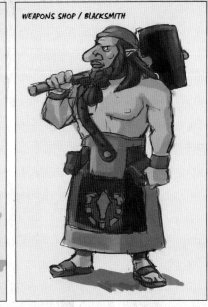

WEAPONS SHOP / BLACKSMITH

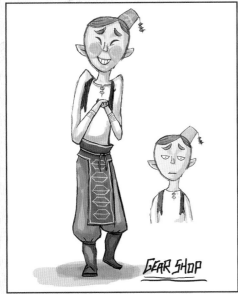

GEAR SHOP

Rupin (Gear Shop) final version

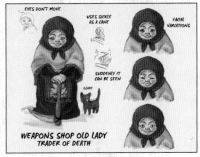

EYES DON'T MOVE

USES SICKLE AS A CANE

FACIAL VARIATIONS

SUDDENLY IT CAN BE SEEN

WEAPONS SHOP OLD LADY
TRADER OF DEATH

There were funny ideas like making deals to stir up business at the fortuneteller's shop behind the Gear Shop or making characters related. I was especially attracted to the weapons shop, the blacksmith, and the Scrap Shop.

—Oyama, designer

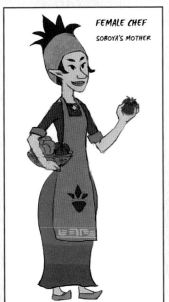

FEMALE CHEF
SOBOYA'S MOTHER

ISLAND RESIDENT 5

SO WOMAN'S COUSIN

SHE WORKS PART TIME AS A WAITRESS AT THE CAFE.

SHE LIVES AN ACTIVE LIFESTYLE AND HER DREAM IS TO SAVE MONEY FROM HER WAITRESS JOB TO TRAVEL AROUND THE ISLANDS.

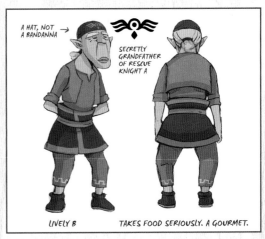

A HAT, NOT A BANDANNA →

SECRETLY GRANDFATHER OF RESCUE KNIGHT A

LIVELY B

TAKES FOOD SERIOUSLY. A GOURMET.

Gourmet Dovos final version

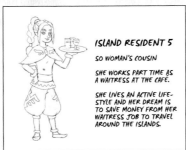

Café chef Piper final version

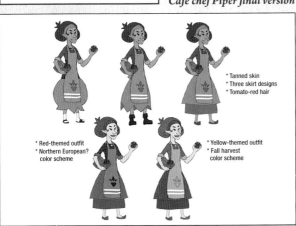

* Tanned skin
* Three skirt designs
* Tomato-red hair

* Red-themed outfit
* Northern European? color scheme

* Yellow-themed outfit
* Fall harvest color scheme

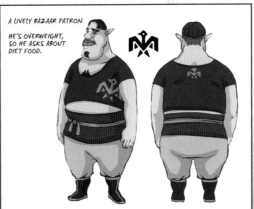

A LIVELY BAZAAR PATRON

HE'S OVERWEIGHT, SO HE ASKS ABOUT DIET FOOD.

Café patron Croo final version

POTION SHOP 10

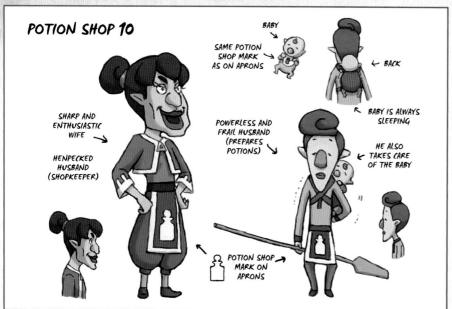

BABY →

SAME POTION SHOP MARK AS ON APRONS

← BACK

SHARP AND ENTHUSIASTIC WIFE →

HENPECKED HUSBAND (SHOPKEEPER)

POWERLESS AND FRAIL HUSBAND (PREPARES POTIONS)

BABY IS ALWAYS SLEEPING

HE ALSO TAKES CARE OF THE BABY

POTION SHOP MARK ON APRONS

Potion Shop couple Luv and Bertie final versions

POTION SHOP

ROLLING ROLLING

A STOPPER THAT CAN BE PLUGGED OR UNPLUGGED FROM THE INSIDE

POTION SHOP 1

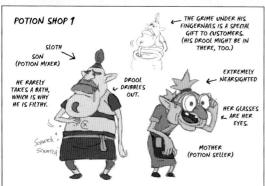

THE GRIME UNDER HIS FINGERNAILS IS A SPECIAL GIFT TO CUSTOMERS. (HIS DROOL MIGHT BE IN THERE, TOO.)

SLOTH SON (POTION MIXER)

HE RARELY TAKES A BATH, WHICH IS WHY HE IS FILTHY.

DROOL DRIBBLES OUT.

EXTREMELY NEARSIGHTED

HER GLASSES ARE HER EYES.

MOTHER (POTION SELLER)

SCRATCH SCRATCH

POTION SHOP TWINS

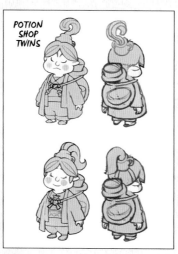

Originally we were going to have one shopkeeper in each shop. We hadn't decided on the details for the Potion Shop keeper and the Item Check keeper, so we asked for sketches from five different designers. As we discussed them, we expanded on the best ideas and fleshed out the characters. There were so many times I thought, "If we don't use this, it will be a real waste!" We were able to work it out so some of those characters were used in other places.

—Hirono, designer

Potion Shop
(Bosom buddy twins)

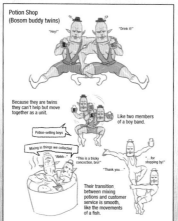

"Hey!"

"Drink it!"

Because they are twins they can't help but move together as a unit.

Potion-selling boys

Like two members of a boy band.

Mixing in things we collected

"Ahhh—"

"This is a tricky concoction, bro!"

"...for stopping by!"

"Thank you..."

Their transition between mixing potions and customer service is smooth, like the movements of a fish.

POTION SHOP
OLD MAN DESIGN

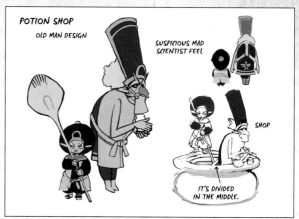

SUSPICIOUS MAD SCIENTIST FEEL

SHOP

IT'S DIVIDED IN THE MIDDLE.

Potion Shop

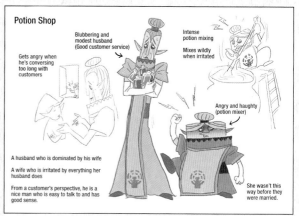

Blubbering and modest husband (Good customer service)

Gets angry when he's conversing too long with customers

Intense potion mixing

Mixes wildly when irritated

Angry and haughty (potion mixer)

A husband who is dominated by his wife

A wife who is irritated by everything her husband does

From a customer's perspective, he is a nice man who is easy to talk to and has good sense.

She wasn't this way before they were married.

POTION SHOPKEEPER IDEA

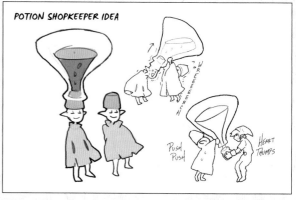

PUSH PUSH

HEART THUMPS

Potion Shop
(They are twins)

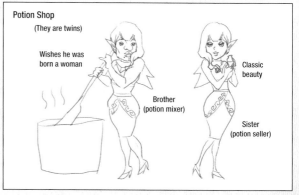

Wishes he was born a woman

Brother (potion mixer)

Classic beauty

Sister (potion seller)

POTION SHOP 3

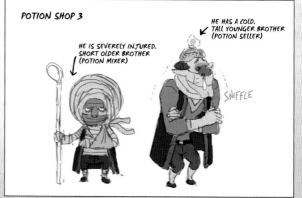

HE HAS A COLD. TALL YOUNGER BROTHER (POTION SELLER)

HE IS SEVERELY INJURED. SHORT OLDER BROTHER (POTION MIXER)

SNIFFLE

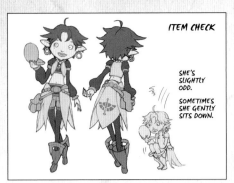

ITEM CHECK

SHE'S SLIGHTLY ODD.

SOMETIMES SHE GENTLY SITS DOWN.

ITEM CHECK

ENNUI

BEFORE LONG, SHE GETS BORED AND BECOMES ABSORBED IN HER KNITTING.

DROPPING OFF? PICKING UP?

SQUAK

WHAT DO YOU WANT TO LEAVE?

FRONT FACE (HUMAN FACE) SEEMS FRIENDLY.

THE REAR FACE (BIRD FACE) SEEMS STRICT.

SHE'S A MYSTERIOUS CHILD.

RUNS IN CIRCLES AROUND THE SHOP

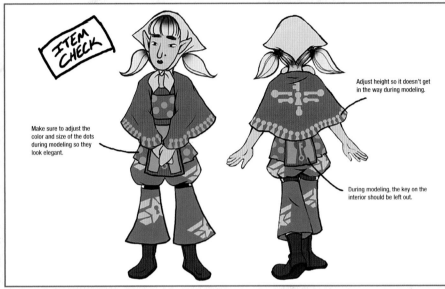

ITEM CHECK

Make sure to adjust the color and size of the dots during modeling so they look elegant.

Adjust height so it doesn't get in the way during modeling.

During modeling, the key on the interior should be left out.

Item Check keeper Peatrice final version

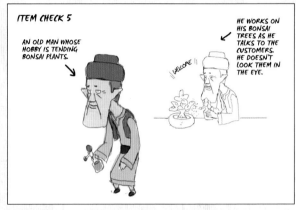

ITEM CHECK 5

AN OLD MAN WHOSE HOBBY IS TENDING BONSAI PLANTS.

WELCOME

HE WORKS ON HIS BONSAI TREES AS HE TALKS TO THE CUSTOMERS. HE DOESN'T LOOK THEM IN THE EYE.

Item Check

Absorbed in making card houses

She asks customers to hold their breath if they get close.

Item Check

He inadvertently started collecting cats. He looks more and more like a child. He isn't interested in customers as much as being a parent to his kittens.

He can make idle chitchat but generally ignores the customers to be with his cats.

Caring for the cats comes before customer service.

The cats have also taken a liking to Link. It would be nice if the cats could have some effect on helping the player heal and recover, but that might be more effort than it's worth.

Unused Bazaar character

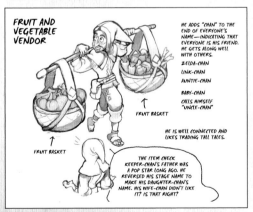

FRUIT AND VEGETABLE VENDOR

HE ADDS "CHAN" TO THE END OF EVERYONE'S NAME—INDICATING THAT EVERYONE IS HIS FRIEND. HE GETS ALONG WELL WITH OTHERS.

ZELDA-CHAN
LINK-CHAN
AUNTIE-CHAN
BABY-CHAN
CALLS HIMSELF "UNCLE-CHAN"

FRUIT BASKET

HE IS WELL CONNECTED AND LIKES TRADING TALL TALES.

FRUIT BASKET

THE ITEM CHECK KEEPER-CHAN'S FATHER WAS A POP STAR LONG AGO. HE REVERSED HIS STAGE NAME TO MAKE HIS DAUGHTER-CHAN'S NAME. HIS WIFE-CHAN DIDN'T LIKE IT? IS THAT RIGHT?

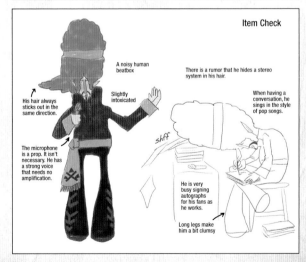

Item Check

A noisy human beatbox

There is a rumor that he hides a stereo system in his hair.

His hair always sticks out in the same direction.

Slightly intoxicated

When having a conversation, he sings in the style of pop songs.

The microphone is a prop. It isn't necessary. He has a strong voice that needs no amplification.

shff

He is very busy signing autographs for his fans as he works.

Long legs make him a bit clumsy

The Legend of Zelda

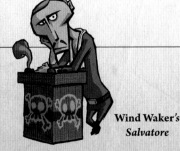

Wind Waker's Salvatore

SHOPKEEPERS WITH UNIQUE PERSONALITIES

There are many unique shopkeepers throughout the *Zelda* series. Maybe this is because over the years, an incredible volume of ideas have been developed for the various games in the series.

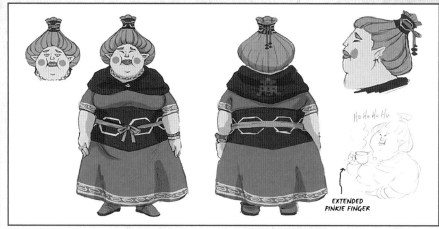

Gear Shop keeper's mother Cart

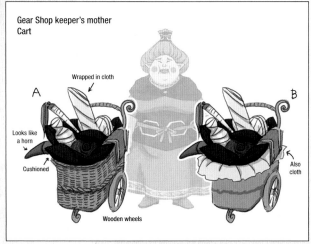

A

Wrapped in cloth

Looks like a horn

Cushioned

Also cloth

B

Wooden wheels

HO HO HO HO

EXTENDED PINKIE FINGER

FAN DESIGN PLANS

① LIKE AN ABACUS

② GEAR SHOP SYMBOL

DIAMOND PATTERN

③ HANDLE IS SHAPED LIKE A SMALL ABACUS.

④

WORLDLY YOUNG LADY

RESIDENTS OF SKYLOFT

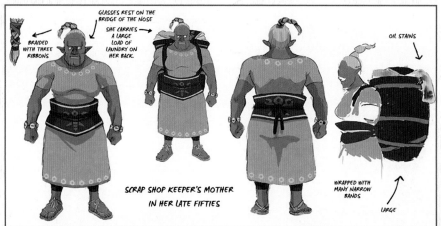

GLASSES REST ON THE BRIDGE OF THE NOSE

BRAIDED WITH THREE RIBBONS

SHE CARRIES A LARGE LOAD OF LAUNDRY ON HER BACK.

OIL STAINS

SCRAP SHOP KEEPER'S MOTHER IN HER LATE FIFTIES

WRAPPED WITH MANY NARROW BANDS

LARGE

The Scrap Shop keeper's mother Greba final version

Mallara final version

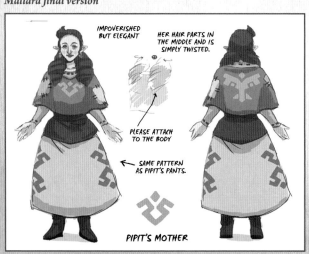

IMPOVERISHED BUT ELEGANT

HER HAIR PARTS IN THE MIDDLE AND IS SIMPLY TWISTED.

PLEASE ATTACH TO THE BODY

SAME PATTERN AS PIPIT'S PANTS.

PIPIT'S MOTHER

Pipit's mother

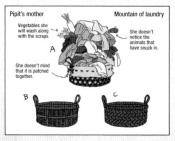

Vegetables she will wash along with the scraps.

Mountain of laundry

She doesn't notice the animals that have snuck in.

A

She doesn't mind that it is patched together.

B C

Scrap Shop keeper's mother Handheld laundry bag

A) Pink straps B) Blue straps

Goselle's cart and Greba's basket appear early in the game when the two are talking on the bridge. We showed these normal (?) middle-aged women going about their business to give a sense of daily life in Skyloft.

—Hirono, designer

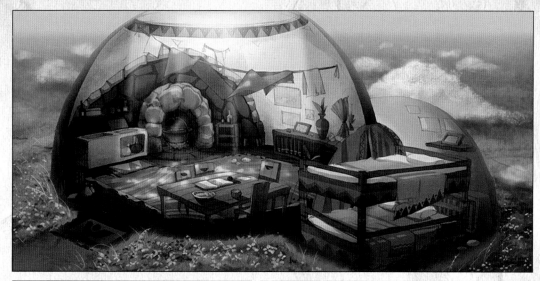

An interior and an exterior look at a design of a home in Skyloft. Details about the furniture inside are carefully decided based on the people who live there and their family dynamics.

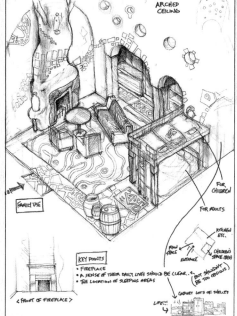

ARCHED CEILING

FAMILY USE

FOR CHILDREN

FOR ADULTS

KITCHEN ETC.

ENTRANCE

RAW SPACE

CHILDREN'S SPACE (BED)

(BUT SHOULDN'T BE TOO OBVIOUS)

CABINET LOTS OF SHELVES

KEY POINTS
• FIREPLACE
• A SENSE OF THEIR DAILY LIVES SHOULD BE CLEAR...
• THE LOCATION OF SLEEPING AREAS

< FRONT OF FIREPLACE >

LATER!!!

A plan to have entrance/exit allowing one to jump from different eaves of the roof

Size adjustment here

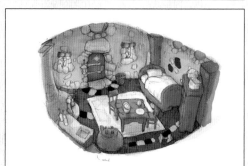

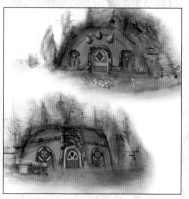

Parrow final version

HE RIDES BIRDS, SO HE'S MORE MUSCULAR THAN A NORMAL PERSON.

BIRD RIDER

MIDDLE-AGED MAN WHO DOESN'T RIDE BIRDS

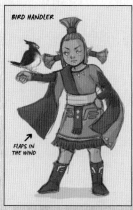

BIRD HANDLER

FLAPS IN THE WIND

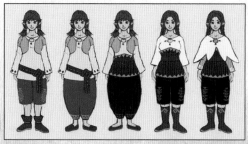

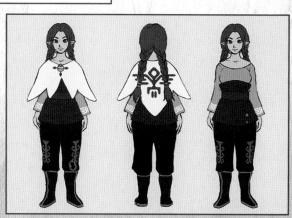

Orielle final version

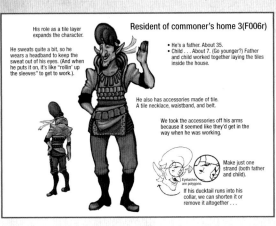

His role as a tile layer expands the character.

He sweats quite a bit, so he wears a headband to keep the sweat out of his eyes. (And when he puts it on, it's like "rollin' up the sleeves" to get to work.).

Resident of commoner's home 3(F006r)

- He's a father. About 35.
- Child . . . About 7. (Go younger?) Father and child worked together laying the tiles inside the house.

He also has accessories made of tile. A tile necklace, waistband, and belt.

We took the accessories off his arms because it seemed like they'd get in the way when he was working.

Make just one strand (both father and child).

Eyelashes are polygons.

If his ducktail runs into his collar, we can shorten it or remove it altogether . . .

Jakamar final version

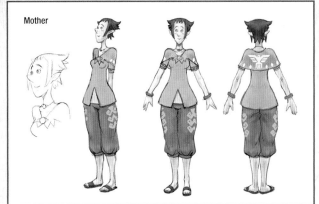

Mother

Wryna final version

Kukiel final version

Rescue Knights

Less individualistic version.*

*They are dressed uniformly so they look like a group or a brigade.

Decoration

Lighting equipment

A female?

A B C

Tile layer's daughter

- Wears a belt and a necklace made by her father. (He made some that fit her, but she said she wanted the ones he wears, wore him down, and finally got them!)
- Shirt is a hand-me-down from her beloved father.
- Quick to blush when people talk to her.

Don't make her pigeon toed.

Rescue Knights final version

Batreaux (devil version)

Large horns

Devil mark (devil version)

When he appears he's scary, but he's actually a nice guy so he usually wears a smile.

He wears cloth over his wings in order to hide them, but the cloth is torn up, and it actually makes him look more frightening.

He wants to become human and dresses himself in the style of clothes they wear.

His robe is torn in the back so his wings can fit through.

Batreaux (human version)

Batreaux as a human. He doesn't look too different from his devil form, but he is much happier.

Small horns

Devil mark (human version)

Smiling. This is how he normally looks.

His wings are gone, so the holes in the cloth that looked like an angry face before now appear to be laughing.

Batreaux final version

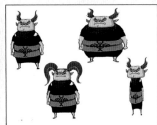

Gully final version

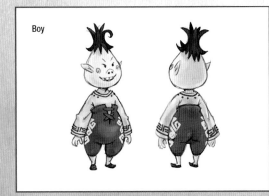

Boy

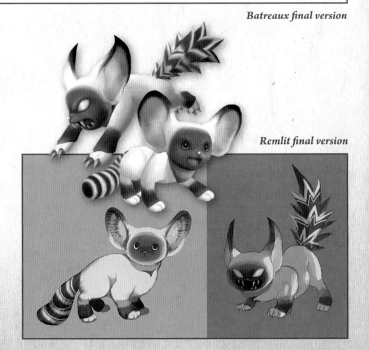

Remlit final version

PEOPLE OF SKYLOFT (UNUSED)

We thought the cleaner was really cool and impressive and wanted to use him in a subevent. The way things worked out, he didn't appear . . . but the core material of the cleaner character shows up in someone else.

—Hirono, designer

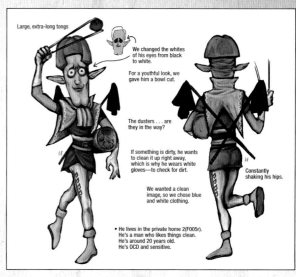

Large, extra-long tongs

We changed the whites of his eyes from black to white.

For a youthful look, we gave him a bowl cut.

The dusters . . . are they in the way?

If something is dirty, he wants to clean it up right away, which is why he wears white gloves—to check for dirt.

Constantly shaking his hips.

We wanted a clean image, so we chose blue and white clothing.

- He lives in the private home 2(F005r). He's a man who likes things clean. He's around 20 years old. He's OCD and sensitive.

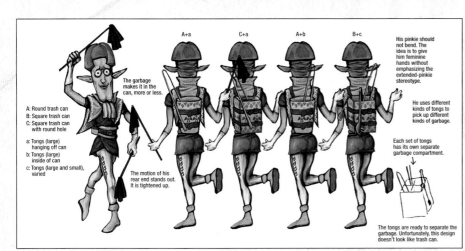

A+a C+a A+b B+c

His pinkie should not bend. The idea is to give him feminine hands without emphasizing the extended-pinkie stereotype.

The garbage makes it in the can, more or less.

A: Round trash can
B: Square trash can
C: Square trash can with round hole

a: Tongs (large) hanging off can
b: Tongs (large) inside of can
c: Tongs (large and small), varied

The motion of his rear end stands out. It is tightened up.

He uses different kinds of tongs to pick up different kinds of garbage.

Each set of tongs has its own separate garbage compartment.

The tongs are ready to separate the garbage. Unfortunately, this design doesn't look like trash can.

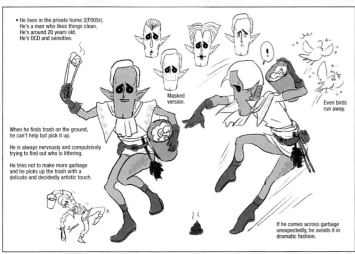

- He lives in the private home 2(F005r). He's a man who likes things clean. He's around 20 years old. He's OCD and sensitive.

Masked version.

Even birds run away.

When he finds trash on the ground, he can't help but pick it up.

He is always nervously and compulsively trying to find out who is littering.

He tries not to make more garbage and he picks up the trash with a delicate and decidedly artistic touch.

If he comes across garbage unexpectedly, he avoids it in dramatic fashion.

BOY WHO LOVES RABBITS

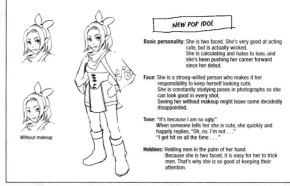

Basic personality: A cheerful boy who loves people and animals. Sometimes, if annoyed, he can switch to "I hate people—they're such a bother" mode. He is deeply attached to his two rabbits.

Body: He is lanky, with a small head. He carries himself with a posture that suggests a lack of energy or enthusiasm. He is very frail and he often gets sick.

Human relationships: He's kind, but since falling for an idol, he often forgets to display this kindness to others.

Tone: "What in the world am I doing?" "Oh, what a pain!"

Hobbies: Walking his rabbits

NEW POP IDOL

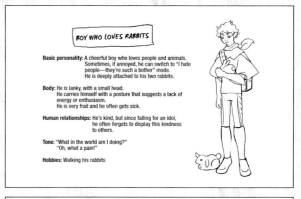

Without makeup

Basic personality: She is two faced. She's very good at acting cute, but is actually wicked. She is calculating and hates to lose, and she's been pushing her career forward since her debut.

Face: She is a strong-willed person who makes it her responsibility to keep herself looking cute. She is constantly studying poses in photographs so she can look good in every shot. Seeing her without makeup might leave some decidedly disappointed.

Tone: "It's because I am so ugly." When someone tells her she is cute, she quickly and happily replies, "Oh, no. I'm not . . ." "I get hit on all the time . . ."

Hobbies: Holding men in the palm of her hand. Because she is two faced, it is easy for her to trick men. That's why she is so good at keeping their attention.

RECTANGULAR LUMBER

ISLAND RESIDENT 1

UNCLE OF STUDENT A OF THE SCHOOL DORMITORY. HE DOES CONSTRUCTION WORK AROUND TOWN. HE IS ALSO A FORMER KNIGHT. HE IS A GOOD UNCLE WHO SOMETIMES WORKS AT THE DORMITORY, SO HE CAN SEE HOW HIS NEPHEW IS DOING.

TOOL POUCH

I AM NOT THE POTION SHOP BERTIE!

ISLAND RESIDENT 2

A MIDDLE-AGED ISLAND VAGABOND WHO TRAVELS AS HE PLEASES AND SOMETIMES SELLS THINGS ON STREET CORNERS. HE LOOKS A BIT LIKE BERTIE FROM THE POTION SHOP, AND IT BOTHERS HIM WHEN HE IS CONFUSED WITH BERTIE BY CHILDREN OR THE ELDERLY.

GUIDE WHO RUNS AROUND THE TOWN

Basic personality: A group of people who run around town gossiping. Occasionally they tell lies, and confuse people.

Hair: They have different hairstyles, and on some, it even goes down past their feet. Some like to keep their hair up.

Human relations: Often seen hanging around with male friends.

Skyward Sword

Tingle from Majora's Mask

CHARACTERS BORN OF TRIAL AND ERROR

The pool of characters in the *Zelda* games is incredibly deep. They leave an impression, probably because each character has many layers that can be seen even in the unused characters. The famous Tingle may have been born from one of these unused backup characters.

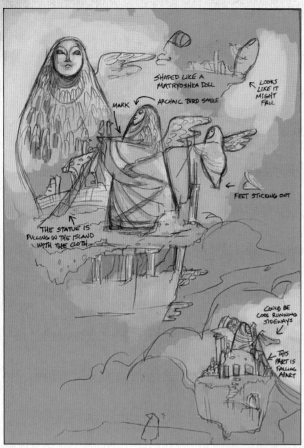

SHAPED LIKE A MATRYOSHKA DOLL

← ARCHAIC BIRD SMILE

MARK

LOOKS LIKE IT MIGHT FALL

FEET STICKING OUT

THE STATUE IS PULLING IN THE ISLAND WITH THE CLOTH

COULD BE COOL RUNNING SIDEWAYS

THIS PART IS FALLING APART

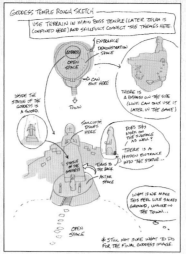

GODDESS TEMPLE ROUGH SKETCH

USE TERRAIN IN MAIN BOSS TEMPLE (LATER ZELDA IS CONFINED HERE) AND SKILLFULLY CONNECT THE THEMES HERE.

ENTRANCE DEMONSTRATION SPACE

GODDESS OPEN SPACE

CAN EXIT HERE

TOWN

INSIDE THE STATUE OF THE GODDESS IS A SWORD.

SAILCLOTH DROPS HERE

STATUE OF THE GODDESS

LEADS TO THE BACK

ALTAR SPACE

THERE IS A BYPASS ON THE SIDE (LINK CAN ONLY USE IT LATER IN THE GAME)

DOES THIS WORK ON THE SURFACE THIS AS WELL?

THERE IS A HIDDEN ENTRANCE INTO THE STATUE...

WHAT IF WE MAKE THIS FEEL LIKE SACRED GROUND, UNLIKE IN THE TOWN...

OPEN SPACE

* STILL NOT SURE WHAT TO DO FOR THE FINAL GODDESS IMAGE.

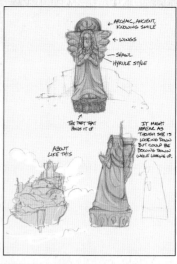

← ARCHAIC, ANCIENT, KNOWING SMILE

← WINGS

← SHAWL HYRULE STYLE

THE PART THAT HOLDS IT UP

ABOUT LIKE THIS

IT MIGHT APPEAR AS THOUGH SHE IS LOOKING DOWN BUT COULD BE BOWING DOWN WHILE LOOKING UP.

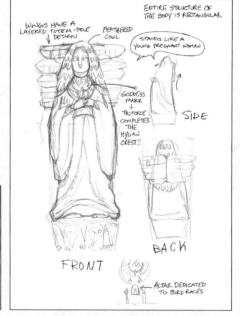

WINGS HAVE A LAYERED TOTEM-POLE DESIGN

FEATHERED COWL

ENTIRE STRUCTURE OF THE BODY IS RECTANGULAR

STANDS LIKE A YOUNG PREGNANT WOMAN

GODDESS MARK + TRIFORCE COMPLETES THE HYLIAN CREST!!

SIDE

BACK

FRONT

ALTAR DEDICATED TO BIRD RACES

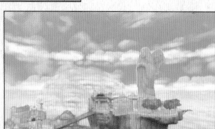

STATUE OF THE GODDESS

Goddess worship is a pervasive element in religion in Skyloft, especially the customs associated with it. The Statue of the Goddess transcends mere religious symbol and has become a special attraction and point of interest. It is a landmark that can be seen from anywhere in the city. The interior, unlike the city around it, uses more straight lines and angles and, coupled with the monochrome coloring, gives the impression of permanence and inflexibility.

—Fujibayashi, director / Hisada, designer

ControlPanel

① ② ③ ④ ⑤

■ ShutterFenced04

With shutter

Carved out

ControlPanel 110210

① ②

Triforce

Basic

Present location

BAMBOO CUTTER

HIS BIRD FRIEND, GIGA, HE LOVES GENTLE THINGS, LIKE BUTTERFLIES AND FLOWERS.

HE IS KIND TO ALL LIVING THINGS, BUT WHEN HE WAS A KNIGHT, HIS SCARY FACE FRIGHTENED ALL THE SKY ISLAND CHILDREN, MUCH TO HIS DISMAY, WHICH CAUSED THIS SENSITIVE YOUNG MAN TO WITHDRAW.

HE HAS A HIGH-QUALITY BLADE, AND DAY AFTER DAY OF CUTTING DOWN BAMBOO SHINES THE BLADE TO THE POINT WHERE IT ALMOST APPEARS TO SPARKLE.

DESPITE HIS GRUFF APPEARANCE, HE IS VERY KIND.

CATCHES HIS BREATH WHEN HE HEARS SOMEONE SAY "SCARY."

HIS HEART EVEN HURTS A LITTLE WHEN HE HEARS THE WORD "MERRY," SINCE IT SOUNDS SIMILAR TO "SCARY."

BAMBOO CUTTER

SHE IS A FORMER KNIGHT WHO IS DISMISSIVE AND WORKS AT HER OWN PACE. SHE IS MARRIED BUT HAS DECIDED TO DEDICATE HER LIFE TO BAMBOO SPLITTING.

SHE IS FRIENDS WITH THE DORMITORY HOUSE-MOTHER, AND THEY GO TO TEA TOGETHER.

WHENEVER LINK TRIES TO TALK TO HER HUSBAND, HE ALWAYS MISSES HIM BY MERE MOMENTS, AND HE ISN'T SURE WHAT HE LOOKS LIKE OR WHAT KIND OF PERSON HE IS.

(HINTS CAN BE FOUND HERE AND THERE, SO IN THE FINAL STAGE, EVEN WITHOUT ALL THE PIECES, SHALL WE HAVE IT SO THE PLAYER GETS A ROUGH IDEA THAT HE IS A SURPRISINGLY WELL-KNOWN CHARACTER?)

SOMETIMES SHE CONFUSES LINK FOR BAMBOO AND TAKES A SLICE AT HIM.

(SHE'LL SAY, "YOU ARE THE SAME COLOR AS BAMBOO. IT'S CONFUSING.")

BAMBOO CUTTER 5

HE TENDS TO FIND EVERYTHING A BOTHER AND IS A GENERALLY LAZY PERSON. HE IS A FORMER KNIGHT AND THE GRANDSON OF THE DORMITORY HOUSEMOTHER. HIS MARTIAL ARTS STUDIES ALLOW HIM TO EXPERTLY HANDLE HIS SPEAR. BEING A KNIGHT WAS A PAIN, SO THAT'S WHY HE QUIT. WHEN HE DOESN'T FEEL LIKE DOING BAMBOO-SPLITTING WORK, HE DOESN'T.

THE HAT AND CHAIN MAIL ARE FROM HIS DAYS AS A KNIGHT. HE IS USED TO BEING A KNIGHT, SO HE ALWAYS WEARS THEM.

THE SAME MARK THAT APPEARS ON THE DORMITORY APRONS IS ON THE SIDE OF HIS PANTS.

BECAUSE HE HAS NO ENERGY TO DO ANYTHING, HE QUITS AFTER TRYING SOMETHING ONE TIME.

Peater final version

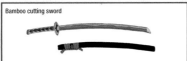

Bamboo cutting sword

Peater's sword

Bamboo Cutter Knight

Setting: Item Check keeper's father (former pop idol)

He is the kind of father that would do anything for his daughter. He was an excellent student at the Knight Academy who had strength, heart, and a fine physique. After the Knight Academy, he decided, "I will make my way as a pop idol" . . . but that was seventeen years ago.

Since retiring as an idol, he has gained considerable weight. In order to lose weight, he picked up his old sword and started swinging again.

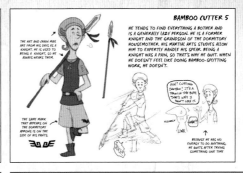

Flat head

This is a hood

He is always glaring.

Photos of wife and daughter in locket

Click

Diet...Ho! Diet...Ha!!

Daughter's applique

Same chain mail as Link

Because of his weight gain, the chain mail he wore as a knight doesn't fit right anymore.

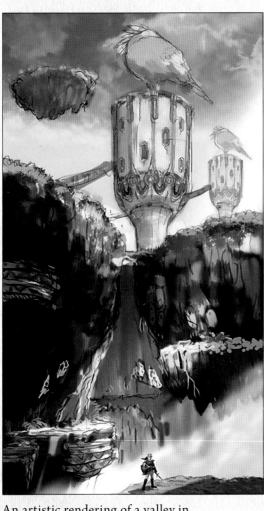

An artistic rendering of a valley in the legendary floating islands. The islands are reminiscent of mountains, standing at different altitudes. At the top, the bird of legends, which many seek as they set out upon their ascent. (Concept image.)

PEOPLE OF THE SKY ISLANDS

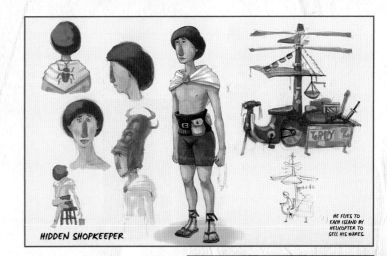

HIDDEN SHOPKEEPER

HE FLIES TO EACH ISLAND BY HELICOPTER TO SELL HIS WARES.

Beedle final version

A

HOOOONK

Fun Fun Island's Dodoh final version

Face Paint pattern

A

B
Makeup with circles around eyes

C
A little mysterious

D
Southern gentleman style

Spinnnnn

E
Smiling face

D
Mask on top of a mask

F
Cylinder

Roulette man idea



35

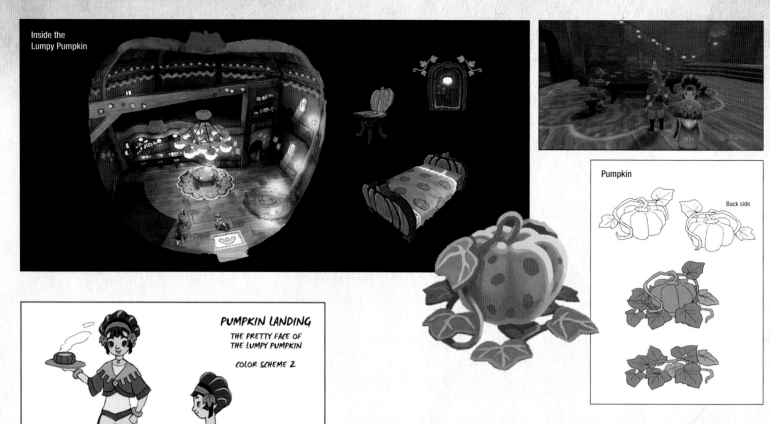

Inside the Lumpy Pumpkin

Pumpkin

Back side

PUMPKIN LANDING

THE PRETTY FACE OF THE LUMPY PUMPKIN

COLOR SCHEME 2

PUMPKIN LANDING

Pumm final version

Kina final version

CALYX SHAPED

LEAF SHAPED

THE BACK IS POOFY

Rusta final version

HE IS ALWAYS IN THE KITCHEN WEARING OVEN GLOVES.

HEY! THIS IS HOT! SOMEONE TAKE IT AWAY!

LUMPY PUMPKIN OWNER 3

HE LIKES COOKING AND PUMPKINS, WHICH IS WHY HE OPENED THE BAR.

HE HAS A SENSITIVE TONGUE AND CAN'T EAT FOOD THAT'S TOO HOT.

HE LIKES SOUP.

AFTER HIS DAUGHTER AND PUMPKINS, HIS NEXT FAVORITE THING IS HIS CHANDELIER.

HOT! HOT! HOT! I THOUGHT THIS WAS A DELICIOUS COLD SOUP...

THE "PUMPKIN SONG" HE WROTE

MY PUMPKINS ARE... THE BEST IN THE WORLD.

LUMPY PUMPKIN OWNER 2

HE LOVES SINGING AND PUMPKINS.

HE IS INTRUSIVE.

HIS SINGING'S PRETTY GOOD.

LOOK AT THIS. IT'S MY PUMPKIN. IT'S AMAZING. DON'T YOU THINK?

HE SINGS AS HE SPEAKS.

HIS OWN STRAW

GLARE

OLDER REGULAR CUSTOMER

HE'S AN OLD ACQUAINTANCE OF THE OWNER AND LOVES THE LUMPY PUMPKIN'S OWNER'S DAUGHTER AS IF SHE WERE HIS OWN GRANDDAUGHTER. TO KEEP HER FROM BEING HARASSED BY UNDESIRABLES, HE SITS ON ONE END OF THE BAR AND KEEPS A WATCHFUL EYE.

HE ONLY SEEMS LIKE A GRANDFATHER WHEN HE'S AROUND THE OWNER'S DAUGHTER.

HELLOOO! GRAMPS IS HERE!

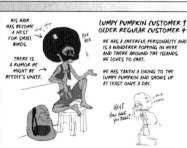

HIS HAIR HAS BECOME A NEST FOR SMALL BIRDS.

THERE IS A RUMOR HE MIGHT BE BEEDLE'S UNCLE.

LUMPY PUMPKIN CUSTOMER 1 OLDER REGULAR CUSTOMER 4

HE HAS A CHEERFUL PERSONALITY AND IS A WANDERER POPPING IN HERE AND THERE AROUND THE ISLANDS. HE LOVES TO CHAT.

HE HAS TAKEN A LIKING TO THE LUMPY PUMPKIN AND SHOWS UP AT LEAST ONCE A DAY.

HEY! HOW HAVE YOU BEEN?

BACK

PUMPKIN LANDING CUSTOMER 1

OLDER REGULAR CUSTOMER MARK PATTERN 3

WHENEVER HE COMES TO THE BAR HE MUMBLES TO HIMSELF.

HE IS THE HUSBAND OF THE DORMITORY HOUSEMOTHER.

SAME SYMBOL AS THE ONE ON THE DORMITORY HOUSEMOTHER'S APRON

sigh

I CAN'T IMAGINE COMING HERE WITH MY WIFE...

mutter mutter

EARS AND TAIL ARE ATTACHED TO THE OUTSIDE.

Ringers are tiny animals that gather around Link if he skydives from a high altitude above Pumpkin Landing.

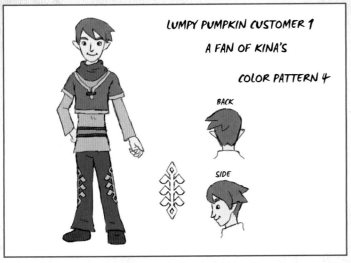

LUMPY PUMPKIN CUSTOMER 1

A FAN OF KINA'S

COLOR PATTERN 4

BACK

SIDE

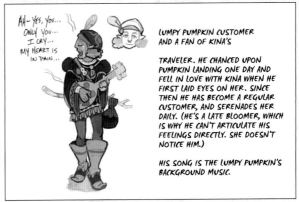

AH~ YES, YOU... ONLY YOU... I CRY... MY HEART IS IN PAIN...

I'M A BIG FAN OF KINA'S.

LUMPY PUMPKIN CUSTOMER AND A FAN OF KINA'S

TRAVELER. HE CHANCED UPON PUMPKIN LANDING ONE DAY AND FELL IN LOVE WITH KINA WHEN HE FIRST LAID EYES ON HER. SINCE THEN HE HAS BECOME A REGULAR CUSTOMER, AND SERENADES HER DAILY. (HE'S A LATE BLOOMER, WHICH IS WHY HE CAN'T ARTICULATE HIS FEELINGS DIRECTLY. SHE DOESN'T NOTICE HIM.)

HIS SONG IS THE LUMPY PUMPKIN'S BACKGROUND MUSIC.

Customer 2

He is a shy poet and calligrapher.

He is unable to look Kina in the eye or speak to her, so he writes poems to her daily.

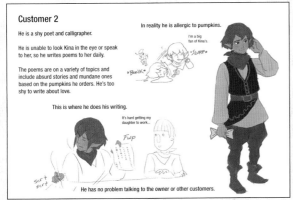

In reality he is allergic to pumpkins.

I'm a big fan of Kina's.

SWAP

Bonk

The poems are on a variety of topics and include absurd stories and mundane ones based on the pumpkins he orders. He's too shy to write about love.

This is where he does his writing.

It's hard getting my daughter to work...

Fwp

Scrt scrt

He has no problem talking to the owner or other customers.

← HE WORKS HARD ON HIS ARTWORK.

HE SPENDS ALL DAY SKETCHING.

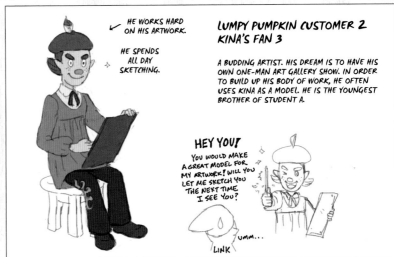

LUMPY PUMPKIN CUSTOMER 2 KINA'S FAN 3

A BUDDING ARTIST. HIS DREAM IS TO HAVE HIS OWN ONE-MAN ART GALLERY SHOW. IN ORDER TO BUILD UP HIS BODY OF WORK, HE OFTEN USES KINA AS A MODEL. HE IS THE YOUNGEST BROTHER OF STUDENT A.

HEY YOU! YOU WOULD MAKE A GREAT MODEL FOR MY ARTWORK! WILL YOU LET ME SKETCH YOU THE NEXT TIME I SEE YOU?

UMM... LINK

Since the theme of this game is the sky, the main featured animal is the bird. We decided not to have ground animals like cows appear. Because of that, pumpkin soup isn't made with milk. Pumpkins are a staple of the diet of the people who live in the sky and they all love it. Kina, the face of the Lumpy Pumpkin, has become an idol of sorts. She has some very surprising fans . . . and it seems like some fans would like to keep their fandom secret.

—Iwamoto, producer / Hirono, designer

CUSTOMER 2

A hard-working student. He is very focused on studying for his exams. He is not wealthy, but he returns his parents' financial help by studying extra hard. One day he rewarded himself for a high score on a test by stopping into Pumpkin Landing for a bowl of soup, which is when he first laid eyes on the owner's daughter.

He uses his modest earnings from his part-time job to eat at the Lumpy Pumpkin. He is a nice guy who never forgets to bring a bouquet of flowers. He is thrifty and good at digging up funds.

He is a young man who values family. He cares very much for his baby brother.

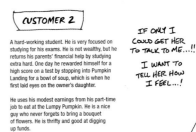

IF ONLY I COULD GET HER TO TALK TO ME...!! I WANT TO TELL HER HOW I FEEL...!

MILK BAR (UNUSED)

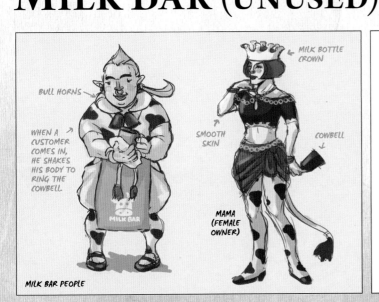

BULL HORNS

WHEN A CUSTOMER COMES IN, HE SHAKES HIS BODY TO RING THE COWBELL

MILK BOTTLE CROWN

SMOOTH SKIN

COWBELL

MAMA (FEMALE OWNER)

MILK BAR PEOPLE

CUSTOMER 2

A farm's delivery boy

The owner orders only the choicest milk. This is the person who delivers that famous milk. In the beginning the delivery boy thought that delivering milk was a hassle, but since meeting the owner's daughter, he is much more enthusiastic. Since then, his customer service has improved markedly. He comes by in his off time to have soup, so the owner sees him as his own milk cow.

He loves his pet weasel. It was a gift from his deceased mother. The weasel is always with him.

The weasel stays in his hood, and pops his face out when he is hungry. He's a greedy little guy.

If you talk to him from the front, you speak to the boy. If you talk to him from the back, you speak to the weasel.

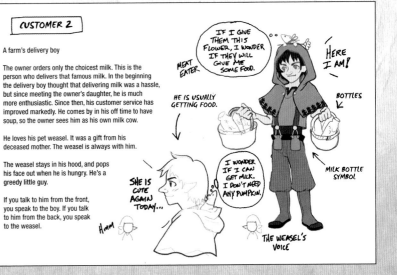

IF I GIVE THEM THIS FLOWER, I WONDER IF THEY WILL GIVE ME SOME FOOD.

MEAT EATER

HE IS USUALLY GETTING FOOD.

HERE I AM!

BOTTLES

MILK BOTTLE SYMBOL

SHE IS CUTE AGAIN TODAY...

Hmm

I WONDER IF I CAN GET MILK. I DON'T NEED ANY PUMPKIN.

THE WEASEL'S VOICE

Levias final version

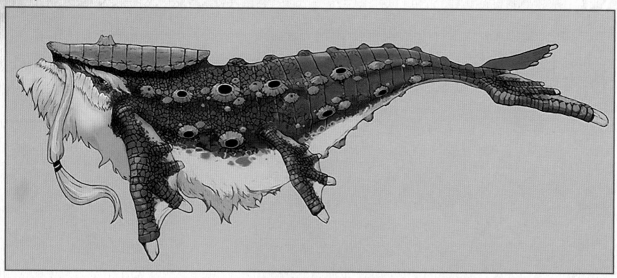

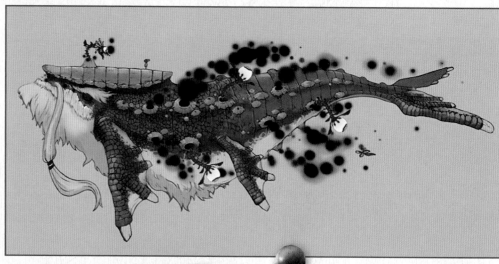

Levias (when possessed) final version

INSIDE THE THUNDERHEAD

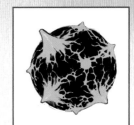

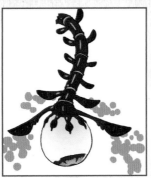

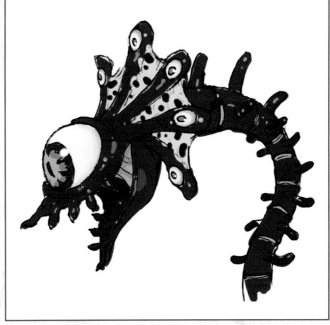

Ocular Parasite Bilocyte final version

The original concept was "A boss fight while riding a Loftwing!" After Link fights Bilocyte while riding the Loftwing, we decided that during the second part of the fight, Link would get off his bird and do the dirty work with his sword.

—Fujibayashi, director

Skytail final version

Variations, excluding the mouth
* The blowhole is the same.
* Barnacles on the underside of its body.

A) Only the shell edge attached

B) Looks like Lao Tzu

C) Alternate shell configuration

D) Goat eyes

E) Drooping eyebrows

A) Catfish type
The parasite's tentacles seem to emerge from lumps all over the body.

B) Dugong type
Tentacles come out of gelatinous lumps on the surface of the body.

C) Tortoise + fish type
Tentacles grow out of tattoolike, patterned marks on the body.

D) Sperm whale type
Tentacles seem to come from calcified circular growths or holes on the skin. (Could they be giant barnacles?)

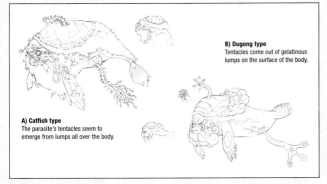

Jabun from Wind Waker

SPIRITS WITH LARGE BODIES

Throughout the titles, spirit creatures like Levias appear many times. Many creatures, like Lord Jabu-Jabu in *Ocarina of Time,* are based on sea animals.

THE SEALED GROUNDS

This is where Link lands when he first arrives from the sky. An evil being slumbers here. It is also where the goddess slept for thousands of years under the protection of the Sheikah.

This is the first place the player lands on the Surface, so we consciously made it dark to really contrast it with the sky and make it a mysterious place. We kept several key elements of the game in mind when designing the Sealed Grounds—namely, the goddess's harp and the birds.

—Kobayashi, designer

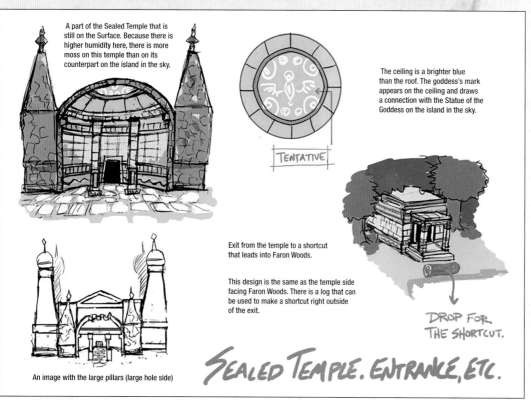

A part of the Sealed Temple that is still on the Surface. Because there is higher humidity here, there is more moss on this temple than on its counterpart on the island in the sky.

The ceiling is a brighter blue than the roof. The goddess's mark appears on the ceiling and draws a connection with the Statue of the Goddess on the island in the sky.

TENTATIVE

Exit from the temple to a shortcut that leads into Faron Woods.

This design is the same as the temple side facing Faron Woods. There is a log that can be used to make a shortcut right outside of the exit.

DROP FOR THE SHORTCUT.

An image with the large pillars (large hole side)

SEALED TEMPLE. ENTRANCE, ETC.

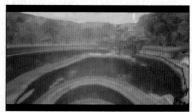

Gate of Time A idea sketches (2011/01/08)

• Proposal A
This one gives a powerful image of the block assembly.

• Proposal B
Looks like a door or a portal (perhaps to make them think that it will open just like this).

• Proposal C
Light leaks out from the inside.

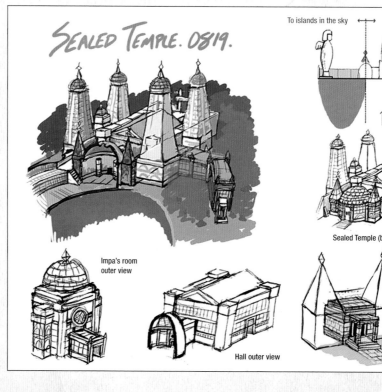

SEALED TEMPLE. 0819.

To islands in the sky ↔ Remains on the Surface

Side view
(before the split)

Impa's room
outer view

Hall outer view

Sealed Temple (before the split)

Exit to Faron Woods.
Unlike the arch side,
this is rectangular.

Four Swords Adventures

THE SEALED GROUNDS AND SACRED PLACES

This sacred place has a unique atmosphere. It is rich in vegetation and wildlife. Warm beams of sunlight bathe the area. The Sealed Grounds probably have no direct connection to other titles, but it's hard not to be reminded of similar places, where items like the Master Sword are found.

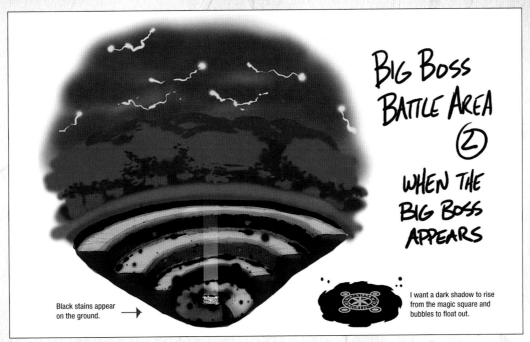

BIG BOSS BATTLE AREA ② WHEN THE BIG BOSS APPEARS

Black stains appear on the ground. →

I want a dark shadow to rise from the magic square and bubbles to float out.

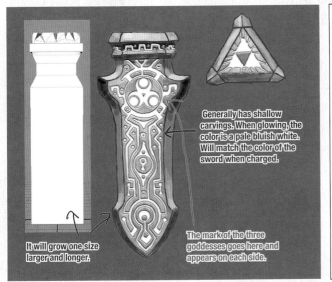

Generally has shallow carvings. When glowing, the color is a pale bluish white. Will match the color of the sword when charged.

It will grow one size larger and longer.

The mark of the three goddesses goes here and appears on each side.

BIG BOSS AREA PLAN 0709.

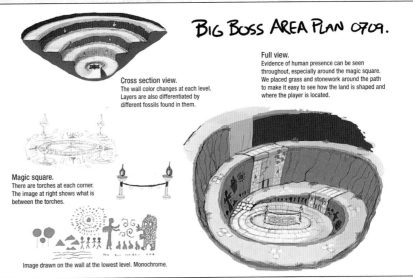

Cross section view.
The wall color changes at each level. Layers are also differentiated by different fossils found in them.

Full view.
Evidence of human presence can be seen throughout, especially around the magic square. We placed grass and stonework around the path to make it easy to see how the land is shaped and where the player is located.

Magic square.
There are torches at each corner. The image at right shows what is between the torches.

Image drawn on the wall at the lowest level. Monochrome.

BOSS AREA VARIATIONS — 0713.

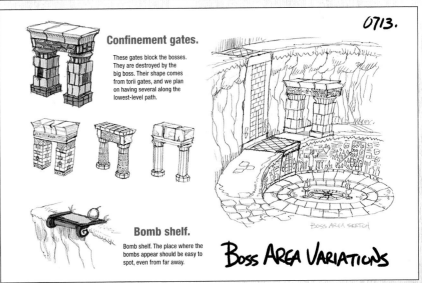

Confinement gates.
These gates block the bosses. They are destroyed by the big boss. Their shape comes from torii gates, and we plan on having several along the lowest-level path.

Bomb shelf. The place where the bombs appear should be easy to spot, even from far away.

BOSS AREA SKETCH

As we were thinking about how we wanted the game play to work with the Imprisoned, we knew the player must be conscious of where the enemy was at all times, so we designed the large corkscrew-shaped hole. It aligns with the bottom of the Isle of the Goddess. As we were planning, we also kept in mind that this land is a sacred but dangerous place where an unspeakable evil was sealed and watched over by the Sheikah.

—Fujibayashi, director / Kobayashi, designer

Ocarina of Time 3D **Oracle of Ages**

THE THREE CRESTS

Carved on the stake in the head of the Imprisoned are the crests of Farore and the other two goddesses. They are modeled on crests that appeared in earlier games. These crests are also associated with the sages and different races, and appear in other games as well as this one.

Faron Woods

The Great Tree stands in the center of a vast forest, and a variety of living things come here to ask for its blessing. The forest is home to the Kikwi, and the Parella live in Lake Floria to the south.

Faron Woods official visual

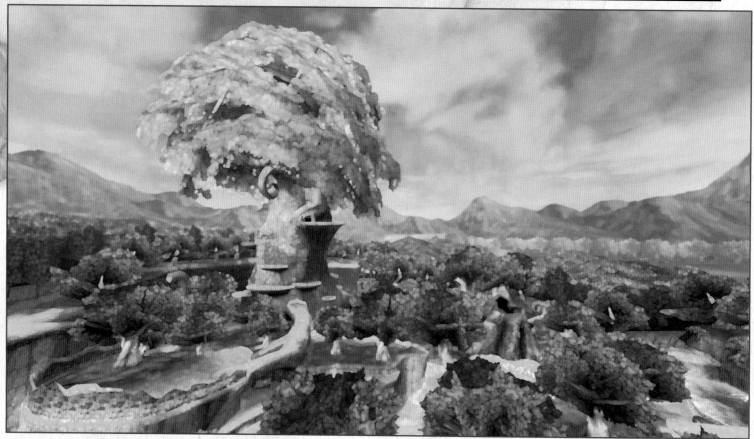

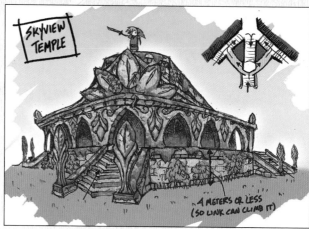

SKYVIEW TEMPLE

4 METERS OR LESS (SO LINK CAN CLIMB IT)

Faron Woods was designed using a painterly style, because we were trying to make a forest world that looked like something out of an illustrated storybook. Since the forest is the first area the player will visit, we tried to make it bright and easy to navigate. To keep people from getting bored, we packed the area with tons of fun things so the players stay engaged.

—Nishibe, designer

GREAT TREE

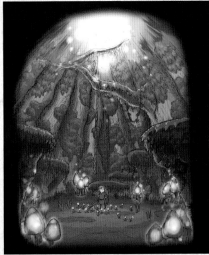

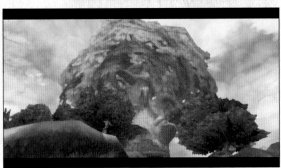

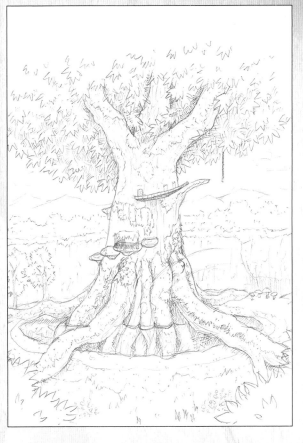

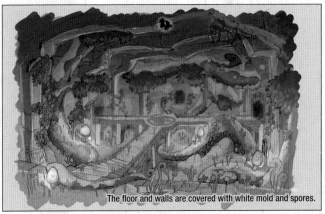

The floor and walls are covered with white mold and spores.

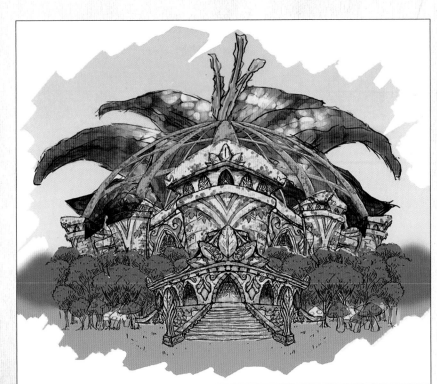

Skyview Temple official visual

SKYVIEW TEMPLE

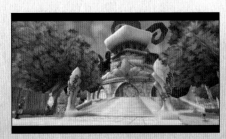

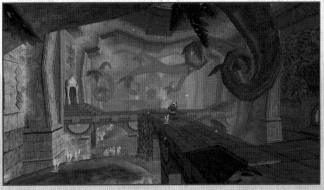

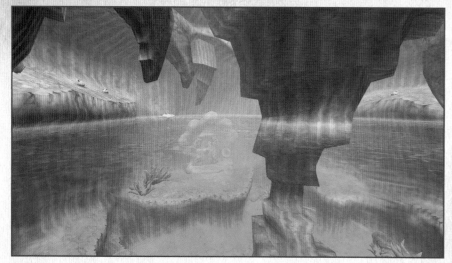

LAKE FLORIA

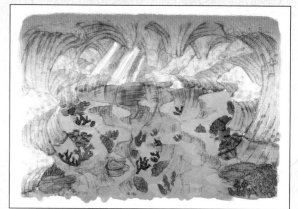

Lake Floria official visual

Lake Floria is the first underwater stage, but it is a little small. We wanted an area where the player could have fun swimming around for hours and decided on an underwater forest. After struggling with the concept, we chose to go with someplace the player had been before, so we flooded Faron Woods to make a massive area for the player to swim around in.

—Fujibayashi, director

FARON THE WATER DRAGON

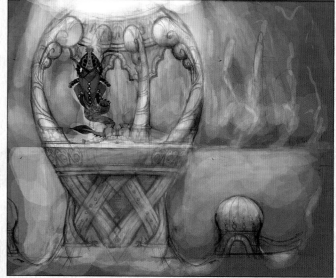

One of the three dragons assigned to protect the Surface for the goddess Farore, Faron has a gruff personality. She flooded the forest to cleanse it of the demons.

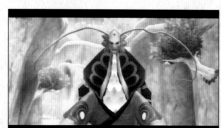

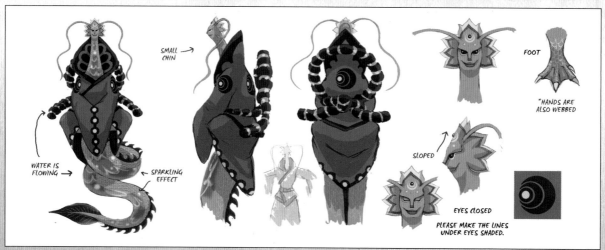

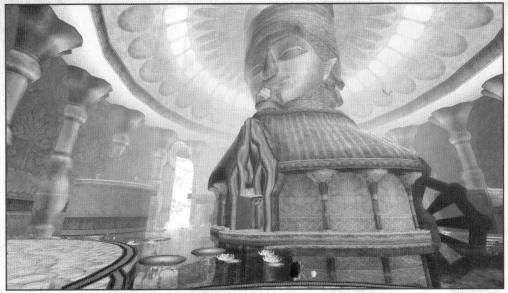

Ancient Cistern official visual

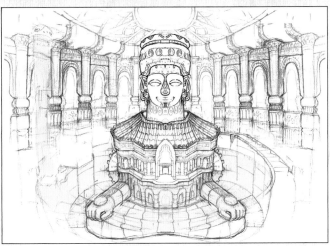

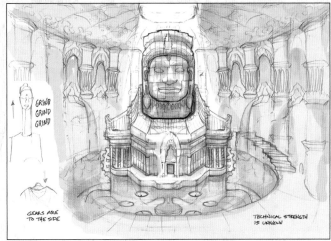

ANCIENT CISTERN

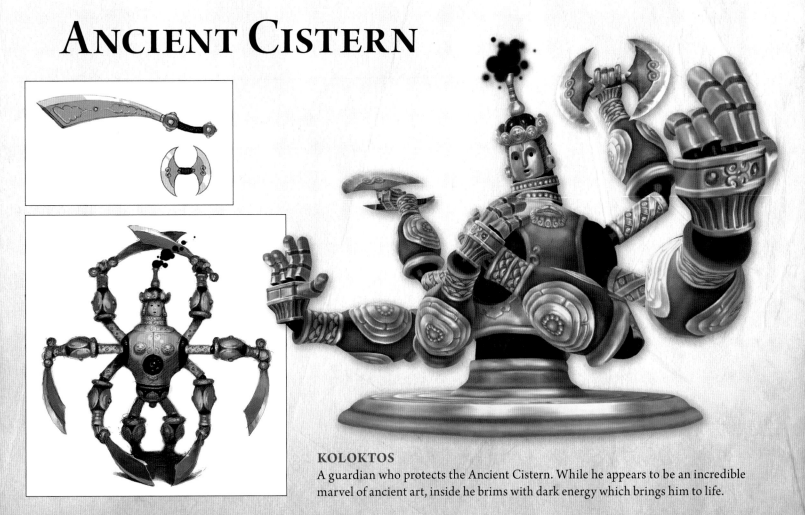

KOLOKTOS
A guardian who protects the Ancient Cistern. While he appears to be an incredible marvel of ancient art, inside he brims with dark energy which brings him to life.

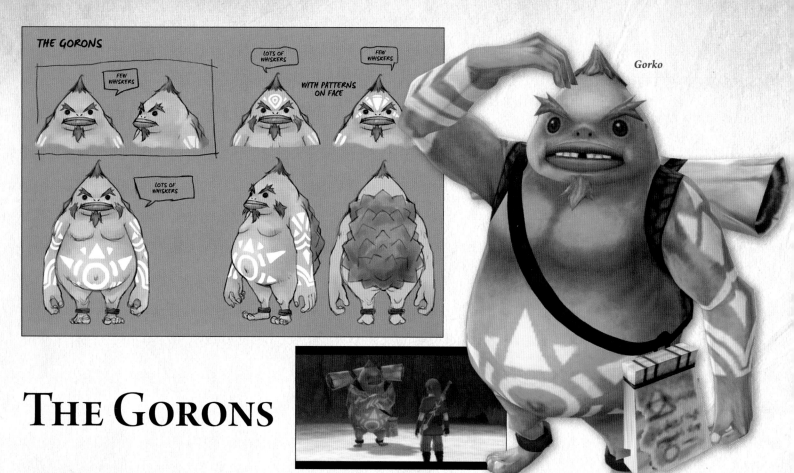

THE GORONS

FEW WHISKERS

FEW WHISKERS

LOTS OF WHISKERS

FEW WHISKERS

WITH PATTERNS ON FACE

LOTS OF WHISKERS

Gorko

THE GORONS

Gortram final version

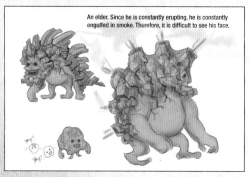

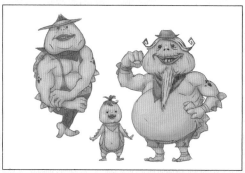

In *Skyward Sword*, the Gorons act as Link's guides. Their curiosity has led them to explore the surface world, and that explains their being located all over it. We originally planned to go with a more primitive design, but as there are many new species in this game, we decided to go with a more familiar look.

—Hirono, designer / Kobayashi, designer

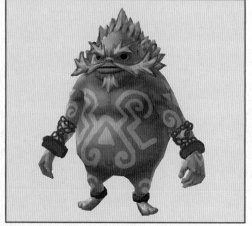

An elder. Since he is constantly erupting, he is constantly engulfed in smoke. Therefore, it is difficult to see his face.

YAY! YAY!

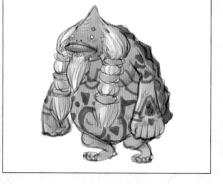

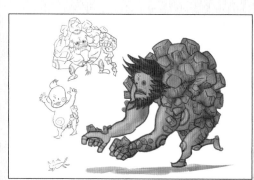

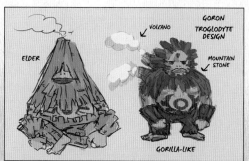

VOLCANO

GORON TROGLODYTE DESIGN

ELDER

MOUNTAIN STONE

GORILLA-LIKE

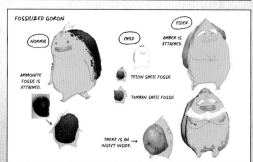

FOSSILIZED GORON

NORMAL

CHILD

ELDER

AMBER IS ATTACHED.

AMMONITE FOSSIL IS ATTACHED.

TELLIN SHELL FOSSIL

TURBAN SHELL FOSSIL

THERE IS AN INSECT INSIDE.

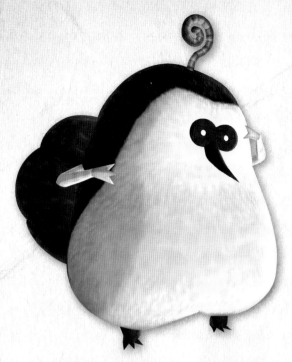

They are gentle and have easygoing personalities. When asked, Fi will reveal a variety of information about each individual. When the opportunity arises, ask her about them.
—Hirono, designer

Yerbal final design

FOREST PERSON (HERMIT)

DRIED OUT

GRAY HAIR

LOOKS LIKE A WITHERED FLOWER

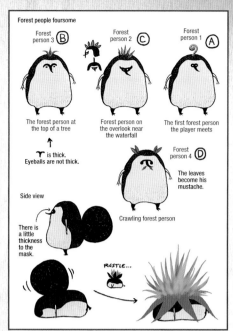

Forest people foursome

Forest person 3 B

Forest person 2 C

Forest person 1 A

The forest person at the top of a tree

Forest person on the overlook near the waterfall

The first forest person the player meets

T is thick. Eyeballs are not thick.

Forest person 4 D

The leaves become his mustache.

Side view

There is a little thickness to the mask.

Crawling forest person

RUSTLE...

Machi / Oolo / Lopsa / Erla final designs

THE KIKWI

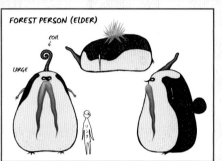

FOREST PERSON (ELDER)

COIL

LARGE

Bucha final design

STANDARD

FRESH SPROUTS

DRIED OUT

ROLLING ESCAPE

PORCUPINE + CHIA PET

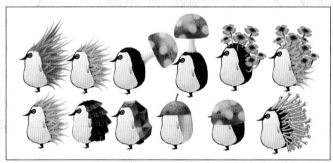

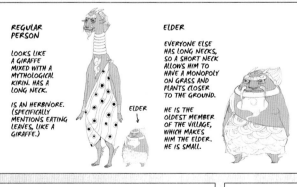

REGULAR PERSON

LOOKS LIKE A GIRAFFE MIXED WITH A MYTHOLOGICAL KIRIN. HAS A LONG NECK.

IS AN HERBIVORE. (SPECIFICALLY MENTIONS EATING LEAVES, LIKE A GIRAFFE.)

ELDER

ELDER

EVERYONE ELSE HAS LONG NECKS, SO A SHORT NECK ALLOWS HIM TO HAVE A MONOPOLY ON GRASS AND PLANTS CLOSER TO THE GROUND.

HE IS THE OLDEST MEMBER OF THE VILLAGE, WHICH MAKES HIM THE ELDER. HE IS SMALL.

DESIGN PLANS FOR FOREST CREATURES

The Kikwi beat out the other designs and were eventually established as the forest creatures because they adhered to the idea that we set out with, which was that of creatures that took the form of and appeared in the guise of grass or other plants. Also, their innocent facial expressions embody the spirit of the forest.

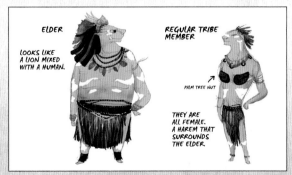

ELDER

LOOKS LIKE A LION MIXED WITH A HUMAN.

REGULAR TRIBE MEMBER

PALM TREE NUT

THEY ARE ALL FEMALE. A HAREM THAT SURROUNDS THE ELDER

THIS IS THE SOURCE OF SOUNDS OF GRASS RUSTLING AND STEPPING ON FALLEN LEAVES AND STICKS. WHEN ONE LOOKS FOR THE SOURCE OF THE SOUND, THEY FIND NOTHING.

SNAP

NORMALLY CAN'T BE SEEN

THEY OPERATE LIKE THE GAME RED LIGHT, GREEN LIGHT

WHA—? YOU HAVE A WAY TO SEE ME.

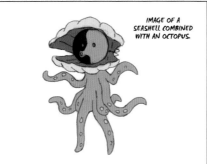

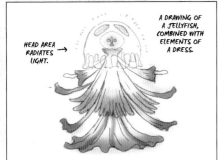

HEAD AREA RADIATES LIGHT.

A DRAWING OF A JELLYFISH, COMBINED WITH ELEMENTS OF A DRESS.

IMAGE OF A SEASHELL COMBINED WITH AN OCTOPUS.

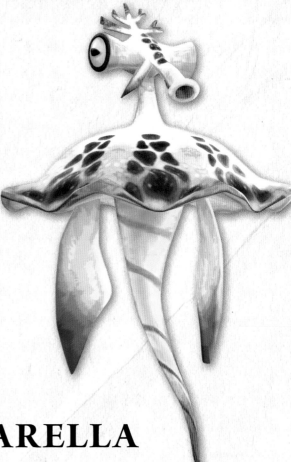

THE PARELLA

The sketches started with images of small fish laughing, darting about, and having fun. We decided on the design of the standard Parella with what looks like small pieces of coral on its head. The leader of the Parella who guides Link has a larger coral on her head, which she uses as a key to unlock a door.

—Kaneko, designer

DIFFERENT COLOR

LOOKS LIKE A DEEP-SEA FISH (LARGE EYES)

SHELLS EMBEDDED.

LIKE A MONKFISH

ALLURING. LOOKS LIKE AN ANCIENT FISH.

HEAD

TAIL

FIN

THE PHANTOM ZORA
We originally planned to have a race that closely resembled the Zora, but we were told to design a more primitive race, and the idea was rejected.

ELDIN VOLCANO

It is an area of active eruptions, and over half the land is covered in lava. That's the reason that there are many fire-tinged monsters living there. The Mogma, who are excellent diggers and move underground, also live there.

We wanted to allow the player to have fun with differences in elevation, so we immediately decided to add mountains. In the primitive volcanic belt lie ruins that have slowly lost the battle with time and have the reputation of being infested with Bokoblin monsters. The dungeon design was based off Southeast Asian architecture and coloring, which is why you see extensive use of vibrant, primary colors.

—Fujibayashi, director / Shirai, designer

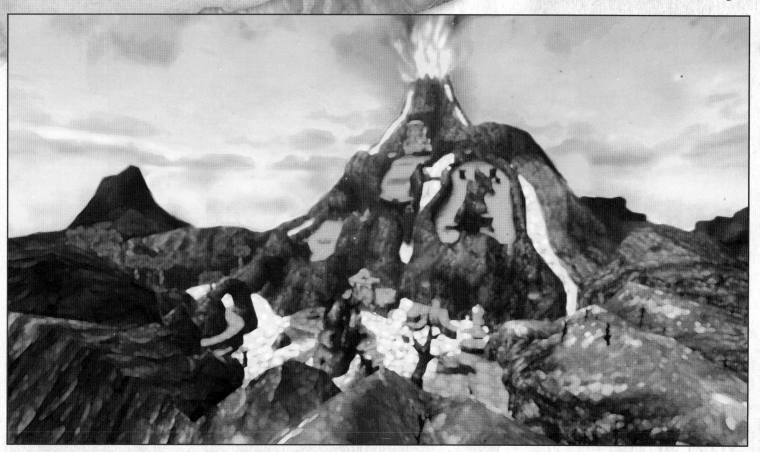

Eldin Volcano official visual

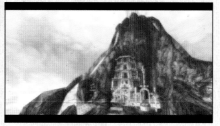

ELDIN THE FIRE DRAGON
One of the three dragons, he is the protector of Eldin Province. He lives a secluded and hermetic life at the top of the volcano.

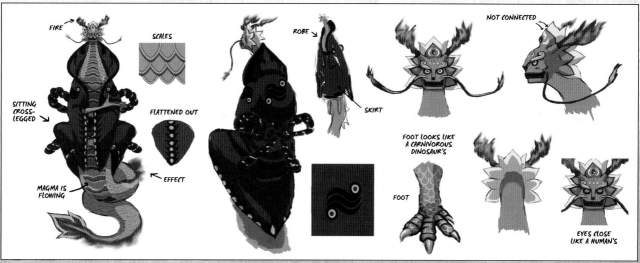

FIRE

SCALES

ROBE

NOT CONNECTED

SITTING CROSS-LEGGED

FLATTENED OUT

SKIRT

EFFECT

MAGMA IS FLOWING

FOOT LOOKS LIKE A CARNIVOROUS DINOSAUR'S

FOOT

EYES CLOSE LIKE A HUMAN'S

49

EARTH TEMPLE

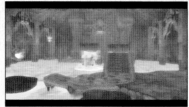
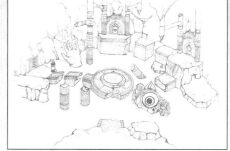

Earth Temple official visual

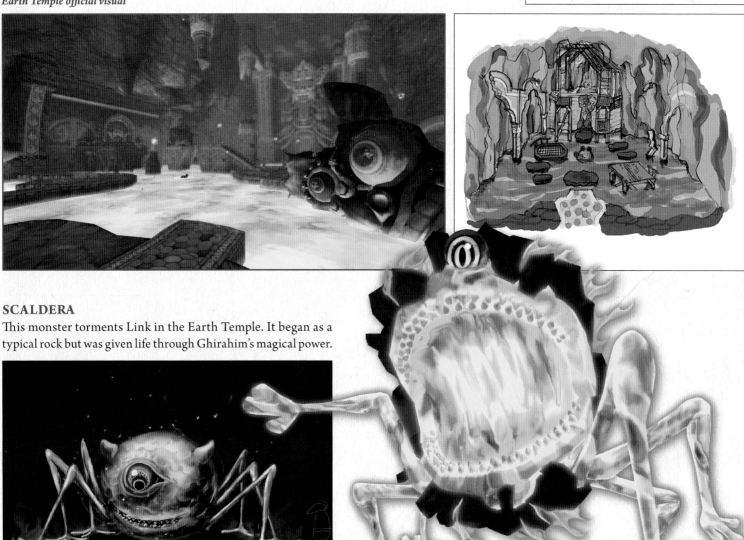

SCALDERA

This monster torments Link in the Earth Temple. It began as a typical rock but was given life through Ghirahim's magical power.

FIRE SANCTUARY

Fire Sanctuary official visual

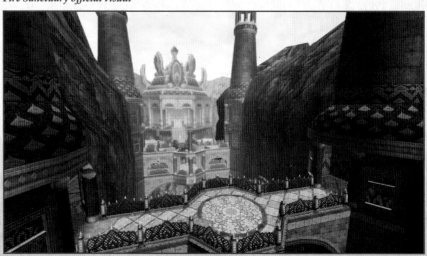

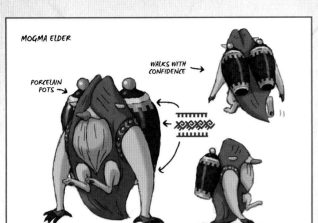

MOGMA ELDER

PORCELAIN POTS

WALKS WITH CONFIDENCE

Guld final version

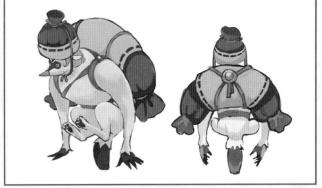

Bronzi final version

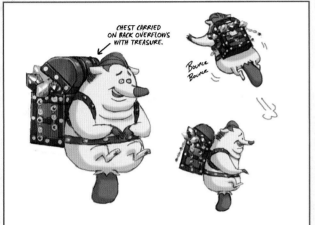

CHEST CARRIED ON BACK OVERFLOWS WITH TREASURE.

Bounce Bounce

Plats final version

Silva final version

THE MOGMAS

We wanted the Mogmas to be a race of burrowers. Despite being tenacious treasure hunters, they are surprisingly timid. They actually have a very developed culture. In the initial designs, they looked a bit more human. (*laughs*)

—Hirono, designer

Ledd

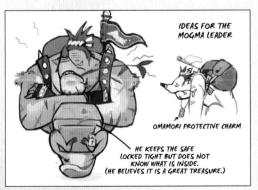

IDEAS FOR THE MOGMA LEADER

OMAMORI PROTECTIVE CHARM

HE KEEPS THE SAFE LOCKED TIGHT BUT DOES NOT KNOW WHAT IS INSIDE. (HE BELIEVES IT IS A GREAT TREASURE.)

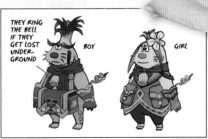

THEY RING THE BELL IF THEY GET LOST UNDERGROUND

BOY GIRL

LIGHT

SACK

ANY SORT OF ITEM CAN BE RETRIEVED FROM INSIDE THE SACK

ALBINO VERSION

SKIN HAIR SKIN HAIR

MALE FEMALE

LANAYRU DESERT

A widespread, arid area. Long ago it was lush with greenery, but several hundred years ago, it began a sudden transition into desertification. Before it was a desert, ancient robots were used here to mine a powerful ore known as Timeshift Stone.

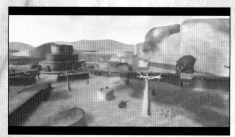

Lanayru Desert official visual

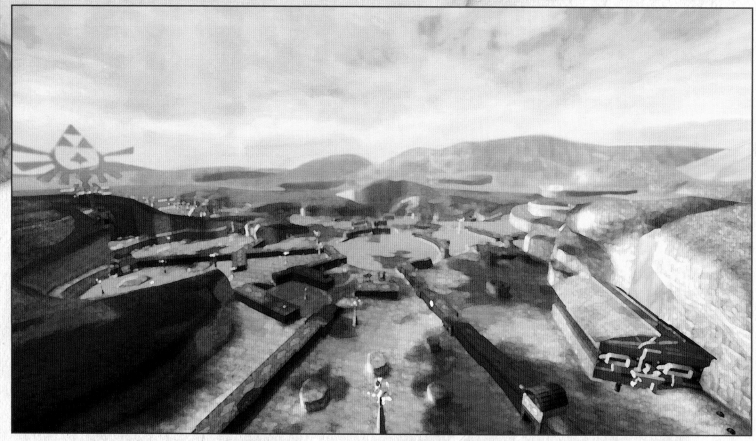

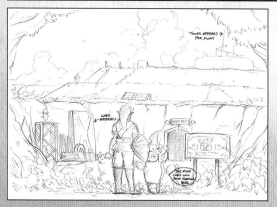

We were thinking about creating an area that drastically transformed from one landscape to another and thought, "What would be a fitting landscape to show a dramatic change?" We decided on a desert that used to have plant life and a great sea. In the Lanayru Sand Sea area, the dungeon has fairy-tale qualities, so we decided to make the dungeon a ship that floats over the desert. We also wanted it to be mobile, which is another reason that we decided on a ship.

—Fujibayashi, director / Shimizu, designer

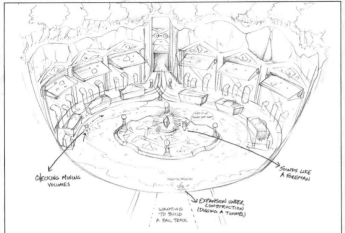

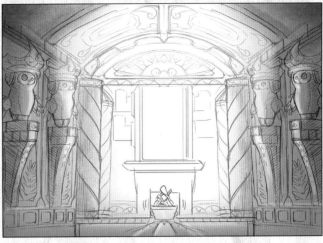

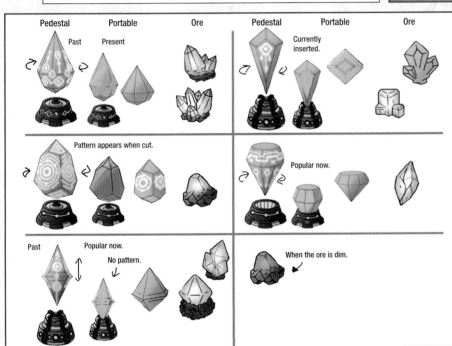

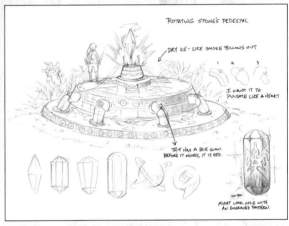

RETATING STONE'S PEDESTAL

DRY ICE-LIKE SMOKE BILLOWS OUT

I WANT IT TO PULSATE LIKE A HEART

THIS HAS A BLUE GLOW. BEFORE IT MOVES, IT IS RED.

MIGHT LOOK NICE WITH AN ENGRAVED PATTERN.

Timeshift Stone designs

Pedestal Portable Ore Pedestal Portable Ore

Past Present

Currently inserted.

Pattern appears when cut.

Popular now.

Past Popular now.

No pattern.

When the ore is dim.

Stone statue designs

With the activation of the Timeshift Stones, this area transitions between the present and the past, and we were tasked with using this theme in a desert. First, we thought about how the game play would work with this time change, and from there, how that change could keep the game interesting without sacrificing game play.
—Shimizu, designer

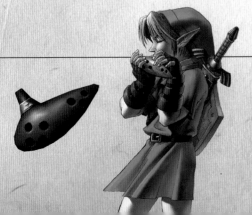

THE POWER TO CONTROL TIME

With this talk of controlling time, one can't help but think of *Ocarina of Time*. The ocarina is the same color as the Timeshift Stones. Could they be made of the same material?

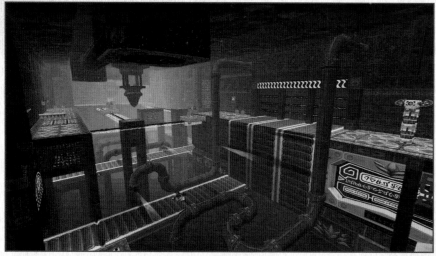

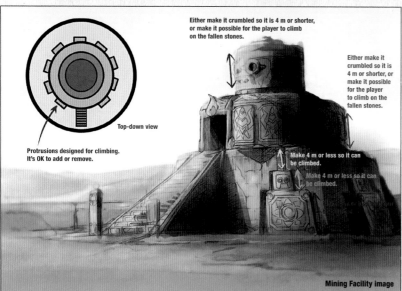

Either make it crumbled so it is 4 m or shorter, or make it possible for the player to climb on the fallen stones.

Either make it crumbled so it is 4 m or shorter, or make it possible for the player to climb on the fallen stones.

Top-down view

Protrusions designed for climbing. It's OK to add or remove.

Make 4 m or less so it can be climbed.

Make 4 m or less so it can be climbed.

Mining Facility image

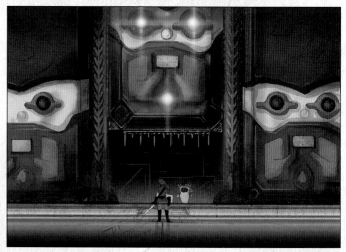

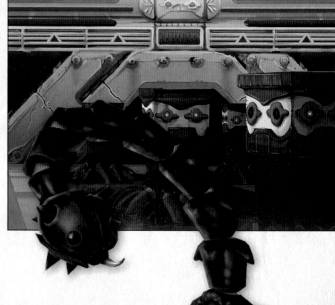

LANAYRU MINING FACILITY

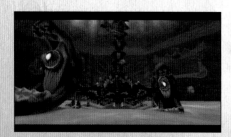

THE THOUSAND-YEAR ARACHA MOLDARACH

A monster that inhabits the inner depths of the mining facility. It is said that when an Aracha lives for a thousand years, it becomes a Moldarach.

ANCIENT HARBOR

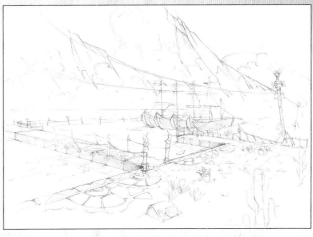

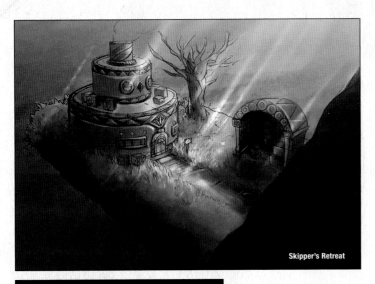

Skipper's Retreat

Skipper's boat final version

SKIPPER'S RETREAT

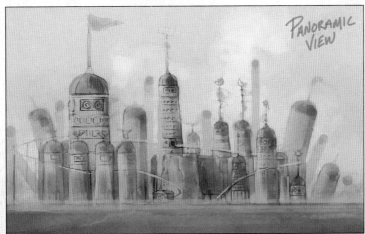

PANORAMIC VIEW

MINING CAR PRELIMINARY DESIGN

TWO RAILS

• APPEARS STABLE: LOOKS LIKE A FREEWAY OVERPASS

SHIPYARD

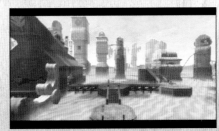

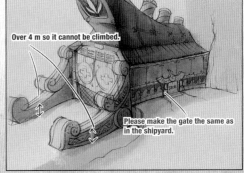

Over 4 m so it cannot be climbed.

Please make the gate the same as in the shipyard.

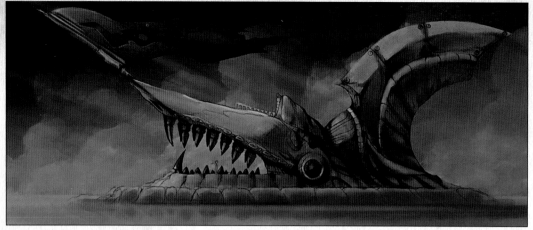

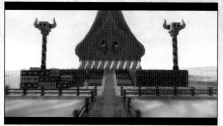

PIRATE STRONGHOLD

SANDSHIP

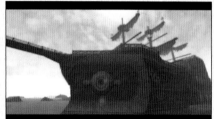

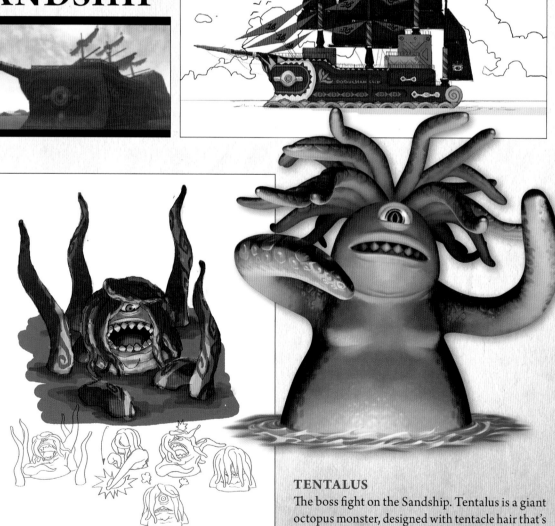

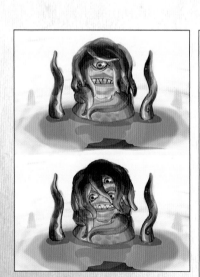

TENTALUS

The boss fight on the Sandship. Tentalus is a giant octopus monster, designed with tentacle hair that's hard not to notice.

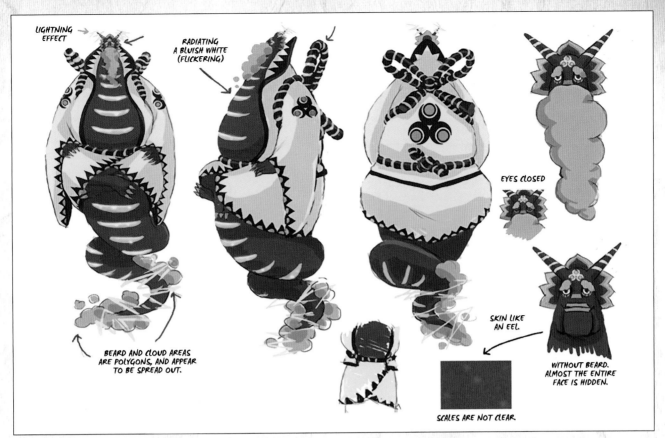

LIGHTNING EFFECT

RADIATING A BLUISH WHITE (FLICKERING)

EYES CLOSED

BEARD AND CLOUD AREAS ARE POLYGONS, AND APPEAR TO BE SPREAD OUT.

SKIN LIKE AN EEL.

SCALES ARE NOT CLEAR.

WITHOUT BEARD. ALMOST THE ENTIRE FACE IS HIDDEN.

THUNDER DRAGON LANAYRU

One of the three dragons, he is the protector of Lanayru Desert. He looks forward to someone finding him and accepting his challenge.

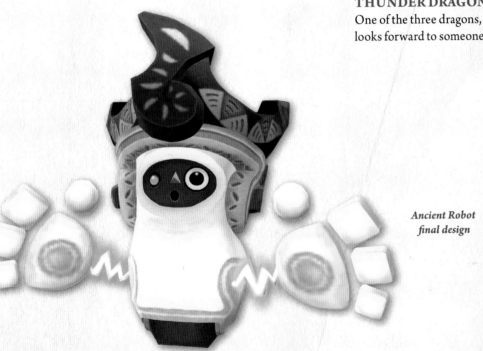

Ancient Robot final design

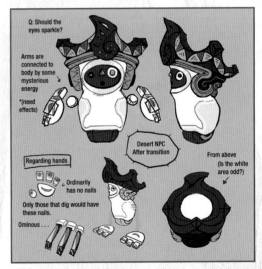

Q: Should the eyes sparkle?

Arms are connected to body by some mysterious energy

*(need effects)

Desert NPC After transition

From above (Is the white area odd?)

Regarding hands

Ordinarily has no nails.

Only those that dig would have these nails.

Ominous . . .

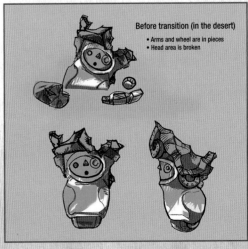

Before transition (in the desert)
- Arms and wheel are in pieces
- Head area is broken

ANCIENT ROBOT

We wanted to create a robot but did not want it to come across as cold and lifeless, so we decided to make it look more like a clay figurine. After we had the general direction, everything else came together rather quickly.

—Hirono, designer

SILENT REALM

The Silent Realm is a spiritual realm. Only those who have been chosen by the goddess are allowed to enter. In order to complete the Master Sword, Link must brave hitherto-unknown challenges in a mysterious world that remains closed to outsiders.

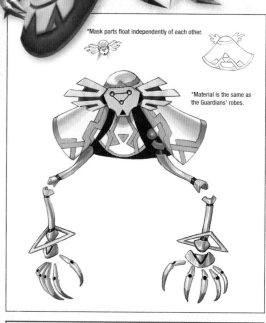

*Mask parts float independently of each other.

*Material is the same as the Guardians' robes.

Guardian final version

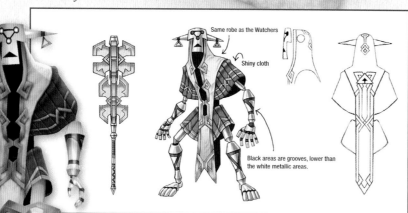

Same robe as the Watchers

Shiny cloth

Black areas are grooves, lower than the white metallic areas.

Watcher final version

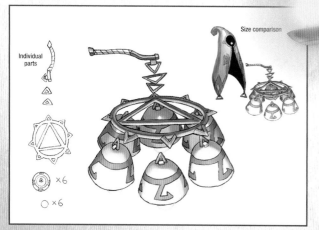

Individual parts

Size comparison

× 6

× 6

Stem grows in a loose spiral

15 buds

Spirit Vessel final version

The Guardians were designed to be the guardians of the goddess, so their clothes are covered with designs that reference the Triforce. While we wanted them to be scary, they are not evil, and so we decided to give them neutral expressions.
—Kiuchi, designer

SILENT REALM AND TWILIGHT
Collecting the glowing Sacred Tears in the Silent Realm harks back to *Twilight Princess*, where the Tears of Light are assembled within the Vessel of Light in order to resurrect the spirits within.

MONSTERS THAT HAUNT THE SURFACE

Not all residents of the Surface are friendly. Some are the subordinates of the demon kings from ancient wars. Since the demise of the demon kings, their numbers have multiplied, and now they are destroying the Surface.

Keese

Fire Keese final version

Dark Keese final version

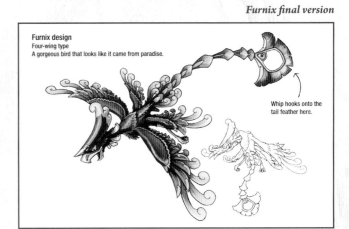

Thunder Keese final version

THREATS OF THE SKY

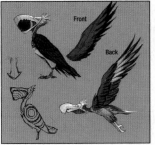

Front

Back

Hrok final version

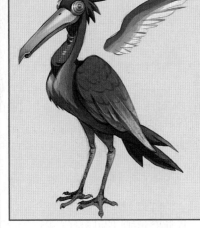

Back

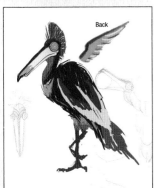

Furnix final version

Furnix design
Four-wing type
A gorgeous bird that looks like it came from paradise.

Whip hooks onto the tail feather here.

The dark colors make it look like a crow, so to distinguish it, we gave it the shape of a cormorant.

Guay final version

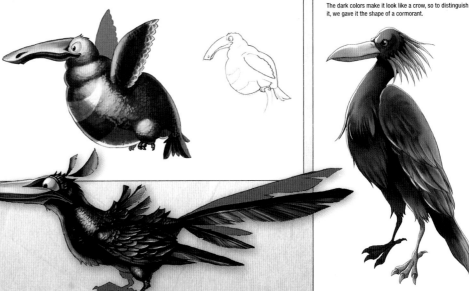

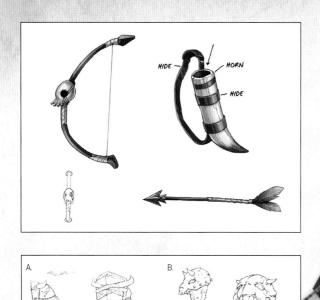

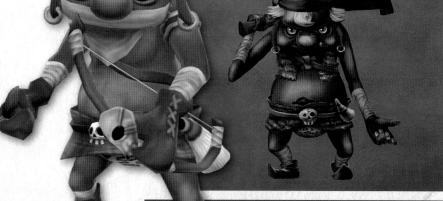

HIDE — HORN
HIDE

A. B.

C. D.

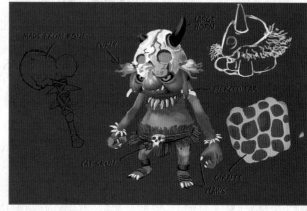

Red Bokoblin final version

Blue Bokoblin final version

MADE FROM BONE
CURLY
LARGE HORN
PIERCED EAR
CAT SKULL
GIRAFFE CLAWS

Green Bokoblin final version

Their initial designs looked pretty cute, but we realized that if they looked too cute, it took the fun out of attacking them. So, in order to make them look scarier, we sharpened their teeth and made their eyes smaller and narrower. Once we had the design for the first Bokoblin, the other types were developed from there. They are important players in many different places.

—Kiuchi, designer

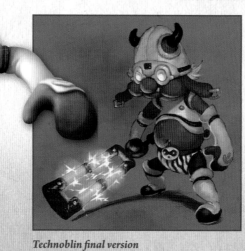

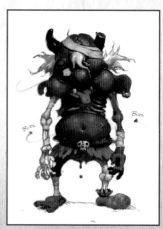

Technoblin final version

Cursed Bokoblin final version

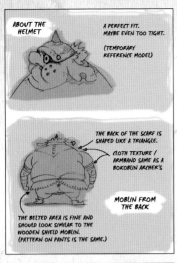

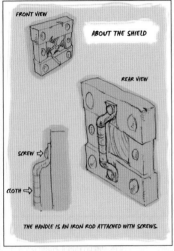

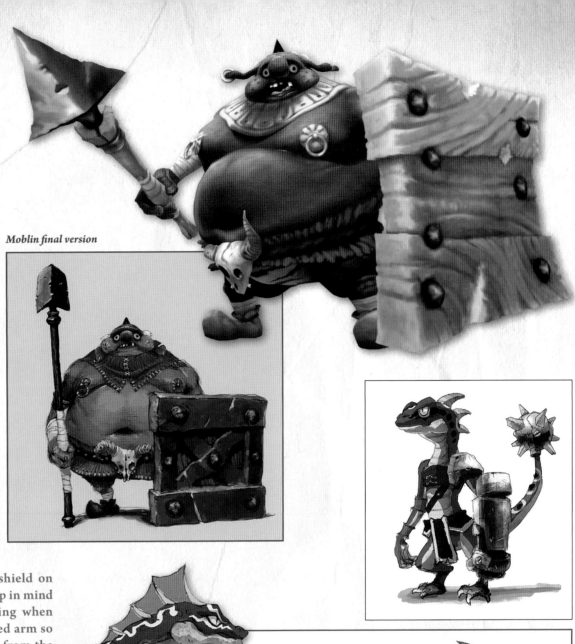

Moblin final version

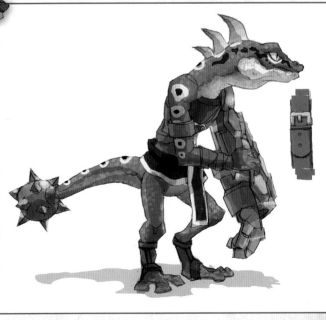

The Lizalfos carries his shield on his arm. We wanted to keep in mind which direction he's facing when he strikes with his armored arm so that the player can attack from the opposite direction. For variety, we made left- and right-handed versions.
—Kawanishi, designer

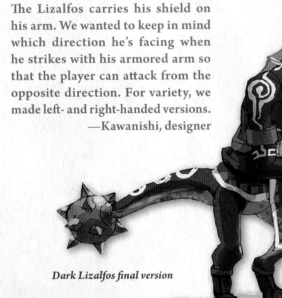

Dark Lizalfos final version

Lizalfos final version

Ocarina of Time
Moblin

Wind Waker
Bokoblin

EVOLUTION OF THE MOBLIN AND THE BOKOBLIN

The Bokoblin and the Moblin are familiar enemies who have appeared in other *Zelda* games. Their appearance and the weapons they carry have evolved, but regardless of the timeline, they never stop attacking Link.

LIFE LURKING ACROSS THE LAND

When designing the Deku Baba, we kept in mind the player's ability to make both vertical and horizontal attacks in this game and incorporated that into the design to make fighting them more fun. We think that's one of the reasons Mr. Miyamoto liked it. When designing monsters, I think it is best to keep it simple and functional.

In order to show the Spume getting ready to spit magma, we thought it would be funny to make its body inflate, so we designed it with a froglike appearance.

—Kawanishi, designer

Deku Baba final design

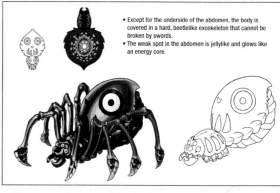

- Except for the underside of the abdomen, the body is covered in a hard, beetlelike exoskeleton that cannot be broken by swords.
- The weak spot in the abdomen is jellylike and glows like an energy core.

Octorok final design

Spume final design

Skulltula

Skullwalltula final design

THREE SUCCESSIVE SHOTS!!

TAKES A DEEP BREATH

THE HIGHLY ADAPTABLE OCTOROK

Throughout the series the Octoroks haven't changed much. In *Skyward Sword* the versatile Octoroks imitate plants, but in *Ocarina of Time* they are found in watery locations. This adaptability might answer the question of how they have been around for so long . . .

Ocarina of Time

Spirit Tracks

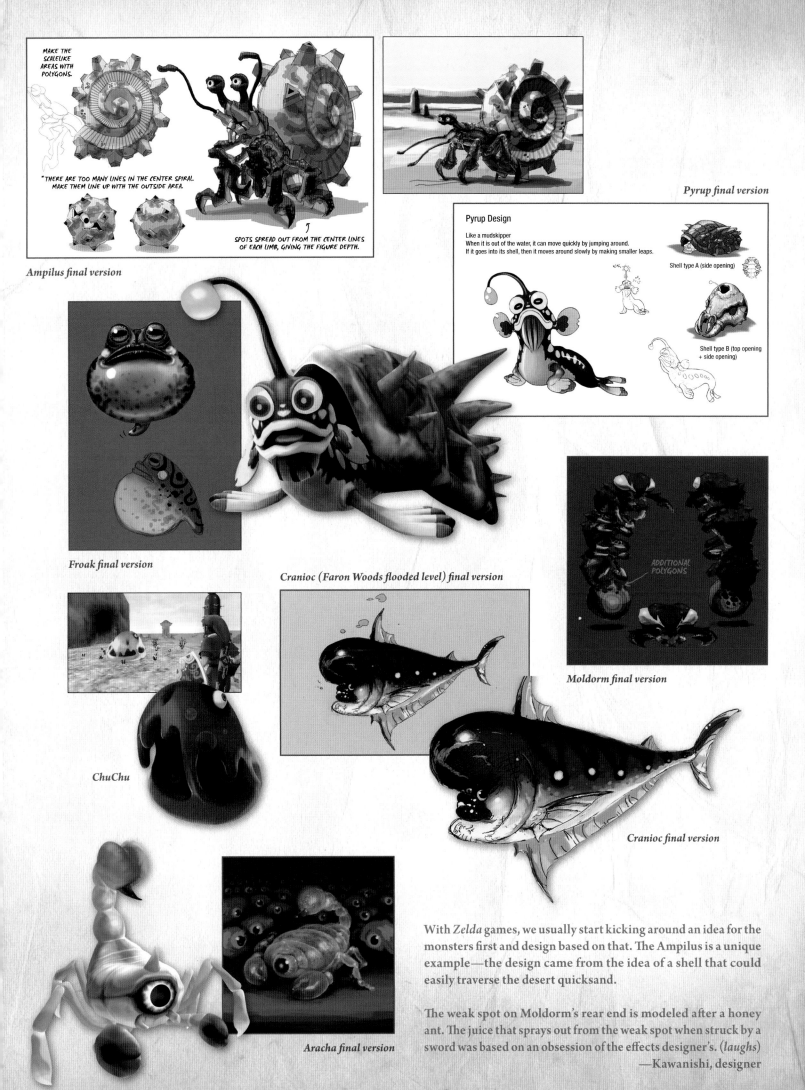

MAKE THE
SCALELIKE
AREAS WITH
POLYGONS.

"THERE ARE TOO MANY LINES IN THE CENTER SPIRAL.
MAKE THEM LINE UP WITH THE OUTSIDE AREA.

SPOTS SPREAD OUT FROM THE CENTER LINES
OF EACH LIMB, GIVING THE FIGURE DEPTH.

Ampilus final version

Pyrup final version

Pyrup Design

Like a mudskipper
When it is out of the water, it can move quickly by jumping around.
If it goes into its shell, then it moves around slowly by making smaller leaps.

Shell type A (side opening)

Shell type B (top opening + side opening)

Froak final version

Cranioc (Faron Woods flooded level) final version

ADDITIONAL
POLYGONS

Moldorm final version

ChuChu

Cranioc final version

Aracha final version

With *Zelda* games, we usually start kicking around an idea for the monsters first and design based on that. The Ampilus is a unique example—the design came from the idea of a shell that could easily traverse the desert quicksand.

The weak spot on Moldorm's rear end is modeled after a honey ant. The juice that sprays out from the weak spot when struck by a sword was based on an obsession of the effects designer's. *(laughs)*
—Kawanishi, designer

The Dead Warriors

Stalfos

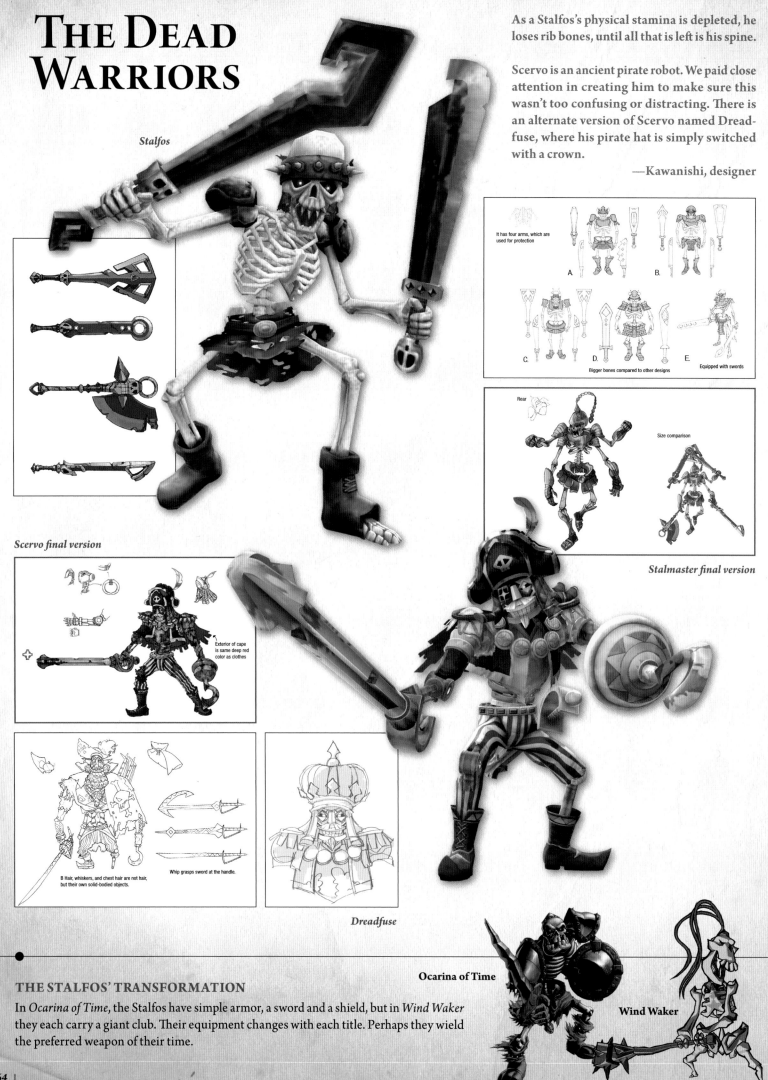

As a Stalfos's physical stamina is depleted, he loses rib bones, until all that is left is his spine.

Scervo is an ancient pirate robot. We paid close attention in creating him to make sure this wasn't too confusing or distracting. There is an alternate version of Scervo named Dreadfuse, where his pirate hat is simply switched with a crown.

—Kawanishi, designer

It has four arms, which are used for protection

A. B.

C. D. E.

Bigger bones compared to other designs Equipped with swords

Rear

Size comparison

Stalmaster final version

Scervo final version

Exterior of cape is same deep red color as clothes

B Hair, whiskers, and chest hair are not hair, but their own solid-bodied objects.

Whip grasps sword at the handle.

Dreadfuse

THE STALFOS' TRANSFORMATION

In *Ocarina of Time*, the Stalfos have simple armor, a sword and a shield, but in *Wind Waker* they each carry a giant club. Their equipment changes with each title. Perhaps they wield the preferred weapon of their time.

Ocarina of Time

Wind Waker

MAGICAL BEINGS

Magmanos final version

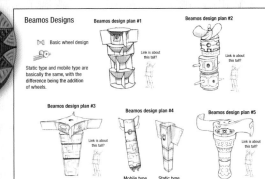

Staldra final version

Beamos Designs

Basic wheel design

Static type and mobile type are basically the same, with the difference being the addition of wheels.

Beamos design plan #1

Link is about this tall?

Beamos design plan #2

Link is about this tall?

Beamos design plan #3

Link is about this tall?

Beamos design plan #4

Mobile type Static type

Beamos design plan #5

Link is about this tall?

Model 1 Model 2

REMNANTS OF AN ANCIENT CIVILIZATION

Stabilized mode Tread mode

CATERPILLAR STYLE

Beamos final version

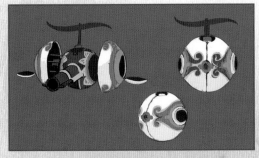

Sentrobe final version *Armos final version*

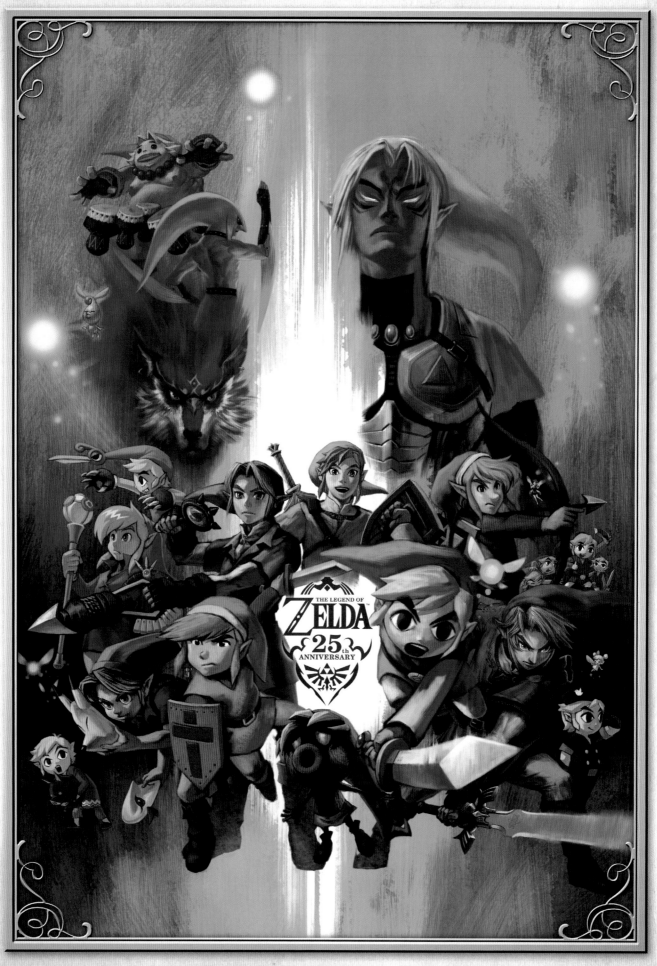

25th Anniversary Special Illustration

A special illustration created for the twenty-fifth anniversary. From the beginning to *Skyward Sword*, all the Links are here!

THE HISTORY
OF HYRULE

A Chronology

A CHRONOLOGY OF HYRULE, LAND OF THE GODS

The History of the Cycle of Rebirth and the Triforce

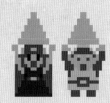

... THIS IS A TELLING OF TALES, PASSED ON THROUGH THE AGES BY HUMANS ...

This is an introduction to the history of Hyrule, told chronologically, which weaves together the numerous *Legend of Zelda* stories. Is it a legend? Is it an accurate history of a cycle of rebirth? There is evidence that the story of *The Legend of Zelda* begins with *Skyward Sword*. Up to this point, the legends of *Zelda* have been surrounded by myth and mystery, but now, with the help of the following information, you will be able to discover for yourself the real history of Hyrule.

 BEFORE YOU DELVE ANY FURTHER INTO THIS CHAPTER, READ THIS.

WEAVING HISTORY

This chronicle merely collects information that is believed to be true at this time, and there are many obscured and unanswered secrets that still lie within the tale. As the stories and storytellers of Hyrule change, so, too, does its history. Hyrule's history is a continuously woven tapestry of events. Changes that seem inconsequential, disregarded without even a shrug, could evolve at some point to hatch new legends and, perhaps, change this tapestry of history itself.

AND THE HERO SHALL BE CALLED "LINK" ...

The heroes of these chronicles all share the name Link. These Links might have been the same person, a series of familial descendents, or a number of heroes with different names entirely. The Links of certain eras may also have been named after the legendary hero. Hylian princesses bearing the name Zelda have also appeared throughout the history of Hyrule. It is likely that the name was handed down through the generations.

HOW TO READ THE CHRONICLES

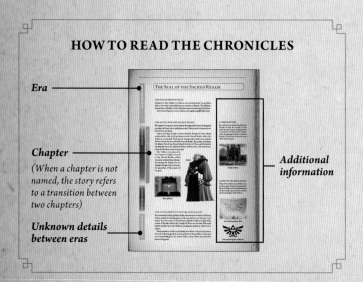

Era

Chapter
(When a chapter is not named, the story refers to a transition between two chapters)

Additional information

Unknown details between eras

STORIES NOT INCLUDED IN THE CHRONICLES

The series contains a few spinoff games, such as *Link's Crossbow Training*, that have not been included in these chronicles.

BS The Legend of Zelda

Link's Crossbow Training

THE LEGEND OF THE GODDESSES AND THE HERO (P. 70)

Creation	**The Creation of the Land and Sky**
Era of the Goddess Hylia	*Skyward Sword*
	The Ancient Battle and the Reincarnation of the Goddess Hylia
Sky Era	**A Return to the Surface**

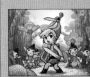

A CHRONOLOGY OF THE HISTORY OF HYRULE

The chronology begins with the creation of heaven and earth, immediately followed by the events of *Skyward Sword*. It splits after *Ocarina of Time*, with one timeline depicting the events that follow Link's triumph over Ganon, and the other his defeat. The section of the timeline where Link triumphs is further divided into two separate realities: the Child Era, where Link returns to his original time, and the Adult Era, where the Hero of Time disappears and Ganondorf is free to return unopposed.

Era of Chaos	**The Sacred Realm Is Sealed**
Era of Prosperity	**The Establishment of Hyrule Kingdom**
Force Era	*The Minish Cap*
	The Rise of the Evil Vaati

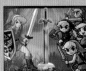

	Four Swords
	The Resurrection of Vaati

Era of the Hero of Time *(Child Era/Adult Era)*	**Hyrulean Civil War**
	Ocarina of Time
	The Sacred Realm Becomes the Dark World
	Ganondorf Becomes Demon King Ganon

THE HERO IS DEFEATED

THE HERO IS TRIUMPHANT

| *Child Era* | **The Sacred Realm Remains Protected** | *Adult Era* | **Ganondorf Is Sealed** |

THE DECLINE OF HYRULE AND THE LAST HERO (P. 92)

THE TWILIGHT REALM AND THE LEGACY OF THE HERO (P. 110)

THE HERO OF WINDS AND A NEW WORLD (P. 122)

Era of Light and Dark

	The Imprisoning War
	A Link to the Past
	The Resurrection of Ganon

	Oracle of Ages and Oracle of Seasons
	The Resurrection of Ganon

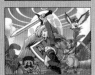

Golden Era

	Link's Awakening

The Monarchs of Hyrule Use the Triforce

The Tragedy of Princess Zelda I

Era of Decline

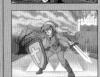

	The Legend of Zelda
	The Resurrection of Ganon
	The Adventure of Link
	The Resurrection of Ganon Is Prevented

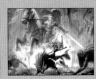

	Majora's Mask

The Demon Thief, Ganondorf, Is Executed

Twilight Era

	Twilight Princess
	The Shadow Invasion

Shadow Era

	Four Swords Adventures
	The Reincarnation of Ganondorf
	The Resurrection of Vaati

Era without a Hero

	Ganondorf Is Resurrected
	Hyrule Is Sealed and Then Flooded

Era of the Great Sea

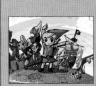

	The Wind Waker
	Ganondorf Is Resurrected

Era of the Great Voyage

	Phantom Hourglass

New Continent Discovered

A New Hyrule Kingdom Is Founded

Era of Hyrule's Rebirth

	Spirit Tracks
	Demon King Malladus Is Resurrected

THE LEGEND OF THE GODDESSES AND THE HERO

This world was created by the three goddesses. They did not intend to unite the regions of this world but instead let the inhabitants have free rein of the land. In this world, the three goddesses left behind the omnipotent Triforce . . .

THE CREATION

THE WORLD CREATED BY THE GODDESSES

This world was created by the three goddesses during a time of chaos. Din, the goddess of power, created the land. Nayru, the goddess of wisdom, created order. Farore, the goddess of courage, created the diverse inhabitants.

Upon leaving the world, the goddesses left behind the Triforce: three golden triangles. It is said that any wish the possessor of the Triforce desires will come true . . .

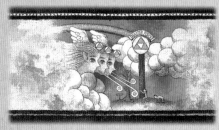

The creation

The three golden goddesses

The Triforce

THE LEGACY OF THE GODS: THE TRIFORCE

The golden goddesses departed from the world they created and left the Triforce in care of the goddess Hylia. It is unknown why the Triforce was left behind.

● THE THREE GODDESSES

Din, Nayru, and Farore each left a crest behind. Each of these symbols—the crests of power, wisdom, and courage—can be found in a location related to its respective goddess.

Crest of Din

Crest of Nayru

Crest of Farore

THE OMNIPOTENT TRIFORCE

The Triforce grants wishes to those who touch it. Since the Triforce does not distinguish between good or evil, it allows both good and bad wishes.

A strong heart, innate ability, and a balance of the three virtues (power, wisdom, and courage) are required to be granted a wish. If one who does not possess the balance of the three virtues touches the Triforce, its three pieces split apart. The finder is left with the piece that personifies what he or she values most. The other two pieces will appear on the hands of two individuals, chosen by the will of the goddess. One must reunite the three pieces in order to obtain true power.

The three goddesses and the statue of the Triforce

THE ANCIENT BATTLE

THE GODDESS HYLIA AND THE ANCIENT BATTLE

During the era of the goddess Hylia, many demons arose in pursuit of the Triforce. The leader, Demise, the Demon King, tried to take over the world with his evil powers.

After a battle against the demonic forces, Hylia gathered the humans who had survived, along with the Triforce, onto a plot of land and sent it into the sky. She positioned a heavy barrier of clouds between the island in the sky and the land below to protect the humans and the Triforce.

The goddess and the remaining tribes on the Surface battled for their lives against Demise. They were victorious, and they sealed him away.

The Demon King Demise

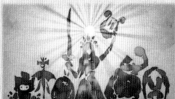

The goddess Hylia and the Surface tribes

SEALED IN THE LAND OF THE GODDESS

The land was saved, but the seal that kept the Demon King imprisoned was weak. In an attempt to destroy Demise, the goddess Hylia tried to use the power of the Triforce. However, a goddess cannot wield its power. Thus, the goddess Hylia decided to renounce her divinity and be reborn as a human.

With Hylia's passing, Impa of the Sheikah tribe was entrusted with watching over the sealed prison of the Demon King until she returned.

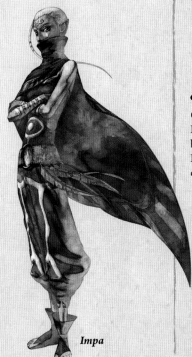

Impa

● DEMISE

It is said that Demise, the most evil of all evil, who commands enough power to destroy the world, appears in each era and looks different to each person who sees him. His ultimate goal is to obtain the Triforce and take over the land with his demonic minions.

● THE SURFACE TRIBES

Nonhuman tribes, such as the stone-eating Goron.

● THE CLOUD BARRIER

The thick, vast expanse of clouds placed between the sky and the land, sealing them away from each other. No one is allowed to pass from one place to the other.

● THE SHEIKAH TRIBE

One of the tribes that serve the goddess Hylia. They are blithe individuals chosen by the goddess to watch over the sealed Demon King. This role is passed on from one generation to the next.

THE LAND OF HYLIA

The center of the world, where the Temple of Hylia was built. This is where the goddess Hylia gathered the surviving humans onto a plot of land and sent them into the sky. It is here, also, where the Demon King was sealed away, which is why the land became known as the Sealed Grounds and the Temple of Hylia as the Sealed Temple.

The Temple of Hylia

The Sealed Grounds

SKYLOFT AND THE LEGEND OF THE GODDESS

The plot of land Hylia sent into the sky became known as the Isle of the Goddess.

The islands in the sky where the surviving humans dwell became known as Skyloft. There the humans lived with guardian birds, known as Loftwings, given to them by Hylia.

Only a few individuals on the Surface knew of the existence of the goddess and Skyloft. After a few thousand years, their story was forgotten and became legend.

Isle of the Goddess

Skyloft

● ISLE OF THE GODDESS

The area on the Surface where Hylia gathered the humans, rent the earth, and sent them into the sky. Depictions of the Triforce and what would later be known as the Sage Medallions can be seen on the ceiling of the entrance to the temple. When the land was split from the Surface, half of the temple was as well, along with half of the depictions of the six medallions.

Remains of the temple

THE DEVELOPMENT OF SKYLOFT

During the ancient battle, the humans had no choice but to flee the Surface to survive. On Skyloft, they developed a militia and slowly built up their strength.

Gaepora, the keeper of the legends that had been passed down through his family, built the Knight Academy.

Gaepora brought kendo training and Loftwing riding together and established the order of the knights.

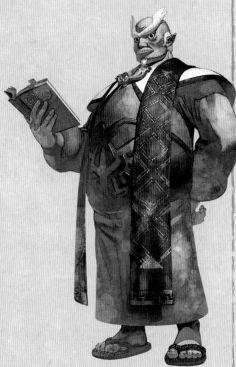

Gaepora

● SKYLOFT

Skyloft is connected to the Isle of the Goddess by a bridge. It is a paradise with springlike weather year round.

● THE LEGEND KEEPERS

The keepers of the legends protect the secrecy of the ancient documents about the Surface and the Goddess Sword, which is located in the Statue of the Goddess.

THE ALPHABET

These characters date back to the time when the goddess Hylia was governing the land. They can be found on the pedestal of the Statue of the Goddess and on various buildings on the Surface. They are ancient and are now impossible to interpret.

Characters on the Gate of Time

THE GODDESS HYLIA'S REINCARNATION

As the seal of Demise, the Demon King, began to weaken, a human girl was born. That girl was named Zelda, and she was the goddess Hylia reincarnated.

Zelda grew up to be a beautiful woman who was chosen to play the role of the goddess for the Wing Ceremony at the Knight Academy. Skillfully handling his rare Crimson Loftwing, Link was victorious in his year's Wing Ceremony and so won the honor of performing the ceremony of the goddess opposite Zelda.

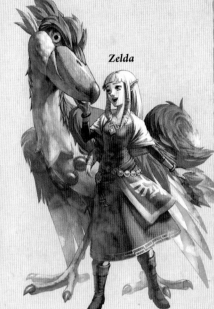
Zelda

Statue of the Goddess

DEMON LORD GHIRAHIM

Around the same time, Demise sent his follower Ghirahim to the Surface, where Ghirahim gave himself the title of lord. Through secret plotting and scheming, he unleashed demon hordes on the land in an attempt to find the goddess and resurrect the Demon King Demise.

Ghirahim finally found Zelda in the sky. He produced a tornado that penetrated the clouds and caused her to fall to the Surface.

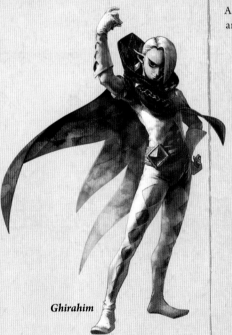
Ghirahim

● **THE WING CEREMONY**

The exam that allows students to academically advance in the Knight Academy. The one who rides their Loftwing skillfully enough to obtain the bird statuette before the others becomes the champion and advances to their senior year.

● **THE CEREMONY OF THE GODDESS**

The champion of the Wing Ceremony receives the gift of the Sailcloth from the individual playing the goddess. The Sailcloth is used at the end of the ritual, when the winner demonstrates their courage by leaping off a precipice and opening the cloth at the last moment to glide safely to the ground. The goddess role is played out just as it always has been since ancient times. This year, the twenty-fifth anniversary of the Knight Academy, the Sailcloth is given to the champion atop the Statue of the Goddess.

● **DEMON LORD GHIRAHIM**

A master sorcerer, Ghirahim can teleport and summon demons.

KNIGHT ACADEMY

A school dedicated to training young students to become knights. The honor students become the Rescue Knights. Their duties include saving people who have fallen from the islands in the sky and patrolling at all hours upon a Loftwing.

The students who pass the Wing Ceremony become seniors and are given uniforms. Each year the uniforms are a different color. In the twenty-fifth anniversary year, when Link becomes a senior, the uniforms are green.

Senior uniform

Rescue Knight

THE SPIRIT GUIDE FI AND THE HERO

Following the path of his destiny in the legend passed on to Gaepora, Link was guided to the Goddess Sword enshrined within the Statue of the Goddess.

In order to find Zelda, Link was escorted by Fi, the spirit of the sword, down to the land of legend. Link's quest began as he plunged through the clouds holding the Sailcloth given to him by Zelda . . .

Fi

A PILGRIMAGE OF SELF-DISCOVERY

After her fall from the heavens, Zelda, now on the Surface, was rescued by an old woman. The old woman told Zelda that she was the reincarnation of Hylia and needed to cleanse herself in the temples of the sky and the earth. Understanding her destiny, and clothed in the garments of the goddess, Zelda set off for the Skyview and Earth springs.

At the Earth Spring, Zelda was captured by Ghirahim's henchmen, the Bokoblins, but saved by Impa, of the Sheikah tribe, whose responsibility was to protect the reincarnated goddess.

Link and the Goddess Sword

Zelda, just after the fall

The old woman

● THE GODDESS SWORD

The sword kept inside the Statue of the Goddess, within the Chamber of the Sword. The goddess Hylia left the sword and its spirit, Fi, to guide the Hero. The sword and its legend have always been protected by Gaepora's family. Legend has it that when evil returns to the land, the sword will begin to glow and can be drawn by the chosen hero.

● GARMENTS OF THE GODDESS

The same white dress that the goddess Hylia wore. It has been told that the harp also once belonged to the goddess.

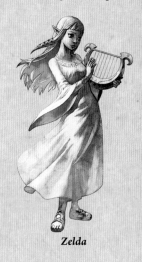
Zelda

● THE OLD WOMAN

She has been the protector of the Sealed Temple for thousands of years. She is actually the same Impa that saved Zelda, but of this era.

MAP OF THE SURFACE

The Surface is divided into three regions. Each region is named after one of the dragons, Faron, Eldin, and Lanayru, who protect the Sacred Flames.

A thick forest grows in the Faron region. The Eldin area is volcanic, and Lanayru is a desert, though it was previously a lush, green landscape.

ZELDA'S RETURN TO THE PAST

Zelda prayed at the two springs, purifying herself and regaining her memories as the goddess Hylia. In order to strengthen the seal that imprisoned the Demon King Demise, Zelda attempted to return to the ancient era from the Temple of Time in the desert. However, Ghirahim found her.

Link showed up just in time. He fought with Ghirahim, protecting Zelda and Impa while they entered the Gate of Time. Upon entering, Impa destroyed the gate so that Ghirahim could not follow them to the ancient past.

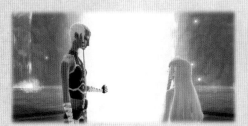

The Earth Spring

The Temple of Time

LINK BECOMES A TRUE HERO

The other Gate of Time, located at the Sealed Temple, was broken.

As the seal holding the Imprisoned began to break, Link and his comrade Groose held the monster back. All the while, Link continued with his task of tempering the Goddess Sword in the Sacred Flames of the Golden Goddesses. Imbued with the immense, sacred power of the Force, the Goddess Sword was transformed into the Master Sword. To reactivate the Gate of Time, Link pointed his sword skyward, charging it with energy and readying it for a Skyward Strike!

Sword gaining the power of a Sacred Flame

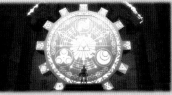

The Gate of Time

A BRIEF ENCOUNTER

After passing through the Gate of Time, Zelda and Impa arrived at the Sealed Grounds in the ancient past. Link, using the second gate, followed them there. Zelda told Link that in order to strengthen the seal imprisoning Demise, she must slumber in the Sealed Temple.

The Surface became stable and Skyloft flourished. Thousands of years passed.

Zelda falls asleep

● THE TWO SPRINGS

When Zelda purifies her body in Skyview Spring and Earth Spring, dedicating her prayers to the Statue of the Goddess, her memory of being Hylia returns.

Zelda praying

● GROOSE

A young man of Skyloft who comes down to the Surface looking for Zelda.

● FORCE

The sacred power the gods gave to the world. It's the breath of life itself.

● SKYWARD STRIKE

The power collected by pointing the sword skyward. When the Goddess Sword becomes the Master Sword, its powers are enhanced and it emits a great light.

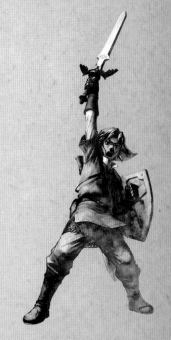

THE DESTRUCTION OF DEMISE

After returning to his own era, Link found the legendary Triforce. He became worthy of its omnipotent power upon the completion of a number of trials, at which time he received the crest of the Triforce. He was granted his wish: the Statue of the Goddess returned to its former place in the Sealed Grounds, where it destroyed the Demon King Demise.

After thousands of years of sleep, Zelda awoke.

The Triforce

THE RESURRECTION OF THE DEMON KING DEMISE

The enraged Ghirahim kidnapped Zelda and took her through the Gate of Time. After arriving in the past, Ghirahim performed the ritual to resurrect the Demon King Demise. Link followed, battling and defeating Ghirahim, but he was too late. Demise was reawakened! After an intense battle, Link defeated the demon. Upon his termination, the Demon King's hatred was absorbed and sealed in the Master Sword. The demons on the Surface no longer terrorized its inhabitants.

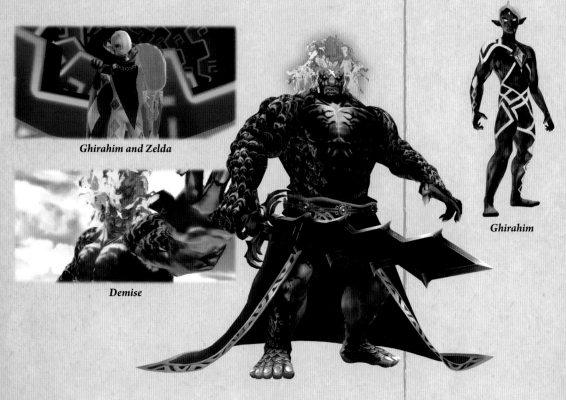

Ghirahim and Zelda

Demise

Ghirahim

A RETURN TO THE SURFACE

Zelda and the others returned to the present time. The atmosphere was peaceful and there was a feeling of a new beginning. Zelda resolved to live on the Surface and to protect the Triforce.

However, the destruction of Demise was not the end of the battle. It was the beginning of a curse: a never-ending cycle of the reincarnation of the Demon King, whose hatred for those with the blood of the Goddess and the spirit of the Hero is everlasting.

● THE CREST OF THE TRIFORCE

The proof of the complete power of the Triforce appears as marks on the back of the hand. The top triangle represents power, the bottom left represents wisdom, and the bottom right represents courage. Once the bearer of the three triangles attains a perfect balance of the attributes they represent, the true power of the Triforce is revealed.

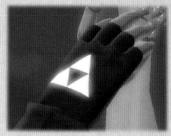

The crest of the Triforce

● THE RITUAL

To resurrect the Demon King, his loyal follower Ghirahim must sacrifice Zelda, releasing the goddess Hylia's spirit. Ghirahim's true form is the evil spirit of Demise's sword.

● FI AND IMPA

Fi's role as Link's guide is complete. The Master Sword and its spirit, Fi, are returned to their resting place in the pedestal inside the Statue of the Goddess. Impa returns to the past and continues to look after the Master Sword and protect it from the curse.

THE SEAL OF THE SACRED REALM

THE KINGDOM OF HYRULE

Created by the Golden Goddesses and protected by the goddess Hylia, the world eventually became known as Hyrule. The Hylians, descendents of Hylia, lived in Hyrule and possessed magical abilities.

After years of peace, a wave of chaos once again engulfed the land.

THE BATTLE FOR THE SACRED REALM

The legend of a supreme power spread throughout the land, whetting the appetites of those who would possess the Triforce and inciting vicious battles between them.

Rauru, the Sage of Light, constructed the Temple of Time, which contained the only existing entrance to the Sacred Realm, where the Triforce was located. With power stronger than both time and the Master Sword, Rauru sealed the Sacred Realm. The pedestal holding the Master Sword was closed behind the Door of Time, and the keys to opening the door (the Spiritual Stones of forest, fire, and water) were protected by their respective people.

The Triforce was placed in the Temple of Light, located in the Sacred Realm, which was now isolated from Hyrule. Protecting the Triforce in the Temple of Light, Rauru became the guardian of the power of the gods.

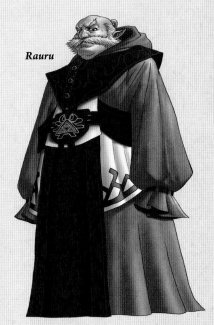

Rauru

Door of Time

● TEMPLE OF TIME

The only entrance to the Sacred Realm's Temple of Light, the Temple of Time shares the same name as the temple in the Lanayru Desert of the Era of the Goddess Hylia. It is thought that Rauru built the Temple of Time directly over the ruins of the Sealed Temple.

Temple of Time

● CREST OF THE ROYAL FAMILY

The goddess Hylia had a birdlike crest, and the people of Skyloft rode giant birds. The crest of the royal family incorporates the historically important bird, as well as the three triangles of the Triforce.

Crest of the goddess Hylia

THE ESTABLISHMENT OF HYRULE KINGDOM

The descendents of the goddess Hylia, who was reincarnated as Princess Zelda, established the kingdom of Hyrule and became Hyrule's royal family. In order to protect the Triforce, Hyrule Castle was built in the center of Hyrule, where the Temple of Time was located. The royal family watched over the Triforce, keeping its existence unknown to others.

Many members of the royal family were born with special powers because of the lineage that connected them to the goddess. Princesses were repeatedly given the name Zelda, a name that came from the historical legends.

Crest of the kingdom of Hyrule

77

THE PICORI AND THE LIGHT FORCE

THE HERO OF MEN

In the first major event to happen since the kingdom of Hyrule was established, the world was engulfed by evil beings and shrouded in darkness. It was then that a tiny Picori descended from the sky bringing a golden light and a sword. Using the sword, the Hero of Men sealed the evil beings away in the Bound Chest and brought peace to the world once again.

The golden light was the Light Force.

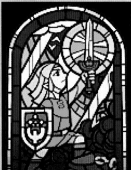
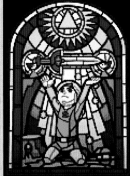

The legend of the Light Force

THE ROYAL FAMILY AND THE PICORI

After sealing away the evil beings, the royal family of Hyrule became the careful overseers of the sword, which became known as the Picori Blade. Furthermore, the royal family kept the existence of the land of the Picori, the Minish Realm, hidden.

In gratitude to the Picori, the people held a Picori Festival once a year.

Picori

THE SWORD-FIGHTING TOURNAMENT AND THE PICORI BLADE

Legend said that every hundred years, a secret door would open up, and the Picori would pass through and enter the world of the humans.

The customs of the Picori Festival had continued for many, many years. Among them was a sword-fighting tournament. The awards ceremony was held in front of the Picori Blade and was the only chance to see the blade.

The sword-fighting tournament's awards ceremony

● **THE SWORD-FIGHTING TOURNAMENT**

A tournament that happens during the Picori Festival at Hyrule Castle. The champion of the tournament is customarily presented with an award in front of the Picori Blade.

VAATI REBORN AND THE FOUR SWORD TRAINING

UNEXPECTED EVIL AT THE PICORI FESTIVAL

For the one hundredth year of the Picori Festival, there was an unusually grand celebration. In the customary sword-fighting tournament, an unknown man named Vaati was the victor.

Vaati believed the Light Force was in the Bound Chest. He broke the Picori Blade to unseal the chest and found that it did not contain the Light Force at all. The evil that had been sealed inside poured forth from the chest.

Vaati turned Princess Zelda into stone and headed off in search of the Light Force.

Vaati

● PRINCESS ZELDA

The princess of Hyrule, said to have mysterious powers. Afraid Princess Zelda will get in his way, Vaati turns her into stone.

Princess Zelda

THE SECRET OF THE PICORI

The curse placed on Princess Zelda could only be broken with the sacred power of the Picori Blade. The tribe of the Picori, also called the Minish, were the only ones able to fix the Picori Blade, and they could only be seen by children. Therefore, Smith, the great blacksmith, proposed that the king of Hyrule enlist the help of the young Link. The king told Link where the Minish dwelled. Then, with the broken Picori Blade and the Smith's Sword in hand, Link set off in search of their land.

Link

● SMITH AND LINK

Smith is a blacksmith and Link, his apprentice. Smith makes an impressive sword that is to be given to the winner of the sword-fighting tournament. Link and Princess Zelda are childhood friends who are both in attendance at the tournament.

● THE EVIL SORCERER VAATI

Originally the Minish sage Ezlo's apprentice, Vaati courted the evil within the hearts of humans and eventually fulfilled his wish of becoming an evil sorcerer. Vaati believes that the Light Force is kept within the Bound Chest sealed with the Picori Blade. He takes part in the sword-fighting tournament to get close to it.

MEETING EZLO

On his way to the Picori's home in the Minish Woods, young Link met Ezlo, a man suffering from a curse.

Link came to learn that Ezlo had been a Minish sage and Vaati had been his apprentice. When Vaati put on the Mage's Cap made by Ezlo, he gained evil powers and cursed Ezlo by changing him into the shape of a cap.

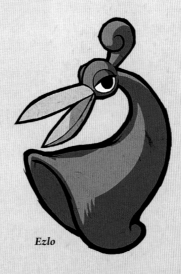

Ezlo

Vaati, as a simple Minish

THE MINISH VILLAGE AND THE FOUR ELEMENTS

Feeling responsible for Vaati's actions, Ezlo teamed up with Link and set off for the portal to the Minish Village. The Minish were so tiny they could easily fit into the palm of a grown human's hand. When Link entered the portal, he shrank down to their size and gained entry to the Minish Village in the woods.

In order to break the curse on Zelda, Link needed to repair the Picori Blade and use its sacred power. There were four elements hidden around the world that Link needed to obtain and then place on the pedestal in the Elemental Sanctuary to restore the sacred power to the blade.

Minish Portal

Picori and Link

Link and Ezlo

Wind Tribe

VAATI'S TACTICS

Still on a quest to obtain the Light Force, Vaati took control of the king of Hyrule and had him order his soldiers to search for the Light Force.

Vaati learned from the legend of the Wind Tribe that when the Four Elements were collected and placed in the Elemental Sanctuary, a holy sword would be born, and the path to the Light Force would open.

Knowing that Link was collecting the Four Elements, Vaati waited until a time when he could take the elements from Link.

● THE FOUR ELEMENTS

The Four Elements are crystalline forms of the spiritual energy that exists in the world—earth, fire, water, and wind. In order for Link to collect all Four Elements, he must utilize specific items to accomplish his goals, some of which are similar to the ones used by heroes of the past.

Gust Jar

Mole Mitts

● THE WIND TRIBE

The Wind Tribe originally lived on the land. After mastering the wind, they moved their palace up into the sky. They live even higher than the clouds, and the winds carry news of everything to them.

The land that they left behind became known as the Wind Ruins. They can ride the wind to travel back and forth between the sky and the land.

THE LAND OF THE MINISH

The Picori are a tribe of tiny people. Link becomes the size of a Minish and enters their realm, a land most people would not be able to locate. Being very tiny has its disadvantages for Link; weak goblins and enormous enemies alike stand in the way of his quest. A small puddle seems like a massive lake. For a tiny person, the dangers are many.

THE ELEMENTAL SANCTUARY

After collecting all of the Four Elements, Link placed them on the sacred pedestal. The Picori Blade became infused with sacred power and transformed into the Four Sword, which gave the wielder the ability to split into four identical copies of himself.

Simultaneously, a door beyond the pedestal opened, revealing the legend that the Light Force dwelled within the princess Zelda, generation after generation.

The Elemental Sanctuary

VAATI'S WRATH

After Vaati followed Link and learned about the Light Force, he took Princess Zelda to the roof of the castle and, little by little, extracted what he could of the Light Force from her body in order to transform himself. Link stopped the ritual, but Vaati was still able to use the power of the Light Force to transform into Vaati's Wrath. Using the power of the Four Sword, Link destroyed Vaati's Wrath and broke the curses on Princess Zelda and Ezlo.

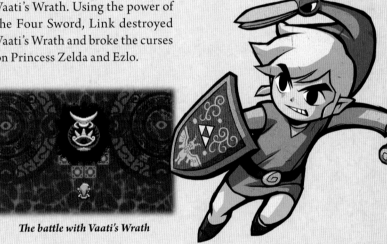
The battle with Vaati's Wrath

THE MAGE'S CAP

The battle between Link and Vaati's Wrath brought Hyrule Castle down around them. Ezlo gave the Mage's Cap to Princess Zelda, who, with the small amount of Light Force left within her, made a wish to restore Hyrule to its original condition. Not long after, the door to the Minish Village began to close, but before it shut, Ezlo presented Link with a green cap and then returned to the Minish Village.

The Minish Ezlo and Princess Zelda making a wish

The legend of Link

● THE ELEMENTAL SANCTUARY

The Elemental Sanctuary is a sacred place that human adults are unable to see. The entrance is located within the garden of Hyrule Castle. It holds the pedestal of the Four Elements and contains the secret of the Light Force.

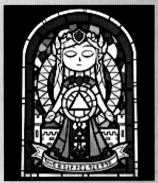
Legend of the Light Force

● THE MAGE'S CAP

The Mage's Cap was originally a gift for the humans made by a Minish named Ezlo. It grants the wish of its wearer. The stronger the heart of the wearer, the greater the power the cap exhibits.

THE SEAL IS BROKEN

Peace was fleeting in Hyrule. Vaati, presumed dead, suddenly reappeared, and terror returned to the land.

Vaati occupied the Palace of Winds and kidnapped every beautiful young woman in Hyrule, one by one.

That was when the Hero, carrying the legendary Four Sword, appeared. Tapping into the sword's power, the Hero's body split into four, and the combined power of the Heroes was enough to defeat Vaati. Vaati was sealed in the Four Sword and enshrined in the Elemental Sanctuary.

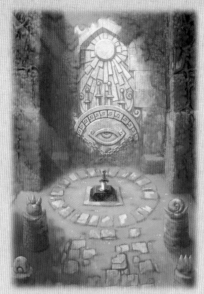

The sealed Four Sword

THE RESURRECTION OF THE WIND MAGE

For generations, Princess Zelda and her descendents looked after the sealed Four Sword, but a day came when the seal began to weaken.

When Princess Zelda went to check on the seal, it broke. Vaati escaped his prison, kidnapped Zelda, and took her to the Palace of Winds.

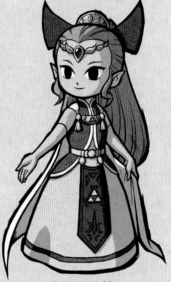

Princess Zelda

THE POWER OF THE FOUR SWORD

Link witnessed the resurrection of the evil Vaati. Shortly after, a fairy appeared to Link and instructed him to draw the legendary Four Sword. As he did so, he split into four. The Great Fairies said that they could help Link get to the Palace of Winds, but he first had to prove his courage by defeating dangerous foes and collecting rupees.

● VAATI, THE WIND MAGE

Vaati, who has no memory of his life as a Picori, goes on a mindless rampage. With the ability to manipulate the wind, Vaati calls himself the Wind Mage, and takes over the Palace of Winds.

● THE HERO OF THE FOUR SWORD

Not much is known about the origin of this hero, but it is possible that he is a descendent of the Link who defeated Vaati previously.

● THE KIDNAPPED PRINCESS ZELDA

Vaati kidnaps Princess Zelda to make her his bride in commemoration of his resurrection, not to obtain the Light Force.

The four Links

THE FOUR HEROES

After the Links collected rupees from the three regions protected by the three Great Fairies, and earned the titles of "little eggs," "brave heroes," and finally, "the greatest of heroes," the Links were given the keys to the Palace of Winds, now known as Vaati's Palace.

After earning the keys, Vaati's Palace appeared, and the four Links set off to confront the Wind Mage.

● THE THREE GREAT FAIRIES

The Great Fairy of Forest protects the region known as the Sea of Trees. The Great Fairy of Ice protects the Talus Cave, and the Great Fairy of Flame protects Death Mountain.

The Great Fairies

THE PALACE OF WINDS REAPPEARS

The four Links confronted Vaati in the depths of the palace. Using their combined power, the four Links attacked Vaati, defeated him, and rescued Princess Zelda.

Vaati was again sealed into the Four Sword, and the Four Sword was returned to its proper place in the pedestal. With the power of the Four Sword once again dormant, the four Links merged back into a single body.

Princess Zelda and the people of Hyrule again kept a strict watch over the seal.

Vaati

THE REGIONS PROTECTED BY THE GREAT FAIRIES

The regions protected by the three Great Fairies are the dense forested area called the Sea of Trees, the frozen Talus Cave, and the volcanic Death Mountain.

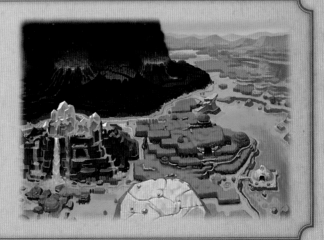

HYRULE KINGDOM IN CHAOS

HYRULE, ENGULFED BY THE FIRES OF WAR, AND THE KINGDOM UNITED

The war in Hyrule raged unabated for countless eras.

In the midst of the confusion, a lone woman fled the fires of war, babe in arms, and escaped to the Forbidden Forest. She entrusted her child to the spirit of Kokiri Forest, the Deku Tree. The Deku Tree, sensing that the infant's destiny was intertwined with Hyrule's future, took the child in.

Once the child's mother had breathed her last, the babe was raised as a Kokiri. This boy would later become Link the Hero.

The fighting was eventually quelled by the king of Hyrule, and the entire land was unified under his kingdom.

Deku Tree

Kokiri Forest

● FORBIDDEN FOREST

This is the name given to Kokiri Forest and the Lost Woods by the humans living outside its leafy borders. Adults lost among the trees turn into Stalfos, while children turn into Skull Kids; both are doomed to wander the woods.

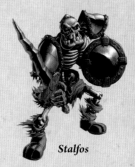

Stalfos

Skull Kid

A BRIEF TRANQUILITY

The scars of war faded from Hyrule, and it seemed that, at last, the world was at peace.

Ganondorf, leader of the Gerudo, the people of the desert, once again swore fealty to the king of Hyrule. However, Ganondorf's true aim was the Triforce, said to lie somewhere within the kingdom. Seeking the three Spiritual Stones necessary to open the gateway to the Sacred Realm, he carried out his plots in secret, in every corner of the land.

Hyrule Castle

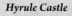
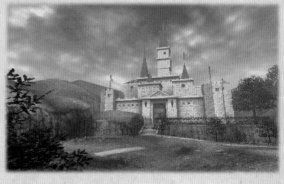

A MAP OF THE ERA

Hyrule Castle is located within Hyrule Field, which lies at the center of the kingdom. To the northeast, Death Mountain erupts continuously. To the east is the forest; to the south, Lake Hylia. The west is home to Gerudo Desert. The terrain doesn't differ much from that of the Era of the Sky.

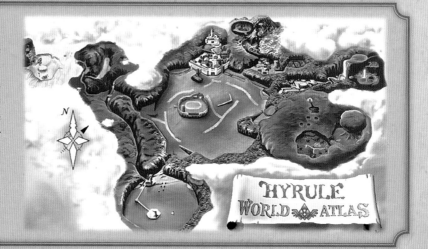

THOSE CHOSEN BY THE TRIFORCE

THE PROPHETIC DREAM OF THE DIVINE PRINCESS

When she was little, Princess Zelda of Hyrule was chosen by the gods to wield divine power. One day, the destiny of Hyrule was revealed to the princess in a dream: Ganondorf sought the Triforce that rested in the Sacred Realm, and was liable to destroy the world . . .

Princess Zelda knew the truth, but her father, the King of Hyrule, didn't believe what the prophecy had foretold. Princess Zelda and her companion, Impa, took it upon themselves to keep a close eye on Ganondorf during his visit to the castle.

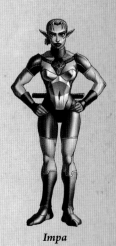

Ganondorf the thief

Princess Zelda

● PROPHECY IN A DREAM

From the farthest reaches of the desert came a man who shrouded the kingdom of Hyrule beneath dark clouds. Out of the darkness, the light of salvation appeared in the shape of a boy led by a fairy.

● IMPA

Princess Zelda's attendant. One of the last surviving members of the Sheikah tribe, who have served the royal family since ancient times.

Impa

THE BOY LED BY THE FAIRY

In the midst of these events, Princess Zelda received a visitor from Kokiri Forest: A young boy led by a fairy. Link had obtained one of the three Spiritual Stones that served as the key to opening the Sacred Realm.

Princess Zelda, a strong believer in the dream's prophecy, realized that she needed to locate the Sacred Realm before Ganondorf did, and use the power of the Triforce to bring about his downfall. She entrusted Link with the task of finding the two remaining Spiritual Stones.

Princess Zelda and Link, the boy from the forest

● THE FAIRY

Navi the fairy was sent by the Deku Tree to serve as Link's guide. She partners with Link, aiding him on his adventure.

LINK'S TRAVELS AND THE KOKIRI TRIBE

Each member of the Kokiri tribe possesses his or her own fairy partner. Though they never grow up, it is said that they will die upon leaving the forest.

Because Link was Hylian by birth, he did not have his own fairy. However, on the fateful day Link set out on his journey, the Deku Tree sent Navi the fairy to his side. The green clothes Link wears are characteristic of the Kokiri.

Kokiri tribe

The Deku Tree and Link

GANONDORF'S REBELLION

While Link collected the three Spiritual Stones, Ganondorf launched an attack on Hyrule Castle. This extreme measure was an attempt to steal the Ocarina of Time, a treasure of the Sacred Realm under the protection of the royal family.

With the help of Impa, Princess Zelda escaped from the castle. Spotting Link, the princess tossed him the Ocarina of Time, praying that he would protect the Triforce.

Princess Zelda flees

Ganondorf appears before Link

THE DOOR OF TIME IS OPENED

Link restored the three Spiritual Stones to their places in the Temple of Time, and opened the Door of Time by playing the ocarina. The legendary Master Sword that lay behind the door served as the final key to the Sacred Realm.

Ganondorf, apprised of Link's movements, invaded the Sacred Realm to lay his hands on the Triforce. However, only the Triforce of Power remained, as the Triforces of Wisdom and Courage had scattered, seeking those with the ability to wield them.

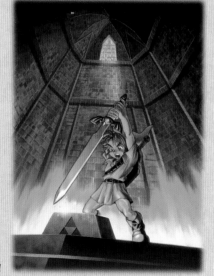

Link draws the Master Sword

● THE OCARINA OF TIME

Protected by the royal family, the Ocarina of Time is one of the keys to the Sacred Realm. It can play songs capable of manipulating both time and space. Its blue-white radiance brings to mind the Timeshift Stones found in the eras of antiquity.

The Ocarina of Time

● THE MASTER SWORD

A sacred blade that cannot be touched by the wicked, it harbors the power to eradicate evil. The sword can only be drawn by one who is worthy of the title "Hero of Time." Link proves his power, wisdom, and courage by obtaining the three Spiritual Stones.

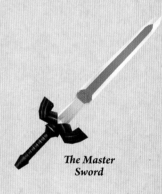

The Master Sword

THE THREE SPIRITUAL STONES

There are three Spiritual Stones, each representing one of three elements: forest, fire, and water. The first is the Kokiri's Emerald, guarded by the Deku Tree. The second is the Goron's Ruby, guarded by the Goron tribe. The third is the Zora's Sapphire, guarded by the Zora.

In order to obtain the stones, Ganondorf placed a curse on the Deku Tree and Jabu-Jabu, the guardian deities of forest and water, and threatened the Goron tribe. The shape of each Spiritual Stone resembles its tribe's symbol.

The Spiritual Stones of forest, fire, and water, and the tribal symbols of each.

Jabu-Jabu

DARK CLOUDS BEGIN TO ENSHROUD HYRULE

The Sacred Realm is a mirror that reflects the hearts of those who set foot in it. An evil heart will turn the realm into a living hell. A pure heart will transform it into paradise. Using the Triforce of Power, Ganondorf became the Demon King. The Sacred Realm was distorted into a nightmarish world where demons ran amuck.

Hyrule Castle and Castle Town fell under Ganondorf's control, and the survivors fled to Kakariko Village.

THE YOUNG HERO BEGINS HIS SLEEP

Meanwhile, despite the fact that Link was worthy of drawing the Master Sword, his youthful body made him unfit to serve as the Hero of Time. Accordingly, the Master Sword sealed Link within the Sacred Realm.

Within the Temple of Light, the cornerstone of the Sacred Realm, the ancient sage Rauru watched over Link in a small area called the Chamber of Sages. Link, guarded by Rauru, slept for seven long years.

Princess Zelda had no choice but to wait for the seal on Link to be broken. In order to escape the Demon King's pursuit, she went into hiding by disguising herself as a boy of the Sheikah tribe and adopting the name Sheik.

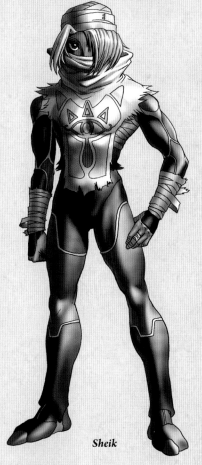

Sheik

● KAKARIKO VILLAGE

A secret ancestral village founded by the Sheikah tribe. Princess Zelda's attendant, Impa, was raised here. The graveyard behind the village contains the Royal Family's Tomb, where Hyrule's blood-stained history of ceaseless conflict is written.

● RAURU

The sage who created the Temple of Time in eras long past. Before Link drew the Master Sword, Rauru took on the form of an unusual bird named Kaepora Gaebora, watching over the boy as he progressed in his adventure.

Kaepora Gaebora

HYLIAN IN THIS ERA

This Hylian syllabary is characterized by its wedgelike shapes. It is possible to decipher the Hylian characters using the chart on the right by matching them to their Japanese equivalents.

A sign reading "Kakariko Mura," meaning "Kakariko Village" in Japanese.

a	i	u	e	o		ha	hi	fu	he	ho
ka	ki	ku	ke	ko		ma	mi	mu	me	mo
sa	shi	su	se	so		ra	ri	ru	re	ro
ta	chi	tsu	te	to		ya	yu	yo		
na	ni	nu	ne	no		wa	wo	n		

THE HERO AWAKENS

Wielding the Master Sword in his left hand and carrying the Hylian Shield in his right, Link returned as an adult.

When Princess Zelda played her harp, she imparted her wisdom to Link. She instructed the hero to break the curse on each of the five temples and awaken the sages within.

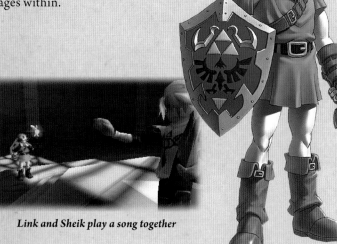

Link and Sheik play a song together

THE ACTIONS OF THE HERO OF TIME

Link, the Hero of Time, spurred his horse across the land and traveled through time, breaking each temple's curse. Receiving medallions from the awakened sages, he gradually added their power to his own.

A battle with Volvagia inside the Fire Temple

Link gallops across the fields

● SHEIK'S HARP

Playing her harp, Princess Zelda teaches Link special songs that guide him to the temples.

● THE HYLIAN SHIELD

An indestructible shield decorated with the same design that was favored in the Era of the Goddess Hylia. It is strong enough to withstand fire and cannot be broken.

The Hylian Shield

● THE SAGES' MEDALLIONS

Medallions imbued with the power of the awakened sages. With each medallion he obtains, the Hero of Time attains even greater power.

LINK'S BELOVED HORSE EPONA AND LON LON RANCH

In Hyrule Field sits Lon Lon Ranch. It is run by its lazy owner, Talon; his daughter, Malon, who enjoys singing; and their ranch hand, Ingo.

Ever since Link was young, he has had a special affinity with the horse called Epona. In the Adult Era, Ingo falls under the control of an evil mind, and forcefully takes over the ranch from its owners. However, Link manages to win Epona from him in a successful wager.

Link and Epona **Talon** **Malon** **Ingo**

THE SIX SAGES ARE RESTORED

Rauru was the Sage of Light, who had continued his vigil over the Sacred Realm since time immemorial. Saria of the Kokiri tribe was the Sage of the Forest. Darunia of the Goron tribe was the Sage of Fire. Princess Ruto of the Zora tribe was the Sage of Water. Impa, Zelda's attendant, was the Sage of Shadow. Nabooru, the chivalrous thief, was the Sage of Spirit.

At last, all six sages had been restored.

● SARIA, THE FOREST SAGE

The only Kokiri who really understands Link. She sees the truth, realizing that he is not a member of the Kokiri tribe. Saria used to sit in the depths of the forest, playing her ocarina. Her special spot was actually the entrance to the Forest Temple.

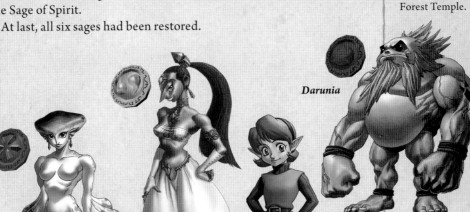

Darunia

Ruto

Nabooru

Saria

● DARUNIA, THE FIRE SAGE

The leader of the Goron tribe. He has a fiery personality. Impressed by Link's courage, he names his son after the hero.

● RUTO, THE WATER SAGE

Princess of the Zora tribe. She was aided by Link in the Child Era and Sheik in the Adult Era, eventually awakening as a sage.

● NABOORU, THE SPIRIT SAGE

A chivalrous thief of the Gerudo tribe. Because she opposes Ganondorf, she is brainwashed by his surrogate mothers, the pair called Twinrova.

REUNION WITH PRINCESS ZELDA

Princess Zelda was the leader of the sages and the seventh sage. She bore the Triforce of Wisdom on her hand. Once the right moment had arrived, Sheik revealed his true identity to Link, confessing that he was actually Princess Zelda.

The princess intended to draw Ganondorf into the abyss, whose seal had been rent open by the six sages. She would then use her own power to it off from the outside world. In order to do this, however, Princess Zelda would need the might of Link the Hero.

Princess Zelda

Twinrova
(after combining)

GORONS, THE PEOPLE OF FIRE, AND ZORA, THE PEOPLE OF WATER

The Goron tribe, who guard the Spiritual Stone of Fire, is a group of rock eaters that make their home on Death Mountain. In this era, their leader is Darunia.

The Zora tribe, who protect the Spiritual Stone of Water, live in Zora's Domain, located at the headwaters of Zora's River. The tribe was unified by a ruler known as King Zora. The king Link meets in this era is known as Zora De Bon XVI. His daughter is Princess Ruto.

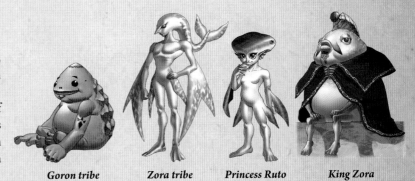

Goron tribe

Zora tribe

Princess Ruto

King Zora

THE DECISIVE BATTLE WITH GANONDORF

Ganondorf, who had placed Link under surveillance, kidnapped Princess Zelda and brought her to his castle. He attempted to lure Link there also, seeking the final piece of the Triforce.

The Triforce of Power possessed by Ganondorf, the Triforce of Wisdom borne by Princess Zelda, and the Triforce of Courage that dwelt within Link . . . Once the three pieces were united, they would resonate together. At last, the time had come for the battle with Ganondorf.

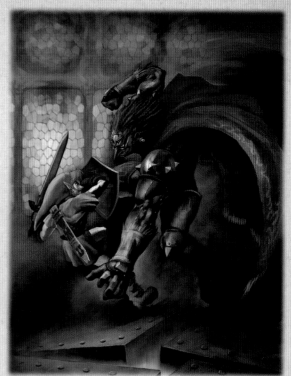

Link vs. Ganondorf

If the Hero of Time is defeated, a different timeline will unfold. (Turn to page 92.)

TRANSFORMING INTO THE DEMON KING GANON

Link was victorious in his one-on-one battle with Ganondorf. However, the thief used the last of his power to transform into a demonic, evil beast. The Demon King Ganon cornered Link and Princess Zelda.

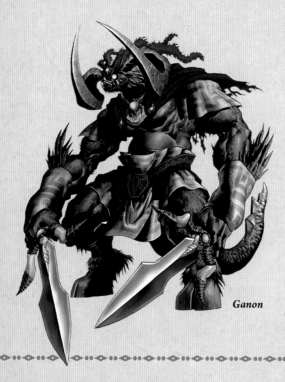

Ganon

● GANON'S CASTLE

The castle that once belonged to Hyrule's royal family is occupied by Ganondorf, who transforms it into a sinister fortress. Though it is protected by a complex barrier, Link, wielding the power of the sages, advances to the highest floor, where Ganon lies in wait.

Ganondorf's chamber

● THE DEMON KING GANON

Though "Ganon" is also a nickname for Ganondorf, here it refers to the beastlike form adopted by the thief following his transformation. The Demon King resembles a giant boar.

THE GERUDO TRIBE: PEOPLE OF THE DESERT

A group of thieves that inhabit the Gerudo Desert. The tribe bears only female children, who occasionally wander into Hyrule to search for boyfriends. Their customs decree that a male child, born to the tribe once every hundred years, will be crowned their king.

Ganondorf was raised by Kotake and Koume, a pair of twin witches called Twinrova. Twinrova worship Ganondorf as the Demon King. It could be said that the sisters, who have lived for over four hundred years, rule the tribe from behind the scenes.

Kotake and Koume

ABCDEFGHIJKLMNOP

QRSTUVWXYZ : 51 ! ?

Gerudo alphabet

LINK THE HERO IS VICTORIOUS

Following a fierce battle, Princess Zelda entrapped Ganon with waves of light, and Link delivered the finishing blow. The six sages completed the task by imprisoning the beast in a sealed void that had been rent in the Sacred Realm.

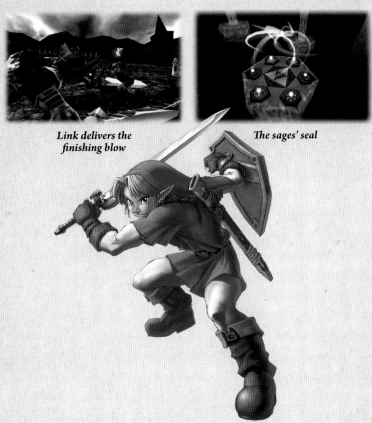

Link delivers the finishing blow

The sages' seal

PEACE RETURNS TO HYRULE

Thus, the curtain fell on the battle for Hyrule.

Seven years earlier, Princess Zelda had mistakenly allowed Ganondorf to enter the Sacred Realm in her attempt to maintain control over the holy domain. In order to right her wrongs, she played the ocarina, returning Link to his original era and allowing him to regain the seven years that had passed while he remained sealed.

Peace had been restored to the land of Hyrule, but its return marked the parting of Link and Princess Zelda.

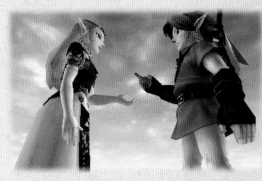

Link returns the Ocarina of Time

● GANONDORF IS SEALED AWAY

Ganon, having lost the battle, is sealed away, along with the Triforce of Power. Though he has regained his human form, Ganondorf's intense animosity toward Princess Zelda, Link, and the sages will bring about disaster in eras to come.

Ganondorf is sealed

● HYRULE AT PEACE

A large crowd gathers at Lon Lon Ranch to celebrate. In Kokiri Forest, the Deku Tree Sprout takes root, and the world begins to return to a state of purity.

The Deku Tree Sprout

A cyclical tale arose from an ancient battle...

The life of the time-traveling hero caused the chain of history to branch off in multiple directions. From this point onward, the chronology of Hyrule diverges dramatically. This marks the end of "The Legend of the Gods and the Hero of Time."

For the timeline that unfolds following the Hero of Time's return to the Child Era, please turn to page 110.

For the timeline that unfolds following the Hero of Time's departure from the Adult Era, please turn to page 122.

THE DECLINE OF HYRULE AND THE LAST HERO

Of all possible outcomes, Link, the Hero of Time, faced defeat at the hands of Ganondorf.

The thief obtained the three pieces of the Triforce, transformed into the Demon King, Ganon, and continued to threaten the world in future eras.

The conflict surrounding the Triforce continued without end, the blood of the gods weakened, and the kingdom of Hyrule shrank to a shadow of its former glory.

ERA OF THE HERO OF TIME (ADULT ERA)

OCARINA OF TIME

THE DEMON KING OBTAINS THE COMPLETE TRIFORCE

THE HERO OF TIME'S DEFEAT

Ganondorf the thief obtained the Triforce of Power and managed to get his hands on Princess Zelda. The Hero of Time, Link, challenged him in a battle that would determine Hyrule's very existence, and lost.

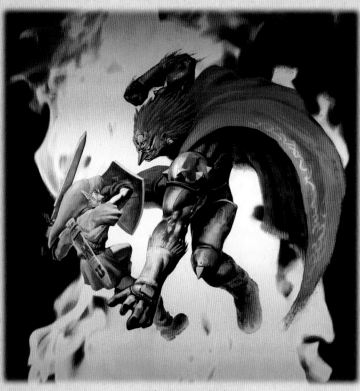

Link vs. Ganondorf

THE SEVEN SAGES SEAL AWAY THE DEMON KING

At last, Ganondorf found himself in the possession of the Triforce of Wisdom that dwelt within Princess Zelda, and the Triforce of Courage that dwelt in Link. His true power achieved, he transformed into the Demon King. The Seven Sages of Hyrule, led by Princess Zelda, sealed Ganon and the Triforce in the Sacred Realm as a final resort.

THE IMPRISONING WAR

For a brief time, it seemed as though peace had returned to the kingdom.

However, there were many who knew of the existence of the Triforce and the entrance to the Sacred Realm because of the events set in motion by Ganondorf. Their lust aroused, they rushed to gain access to the holy land in their quest to obtain the power of the gods.

Little did they realize that the Sacred Realm had been transformed into the Dark World by Ganondorf's evil heart. None returned from their adventures. Instead, only the power of darkness flowed forth.

Rivals embroiled in the conflict surrounding the Sacred Realm

THE SACRED REALM IS SEALED BY THE SAGES

The king of Hyrule ordered the Seven Sages to seal the Sacred Realm. The Knights of Hyrule guarded the sages as they offered up their prayers, but demons descended upon them from within the Sacred Realm, and a fierce battle unfolded in which the majority of the combatants were killed.

The entrance to the Sacred Realm was sealed once again, tight enough that it should never have been reopened.

The Seven Sages seal the Sacred Realm

● THE KNIGHTS OF HYRULE

The Knights of Hyrule are a clan that protect the Royal Family, their members descended from the Hero who governed the Crest of Courage. Legend has it that the Hero will one day reappear within their ranks.

Looking back through the ages, it is possible that Link, the Hero of Time, was once a Hylian Knight himself. This may be the reason his mother became embroiled in the fires of war.

THE HYLIAN BLOODLINE WEAKENS

Until the era of the Hero of Time, the kingdom of Hyrule was mostly inhabited by the Hylian people, whose existence was linked to their goddess, Hylia. Hylians possessed a special power: it was said that their long ears allowed them to hear the voices of the gods.

However, the kingdom fell into ruin during the Imprisoning War, and the bloodline of the Hylians weakened with the ages, until their existence was naught but a thing of the past. The sages' power also waned, and Hyrule, once called the Kingdom of the Gods, became nothing more than an ancient legend.

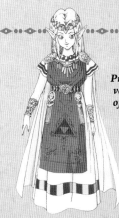

Princess Zelda. In her veins flows the blood of the goddess Hylia.

THE PRINCESS OF LIGHT AND THE KNIGHTS' DESCENDENTS

THE PRIEST'S PLOTS

Though the power of the Triforce and the blood of the Hylians continued to wane, Hyrule remained at peace. That is, until the appearance of a man who sought to break the seal on the Sacred Realm, which had been transformed into the Dark World. He was a priest who went by the name of Agahnim, and he wielded powerful magic.

Agahnim sent the king to an early grave. Putting the soldiers of the kingdom under his spell, he kidnapped the maidens in whose veins flowed the blood of the Seven Sages. One by one, he sacrificed the girls, sending them to the Dark World, and was about to offer up Princess Zelda as well.

Princess Zelda imprisoned

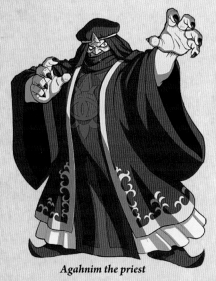
Agahnim the priest

The death of the king of Hyrule

PRINCESS ZELDA CALLS FOR HELP

Princess Zelda, imprisoned in the dungeon, sent out a telepathic cry for help. It was the young boy, Link, and his uncle, who lived together near the castle, who heard her plea. The two were the last surviving members of the Knights of Hyrule.

In order to rescue Princess Zelda, Link's uncle entered the castle. However, he was defeated by the guards and entrusted his sword to Link, who followed after him.

Link hears the voice of Princess Zelda

Link takes up the sword

● AGAHNIM

A priest of darkness who plunges Hyrule into chaos. In truth, he is an offshoot of Ganon, sent forth from the Dark World.

Agahnim holds Princess Zelda captive

● PRINCESS ZELDA

The princess of Hyrule, and one of the maidens whose veins carry the blood of the sages. For generations, her line has possessed a mysterious power.

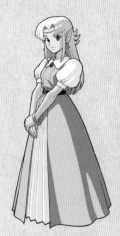
Princess Zelda (casual dress)

● THE SURVIVING KNIGHTS OF HYRULE

Link and his uncle are descendents of the Knights of Hyrule. Link, said to be one of the last surviving Knights, possesses the qualities of the mythical Hero.

RESCUING PRINCESS ZELDA

Link rescued Princess Zelda from the dungeon and escaped to the Sanctuary using a hidden passage. The Loyal Sage at the Sanctuary agreed to shelter Princess Zelda, and Link left on a quest to seek the Master Sword that he would need to defeat Agahnim.

Link paid a visit to the Sage Sahasrahla and obtained the Pendant of Courage. He then had to acquire the other two Pendants of Virtue in order to prove his worth as the Hero, the one capable of wielding the Master Sword.

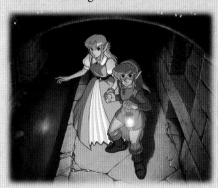

Princess Zelda and Link make their escape

● SAHASRAHLA

An elder of Kakariko Village, Sahasrahla is a descendent of the Seven Sages. He is well versed in the legends of Hyrule and aids Link on his adventure.

THE PATH TO THE DARK WORLD

Agahnim sent the Seven Maidens, in whose veins flowed the blood of the sages, to the Dark World. This opened the passage to what had once been the Sacred Realm. Those who stepped on the Magical Warp Tiles that served as entrances would be lost to the Dark World, transformed into demons. Link, who possessed the qualities of the Hero, did not become a demon, but was instead turned into an animal (in this case, a pink bunny).

He managed to obtain the Moon Pearl, which prevented him from being transformed while in the Dark World, and the Magic Mirror, which allowed him to return to the Light World.

● THE MOON PEARL

A jewel that repels magic. It protects the bearer from the evil power of the Demon King who controls the Dark World, and prevents any transformation to the bearer when they cross into the Dark World from the Light World.

A Magical Warp Tile leading to the Dark World

Link is transformed into a bunny

● THE MAGIC MIRROR

A clear, blue, beautiful mirror. It can be used as a means to return to the Light World from the Dark World.

THOSE LOST IN THE DARK WORLD

During his travels between the two worlds, Link comes into contact with souls lost within the Dark World. There, he bears witness to the tragic fate of those who have disappeared from the Light World.

Blind the Thief, who lived in hiding in Kakariko Village, now inhabits the Village of Outcasts in the Dark World. He attempts to mislead Link. The boy who once played his ocarina for the animals has been transformed into a creature resembling a fox. Link finds the boy's ocarina and plays it for him. The boy asks him to play the same song for his father, and turns into a tree. Finally, he can rest in peace.

Remembering the boy who played the ocarina (translated as "flute" in the English version)

THE MASTER SWORD, ASLEEP IN THE FOREST

Link obtained clues regarding the whereabouts of the pendants from the stone monuments scattered about the land, and was thus able to acquire the Pendant of Wisdom and the Pendant of Power. He then drew the Master Sword from its pedestal in the forest.

However, Princess Zelda, who had taken shelter in the Sanctuary, was found by the castle guards and brought before Agahnim.

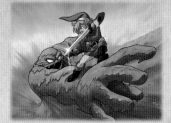

Link's battle

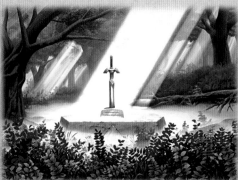

The Master Sword, asleep in the forest

THE SEAL OF THE SEVEN SAGES IS BROKEN

Link entered Hyrule Castle, only to see Agahnim send Princess Zelda to the Dark World, right before his eyes. The seal of the Seven Sages had been broken.

Link took on Agahnim, managing to corner the priest, but was pulled into the Dark World. At last, the seal on the Sacred Realm had been broken, and a passage to the Dark World had opened in Hyrule Castle.

A possessed Hylian soldier

The Pyramid of Power

● STONE MONUMENTS

Instructions for how to obtain the three pendants are written on stone monuments. The information is rendered in an ancient Hylian script. To decipher it, one must acquire the Book of Mudora from Kakariko Village.

The ancient script

● THE LOST WOODS

The Master Sword was once stored within a temple, but the temple decayed and turned into a forest.

● THE PYRAMID OF POWER

An enormous structure at the heart of the Dark World. Its location parallels that of Hyrule Castle in the Light World.

THE LIGHT WORLD (THE SURFACE WORLD)

A world of life where the people of Hyrule dwell. Hyrule Castle stands at its center. It was created by the hands of the gods, its soil abundant with plant life and water.

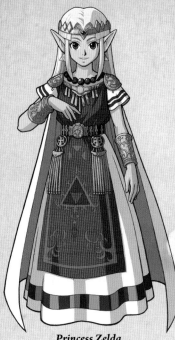

Princess Zelda

RESCUING THE MAIDENS

If the passage to the Dark World were to widen, the Demon King Ganon would emerge into the Light World once again. The only way to prevent this was to defeat Ganon and take back the Triforce. Link traveled back and forth between the worlds. His first task? Rescuing the Maidens that had been sacrificed to the Dark World.

He saved Princess Zelda last. The princess succeeded in breaking the **barrier** around Ganon's Tower using **the p**ower of the sages. Link then **defeated** Agahnim, who attempted to block his path, and made his way toward Ganon. The pyramid was now set to serve as the site of the decisive battle.

THE FINAL BATTLE IN THE PYRAMID

Ganon, in the form of a giant demonic beast, pressed his attack, wielding dark magic and a three-pronged trident. Link, evading the power of darkness, succeeded in destroying him.

The Hero laid his hands on the Triforce and wished for peace to return to the world. The people who had been sacrificed, including Link's uncle and the king of Hyrule, were also restored to good health.

The Triforce once again rested in the hands of Hyrule's royal family. With Ganon suppressed, the Dark World that had been born of his wicked heart gradually faded away.

● **THE BARRIER AROUND GANON'S TOWER**

A force-field barrier was erected around Ganon's Tower to defend it against intruders.

The battle with Ganon

THE DARK WORLD (THE UNDERWORLD)

The Sacred Realm, once home to the Triforce, was plunged into darkness by Ganondorf's wicked heart. It could also be thought of as the Underworld counterpart to the Light World.

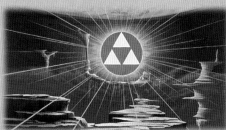

THE TRIAL OF THE TRIFORCE

TWINROVA'S TRICKS

The twin witches known as Twinrova were plotting ways to perform the ceremony that would resurrect the Demon King. For the resurrection ceremony to occur, it was necessary to light the Flame of Destruction, the Flame of Sorrow, and the Flame of Despair, derived from the chaos, sorrow, and hopelessness of humanity. They would also need to offer up a sacred sacrifice. In order to obtain the Flame of Destruction and the Flame of Sorrow, Twinrova sent Onox, the General of Darkness, to the land of Holodrum, and Veran, the Sorceress of Shadows, to the land of Labrynna.

DIN, ORACLE OF SEASONS

Link, the boy who had saved the land of Hyrule, was guided by the Triforce in Hyrule Castle and transported to the unfamiliar soil of Holodrum. After arriving in this new land, the Hero lay sprawled on the ground, unconscious. Just then, a dancer called Din happened to pass by. The traveling performer affectionately nursed Link back to health.

When Link awoke, Din invited him to dance. Suddenly, darkness engulfed her troupe of performers. Whirlwinds raged around them, accompanied by the voice of Onox, General of Darkness. Onox sought Din, the oracle who safeguarded the four seasons. Link issued a bold challenge to the general, but Onox succeeded in kidnapping the oracle.

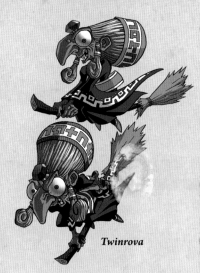

Twinrova

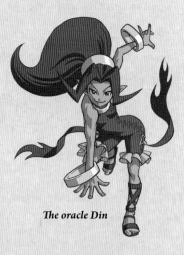

The oracle Din

●TWINROVA

These witches raised Ganon back when he was known as Ganondorf the Thief. They worship Ganondorf as the Demon King Ganon and plot to resurrect him.

●LINK'S TRIALS

Putting his affairs in order, Link sets off on a journey to further his training. Following his departure from Hyrule, Link encounters new allies, such as Ricky the kangaroo and Maple the witch.

Link and Ricky

Maple

ADVENTURE IN THE LAND OF HOLODRUM

Once Din, the Oracle of Seasons, was sealed away, the four seasons of the land of Holodrum were thrown into chaos. Wielding the Rod of Seasons, Link set out in search of the eight Essences of Nature. With the aid of the Maku Tree, guardian of Holodrum, Link ousted the power of darkness and set out to tackle Onox's Castle, located in the northern reaches of the land.

●THE MAKU TREES

Giant, sacred trees that protect the lands of Holodrum and Labrynna. The tree in Holodrum takes on the appearance of an old man who can frequently be found dozing off, and the tree in Labrynna looks like a young girl. Once Link gathers the Essences of Nature and the Essences of Time, the trees entrust him with a Huge Maku Seed capable of destroying the barrier of darkness.

Link and the Rod of Seasons

The Holodrum Maku Tree

ONOX, THE GENERAL OF DARKNESS, AND DIN'S RESCUE

Link defeated Onox's true form, the Dark Dragon, and rescued Din, returning the power of the seasons to the land of Holodrum.

Onox

● ONOX

The armored menace who kidnaps the oracle Din in order to light the Flame of Destruction. His true form is a giant dragon.

LINK JOURNEYS TO HIS SECOND TRIAL

Next, Link alighted in the unfamiliar land of Labrynna. He came to the aid of Impa, who was surrounded by demons. Impa had other troubles, however, finding herself unable to move a boulder with the crest of the royal family on it. Link removed the rock with ease and pressed on, only to encounter a singing Nayru surrounded by animals.

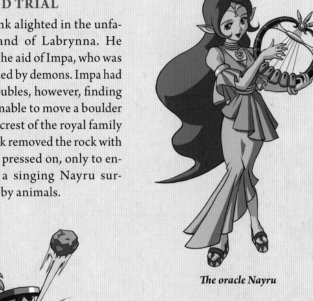

The oracle Nayru

● IMPA

Princess Zelda's nursemaid. She is under secret orders to bring Din, the Oracle of Seasons, back to Hyrule. She's a well-built, middle-aged woman with no shortage of valor.

Impa

Link

THE PEOPLES ENCOUNTERED BY LINK

The same peoples who can be found in Hyrule also inhabit Holodrum and Labrynna, such as the Goron tribe, who dwell in the mountains.

The tribe of the Sea Zora dwell in the ocean, constantly at odds with the River Zora, who take on the forms of demons. Ever since their king succumbed to a sudden illness in the distant past, ages have elapsed without the tribe appointing another ruler.

Finally, a tribe of people known as Subrosians exist in a parallel universe called Subrosia.

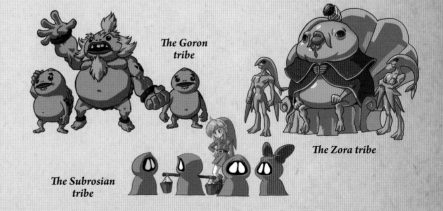

The Goron tribe

The Zora tribe

The Subrosian tribe

NAYRU, THE ORACLE OF AGES

A sudden darkness fell upon them, and Veran, the Sorceress of Shadows, appeared from within Impa, taking control of Nayru's body. In truth, Nayru was the Oracle of Ages, who governed the passage of time in the land of Labrynna. The oracle, now possessed by Veran, vanished.

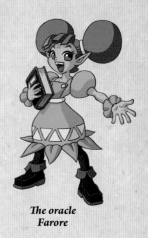

The sorceress Veran

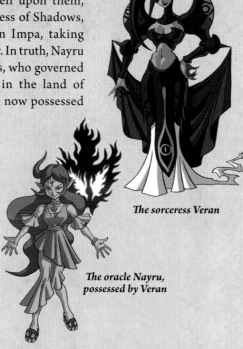

The oracle Nayru, possessed by Veran

● THE THREE ORACLES

There are three oracles, each sharing a name with the gods who created Hyrule. Din serves as Holodrum's Oracle of Seasons, Nayru serves as Labrynna's Oracle of Ages, and Farore, Oracle of Secrets, makes her home in a hole in the Maku Tree. Taking into account the fact that Link was guided to these worlds by the Triforce, one could not be faulted for thinking that the gods of creation might have some connection to these events.

The oracle Farore

ADVENTURE IN LABRYNNA

With the Oracle of Ages lost, the flow of time in the land of Labrynna fell into chaos, and strange events began to occur all over the realm. Veran, using the power of Nayru to manipulate time, traveled back to Labrynna's past and forced the reigning queen, Ambi, to construct a giant tower.

As requested by the guardian of Labrynna, the Maku Tree, Link shouldered the Harp of Ages and set out in search of the eight missing Essences of Time.

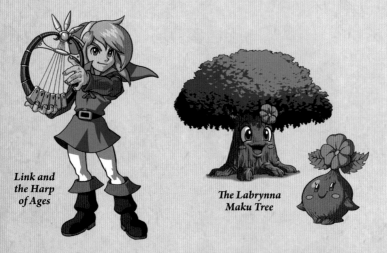

Link and the Harp of Ages

The Labrynna Maku Tree

● THE HARP OF AGES

An instrument with the power to manipulate time. Link uses it to play the Tune of Echoes, the Tune of Currents, and the Tune of Ages. The crests that represent these songs correspond to the crests of the gods that created Hyrule.

THE CITIZENS OF HOLODRUM AND LABRYNNA

The events in Holodrum and Labrynna did not occur independently of one another. The citizens of these lands are sacrificed in order to light the Flame of Destruction and the Flame of Despair, needed for the ceremony to resurrect the Demon King.

The citizens of Holodrum and Labrynna

CRUSHING VERAN, THE SORCERESS OF SHADOWS, AND NAYRU'S RESCUE

With the help of the Maku Tree, Link was able to enter the Black Tower and successfully drive out Veran, who had been possessing the body of Queen Ambi. He defeated Veran's true form and rescued Nayru, returning the flow of time in Labrynna to its regular state.

Queen Ambi

● **QUEEN AMBI**
A queen who reigned during Labrynna's past. Ralph, an old friend of Nayru's, is descended from this ruler.

Ralph

THE CEREMONY OF RESURRECTION IS NEARLY COMPLETE

Twinrova, who had lurked behind the scenes in Holodrum and Labrynna, pulling the strings, managed to light the Flame of Destruction and the Flame of Sorrow. All that remained was to kidnap Princess Zelda and light the Flame of Despair. Using the princess as a sacred sacrifice, they attempted to resurrect Ganon.

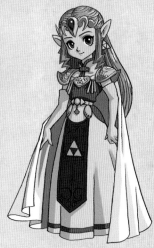

Princess Zelda

THE CEREMONY OF RESURRECTION AND THE DEMON KING'S REVIVAL

Link borrowed the power of the Oracle of Seasons and the Oracle of Ages and threw himself upon the ceremonial altar. He cornered and defeated Twinrova, but the twin witches sacrificed themselves to resurrect Ganon. Because the ceremony had not been completed, however, Ganon returned as a witless, demonic beast. Link brought down the rampaging Demon King and rescued Princess Zelda, restoring peace to the lands of Holodrum and Labrynna.

Bidding a fond farewell to all the people he had met during his trials, Link boarded a ship and set sail for the next land in which he would train.

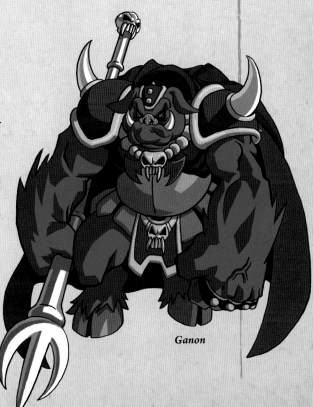

Ganon

ADVENTURE WITHIN A FLEETING DREAM

A RAGING STORM BESETS LINK

Link was in the midst of journeying back to Hyrule by boat after finishing his training.

During the voyage, he was caught up in a storm that sank his ship. Upon regaining consciousness, Link found that he had washed ashore on an island called Koholint.

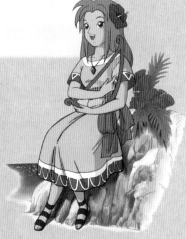

THE MYSTERIOUS ISLAND

Link was rescued by a girl named Marin who lived on the island. He woke up in a house belonging to Tarin, where the two made their home.

Though Link attempted to leave the island, the citizens insisted that there was nothing beyond the ocean.

Marin

● MARIN AND TARIN

Residents of Mabe Village on Koholint Island. Similar characters also appear in Holodrum, and in Hyrule during the Era of the Hero of Time. Tarin and Marin may be the product of Link's memories of Malon and her father Talon, of Lon Lon Ranch.

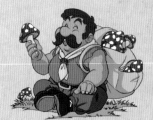

Tarin

Malon and Talon of Holodrum

KOHOLINT ISLAND

An island with abundant natural areas, surrounded by ocean. The large egg sitting atop the island's tallest mountain is Koholint's most notable characteristic.

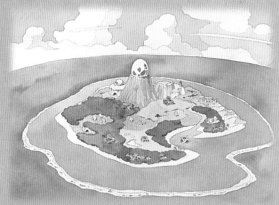

ATTEMPTING TO ESCAPE FROM THE ISLAND

The mysterious owl that appeared before Link informed him that the only way to escape the island was to awaken the Wind Fish. As he collected the Instruments of the Sirens, Link uncovered a shocking truth.

The world in which he had found himself existed within the Wind Fish's dream, and waking the Wind Fish would cause the island to disappear in a stream of bubbles.

The demons had attacked Link in order to preserve themselves and the existence of their island home.

● THE OWL

An owl that frequently appears before Link, guiding him on his journey. It is actually a manifestation of the Wind Fish's consciousness.

Link solves the island's mysteries

● THE INSTRUMENTS OF THE SIRENS

There are eight instruments in all: The Full Moon Cello, the Conch Horn, the Sea Lily's Bell, the Surf Harp, the Wind Marimba, the Coral Triangle, the Organ of Evening Calm, and the Thunder Drum. They are each located in a different part of the island and guarded by a demon.

The owl

KOHOLINT ISLAND VANISHES

Link successfully gathered the Instruments of the Sirens. Standing before the egg in which the Wind Fish slept, the Hero was forced to make a bitter decision.

The only traces of Koholint Island's existence now remained in Link's memories, and the awakened Wind Fish flew off into the sky.

Though Link the Hero had once rescued Hyrule, it came to pass that he was also responsible for the annihilation of the dream world. He set sail on another voyage, and his further whereabouts are unknown.

● THE WIND FISH

Haunted by nightmares, this spirit continues to sleep. His outward appearance resembles a whale.

THE GREAT KING AND THE TRIFORCE OF COURAGE

THE PROSPERITY OF HYRULE

Ever since the crushing defeat of the Demon King Ganon each successive generation of Hylian kings used the Triforce of Power, Wisdom, and Courage, passed down by the royal family to preserve order in the land.

Those who wielded the Triforce were required to possess the unique characteristic of having been born with a heart free from wickedness. The rulers used the power of the Triforce to help the kingdom expand and flourish.

THE MAGIC OF THE GREAT KING OF HYRULE

One great king of Hyrule who had put the Triforce's power to use was concerned that its might would be abused after his death.

In order to prevent this, he hid the Triforce of Courage, placing a spell over the land of Hyrule. The monarch's magic ensured that a crest would appear upon a worthy person who had been properly raised, once they had reached a certain age and gained enough experience.

Though the prince and young princess were already heirs to the throne, the king of Hyrule had his doubts about the worth and character of his son. Seeing more promise in Princess Zelda, he passed on the Triforce to her in secret.

THE TRAGEDY OF PRINCESS ZELDA

Following the king's death, and with no crest appearing upon the hand of the prince, the power of the Triforce he had inherited as the new king was incomplete.

The king was advised by his closest confidant, a wizard, that Princess Zelda seemed to know what was behind these events. Despite being interrogated by the wizard and her brother the king, Princess Zelda confessed nothing. The wizard lost his temper and threatened to use his magic to cast a spell that would cause the princess to sleep for all eternity, but she stubbornly refused to talk. Once the wizard had finished casting his spell, Princess Zelda crumpled where she stood.

● THE POWER OF THE TRIFORCE

The Triforce itself does not judge good and evil. Because of this, the following characteristics are sought from its users: a righteous heart and the mettle to wield the power of the gods.

● THE WIZARD

A close confidant to Zelda's elder brother, the king. He dies after using the last of his power to lay a curse upon Princess Zelda. The true nature of the man who stubbornly hones in on the secret of the Triforce is uncertain. However, it's possible that he is an offshoot of Ganon, much like Agahnim, or merely one of his followers.

THE LEGEND OF PRINCESS ZELDA I

Mad with grief and regretting what he had done, the young king placed his sleeping sister, Princess Zelda, on an altar in the North Castle, in the hopes that she would someday be revived. To ensure this tragedy would never be forgotten, a custom was established that decreed that every girl born into Hyrule's royal family would be given the name of "Zelda." The story became the legend of the first Princess Zelda.

The king reformed his ways and governed the land to the best of his ability, but the kingdom continued to fall into decline.

● PRINCESS ZELDA I

Though the land of Hyrule had seen other princesses bearing the name of Zelda, it was Princess Zelda I who inspired the custom of calling every princess by that name. In the eras that follow her tragic fate, the royal family never fail to name their daughters Zelda.

Princess Zelda, asleep in the North Castle

A KINGDOM IN DECLINE

No one appeared who was able to wield the Triforce, and Hyrule divided again and again, continuing to shrink.

The proud kingdom of Hyrule had once covered a vast area of land, but the passage of the ages saw its decline, and it eventually shrank into a single, small kingdom.

Though the Triforce of Wisdom continued to be handed down from generation to generation, as the long years passed, the existence of the Triforce of Courage and the tragedy of Princess Zelda I were also lost to memory.

A MAP OF LESSER HYRULE

Underground labyrinths dot the regions of Hyrule. To the southeast, the soil is fertile, blanketed by forests and rivers, while the west holds an expansive graveyard and the Lost Woods, where travelers are led astray. In the rugged and mountainous north lies the fortress of the Demon King Ganon. The location of Hyrule Castle is unclear.

SECRETS PASSED DOWN IN THE LESSER KINGDOM OF HYRULE

THE CREEPING HAND OF EVIL

There came a day when the demon army led by the Demon King Ganon invaded Hyrule and stole away the Triforce of Power.

The reigning Princess Zelda divided the Triforce of Wisdom, which was in her possession, into eight pieces, hiding them in different corners of the kingdom. She secretly ordered her nursemaid, Impa, to seek out the one with the courage to defeat the Demon King. Ganon, angered by her actions, captured the princess and sent his followers after Impa.

Princess Zelda

THE CHANCE MEETING OF IMPA THE NURSEMAID AND LINK THE BOY

Impa continued her desperate flight, but finally found herself surrounded by Ganon's underlings. Just then, a boy named Link appeared. Using his wits to throw Ganon's underlings into confusion, he managed to rescue the nursemaid. Impa explained her circumstances, and Link made the decision to defeat Ganon and rescue Princess Zelda.

Link and Impa

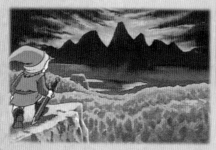

Link on his travels

● THE DEMON KING GANON

The Demon King has been defeated countless times by heroes in the past. He is thought to have been resurrected after many years. Leading a demon army, he invades Lesser Hyrule, seeking the Triforce. No longer bearing any trace of the man known as the Great Thief, Ganondorf, he opposes Link in the form of a demonic beast, bereft of intelligence.

● IMPA

Princess Zelda's nursemaid is descended from a long line that has served the royal family of Hyrule for generations. Her role is to care for various articles related to the royal family, as well as pass down the kingdom's history and folklore. Her line treasures the heirlooms of the great kings, and passes down the tragedy of Princess Zelda I.

● LINK

A young traveler. He encounters Impa while visiting Hyrule. It is thought that he may be the descendent of the Link who defeated Ganon and departed on a journey to continue his training during the Era of Light and Dark.

THE PEOPLE OF LESSER HYRULE

Surrounded by harsh but abundant nature, the people have taken up residence and live out their day-to-day lives in caves and dwellings under the earth. Likewise, the traders of Hyrule peddle their wares in caves underground, selling a variety of objects. One can also find springs where fairies reside, which act as places of healing for travelers.

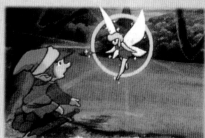

SEEKING THE EIGHT SHARDS OF THE TRIFORCE

Link, after much suffering, managed to locate the eight dungeons, collect the shards of the Triforce from within them, and complete the Triforce of Wisdom.

THE TRIFORCE OF WISDOM

Using the power of the Triforce of Wisdom, Link crushed the Demon King and saved Princess Zelda.

Thus, the Triforce of Wisdom and the Triforce of Power were restored, and, for a brief time, peace visited the kingdom of Hyrule.

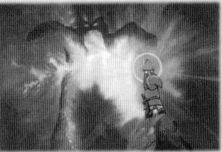

The battle between Link and Ganon

THE DESTRUCTION OF HYRULE

Even after defeating Ganon, Link remained in the kingdom and lent a hand to the reconstruction efforts. However, this was all for naught, as the land of Hyrule was again laid to waste by Ganon's underlings in a plot to resurrect him.

Ganon's underlings

● THE EIGHT DUNGEONS

The eight labyrinthine dungeons are shaped like and named after the eagle, the moon, the *manji*, the snake, the lizard, the dragon, the demon, and the lion. Impa teaches Link their approximate shapes. Within each labyrinth, he is able to obtain a more detailed map.

● RESCUING THE PRINCESS ZELDA

Zelda was imprisoned in the depths of a dungeon prior to Link's life-or-death struggle with Ganon. Link beats back the flames surrounding the princess with his sword, and manages to free her.

● GANON'S RESURRECTION

It is said that Ganon can be resurrected by sacrificing Link, the one who defeated him, and sprinkling the Hero's blood over his ashes.

THE MARK OF THE CREST APPEARS ON LINK

Six years after the suppression of the Demon King, a mark resembling the crest of the royal family suddenly surfaced on the back of the left hand of Link, now sixteen years old. Link, concerned, passed on this information to Impa. Surprised and flustered, she brought Link to the North Castle.

PRINCESS ZELDA I, ASLEEP ON THE ALTAR

Link and Impa arrived before an unopened chamber in the North Castle. Link pressed his crest against the door, and it opened with a clatter. The room within contained an altar, upon which a beautiful girl lay. The sleeping girl was Princess Zelda I, who had been cursed to slumber for all eternity.

● THE UNOPENED CHAMBER

Only the chosen one capable of wielding the Triforce can open it. The means of entry is a secret to everyone but Impa's line.

● THE SCROLL OF THE ROYAL FAMILY

Left behind by the king of Hyrule after his passing, the scroll was handed down by Impa's line. Despite being written in completely unfamiliar script, Link is able to read the scroll as though it speaks to him.

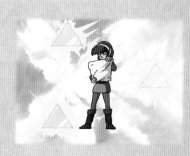

UNRAVELING THE HISTORY OF HYRULE

Impa recounted to Link the story of Princess Zelda I, and entrusted him with six crystals and a scroll bearing the crest of Hyrule's royal family.

THE SETTING OF *THE ADVENTURE OF LINK*

Link's adventure does not take place in Hyrule alone, and his travels bring him to two vast continents. The North Castle lies in the northeast, with Death Mountain, once the lair of Ganon, to the southwest.

 Many years after they sealed away the demonic thief Ganondorf, the sages live on in the names of the towns: Rauru, Ruto, Saria, Nabooru, and Darunia.

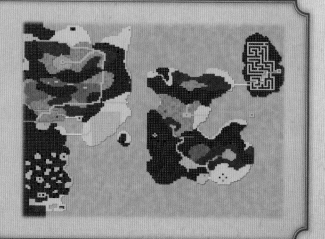

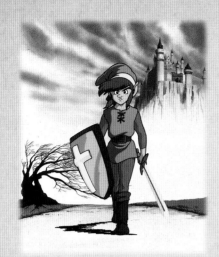

LINK'S DETERMINATION

Recorded on the scroll was the location of the Triforce of Courage. Impa appealed to Link, asking him to complete the Triforce and save Princess Zelda I. Link had made his decision. He set out on his own, heading for the palaces.

THE SIX PALACES AND THE GREAT PALACE AT DEATH MOUNTAIN

Inserting the six crystals he had received from Impa into the stone statues located deep within the palaces dotting Hyrule, Link dispelled the barrier in the Valley of Death and opened the path to the Great Palace.

After achieving victory against the guardian deity that lay in wait for him within the Great Palace, the Hero continued deeper within. In a final trial, Link was attacked by his own shadow, but he managed to defeat it in a battle of life and death.

PEACE IN HYRULE

Link, having obtained the Triforce of Courage, used the Triforce's power to awaken Princess Zelda I from her slumber. He thus prevented Ganon's resurrection and restored peace to the land of Hyrule.

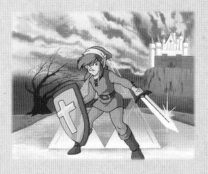

● THE SIX PALACES

These palaces serve as a barrier to the Great Palace, in which the Triforce of Courage is hidden. Guardian deities are placed at their entrances to defend them against outside invaders. Only one who is worthy will be able to defeat them and dispel the barrier.

● THE GREAT PALACE

A palace located in the Valley of Death, deep within the mountains of eastern Hyrule. The final guardian deity, the Thunderbird, protects the Triforce of Courage.

● LINK'S SHADOW

A black shadow whose shape is identical to Link. Once a traveler reaches the depths of the Great Palace, this creature oozes out of their shadow and attacks, serving as their final trial. Like Link, it fights using a sword and shield, jumping at will.

The power of the gods had been restored to Hyrule through the courage of a young boy.

Did generations pass, full of peace and the light of prosperity? Or did the curtain rise on an age of darkness, when people quarreled in their search for power?

The future of this timeline has yet to be unraveled.

The Twilight Realm and the Legacy of the Hero

The Hero of Time was victorious, successfully sealing away Ganon. Link returned to his original time and met with Princess Zelda, setting a new timeline into motion.

An Alternate History of Hyrule

THE RETURN OF THE HERO OF TIME

Princess Zelda used her power to rewind the seven years that Link had spent sleeping, and restored the Hero to his original era.

Upon his return, Link wasted no time in making for Hyrule Castle courtyard. There, he found Princess Zelda watching Ganondorf, just as she had been when they first met.

Navi departs

Meeting Princess Zelda

A PORTENT OF THE FUTURE

Link warned Princess Zelda of what the future would bring. Hearing his words, the princess entrusted the Ocarina of Time to Link and instructed him to travel far away in order to prevent Ganondorf from entering the Sacred Realm.

Just then, the mark of the Triforce of Courage on the back of Link's hand began to glow. Link the Hero, who had won his battle against great evil in the world of the future, left on a secret journey.

LINK'S DEPARTURE

Link set off on his horse, Epona, who lived at Lon Lon Ranch.

Months passed as he wandered in search of his companion, Navi, eventually losing himself in a mysterious forest.

It just so happened that this forest led to a parallel world known as Termina.

● THE HERO'S RETURN

Link finds himself back in the Temple of Time. The Master Sword has not yet been drawn from its pedestal, and the way to the Sacred Realm has yet to be opened. His companion, Navi, disappears into the heavens, and Link steps into a new timeline.

Link

● THE TRIFORCE OF COURAGE

Link bears the proof of his courage on the back of his hand. Because Ganondorf was sealed away along with the Triforce of Power, the rest of the Triforce remained within the chosen ones.

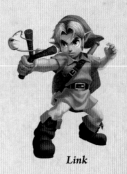
Link, bearer of the crest of the Triforce of Courage

Link and Epona

TURMOIL IN THE PARALLEL WORLD OF TERMINA

THE WORLD THAT ENDS IN THREE DAYS

Termina was in trouble. The moon was plummeting toward the earth, and, in three days' time, the world would be destroyed.

A young imp known as Skull Kid had snatched Majora's Mask from a traveling mask salesman. With the aid of the mask's terrible power, his actions had gone beyond the scope of mischief, and the effects of his pranks could be felt all over Termina.

The imp's trickery didn't stop there. He also snatched Epona and the Ocarina of Time from Link, transforming the Hero into a Deku Scrub.

Deku Link

Skull Kid and Tael the fairy

A NEW ALLY

After regaining possession of the Ocarina of Time, Link was able to return to his original form using a mask. However, the Happy Mask Salesman entreated him to recover Majora's Mask.

Together with Tatl, who was worried about Skull Kid, Link decided to put an end to the imp's excessive meddling.

Link and Tatl the fairy

Happy Mask Salesman

● TERMINA

A strange parallel world, where many of the inhabitants look identical to the people of Hyrule.

Cremia and Romani, sisters who resemble Hyrule's Malon

● MAJORA'S MASK

A sinister mask that was used for incantations long ago.

Majora's Mask

● TATL THE FAIRY

A fairy who, together with her brother, Tael, makes mischief with Skull Kid. She is left behind by the imp while trying to escape from Link, and eventually she joins forces with the Hero.

THE FOUR REGIONS OF TERMINA

Termina is dominated by four regions, to the north, south, east, and west, with Clock Town's Clock Tower at its center. The regions consist of the swampland of Woodfall, the mountains of Snowhead, the ocean of Great Bay, and the canyon of Ikana. The kingdom of Ikana is in ruins, but the other regions are governed by the peoples who inhabit them.

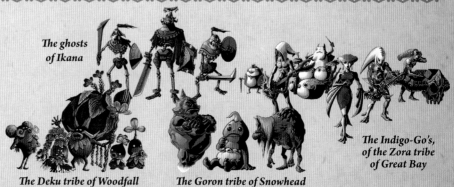

The ghosts of Ikana

The Deku tribe of Woodfall

The Goron tribe of Snowhead

The Indigo-Go's, of the Zora tribe of Great Bay

CLOCK TOWN: AN ATMOSPHERE OF UNREST

Link first found himself in a place called Clock Town. Three days before the local carnival, the town was thrown into chaos when the moon began to fall. The shadow of the lunar body grew bigger with each passing day.

Using the Ocarina of Time, Link was able to rewind the passage of time to three days before the moon fell. He collected a number of mysterious masks and righted the unusual changes that had taken place in the world, reviving the legendary giants that slept in the four regions of the land.

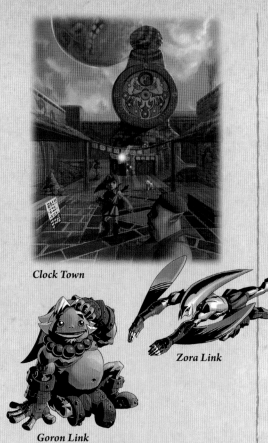

Clock Town

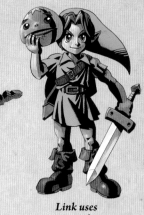

Link uses a mask

Goron Link

Zora Link

THE FOUR GIANTS AND MAJORA'S MASK

The day of destiny had arrived. The Four Giants stretched out their arms and held up the moon, stopping it from plunging into the town.

However, the mastermind behind these events was none other than Majora's Mask. Link pursued the mask to the center of the moon. There, a strange battle unfolded. Link transformed into the Fierce Deity and eradicated the threat.

Majora's Mask was then returned to the Happy Mask Salesman, and the terror caused by the falling moon no longer held the world in its grip.

As night fell on the third day, Clock Town was safe. Link watched the happy citizens enjoying the Carnival of Time.

The Hero took his leave of Termina, and his whereabouts after that are unknown.

Fierce Deity Link

● THE MYSTERIOUS MASKS

The masks, which hold the spirits of the dead, cause the wearer to transform into a shape resembling the departed. Link uses the masks to undergo transformations, gaining powers not native to his human form. Link's transformation into a Deku Scrub is caused by the spirit of a member of the Deku tribe that died in the forest connecting Hyrule and Termina.

● THE LEGENDARY GIANTS

Skull Kid's friends are guardian deities that inhabit each region of Termina. Though they depart to the four corners of the earth to fulfill their purpose, Skull Kid feels that they have abandoned him and goes on a rampage with the power of Majora's Mask.

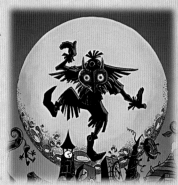

The moon and Skull Kid

CLOCK TOWN AND THE MAYOR'S HOUSEHOLD

Clock Town, seated at the heart of Termina, has a giant clock tower at its center. The yearly carnival brings visitors from all over.

The household of the mayor includes a son named Kafei, who will soon marry a woman named Anju. However, Kafei has been transformed into a child by Skull Kid.

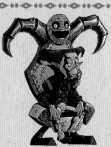

The mayor

Madame Aroma

Kafei, transformed into a child

Kafei's fiancée, Anju

THE DEMON THIEF GANONDORF IS EXECUTED

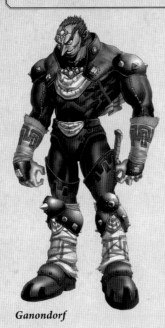

Ganondorf

DARK CLOUDS MENACE HYRULE

In Hyrule, Princess Zelda was informed of what would happen in the future by Link, the Hero of Time. She realized that leaving Ganondorf to his own devices would cause the downfall of her kingdom.

Many years later, Ganondorf, the infamous demon thief who wielded the power of magic, was finally to be executed.

THE ARBITER'S GROUNDS AND THE MIRROR OF TWILIGHT

The Ancient Sages performed the execution of Ganondorf in the Arbiter's Grounds. However, Ganondorf, who had been chosen by the Triforce of Power, did not perish, and managed to kill one of the sages. Thrown into a panic, the remainder of the sages used the Mirror of Twilight to banish Ganondorf to the Twilight Realm.

They were then instructed by the gods to protect the mirror.

A sage

Ganondorf's execution

Exiled by the Mirror of Twilight

Ganondorf and his malice, sent to the Twilight Realm, plunged the shadowy domain into madness.

● THE DEMON THIEF GANONDORF

The Ganondorf of this timeline is able to wield magic due to his possession of the Triforce of Power. However, since Link was able to warn Princess Zelda of the future, Ganondorf did not enter the Sacred Realm or lay his hands on the completed Triforce. Link returning from the future bearing the Triforce of Courage made it so that Ganondorf was unable to consolidate the omnipotent power of the Triforce within himself.

● THE SAGES

Details regarding the sages who exist in this era are largely unknown, including their names. From the crests depicted on their clothing, we can ascertain that the sages represent light, forest, fire, water, shadow, and spirit.

● GANONDORF'S MALICE

Ganondorf is full of wickedness and hatred.

THE HISTORY OF THE TWILIGHT REALM

Long, long ago, the people of the world were filled with piety, and the land knew many years of peace. Before long, however, conflict began to arise in the sacred realm called Hyrule. People began to appear who were proficient with magic, and they attempted to control this sacred realm with their powers.

The gods dispatched four Light Spirits, who sealed the usurpers' magic into Fused Shadows. They then banished the offenders to the Twilight Realm using the Mirror of Twilight, so that they would never be able to return to the Light World. Those who lived in the Twilight came to be known as the Twili.

THE INVASION OF SHADOW AND THE TWILIGHT REALM

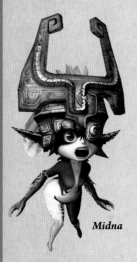

Midna

GANONDORF'S POWERS OF DARKNESS

Ganondorf was sent to the Twilight Realm. There, the Demon King granted the ambitious Zant magical powers and began plotting to unite the Light World and the Twilight Realm into a single realm known as the Dark World.

Zant's influence steadily increased. Clouds of darkness covered the Twilight Realm, and the Twili began transforming into demons. Midna, the Twilight Princess, attempted to oppose him, but was cursed and fled to the Light World.

THE KING OF TWILIGHT, ZANT, INVADES THE LIGHT WORLD

The peace that had reigned in the Light World for hundreds of years was broken by Zant's army of Shadow Beasts. Zant, now known as the King of Twilight, launched an invasion of Hyrule, and Princess Zelda was faced with a decision. Would she allow the kingdom to be destroyed in the fires of war, or would she surrender and allow Hyrule to fall under the domain of the Twilight? The princess chose the latter.

Across the land, the Light Spirits lost their light to the Twili. The Light World was gradually transformed into Twilight, and the people, not realizing what was happening, were filled with a shadowy fear.

Princess Zelda

● MIDNA

Princess of the Twilight Realm. A curse placed upon her by Zant causes her to physically transform and lose her magical abilities. In the Light World, she appears as a shadow.

● THE TWILIGHT REALM

Also known as the Twilight. Humans who enter this domain are transformed into spirits, though they do not realize what has happened.

● THE LIGHT SPIRITS

These spirits who once sealed away the Twili now guard the different regions of Hyrule. Their names are Ordona, Faron, Eldin, and Lanayru.

Faron

Zant's raid

Hyrule Castle enshrouded in Twilight

PEOPLE OF THE TWILIGHT REALM

The Twilight Realm is a beautiful place, enveloped in the calm of a falling dusk. The inhabitants are gentle, pure-hearted creatures who make their homes within the realm's radiance. The Twili wield the power of magic, though its strength does not reach the levels possessed by those who were sealed away in ancient times. Members of the powerful royal family choose one from among themselves to inherit the position of leader.

The people of the Twilight lived in peace for many years, but there were those among them who felt that the denizens of the Light World were oppressing them. Despite Zant's ambitions, he was not chosen to be king, and Princess Midna instead became leader of their people.

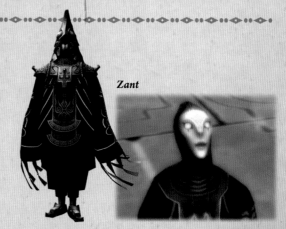

Zant

MIDNA AND LINK MEET

Midna began searching for a way to oppose Zant. Just then, a human appeared who had been transformed into a beast by the Twilight. It was none other than Link, a young man from Ordon Village in whose veins flowed the blood of the Hero of Time.

According to a legend passed down in the Twilight, the savior of the world would appear in the form of a beast. Midna decided to join Link to defeat Zant and take back the Twilight Realm.

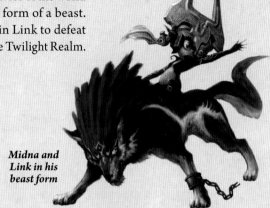

Midna and Link in his beast form

OF FUSED SHADOWS AND LIGHT SPIRITS

Link took on the role of the Hero, restoring light to each region of the land and finally regaining his human form. With the help of Link, Midna began to collect the Fused Shadows. However, she was attacked by Zant, who stole the shadows and left her on the brink of death, suffering from grave wounds. Link was also cursed by Zant, and turned into a beast once more.

The Hero met with Princess Zelda at Hyrule Castle, who advised him to obtain the Master Sword. The princess then poured all her power into Midna, saving her life. Link acquired the Master Sword from the Sacred Grove, and his curse was lifted by the sword's ability to dispel magic.

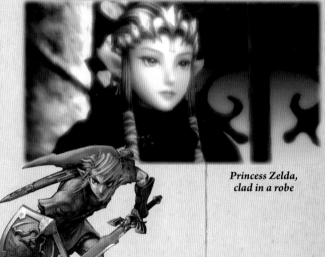

Link draws the Master Sword

Princess Zelda, clad in a robe

●LINK

A young goatherd who makes his home in Ordon Village. He possesses the qualities of the Hero and remains a beast in the Twilight, without being transformed into a spirit.

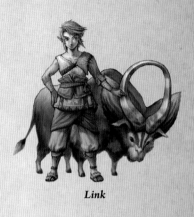

Link

● THE FUSED SHADOW

An ancient magical object that was sealed away by the Light Spirits. Midna, the Twilight Princess, wears one piece as a helmet, while the remaining three shards are hidden in temples.

ORDON VILLAGE AND ITS CITIZENS

The lush hamlet of Ordon Village is located to the south of Faron Woods in the province of Ordona. The inhabitants live in harmony with nature, raising animals such as mountain goats and harvesting crops, including pumpkins.

Link sets out to save the village children following their abduction by Zant.

The mayor

Ilia, the mayor's daughter

Talo and Malo, brothers

Colin

Beth

115

REPAIRING THE MIRROR OF TWILIGHT

Link and Midna at last arrived before the Mirror of Twilight, the entrance to the Twilight Realm. Midna became furious when she learned that Zant had broken the mirror, and that everything that had happened was the result of Ganondorf's banishment to the Twilight Realm.

The two set out to collect the shards of the Mirror of Twilight. Their journey saw them travel not only across the great span of Hyrule, but also to the illusory City in the Sky. They succeeded in repairing the mirror, and then traveled to the Twilight Realm to defeat Zant.

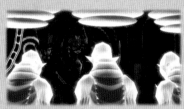
The sages apologize to Midna

The passage created by the mirror

THE USURPER KING ZANT WAITS IN THE PALACE OF TWILIGHT

The light liberated from the Twilight Realm came to rest within Link's sword, driving back Zant's powers of darkness. Even the guardian deity of the Twilight Realm came to recognize him as a hero.

Link confronted Zant in the Palace of Twilight. Midna regained the Fused Shadow from Zant, and destroyed him with the Twilight's ancient powers.

Phantom Zant

● THE MIRROR OF TWILIGHT

The mirror, placed in the Arbiter's Grounds, is the only means of connecting the Twilight Realm and the Light World. Only the ruler of the Twili can cause it to vanish.

● THE CITY IN THE SKY

A city in the heavens where an ancient civilization, the Oocca, flourishes. The city once maintained friendly relations with the royal family of Hyrule. Even today, the folklorist Impaz has inherited the role of guide, lending her wisdom to emissaries bound for the heavens.

Its relation to the Sky Era city of Skyloft is unknown.

Oocca

● THE TWILIGHT REALM

This realm has been covered in darkness by the powers of Zant and Ganondorf, and the Twili have been changed into demonic forms.

A Twili turned into a demon

THE MAP AND THE WRITING SYSTEM OF THE TWILIGHT ERA

Hyrule Castle, located in Lanayru Province, sits at the heart of the world. The provinces known as Lanayru, Faron, Eldin, and Ordona bear the same names as they did in the Era of the Goddess Hylia. They are protected by the Light Spirits who share their names.

As the figure depicts, the writing system corresponds to the English alphabet, making it possible to decipher.

HYRULE CASTLE IS SHROUDED IN TWILIGHT

Zant's defeat did not mark the end of Link's struggles. The King of Darkness yet remained: he who had used Zant to extend the domain of the Twilight and gain control of Hyrule. Link, with the help of the Resistance, advanced on Hyrule Castle, which was enshrouded in Twilight.

● THE RESISTANCE

An organization that uses Telma's Bar in Hyrule Castle Town as a base for its maneuvers. The members are currently investigating the unusual phenomena that have been occurring all across the world. Telma is impressed by Link's skills and invites him to join the group.

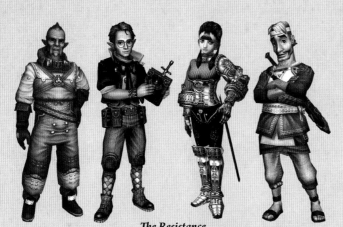

The Resistance

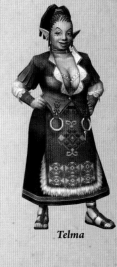

Telma

GANONDORF IS FULLY RESURRECTED

Ganondorf, King of Darkness, who had been resurrected in the Light World, remained seated on the throne of Hyrule Castle. He launched his attack by taking possession of Princess Zelda and transforming into a demonic beast. He later waged a battle with Link on horseback.

Once Princess Zelda's spirit, which remained inside Midna, was returned to her body, she defended Link using the Light Arrows.

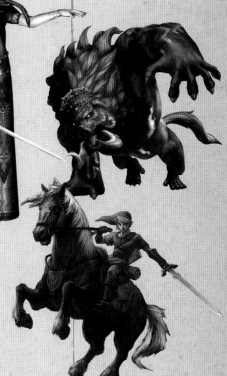

Consecutive battles with Ganondorf

TRACES OF THE ERA OF THE HERO OF TIME

The Goron tribe and the Zora tribe continue to be prosperous during this era. The Kokiri tribe does not make an appearance; all that remains of them is their tribe's symbol in the Forest Temple.

The Temple of Time, home to the Master Sword's pedestal, has rotted away and lies in ruins within the forest.

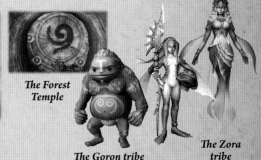

The ruins of the Temple of Time

The Forest Temple

The Goron tribe

The Zora tribe

PRINCESS ZELDA'S RESURRECTION AND GANONDORF'S SUPPRESSION

Ganondorf took up the blade that had been used by the sages in his own execution and commenced the final battle. However, Link was successful in defeating him.

Ganondorf, the King of Darkness, had lost, and the crest of the Triforce of Power faded from the back of his hand. The curtain fell on the destiny of the demonic thief Ganondorf, seeker of the Triforce . . . at least for a time.

However, the invasion by the Twilight had produced much hostility, and the existence of a counterpart world to Hyrule had been exposed. The events of this time left behind a lingering scar whose effects would be felt in future eras.

Ganondorf

● THE TRIFORCE OF POWER

The power that dwells within Ganondorf. When he loses his battle, the crest disappears.

The crest disappears

PRINCESS MIDNA, RESTORED TO HER TRUE FORM AND THE TWILIGHT REALM

Once the curse had been lifted, Midna regained her true form, that of a bewitching princess. She then returned to the Twilight Realm, smashing the Mirror of Twilight so that her world would never intersect with the Light World again. Her final request was that the denizens of the Light World not forget that there was another world within its shadows . . .

Link returned the Master Sword to the forest and went back to Ordon Village. The world received the blessings of the gods once more, and the land was covered in light.

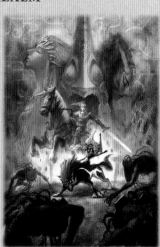

Battle against the Twilight

● MIDNA'S TRUE FORM

The curse that was wrought by the power of darkness is lifted after the defeat of Ganondorf.

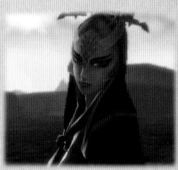

Midna

LINK, THE DESCENDENT OF THE HERO OF TIME

When Link steps into the Twilight, the crest of the Triforce of Courage on the back of his hand begins to glow, and he is transformed into a beast. When he regains his human form, he finds himself wearing the green garb of the Hero.

The spirit of Link's ancestor, the Hero of Time, teaches him his secrets. Ever since returning to the Child Era, the swordsman has lamented the fact that he was not remembered as a hero. This is the reason he passes down the proof of his courage and his secret techniques to the Link of this era, addressing him as "son."

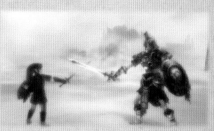

Link and the Hero's shade

Link clad in green

THE TRAP LURKING IN LINK'S SHADOW

THE CYCLE OF THE GERUDO THIEF GANONDORF

Several hundred years after Ganondorf's defeat, relations between Gerudo Village and Hyrule had become friendly once more, and peace had been restored to the land.

However, one day a new Ganondorf was born into the world. He violated the laws of the town, trespassing into an ancient pyramid and taking possession of the Trident. He also stole the Dark Mirror from the Temple of Darkness in the forest in order to turn Hyrule into a place of darkness.

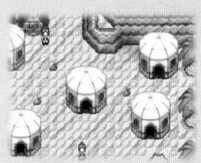

Gerudo Village

PLOTTING TO OBTAIN THE POWER OF DARKNESS

In order to enshroud Hyrule in darkness, Ganondorf began to usurp people's power. The first goal on which he set his sights was the resurrection of the evil wind sorcerer Vaati, who had been sealed away during the Force Era. Ganondorf used the power of the Dark Mirror to bring Shadow Link into the world, throwing Hyrule into chaos.

Shadow Link

THE RESURRECTION OF THE EVIL WIND SORCERER VAATI

The reigning Princess Zelda, wary of the dark clouds that covered Hyrule, brought Link and the six Maidens to the Elemental Sanctuary to see whether the seal on Vaati was weakening. However, the moment the door to the Elemental Sanctuary was opened, the Maidens were swept off to different corners of Hyrule by the power of the darkness.

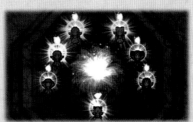

Princess Zelda and the Maidens

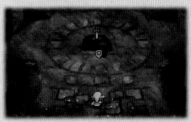

Shadow Link

● THE TRIDENT

An evil weapon born of darkness that slumbers within the pyramid. It is said that no one who enters the pyramid returns alive. On the stone monument that stands beside the pyramid is written, "Does your soul cry for destruction and conquest? We grant you the power to ruin the world."

The pyramid

● THE DARK MIRROR

A mirror that reflects the evil heart of its bearer, spawning demons. It was once used to imprison the Dark Tribe, who attempted to invade Hyrule, and thus it was hidden inside a temple with no connection to the Dark World.

Its relation to the Mirror of Twilight that serves as a path to the Twilight Realm, as well as the magic mirrors that exist in other timelines, is unknown.

● THE EVIL WIND SORCERER VAATI

Using the Four Sword, Vaati was sealed into the Elemental Sanctuary, a place visible only to children, by Link and the reigning Princess Zelda. Following his imprisonment, the sanctuary was watched over by the young Princess Zelda and the Maidens.

● SHADOW LINK

Demons identical to Link that are born of the Dark Mirror and possess the power of darkness. The resentment and evil thoughts of the defeated Ganondorf travel across time and space, emerging as shadows in the shape of the Hero. The ones that appear in the Elemental Sanctuary set a trap aimed at getting Link to break Ganondorf's seal.

THE RESURRECTION OF VAATI

Link, who was left behind, drew the Four Sword that rested deep within the Elemental Sanctuary so he could rescue Zelda and the Maidens. Doing so split his body into four copies, as the legend had foretold. The act of drawing the sword also caused the evil wind sorcerer, Vaati, who had been sealed away, to be released.

Link is split in four

Vaati's release

THE JOURNEY TO GATHER THE LIGHT FORCE AND GANONDORF'S PLOTS

The Four Sword in Link's possession did not contain enough power to crush the darkness. The four facets of the Hero thus set out on a journey to obtain the Light Force while rescuing Princess Zelda and the Maidens.

Meanwhile, Ganondorf resurrected Vaati in Hyrule Castle. Once he became aware of Link's travels, he set out on a new course of action. In order to gain even more dark powers, he used Vaati to turn the Royal Jewels into the gateway to the Dark World. Ganondorf then utilized the power of the Trident to defeat the Knights of Hyrule one by one as they rushed to the rescue, transforming them into demons. He then placed a curse on the Royal Jewels they held.

The now demonic Knights of Hyrule and their Royal Jewels were scattered across the kingdom by Shadow Link and his kin. The Tower of Winds also disappeared from sight. With the Royal Jewels transformed into gateways to the Dark World, demons began appearing in the land of Hyrule once again.

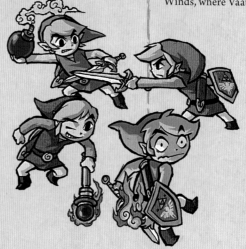

● THE LIGHT FORCE

The power that dwells within all the creatures of the world. It was originally stored within the Four Sword, but the power was lost due to Vaati's magic.

● THE KNIGHTS OF HYRULE

The Blue Knight, the Green Knight, the Red Knight, and the Violet Knight are swordsmen who have protected Hyrule for generations. Gallant and loyal, the pride of Hyrule, these knights would not hesitate to give their lives for their cause.

● THE ROYAL JEWELS

Sacred treasures that open the path to the heavens. For generations, the royal family of Hyrule have entrusted protection of the Royal Jewels to the Knights of Hyrule, in whom they hold great faith.

● THE TOWER OF WINDS

The passage to the heavens that is opened using the four Royal Jewels possessed by the Knights of Hyrule. It appears once the Royal Jewels are enshrined in the Elemental Sanctuary. Ganondorf snatches the jewels, and not only does he curse them, but he also ensures that no one will be able to reach the Palace of Winds, where Vaati dwells.

HYRULE IN THE SHADOW ERA

The Light Force is plentiful in this land, with desert to the west, forest to the east, and a towering mountain range. The construction of the tower that leads to the Palace of Winds is its most notable characteristic.

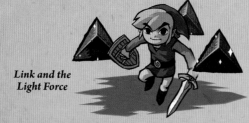

Link and the Light Force

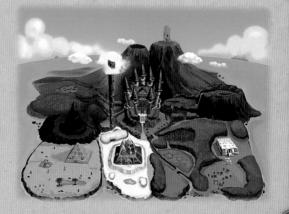

THE FINAL MOMENTS OF THE EVIL WIND SORCERER VAATI

The four Links rescued the Maidens from each corner of the land, liberating the Knights of Hyrule and the Royal Jewels that had fallen into darkness. Upon receiving the four Royal Jewels from the knights, the Links ascended the Tower of Winds from the Elemental Sanctuary using the power of the Maidens.

The Heroes saved Princess Zelda from the top of the tower and continued on to the Realm of the Heavens, where the Dark Mirror that had been incessantly spawning Shadow Links lay. The four Links then recovered the mirror and defeated Vaati in the Palace of Winds.

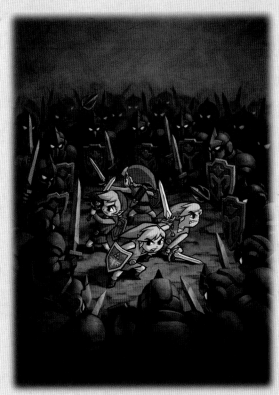

Battling the darkness

THE CONFRONTATION WITH GANON AND RENEWED PEACE

The four Links and Princess Zelda made for the surface world as the Palace of Winds crumbled beneath them. There, Ganon appeared. The facets of Link cooperated with Princess Zelda to crush him, successfully sealing Ganon with the Four Sword. "I am the King of Darkness! I cannot be destroyed by insects like you!" he cried as he was sealed away. Light shone out all around them, and the darkness began to part.

Link placed the Four Sword he had used to seal Ganon back into its pedestal in the Elemental Sanctuary, and his facets were once again united. Returning to Hyrule Castle, the Hero received a grand welcome. Princess Zelda looked down on the proceedings from the hall in the chamber of the Triforce within the castle.

● VAATI

Vaati was once a member of the Minish tribe, but transformed into an evil sorcerer due to his admiration of the hearts of the wicked. After being sealed and resurrected, he is finally defeated.

Vaati

● GANON

No trace remains of the human known as Ganondorf. He was heard to lament, "The power I have attained from the people of Hyrule is not yet enough." From Ganon's words, we can surmise that he did not have the power he needed to cover Hyrule in darkness.

Ganon

The evil sorcerer Vaati had become caught up in the cycle of Ganondorf the Thief.

Will the Light World never be free of the threat of darkness?
There may come a time when the land will have need of the Four Sword once again.

THE HERO OF WINDS AND A NEW WORLD

Ganondorf the Thief had obtained the Triforce of Power and transformed into the Demon King Ganon.

The Hero of Time successfully sealed away his foe. Victorious, he then departed to his original era, and purity began to return to the world once more. However, Hyrule's troubles continued.

ERA OF THE HERO OF TIME (ADULT ERA)

OCARINA OF TIME

MANY YEARS LATER

PEACE IS RESTORED TO HYRULE BY THE HERO OF TIME

THE HERO RETURNS TO HIS ORIGINAL ERA

With the help of the sages and the Hero of Time, Princess Zelda sealed away Ganon and returned Link to his original era. To ensure that the Sacred Realm could not be reopened, she put the Master Sword back in its pedestal and closed the Door of Time.

The passage between eras was sealed, and the Triforce of Courage continued its slumber somewhere in the land.

The Hero's return

The Master Sword

• THE HERO OF TIME'S RETURN

Upon returning to his original era, Link replaces the Master Sword in its pedestal and brings his beloved horse, Epona, back to Lon Lon Ranch.

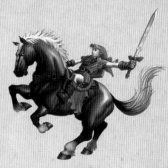

Link and Epona

THE PURIFICATION OF HYRULE

The dark clouds that had gathered over Hyrule parted, and light began to return to the world. However, once enough time had passed that the deeds of the Hero of Time had faded into legend, the creeping hand of evil beset the kingdom once more.

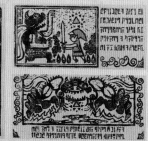

From the Scroll of the Hero of Time

THE DEEDS OF THE HERO OF TIME ARE PASSED ON AS LEGENDS

Even in the eras after the kingdom of Hyrule vanished from the earth, the legend of the Hero of Time and the kingdom where the power of the gods slumbered continued to be passed on from generation to generation. From the Hero's green garb to the details of his departure, the events of the story were handed down in the form of a scroll, becoming a legend from a bygone era.

THE CHRONICLE OF THE SINKING OF HYRULE

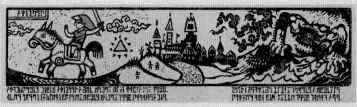

GANONDORF IS RESURRECTED IN THE ERA WITHOUT A HERO

Ganondorf, formerly sealed away, crawled up from the depths of the earth and enshrouded Hyrule in darkness once more. The prayers of the people were in vain, and the Hero never appeared.

Out of hope and out of time, King Daphnes Nohansen Hyrule made his decision: He would entrust the fate of his kingdom to the gods.

From the Scroll of the Hero of Time

THE GODS DECIDE TO SEAL HYRULE AWAY

The gods chose which of the kingdom's subjects would ascend to the new land, telling them to escape to the tallest mountains. They then flooded the world, sinking Ganondorf and Hyrule to the bottom of the ocean and sealing them away.

Though the king was sealed along with his kingdom, the princess took a piece of the Triforce that had been broken in two by the king and managed to escape to the ocean's surface with several of her retainers.

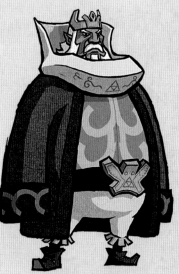

King Daphnes Nohansen Hyrule

● THE CHARM OF THE ROYAL FAMILY

A charm honed from a Gossip Stone, passed down by the royal family since ancient times. It was given by the king of Hyrule to his daughter, the princess. Members of the royal family can converse telepathically via the stone. It continues to be carefully handed down in the present era, known to its bearers as the Pirate's Charm.

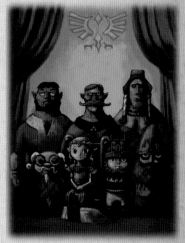

The princess of Hyrule and her retainers

The Pirate's Charm

THE WRITING SYSTEM IN THE ERA WITHOUT A HERO

One of the scripts used in the eras in which the Hylians ruled. The same characters are still in use in New Hyrule hundreds of years later, in the Era of the Great Sea.

It is possible to decipher this writing system using the chart at right to match each character with its Japanese equivalent.

A I U E O	HA HI FU HE HO	GA GI GU GE GO	1 2 3 4 5
KA KI KU KE KO	MA MI MU ME MO	ZA JI ZU ZE ZO	6 7 8 9 0
SA SHI SU SE SO	YA YU YO	DA DZI DZU DE DO	
TA CHI TSU TE TO	RA RI RU RE RO	BA BI BU BE BO	
NA NI NU NE NO	WA WO N	PA PI PU PE PO	

GANONDORF'S REPEATED RESURRECTIONS

GANONDORF'S PLOTS

Hundreds of years passed, and Ganondorf, who should have been sealed at the bottom of the ocean along with Hyrule, was resurrected once again. He gave an order to his minions to attack the Wind and Earth temples, killing the two sages whose prayers gave the Master Sword the ability to destroy evil.

Upon emerging from the sea, he turned the Forsaken Fortress into his base of operations and began his search for Princess Zelda, a descendent of the royal family who possessed the Triforce of Wisdom.

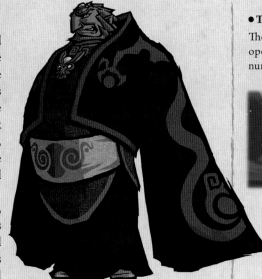

Ganondorf

● **THE FORSAKEN FORTRESS**

The resurrected Ganondorf's base of operations. It is crawling with large numbers of demons.

The Forsaken Fortress

THE GIRL WITH THE BLOOD OF THE ROYAL FAMILY AND THE PIRATES

King Daphnes Nohansen Hyrule, ordered by the gods to put an end to Ganondorf's ambitions, awoke from his slumber. His spirit took up residence in a small red boat known as the King of Red Lions, and he began searching for the new Hero and the descendent of the royal family.

The descendent he sought had grown up as the leader of a group of pirates. Known as Tetra, she had spent her life sailing the seas.

The King of Red Lions

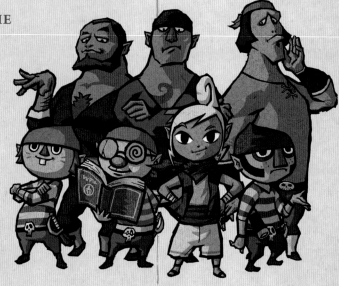

Tetra and the pirates

A MAP OF THE WORLD IN THE ERA OF THE GREAT SEA

The continent that once contained the land of Hyrule has sunk to the bottom of the ocean, and only islands remain. Aside from the Hylians, who rule over the realm, a small number of peoples in whose veins flow the blood of the Kokiri, Goron, and Zora tribes yet survive.

Windfall Island

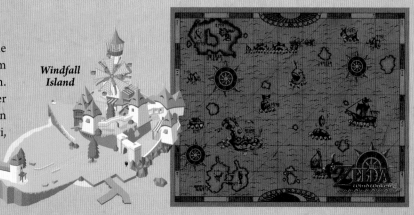

ADVENTURE BROUGHT BY THE WIND

THE BOY MEETS THE KING OF RED LIONS

In order to locate Princess Zelda, Ganondorf took control of an ominous bird, kidnapping girls from all around the sea. In the midst of this villainy, the King of Red Lions discovered a boy named Link from Outset Island who had infiltrated the Forsaken Fortress in an attempt to rescue his kidnapped sister.

Link enters the Forsaken Fortress

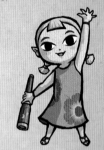

Link of Outset Island

THE BOY FROM OUTSET ISLAND PROVES HIS COURAGE

The King of Red Lions decided to gamble the future of Hyrule on the courage of Link, the boy who was trying to rescue his sister. He bestowed the Wind Waker upon Link, which had been passed down by the royal family, and the two set off on their adventure.

Upon receiving a pearl from each god that watched over the land, Link raised the Tower of the Gods and found himself proving his courage in a great trial.

Link and the King of Red Lions

●THE KIDNAPPED GIRLS

Princess Zelda, in whose veins flows the blood of the Hylians, possesses their characteristic long ears. The ominous bird seeks out girls who share this trait and carries them off to the Forsaken Fortress.

Link's little sister Aryll

The kidnapped girls

●THE WIND WAKER

In ancient times, the Wind Waker was a baton used to play songs that served as prayers to the gods.

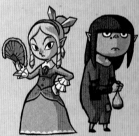

The Wind Waker

THE CUSTOMS OF THE HERO OF TIME ON OUTSET ISLAND

On Outset Island, where Link lives, it is customary for boys who reach a certain age to don green garb in celebration of the Hero of Time. The green clothes are meant to imitate the legendary Hero, and thus they symbolize the hope that the boys will grow up to be courageous. The custom of decorating the inside of a house with a shield is also a vestige of this tradition.

From the Scroll of the Hero of Time

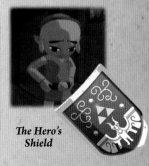

The Hero's Shield

LINK RECEIVES THE APPROVAL OF THE GODS

Link's courage was recognized as he underwent the trials in the Tower of the Gods. He obtained the legendary blade known as the Master Sword in Hyrule, the kingdom sealed deep under the ocean.

He challenged the Forsaken Fortress once again in an attempt to subjugate Ganondorf. However, the Master Sword had lost its ability to repel evil. He was not able to wound Ganondorf even slightly, and the Demon King realized that Tetra was Princess Zelda.

Link and Tetra barely managed to escape from the Forsaken Fortress with their lives.

Hyrule Castle underwater

● THE MASTER SWORD

The legendary blade can only be wielded by the Hero. In this era, it acts as the key to the seal on the sunken kingdom of Hyrule.

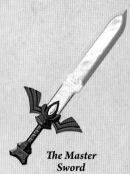
The Master Sword

PRINCESS ZELDA IS AWAKENED BY THE TRIFORCE OF WISDOM

The King of Red Lions, aware of the situation, invited Link and Tetra to the chamber of the Master Sword. There, he revealed his true form as the king of Hyrule.

The fragment of the Triforce possessed by the king and the fragment possessed by Tetra united to form the Triforce of Wisdom, and Tetra awakened as Princess Zelda, the true heir to Hyrule's royal family. Princess Zelda remained hidden within Hyrule Castle, where Ganondorf's hand could not reach her.

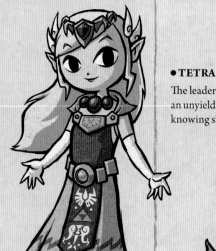
Princess Zelda

● TETRA

The leader of the pirates, Tetra possesses an unyielding spirit. She grew up without knowing she was the princess of Hyrule.

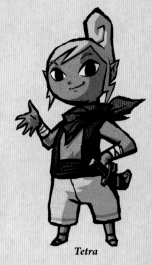
Tetra

*Zelda's awakening
(from Niko's picture show)*

AN ANCIENT BATTLE DECORATES THE INSIDE OF HYRULE CASTLE

Within the walls of Hyrule Castle, which lies at the bottom of the sea, sits a statue that brings to mind the Hero of Time. The Master Sword also rests deep within. The images of Ganon and the six sages are depicted in stained-glass windows. The decorations in the chamber where the Master Sword rests in its pedestal bring to mind the sealing of Ganon by the sages and the Hero of Time.

Stained glass depicting the sages

Link obtains the Master Sword

TAKING MEASURES TO SUPPRESS GANONDORF

The King of Red Lions directed Link to find the pieces of the Triforce of Courage, sunk beneath the sea.

Because the sages Laruto and Fado had been killed by Ganondorf, Medli of the Rito tribe and Makar of the Korok tribe, in whose veins flowed the blood of the sages, headed for their respective temples.

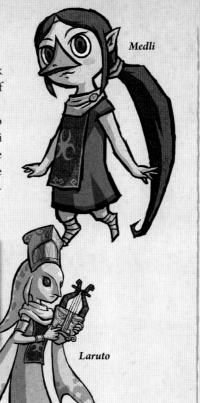

Medli

Laruto

THE PRAYERS OF THE SAGES AND THE POWER TO REPEL MAGIC

The spirits of the previous sages, who had lost their lives at the hands of Ganondorf, awakened the new sages by playing special melodies on their instruments.

Medli, the Sage of Earth, and Makar, the Sage of Wind, offered up their prayers and restored the power to repel magic to the Master Sword.

Makar

Fado

● THE TEMPLES SLUMBERING IN HYRULE

The temples were sunk to the sea floor along with Hyrule, and there they continue to slumber. However, because their entrances sit atop tall mountains, it is possible to access them from the ocean's surface in the Era of the Great Sea.

● THE SAGE OF EARTH

This sage plays a harp. Medli, a maiden of the Rito tribe who later awakens as a sage, is an attendant to the guardian deity Valoo. Her predecessor as Sage of Earth was Laruto of the Zora tribe.

● THE SAGE OF WIND

This sage plays a violin. Makar of the Korok tribe plays the role of accompanist in the Koroks' annual ceremony. He will later awaken as a sage. His predecessor was Fado of the Kokiri tribe.

THE SPIRITS THAT GUARD THE PEARLS OF THE GODDESSES

Even after the land of Hyrule was sealed away, the guardian spirits of the three pearls of the goddesses remain. They are thought to be descended from Volvagia, the Deku Tree, and Jabu-Jabu, spirits that existed during the Era of the Hero of Time.

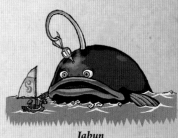

Valoo

The Deku Tree

Jabun

THE BIRTH OF THE HERO OF WINDS

Gathering the eight fragments from the seabed, Link completed the Triforce of Courage. A crest appeared on his left hand, and his courage was recognized to be genuine.

However, once Link and the King of Red Lions returned to Hyrule Castle, they witnessed Ganondorf carrying off Princess Zelda right before their eyes.

Princess Zelda is kidnapped (from Niko's picture show)

Taking a stand against Ganondorf (from Niko's picture show)

● **THE HERO OF WINDS**

Upon witnessing the gods' approval of the boy who manipulates the wind to fill the boat's sails using the Wind Waker, the King of Red Lions dubs Link the Hero of Winds.

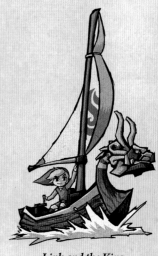

Link and the King of Red Lions

THE FATEFUL DECISION TO WISH UPON THE TRIFORCE

Princess Zelda, who bore the Crest of Wisdom, had been taken to Ganon's Tower, which rested on the ocean floor in Hyrule. When Link arrived bearing the Crest of Courage, the three crests were united and the Triforce took on its true form.

Ganondorf, hoping to resurrect Hyrule and rule over it, reached out to touch the Triforce and settle his fate at last.

Princess Zelda and the Crest of Wisdom

Link and the Crest of Courage

● **THE TRIFORCE**

The divine power that Ganondorf previously failed to attain, these sacred triangles grant the wishes of those who touch them. As Ganondorf has only succeeded in obtaining the Triforce of Power, he needs to gather the Triforce of Wisdom and the Triforce of Courage.

THE KOKIRI AND ZORA TRIBES TAKE ON NEW FORMS

Some of the peoples in the Era of the Great Sea underwent drastic changes in form during the tumultuous eras of the past. The Kokiri now appear plantlike, having transformed into the Korok tribe, who spread greenery around the world with the spirit known as the Deku Tree. The Zora tribe, who now bear birdlike beaks, have transformed into the Rito. They grow their wings upon being blessed with one of the spirit Valoo's scales.

The Goron tribe has not undergone much change, but its members wander the earth as vagabonds.

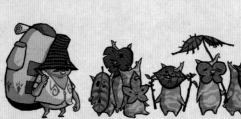
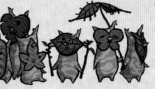
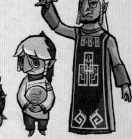

The Goron tribe

The Korok tribe

The leader of the Rito tribe and his son, Komali

THE ANCIENT KINGDOM FADES AWAY

Suddenly, the king of Hyrule appeared and touched the Triforce before Ganondorf was able to. In a sonorous voice, the king declared his wish: "Wash away this ancient land of Hyrule! Let a ray of hope shine on the future of the world!!!"

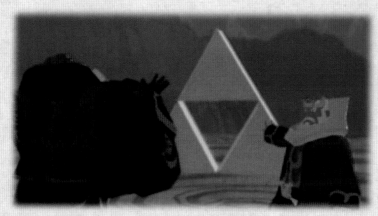

The king of Hyrule lays his hand on the Triforce

GANONDORF'S FINAL MOMENTS

Was it really worthwhile to ask the Triforce to destroy Hyrule in order to build a better future? Link and the princess, to whom the future had been entrusted, launched an attack on Ganondorf. What unfolded next was Hyrule's final battle.

Ganondorf fell to the power of Princess Zelda's Light Arrows and the ability of Link's blade to repel evil, and turned into stone.

As Hyrule began to fade away, the king helped Link and Princess Zelda escape to the surface. In spite of Princess Zelda's entreaty to search for a new land together and Link's outstretched hand, King Daphnes Nohansen Hyrule chose to vanish along with his kingdom.

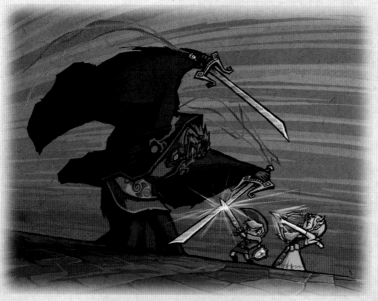

The confrontation with Ganondorf

● GANONDORF'S DESIRE

Ganondorf, obsessed with the idea of resurrecting Hyrule, the kingdom that had sunk to the bottom of the ocean, described the land's destruction by the gods. He spoke of the desert country in which he was raised, how the wind that swept across it brought death, and how he coveted the wind that blew over Hyrule. Was it the wind of Hyrule he felt in his final moments? Or the wind of death . . . ?

The showdown with Ganondorf (from Niko's picture show)

● THE KING AND HYRULE

When the king of Hyrule looked back upon his reign, he was filled with regret. Because, like Ganondorf, his yearning for the past bound him to Hyrule, he decided to disappear with his kingdom. As though asking the forgiveness of Link and the princess, he left behind his final words: "I have scattered the seeds of the future . . ."

The legend of Hyrule

The curtain thus fell on the cyclical history of the sacred realm of Hyrule and the struggle for the Triforce.

THE CURTAIN RISES ON THE ERA OF THE GREAT VOYAGE

THE GREAT VOYAGE OF TETRA, LINK, AND THE PIRATES

Hyrule vanished, and the pirates welcomed back Princess Zelda, who had once again become Tetra the pirate. Tetra, Link, and the pirates received a sendoff from the people of the islands, and set sail in search of a new world.

Tetra and the pirates (from Niko's picture show)

THE EERIE GHOST SHIP APPEARS IN THE OCEAN KING'S WATERS

Several months after their departure, Tetra and the pirates found themselves in waters where the Ghost Ship was rumored to appear. The area fell under the jurisdiction of a great spirit known as the Ocean King, but recently, ships had begun disappearing.

In order to ascertain the truth behind the rumors, Tetra boarded the Ghost Ship when it appeared before them, only to be kidnapped. Link rushed to her aid but was hurled into the depths of the ocean.

The Hero found himself washed ashore on the beach of Mercay Island. On the advice of an old man named Oshus, he departed in search of clues to the Ghost Ship's whereabouts.

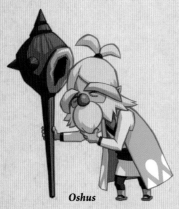
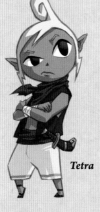

Oshus

Tetra

● NIKO THE PIRATE'S PICTURE SHOW

Niko, a member of Tetra's pirate gang, turns the ballad of Link and his friends into a picture show to tell the story of their adventures.

Niko's picture show

● THE GHOST SHIP

A ship surrounded by a thick fog. The stronghold of the evil Bellum, it sails the waters of the Ocean King. It drains the Life Force of those who approach it.

The Ghost Ship

TRAGEDY IN THE WATERS OF THE OCEAN KING

The waters under the jurisdiction of the Ocean King are full of Life Force, the origin of power, which is the reason they attracted the attention of Bellum, who consumes it. When the Spirit of Power and the Spirit of Wisdom were sealed away, the Ocean King and the Spirit of Courage created alter egos and fled to the island.

Though the waters of the Ocean King exist in a different world from that of Tetra, Link, and the pirates, the crests of Hyrule's three gods can still be found in the Ocean King's temple. Because of this, it is highly possible that the waters of the Ocean King were created by the same gods as Hyrule.

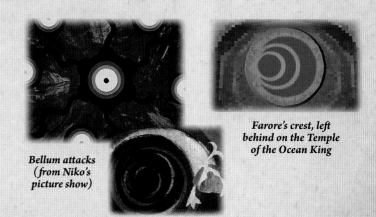

Bellum attacks (from Niko's picture show)

Farore's crest, left behind on the Temple of the Ocean King

ADVENTURE ON THE SS *LINEBECK*

Link befriended Ciela, the fairy that Oshus had taken in, and managed to obtain the cooperation of Captain Linebeck. The three set sail on the SS *Linebeck*, his ship.

Using the Phantom Hourglass, Link managed to unlock the clues that slept within the Temple of the Ocean King bit by bit. He also rescued the Spirits of Power, Wisdom, and Courage.

Link and Captain Linebeck

THE OCEAN KING AND THE EVIL BELLUM

Borrowing the power of the spirits, Link successfully boarded the Ghost Ship. Inside, he discovered that Tetra had turned to stone after Bellum drained her Life Force. Then, Oshus appeared and revealed his true identity as the Ocean King. The Ocean King recognized Link's courage, and asked him to eradicate Bellum.

Tetra is turned to stone

● THE TEMPLE OF THE OCEAN KING

A temple dedicated to the worship of the Ocean King, who governs this region of the ocean. The temple is commandeered by Bellum, who uses offshoots of himself called Phantoms to eject trespassers.

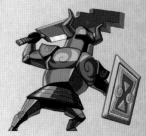

A Phantom

● THE PHANTOM HOURGLASS

This hourglass possesses the power to manipulate time. It is necessary to use it in order to pass through the Temple of the Ocean King unharmed.

The Phantom Hourglass

● THE SPIRITS OF POWER, WISDOM, AND COURAGE

They may look like small fairies, but they possess great powers, such as the ability to sense evil. The fairy Ciela is actually the Spirit of Courage.

The spirits

THE WATERS OF THE OCEAN KING

A great sea composed of four territories. It is a world located at the heart of the ocean, with no landmasses big enough to be called continents.

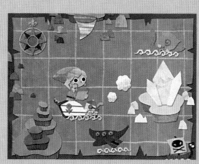
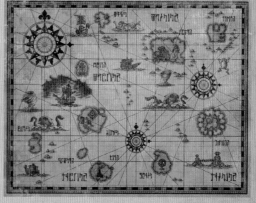

THE CONFRONTATION WITH THE EVIL DREAM GOD BELLUM

Link obtained the only weapon capable of defeating Bellum: the Phantom Sword. He then headed for the depths of the Temple of the Ocean King. Once he crushed Bellum, Tetra would return to normal.

Link pressed his attack against Bellum once again and barely managed to escape with his life, thanks to the courageous actions of Captain Linebeck. Once the dust had cleared on the final battle, Link and his friends stood victorious.

Bellum

● THE PHANTOM SWORD

Oshus added the power of the Phantom Hourglass to this sacred blade, which was forged from three carefully guarded Pure Metals, each found in a different region.

The Phantom Sword

The three Pure Metals

ESCAPING THE WATERS OF THE OCEAN KING

Oshus regained his true form, and peace returned to the waters of the Ocean King. Link and Tetra bid a fond farewell to Oshus and the spirits, and found themselves back in their own world. However, despite the many days they had wandered during their adventure in the waters of the Ocean King, they returned to find only ten minutes had passed.

The turmoil surrounding the Ghost Ship had come to a close, and Tetra, Link, and the pirates resumed their voyage in search of a new world.

The Ocean King regains his true form

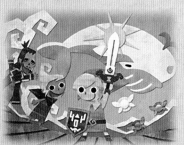

● CAPTAIN LINEBECK LIVES

The people Link meets in the waters of the Ocean King are the inhabitants of another world, and cannot be encountered in Link's own. However, once Link returns to his own world, he seems to make out the shape of the SS *Linebeck* drifting in the distance.

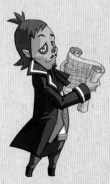

Captain Linebeck

THE PEOPLE OF THE WATERS OF THE OCEAN KING

In addition to humans, Gorons, which look identical to the Gorons of Hyrule, and the Anouki tribe of the Isle of Frost also inhabit the waters of the Ocean King.

The spirits of the Cobble King and his knights also dwell on the island that houses the ruins of their ancient kingdom.

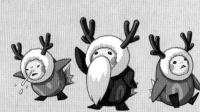

The Anouki tribe

The Goron tribe

THE HISTORY LEADING UP TO NEW HYRULE

DISCOVERING A CONTINENT AND RE-CREATING A KINGDOM

Continuing their journey, Link, Tetra, and the pirates at last came upon a new continent. At the heart of this land sat a structure called the Tower of Spirits, from which the Spirit Tracks spiraled out.

Here, Tetra founded New Hyrule. Another history had begun to unfold.

The Spirit Train runs on the Spirit Tracks

THE EXPANSION OF HYRULE KINGDOM

Trains ran along the Spirit Tracks, and the kingdom developed a network of railroads. The castle was decorated with stained glass depicting Tetra the pirate, and the soldiers adopted green uniforms as a tribute to the Hero of Winds.

Stained glass depicting Tetra

THE TRACKS BEGIN TO VANISH

One hundred years after the country's founding, sections of track began to disappear all over the land.

The reigning Princess Zelda presented an engineer named Link with a soldier's uniform in order to slip out of the castle, and the two headed to the Tower of Spirits with Alfonzo to investigate.

The engineers Link and Alfonzo

● THE TOWER OF THE GODS

The Demon King had been sealed in this tower by the gods in the distant past. The train tracks, which spiraled out from the tower to cover the land, drew the power to maintain the seal from the land's four temples. Sages of the Lokomo tribe were dispatched from the heavens to each of the four temples and the tower.

The Tower of the Gods and the Demon King (from Niko's picture show)

● PRINCESS ZELDA

The Princess Zelda spoken of here is the fifth of her line, the great-great-grandchild of Tetra.

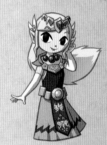

Princess Zelda

● ALFONZO

An engineer from Aboda Village. He is descended from Gonzo, one of Tetra's pirates. He used to serve the royal palace as a swordsman. Though his skill was great enough that people spoke of him as legendary, he was wounded in a fight with Byrne.

THE PICTURE SHOW OF NIKO THE STORYTELLER

Niko, who arrived in the new world one hundred years ago as one of Tetra's pirates, is still going strong in this era. He is affectionately nicknamed "Old Man Niko." He lives with a boy named Link who is identical in appearance to the Hero of Winds.

Niko passes on the legends surrounding the new world and the new adventures of Link in the form of a picture show.

Link

Old Man Niko

Old Man Niko's picture show

The people and the Tower of the Gods (from Old Man Niko's picture show)

Byrne

Chancellor Cole

PRINCESS ZELDA, NOW NOTHING MORE THAN A SPIRIT

On their way to the Tower of Spirits, they concluded that Cole, the chancellor of Hyrule Kingdom, was a creature of evil. Cole was attempting to resurrect Malladus the Demon King, who had been sealed in the Tower of Spirits. He planned to use the body of Princess Zelda as a vessel for Malladus.

Princess Zelda was kidnapped by Cole's ally, Byrne, and her spirit separated from her body. Link and the spirit of Princess Zelda received orders from Anjean the sage at the Tower of Spirits.

Princess Zelda's spirit

●BYRNE

A member of the Lokomo tribe who studies under Anjean. He was not recognized by the gods. Seeking a power superior to that of the gods, he cooperated in the resurrection of the Demon King. Upon losing to Link, he realizes that he was being used by Chancellor Cole and agrees to help Princess Zelda.

●ANJEAN

One of the sages of the Lokomo tribe who was sent to the surface world by the gods in the distant past. A friend to Tetra the pirate, she watches over the Tower of Spirits.

Anjean

THE CHANGES IN THE SPIRIT TOWER

With its tracks disappearing and its barrier lost, the Tower of Spirits was divided, and its guardians, the Phantoms, were possessed by demons.

Princess Zelda's spirit transformed into Phantom Zelda by entering the armor of a Phantom, and, with the cooperation of Link, she made for the top of the tower. However, in order to reach the top floor where the Demon King's spirit slept, the two would need to restore the barriers to the temples.

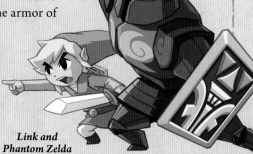

Link and Phantom Zelda

A MAP OF THE NEW WORLD

New Hyrule is split into five regions, with Hyrule Castle and the Tower of Spirits at its center, encircled by the Forest Realm, the Snow Realm, the Ocean Realm, the Fire Realm, and the Sand Realm.

In the past, Tetra was aided by a man called Linebeck. From the existence of his grave and his descendent Linebeck III, it is possible to surmise that he made it to the new world as well.

Linebeck III

THE RESTORATION OF THE BARRIERS

Link traveled the land on the Spirit Train that had once been stored in the tower. Using the Spirit Flute entrusted to him by Princess Zelda, Link borrowed the power of the realm's sages and restored the barriers to the temples.

Once he reached the top of the tower, he found that Malladus the Demon King had been resurrected. In order to return Princess Zelda to her body, Link and his friends would need to enter the Dark Realm.

Gage, the Sage of Forest, and Link

THE SUPPRESSION OF MALLADUS

Following an intense battle with Malladus, Princess Zelda regained her physical form. The mysterious power of Princess Zelda, along with Link's courage, brought about the end of Chancellor Cole and Malladus.

Once the kingdom had been freed from the menace of the Demon King, Anjean and the Lokomo tribe determined that the people no longer required their protection, and returned to the heavens. The land's care was entrusted to Princess Zelda, Link, and their friends, and Hyrule made great strides in its development.

The suppression of Malladus

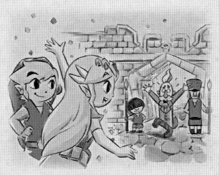

The Lokomo tribe returns to the heavens

Princess Zelda's triumphant return

● THE SPIRIT FLUTE

A mysterious flute passed down by each successive generation of Hylian princesses. It originally belonged to Anjean, who gave it to Tetra, who wanted it in order to build peace in the kingdom.

The Spirit Flute

● THE DARK REALM

A world covered by inky blackness where demons make their nests. Malladus and Chancellor Cole use the Demon Train to travel to the furthest reaches of the darkness, where the final battle unfolds.

The Demon Train

● MALLADUS

The Demon King was sealed away in the tower by the gods. He took possession of Chancellor Cole after the chancellor failed to turn Princess Zelda's body into a vessel, and was defeated by Link and his friends.

The spirit of Malladus

The ancient realm was destroyed, and the wind guided the founders of Hyrule to a new land, where the kingdom set off down another path.

With the lineage of the gods not yet exhausted, who can say what successive generations will bring? The story will continue to unfold.

COMMEMORATIVE MERCHANDISE COLLECTION

These items were released for *The Legend of Zelda*'s twenty-fifth anniversary. *The Legend of Zelda: Symphony of the Goddesses,* a new orchestral work, debuted in October 2011.

THE LEGEND OF ZELDA: FOUR SWORDS ANNIVERSARY EDITION

A Nintendo DSiWare version of *Four Swords,* which originally came packaged with *The Legend of Zelda: A Link to the Past.* The limited-edition game was distributed for the Nintendo 3DS, DSi, and DSi XL until February 20, 2012.

NINTENDO PRIVATE CARD

A specially designed card that was released for a limited time. There were three versions: *Ocarina of Time 3D, Skyward Sword,* and a special illustration.

PLAYING CARDS

A set of playing cards featuring character designs from different eras. It was released for the twenty-fifth anniversary, but it is not a limited-edition product.

THE LEGEND OF ZELDA 25TH ANNIVERSARY EDITION NINTENDO 3DS

A limited-edition 3DS released via Nintendo Online. Its design features the crest of Hyrule in the center. This is a high-quality product.

CREATIVE FOOTPRINTS

Documenting 25 Years of Artwork

The Legend of ZELDA

LINK

Link was depicted in early art examples as right handed. However, in order to aid in the creation of the pixel art and for the purposes of configuration in game screens, he was altered to be left handed.

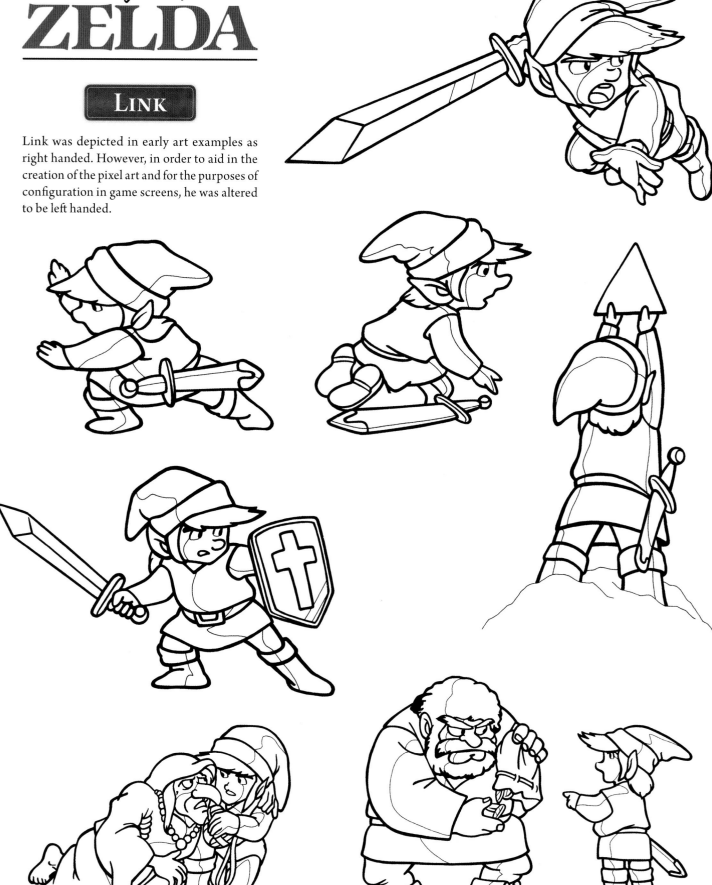

DEVELOPMENT MATERIALS

Development materials for *The Legend of Zelda*, drawn by Shigeru Miyamoto. Some of the images below are making their first public appearance in this book. From the design of the enemies to the configuration of the dungeons, Miyamoto either created or had a hand in almost every aspect.

CONCEPT ART

These enemies may seem familiar, due to their appearance in later games of the series. Darknuts, Peahats, Leevers, and Octoroks are depicted here.

The second illustration from the top on the
left-hand side is a shield-eating Like Like. To
its right, the illustration of a hand extending out
of the wall may depict a prototype Wallmaster.

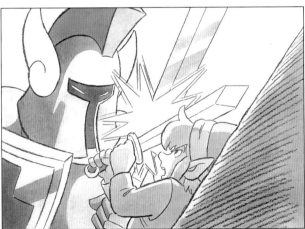

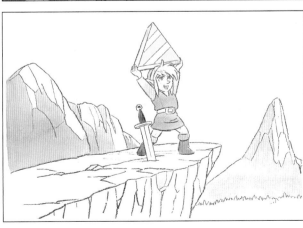

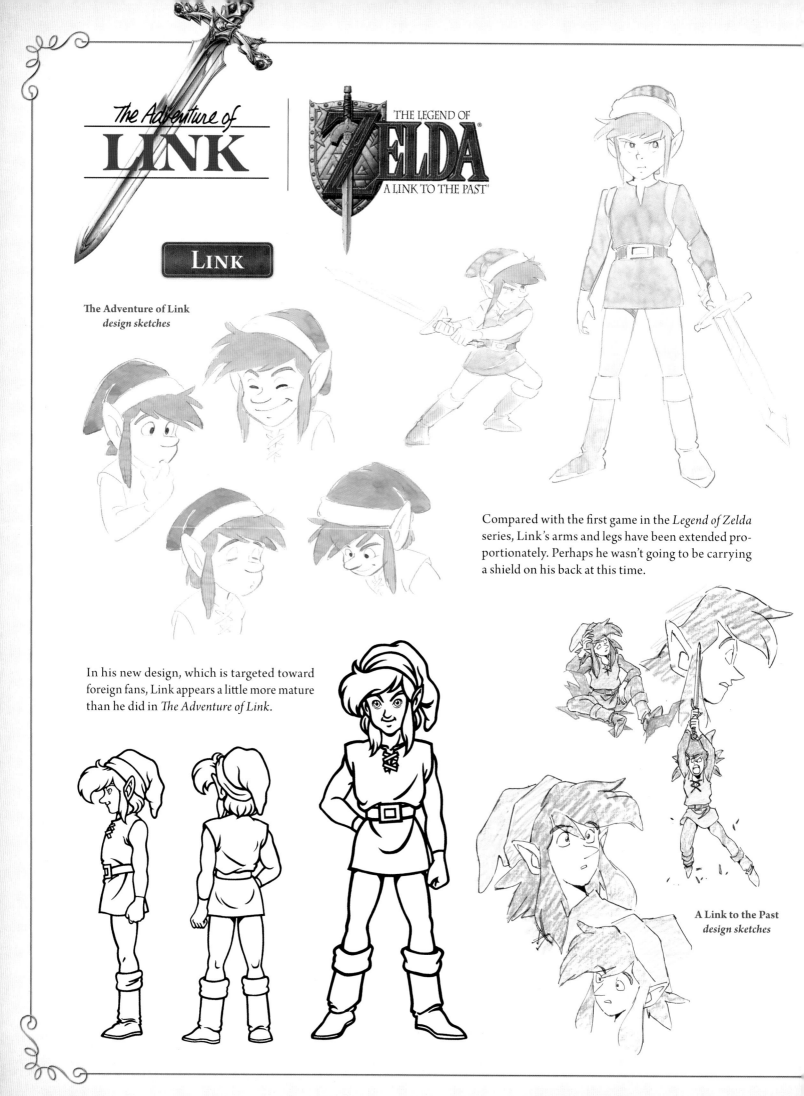

The Adventure of LINK | THE LEGEND OF ZELDA · A LINK TO THE PAST

LINK

The Adventure of Link
design sketches

Compared with the first game in the *Legend of Zelda* series, Link's arms and legs have been extended proportionately. Perhaps he wasn't going to be carrying a shield on his back at this time.

In his new design, which is targeted toward foreign fans, Link appears a little more mature than he did in *The Adventure of Link*.

A Link to the Past
design sketches

ZELDA

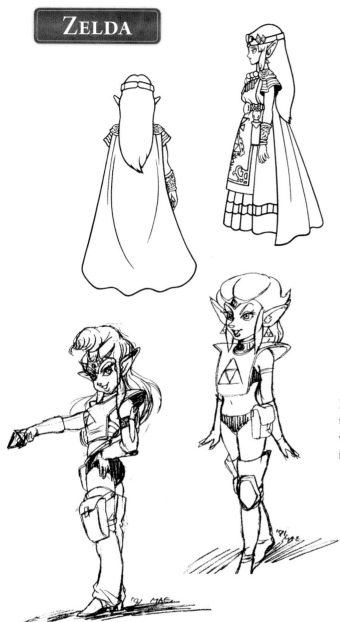

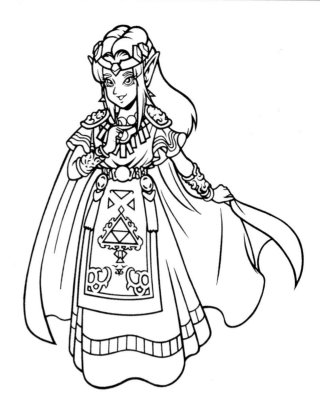

Princess Zelda, clad in a magnificent dress. This would become the prototype for her gown. In the picture to the left, Zelda is wearing a sci-fi-themed costume. It does not make an appearance in the game.

GANON

You can see how huge Ganon is by examining the comparison chart below. For some reason, a few other familiar characters have been added to the mix . . .

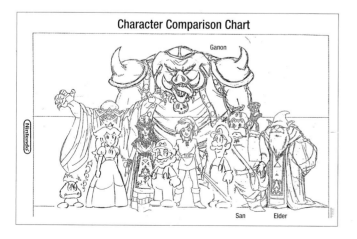

A Link to the Past

THE LEGEND OF **ZELDA**
LINK'S AWAKENING™

DEVELOPMENT MATERIALS

To the right are storyboards depicting scenes from the game, including the opening sequence. Below are sketches with ideas for enemy attack patterns. Everything is drawn out in detail, from the animations to what the player must do to defeat or overcome the enemy.

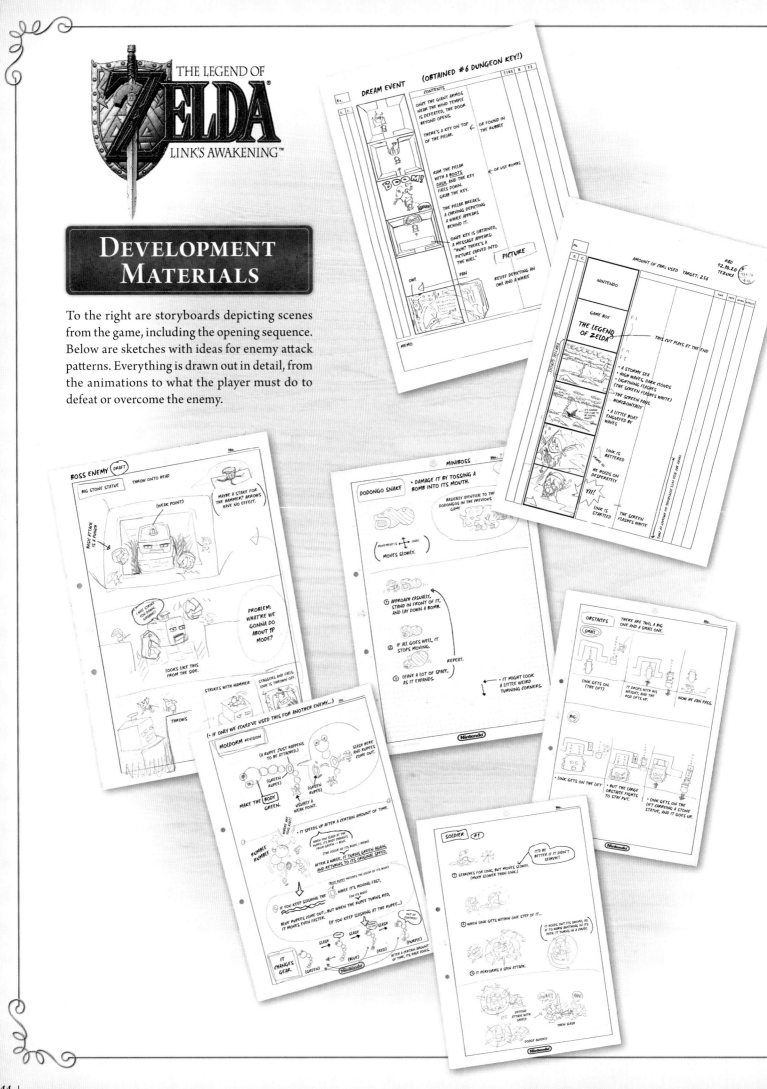

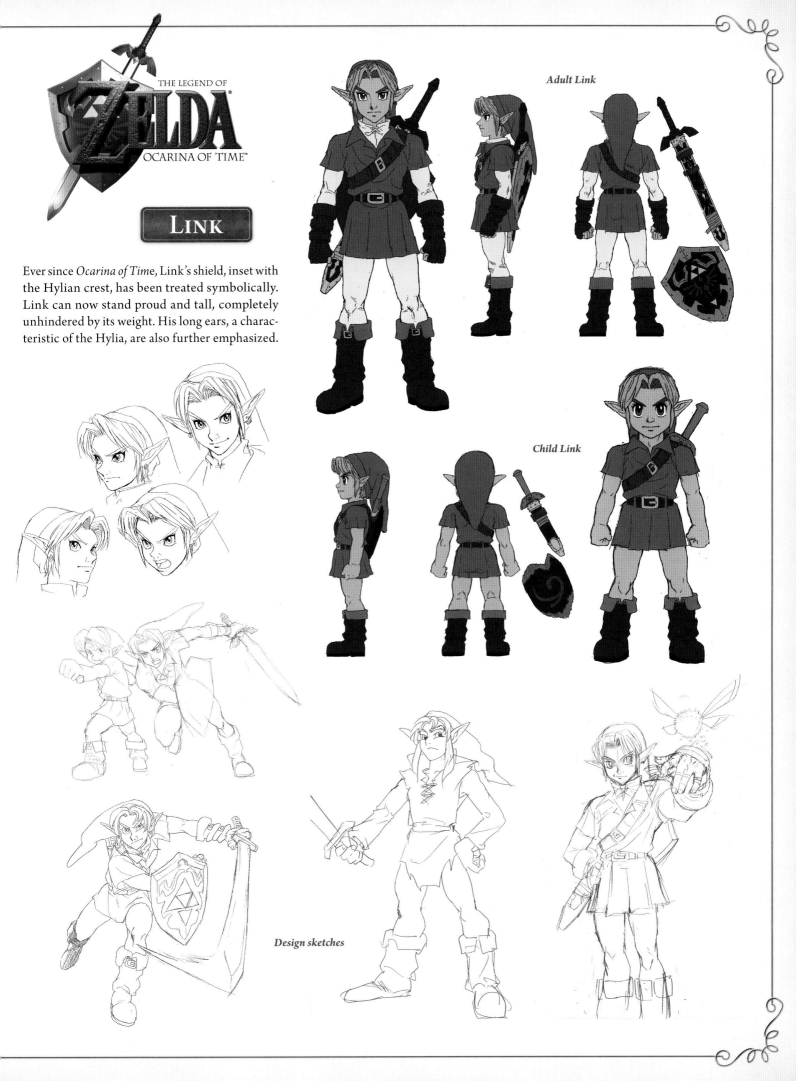

THE LEGEND OF ZELDA
OCARINA OF TIME™

LINK

Ever since *Ocarina of Time*, Link's shield, inset with the Hylian crest, has been treated symbolically. Link can now stand proud and tall, completely unhindered by its weight. His long ears, a characteristic of the Hylia, are also further emphasized.

Adult Link

Child Link

Design sketches

ZELDA

The design of Princess Zelda's tabard depicts the Sheikah coat of arms, in addition to the crest of Hyrule's royal family.

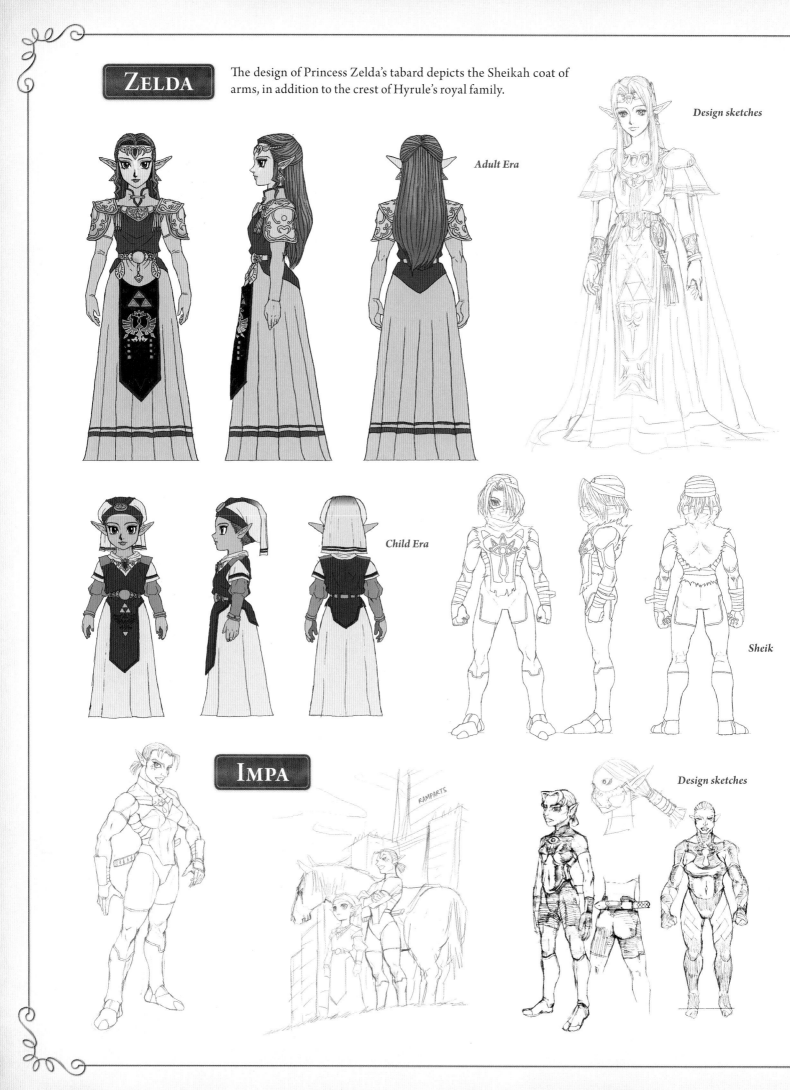

Design sketches

Adult Era

Child Era

Sheik

IMPA

Design sketches

RAMPARTS

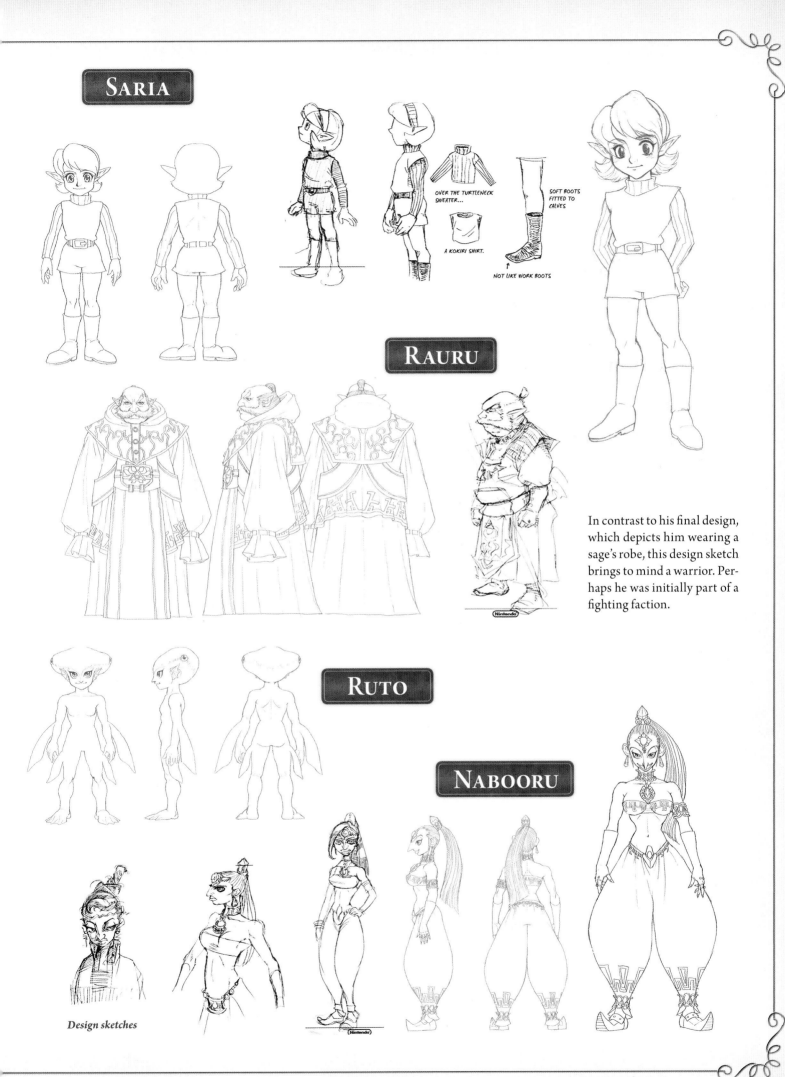

SARIA

OVER THE TURTLENECK SWEATER...

A KOKIRI SHIRT.

SOFT BOOTS FITTED TO CALVES

NOT LIKE WORK BOOTS

RAURU

In contrast to his final design, which depicts him wearing a sage's robe, this design sketch brings to mind a warrior. Perhaps he was initially part of a fighting faction.

RUTO

NABOORU

Design sketches

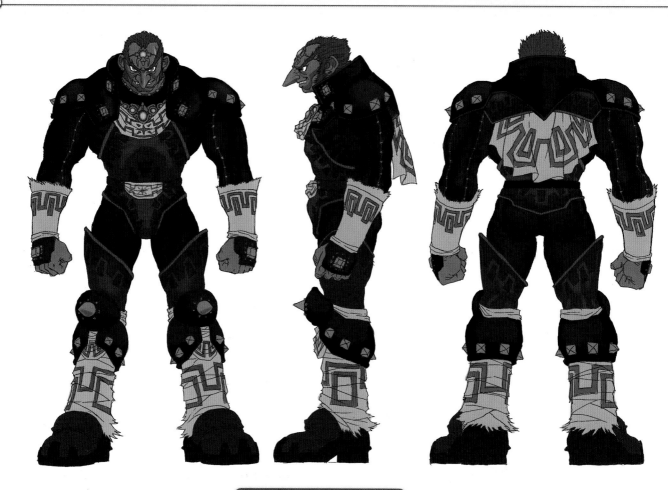

GANONDORF

Ganondorf, drawn for the first time in human form. His sharp, birdlike nose is characteristic of the Gerudo.

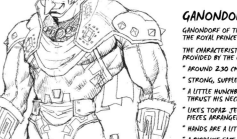

GANONDORF

GANONDORF OF THE DEMON THIEVES, THE ROYAL PRINCE OF EVIL.

THE CHARACTERISTICS BELOW WERE PROVIDED BY THE GAME STAFF.

* AROUND 230 CM TALL.
* STRONG, SUPPLE MUSCLES.
* A LITTLE HUNCHBACKED, TENDS TO THRUST HIS NECK OUT. SMALL FACE.
* LIKES TOPAZ JEWELRY. HAS SEVERAL PIECES ARRANGED ALL OVER HIS BODY.
* HANDS ARE A LITTLE LONG.
* A BIRDLIKE FACE, CHARACTERISTIC OF THE GERUDO TRIBE.
* WEARS A LEATHER LEOTARD ON TOP OF A THIN BLACK BODYSUIT. WRAPPED IN FABRIC FEATURING GERUDO DESIGNS. A LEATHER GUARD COVERS HIS SHOULDERS AND NECK.

GANONDORF'S HORSE

GERUDO DESIGNS

* COVERED IN DEEP CRIMSON DECORATIVE FABRIC, WITH CHAIN MAIL ON TOP OF THAT. NECK, CHEST, SHOULDERS, AND FACE CLAD IN METAL ARMOR. CHAIN MAIL ON LEGS, TOO.

* JET-BLACK BODY AND RED MANE. HAS A LARGE BUILD, AROUND TWICE AS BIG AS LINK'S HORSE.

HE CARRIES A SMALL BLADE, LIKE THE ONE SEEN AT LEFT, ON HIS LEFT THIGH.

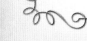

WEARS A LEATHER LEOTARD ON TOP OF A THIN BLACK BODYSUIT. WRAPPED IN FABRIC FEATURING GERUDO DESIGNS. A LEATHER GUARD COVERS HIS SHOULDERS AND NECK. HE'S ALSO WEARING JEWELRY.

THE GREAT DEMON KING GANON
INITIAL DRAFT SKETCH

HOW HE DIFFERS FROM GANONDORF:

- FACE TWISTED INTO A MASK OF RAGE
- LONGER HAIR
- WEARING CLOAK
- HANDS AND FEET HAVE BECOME BESTIAL

GANON AND UNDERLINGS

CARVED INTO TREE

BRAND BURNED INTO TREE

GANON THE THIEF

As might be expected with a key character like Ganondorf, it seems that a number of sketches were considered for his design, including ones for the bestial form that follows his protean transformation.

CONCEPT ILLUSTRATIONS

Because *Ocarina of Time* is so story oriented, the concept illustrations are designed with that in mind and drawn to resemble movie posters. The vertical symmetry of the illustrations below is modeled on the backs of playing cards.

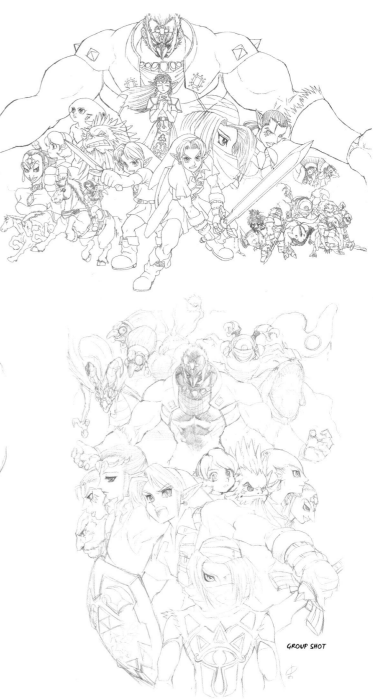

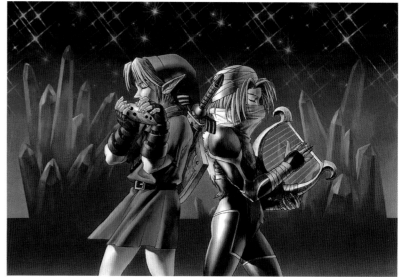

GROUP SHOT

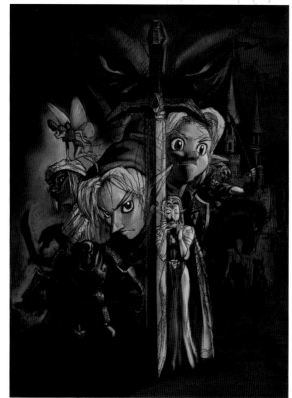

THE LEGEND OF ZELDA
MAJORA'S MASK

Design sketches

Only Child Link appears in *Majora's Mask*, but, for some reason, there are illustrations for Adult Link. Perhaps they were prototypes of Fierce Deity Link, who appears in the final game.

LINK

GORON LINK

Design sketches

HIS BACK IS MADE OF ROCK.

LINK

DEKU LINK

Design sketches

ZORA LINK

Design sketches

RECESSED?

SKULL KID

GROUP SHOT
An illustration that emphasizes shadow, capturing the dark atmosphere of *Majora's Mask*. It was used on the interior packaging of the Japanese game.

WHO IS TINGLE?

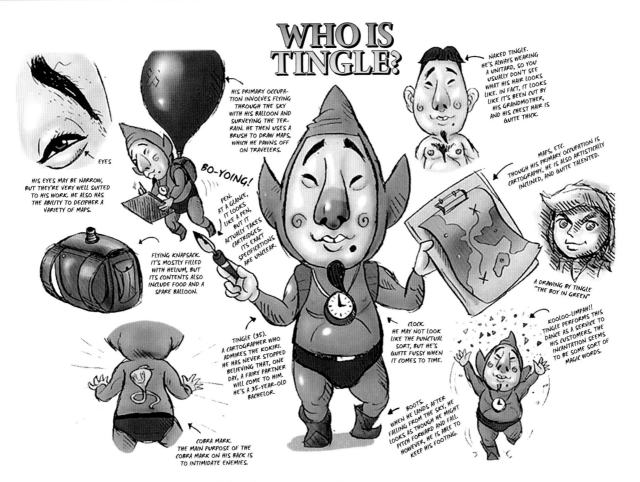

EYES

HIS EYES MAY BE NARROW, BUT THEY'RE VERY WELL SUITED TO HIS WORK. HE ALSO HAS THE ABILITY TO DECIPHER A VARIETY OF MAPS.

HIS PRIMARY OCCUPATION INVOLVES FLYING THROUGH THE SKY WITH HIS BALLOON AND SURVEYING THE TERRAIN. HE THEN USES A BRUSH TO DRAW MAPS, WHICH HE PAWNS OFF ON TRAVELERS.

NAKED TINGLE. HE'S ALWAYS WEARING A UNITARD, SO YOU USUALLY DON'T SEE WHAT HIS HAIR LOOKS LIKE. IN FACT, IT LOOKS LIKE IT'S BEEN CUT BY HIS GRANDMOTHER, AND HIS CHEST HAIR IS QUITE THICK.

BO-YOING!

PEN. AT A GLANCE, IT LOOKS LIKE A PEN, BUT IT ACTUALLY TAKES CARTRIDGES. ITS EXACT SPECIFICATIONS ARE UNCLEAR.

FLYING KNAPSACK. IT'S MOSTLY FILLED WITH HELIUM, BUT ITS CONTENTS ALSO INCLUDE FOOD AND A SPARE BALLOON.

MAPS, ETC. THOUGH HIS PRIMARY OCCUPATION IS CARTOGRAPHY, HE IS ALSO ARTISTICALLY INCLINED, AND QUITE TALENTED.

A DRAWING BY TINGLE "THE BOY IN GREEN"

TINGLE (35). A CARTOGRAPHER WHO ADMIRES THE KOKIRI. HE HAS NEVER STOPPED BELIEVING THAT, ONE DAY, A FAIRY PARTNER WILL COME TO HIM. HE'S A 35-YEAR-OLD BACHELOR.

CLOCK. HE MAY NOT LOOK LIKE THE PUNCTUAL SORT, BUT HE'S QUITE FUSSY WHEN IT COMES TO TIME.

KOOLOO-LIMPAH!! TINGLE PERFORMS THIS DANCE AS A SERVICE TO HIS CUSTOMERS. THE INCANTATION SEEMS TO BE SOME SORT OF MAGIC WORDS.

BOOTS. WHEN HE LANDS AFTER FALLING FROM THE SKY, HE LOOKS AS THOUGH HE MIGHT PITCH FORWARD AND FALL. HOWEVER, HE IS ABLE TO KEEP HIS FOOTING.

COBRA MARK. THE MAIN PURPOSE OF THE COBRA MARK ON HIS BACK IS TO INTIMIDATE ENEMIES.

TINGLE

A ton of detail was put into this character, from the shape of his hair to the items he carries, and even his eyesight. One can sense an unparalleled love for Tingle!

CONCEPT ART

An illustration depicting a town of mask-wearing inhabitants. These masks would later evolve into designs for *Majora's Mask*.

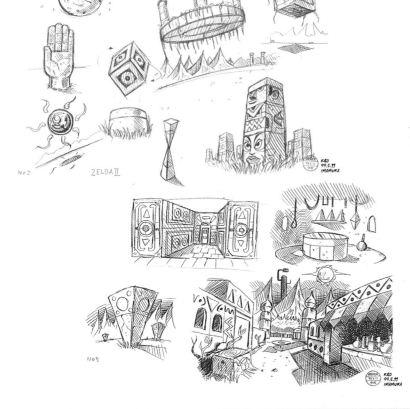

THE LEGEND OF ZELDA
the Wind Waker

This version of Link is characterized by his large eyes. Given that eye movement was to be emphasized in the game, his eyebrows came to be drawn on top of his bangs.

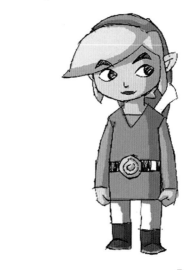

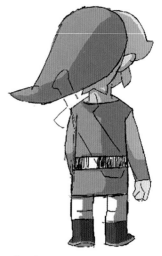

In this drawing, Link has a smaller head-to-body ratio, far removed from his final design. It would have been interesting to see this version of Link rendered in a cel-shaded style.

Design sketches

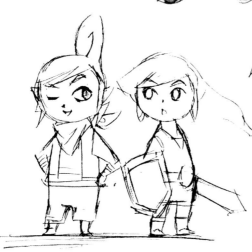

Link strikes a determined pose, with Tetra and the girls at his back (and an additional character at his side . . .).

Tetra is characterized by the swirl of her hair. The hairstyle was chosen to match the design of the wind and smoke that appear in the game.

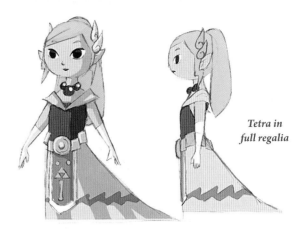

Tetra in full regalia

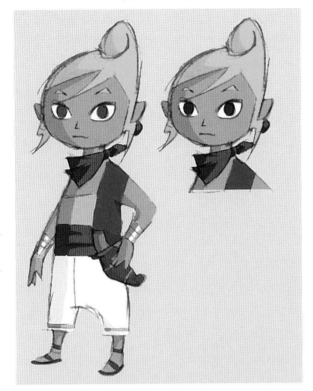

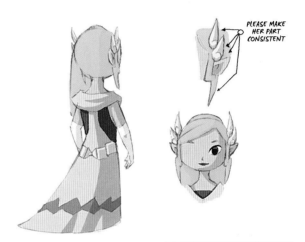

PLEASE MAKE HER PART CONSISTENT

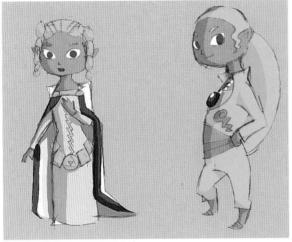

Design sketches

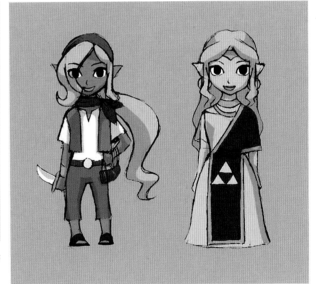

Tetra and her pirate underlings, dressed in a style of clothing that evokes the South. Could that be Gonzo, standing beside her and holding an ax? Or Senza, perhaps?

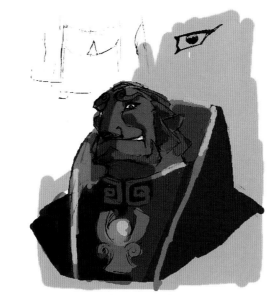

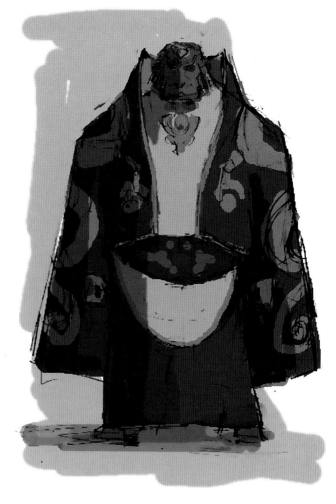

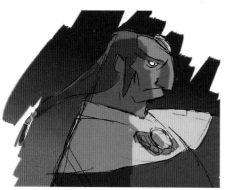

GANONDORF

Ganondorf has gotten older since his appearance in *Ocarina of Time*. He now looks middle aged. These drawings have an Eastern flavor to them.

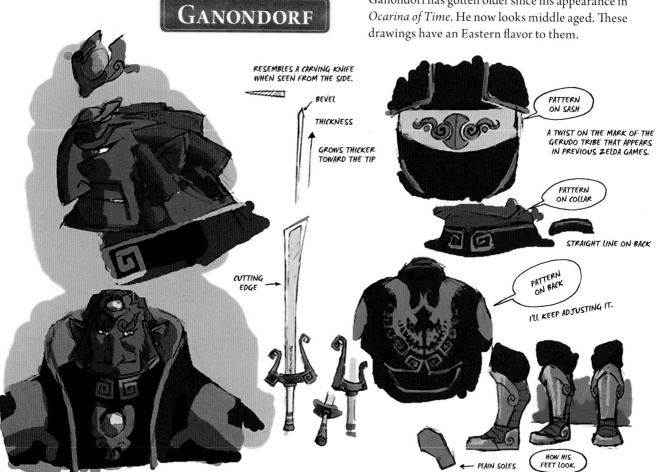

RESEMBLES A CARVING KNIFE WHEN SEEN FROM THE SIDE.

BEVEL

THICKNESS

GROWS THICKER TOWARD THE TIP

CUTTING EDGE

PATTERN ON SASH

A TWIST ON THE MARK OF THE GERUDO TRIBE THAT APPEARS IN PREVIOUS ZELDA GAMES.

PATTERN ON COLLAR

STRAIGHT LINE ON BACK

PATTERN ON BACK

I'LL KEEP ADJUSTING IT.

PLAIN SOLES

HOW HIS FEET LOOK.

KING OF RED LIONS

King of Red Lions was originally designed to appear as though he was handcrafted out of wood. Ultimately, a more Eastern style was emphasized in his look.

ZEPHOS & CYCLOS

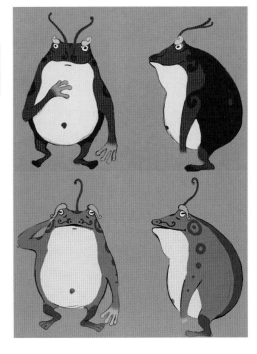

TETRA'S UNDERLINGS

A design sketch depicting Tetra's pirate underlings. One can assume from his blue bandanna and short stature that the person on the left is Niko.

DEKU TREE

IS THIS WHAT YOU DESIRE?

HRMM...

THEN COME UP HERE AND GET IT.

This piece of concept art shows the Deku Tree presenting Link with the Deku Leaf. His final design bears a closer resemblance to the Deku Tree in *Ocarina of Time*.

FISHMAN

LENZO

PICTOGRAPH MAN

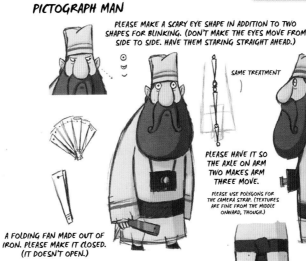

PLEASE MAKE A SCARY EYE SHAPE IN ADDITION TO TWO SHAPES FOR BLINKING. (DON'T MAKE THE EYES MOVE FROM SIDE TO SIDE. HAVE THEM STARING STRAIGHT AHEAD.)

SAME TREATMENT

PLEASE HAVE IT SO THE AXLE ON ARM TWO MAKES ARM THREE MOVE.

PLEASE USE POLYGONS FOR THE CAMERA STRAP. (TEXTURES ARE FINE FROM THE MIDDLE ONWARD, THOUGH.)

A FOLDING FAN MADE OUT OF IRON. PLEASE MAKE IT CLOSED. (IT DOESN'T OPEN.)

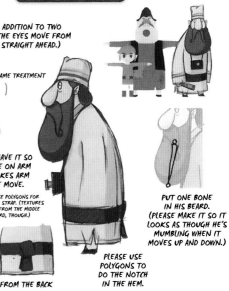

PUT ONE BONE IN HIS BEARD. (PLEASE MAKE IT SO IT LOOKS AS THOUGH HE'S MUMBLING WHEN IT MOVES UP AND DOWN.)

FROM THE BACK

PLEASE USE POLYGONS TO DO THE NOTCH IN THE HEM.

KOROK TRIBE

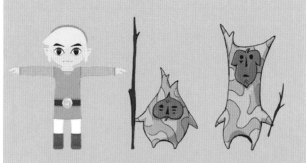

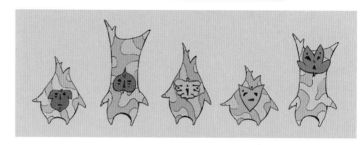

RITO TRIBE

Design sketches

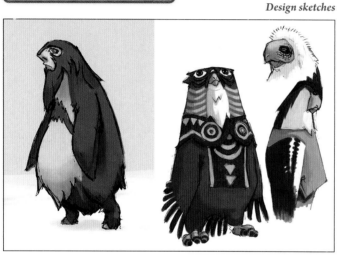

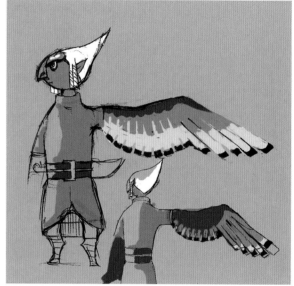

MALE →

FEMALE

THE CHILDREN HAVE ROUND BOTTOMS, OF COURSE.

ALWAYS ANGRY

WHEN THEY GET ANGRY, THEY BOUNCE AROUND.

IF YOU LOOK CAREFULLY, YOU'LL SEE THAT THERE ARE CHILDREN HIDDEN IN THEIR FUR.

THE CHILDREN REMAIN THERE UNTIL THEIR OWN FUR GROWS.

HEH HEH HEH... YOU INTEND TO CLIMB THE MOUNTAIN, YOU SAY? A HA HA ... NOW, THAT'S A LAUGH!

TALKING PEA PEOPLE

DROPS DOWN FROM THE TREETOP AND BEGINS TO SPEAK

As the design sketches indicate, the wings of the Rito were smaller in early development. However, once it became necessary for them to fly to various places, their design was changed to emphasize their wings. The two pictures at the bottom are design sketches for unused races that never made it into the game.

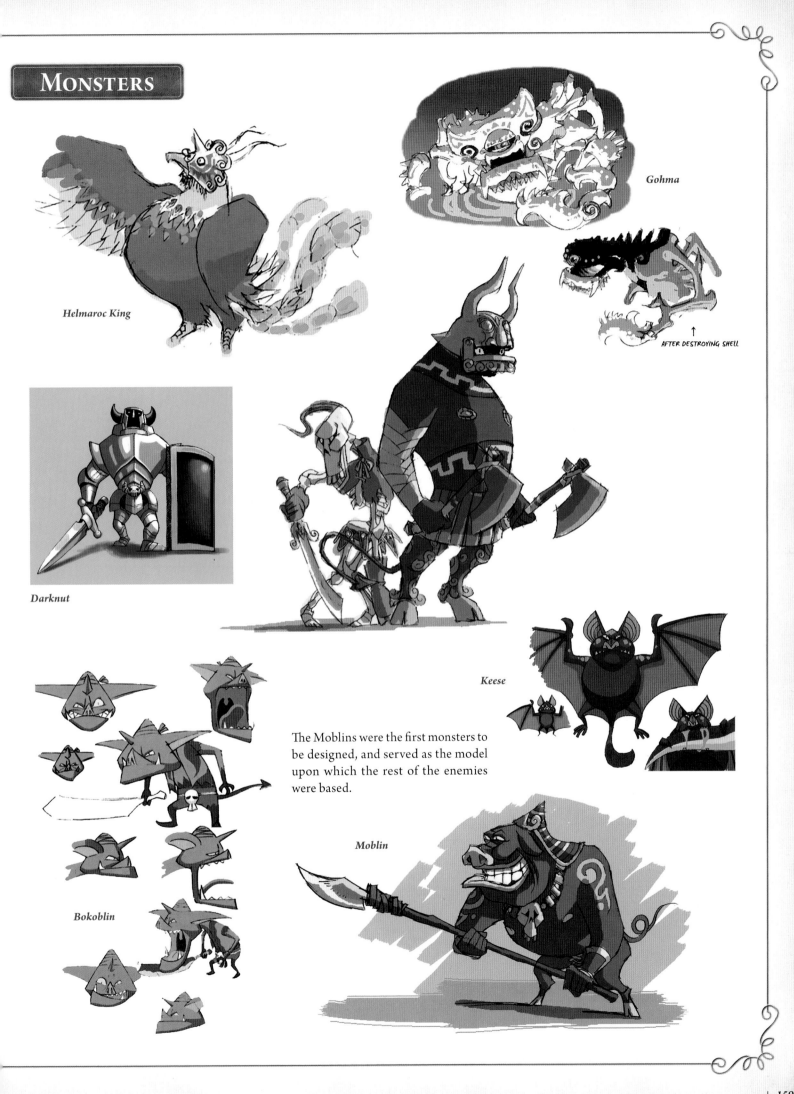

MONSTERS

Gohma

Helmaroc King

AFTER DESTROYING SHELL

Darknut

Keese

Darknut

The Moblins were the first monsters to be designed, and served as the model upon which the rest of the enemies were based.

Moblin

Bokoblin

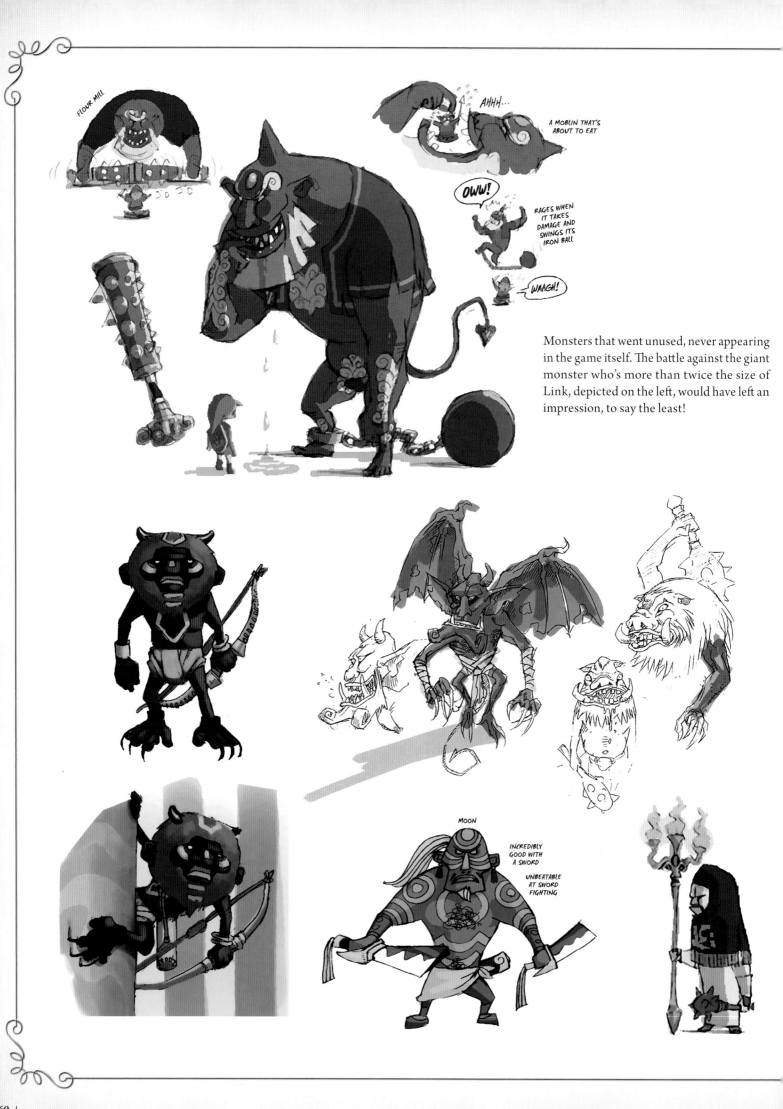

FLOUR MILL

AHHH...

A MOBLIN THAT'S ABOUT TO EAT

OWW!

RAGES WHEN IT TAKES DAMAGE AND SWINGS ITS IRON BALL

WAAGH!

Monsters that went unused, never appearing in the game itself. The battle against the giant monster who's more than twice the size of Link, depicted on the left, would have left an impression, to say the least!

MOON

INCREDIBLY GOOD WITH A SWORD

UNBEATABLE AT SWORD FIGHTING

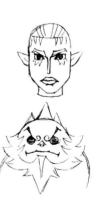

STAINED GLASS

The stained glass that decorates the walls of Hyrule Castle. The windows depict the six sages of *Ocarina of Time*, in addition to Ganon and the Triforce. Take a look at the crests of the six sages, as well.

CAFE LIGHTHOUSE
PICTOGRAPH SHOP SINKING SHIPS GAME
HOUSE OF WEALTH
CAFE
BAR
PICTOGRAPH SHOP HOUSE OF WEALTH 1
SCHOOL OF JOY HOUSE OF WEALTH 2
BOMB SHOP HOUSEBOAT
BOMB SHOP

WINDFALL ISLAND

FORSAKEN FORTRESS
The first illustration of the Forsaken Fortress. The design has been faithfully reproduced in the game.

HYRULE CASTLE

CONCEPT ART

Hyrule Castle
A beautiful white castle that rises from the surface of a lake. Because of its resemblance to a great white bird unfolding its wings, it is also known as the "Swan Castle."

STOVEPIPE ISLAND AND GC ISLAND
Island concept sketches. The motif for GC Island is the Nintendo GameCube. Neither of these islands appears in the game.

ENTER FROM HERE?

(CAVE)

(HOT SPRING LAKE)

STOVEPIPE ISLAND
AN ISLAND OF STEAM AND SMOKE.

(MAGMA VALLEY)

EVERYONE LIKES TOBACCO

GC ISLAND

Concept sketches depicting areas that were never used in the game, including an underwater scene. Only Jabun, the sea creature at the lower right that resembles a giant anglerfish and lives on the far side of Outset Island, is seen in the game.

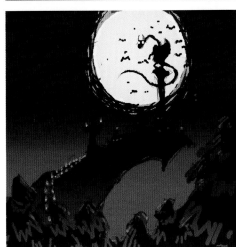

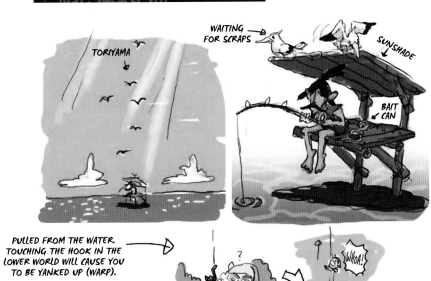

TORIYAMA

WAITING FOR SCRAPS

SUNSHADE

BAIT CAN

PULLED FROM THE WATER TOUCHING THE HOOK IN THE LOWER WORLD WILL CAUSE YOU TO BE YANKED UP (WARP).

WHOA!

HOW ABOUT USING A FISHHOOK AS A WARP ITEM?

TSK... MORE GARBAGE?

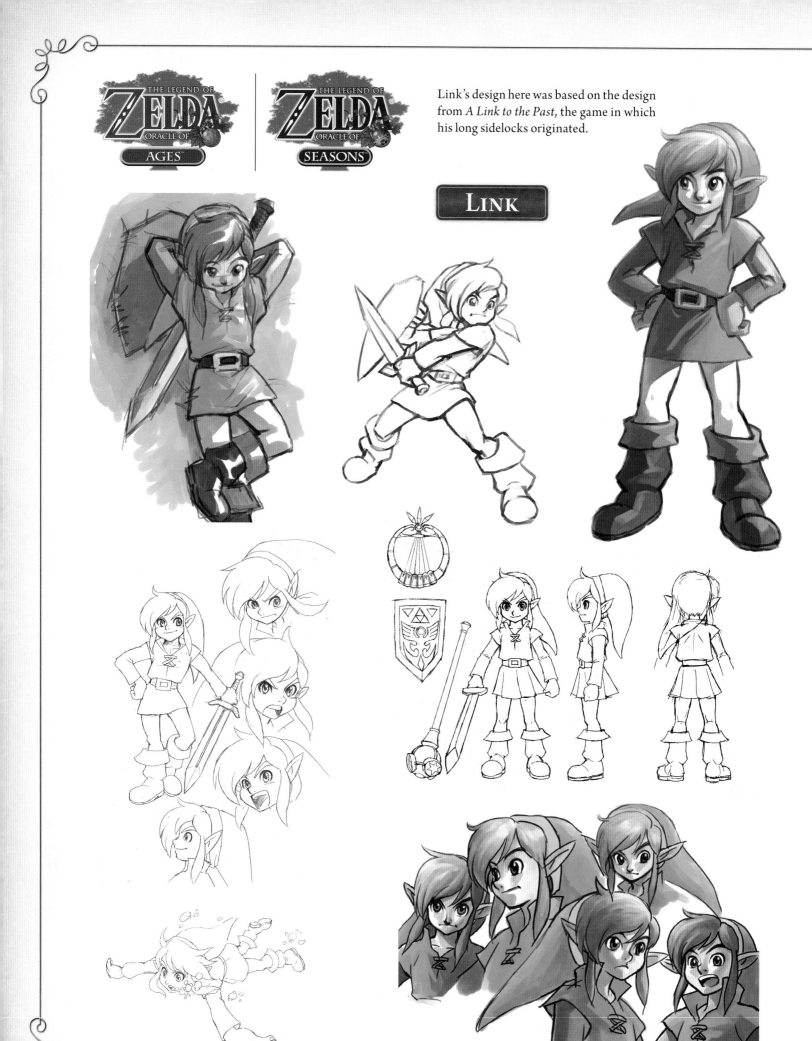

Link's design here was based on the design from *A Link to the Past*, the game in which his long sidelocks originated.

LINK

NAYRU

Nayru is occasionally depicted holding a brush because in the early stages of development, there was an item called the Magic Paintbrush. It was created to make use of the Game Boy Color.

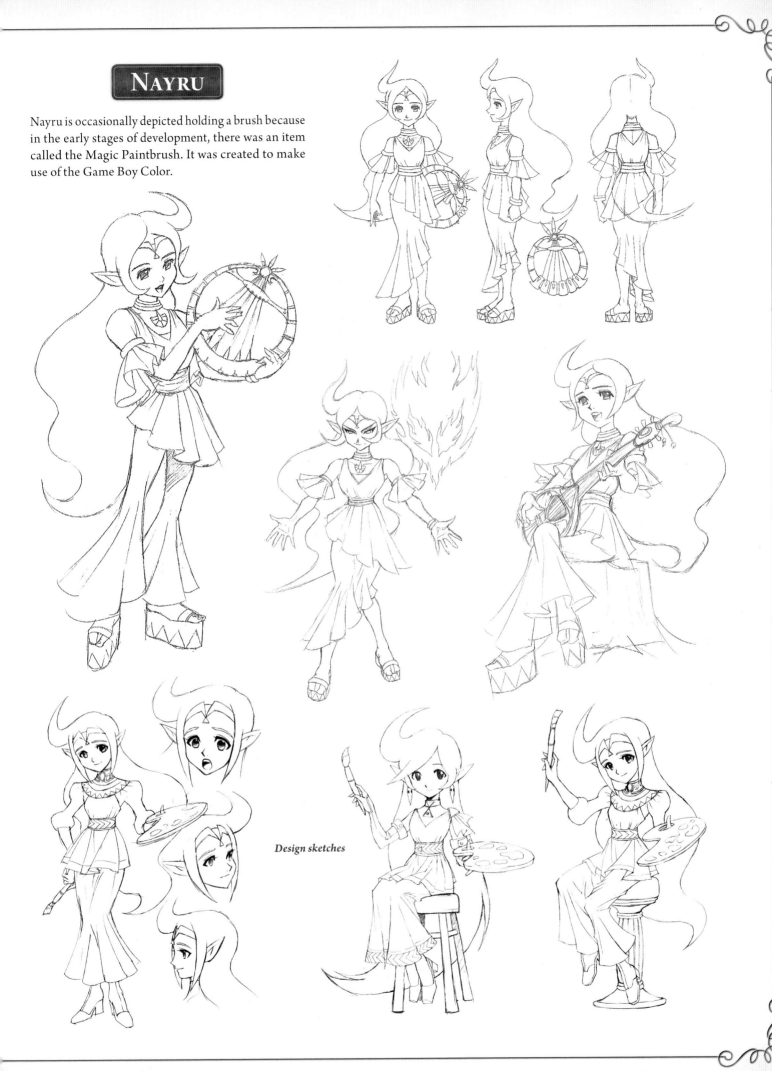

Design sketches

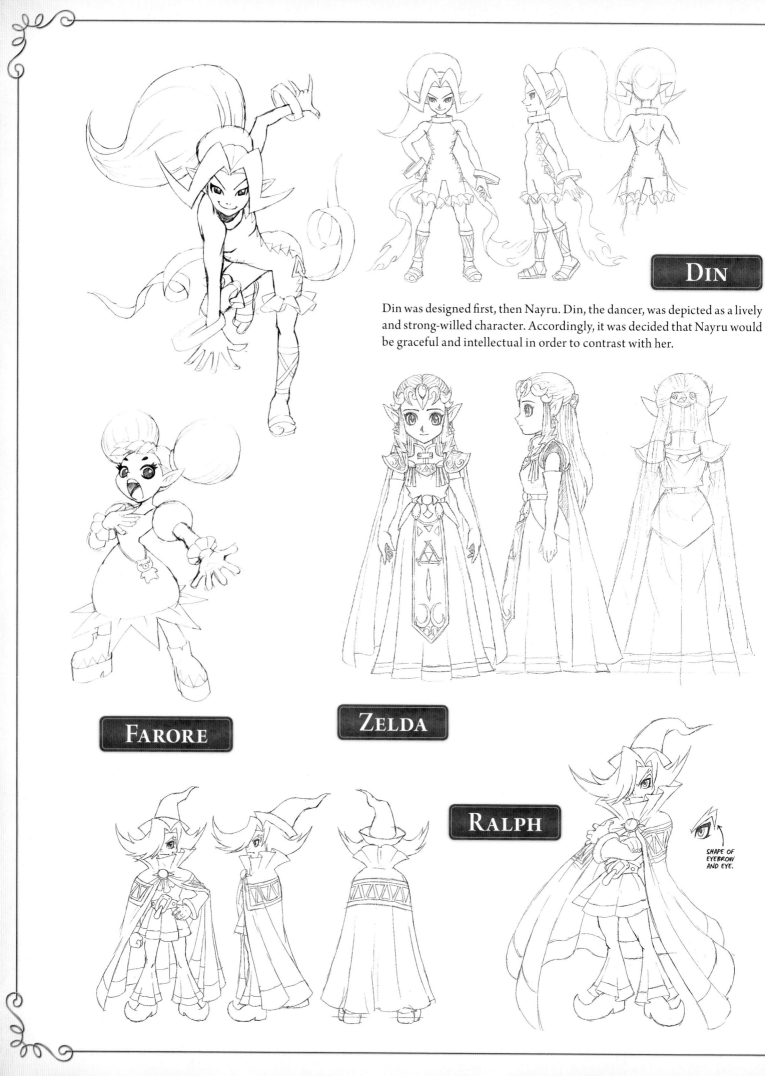

DIN

Din was designed first, then Nayru. Din, the dancer, was depicted as a lively and strong-willed character. Accordingly, it was decided that Nayru would be graceful and intellectual in order to contrast with her.

FARORE

ZELDA

RALPH

SHAPE OF EYEBROW AND EYE.

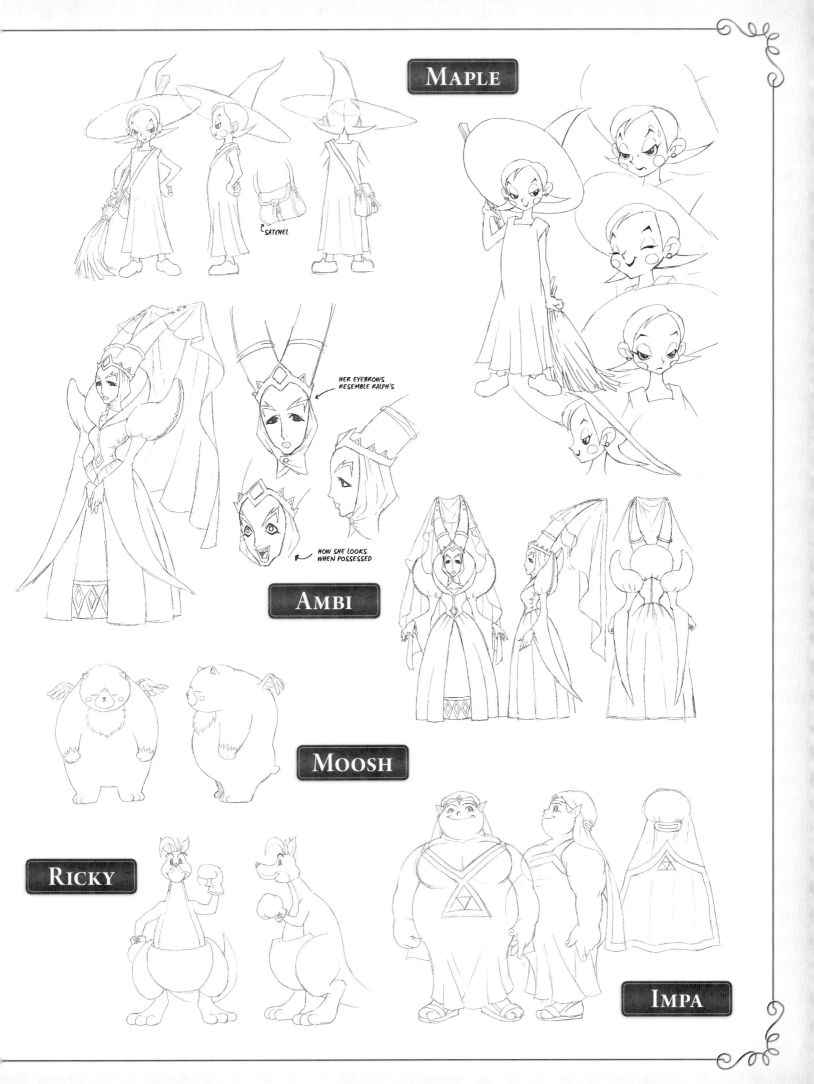

MAPLE

AMBI

HER EYEBROWS
RESEMBLE RALPH'S

HOW SHE LOOKS
WHEN POSSESSED

SATCHEL

MOOSH

RICKY

IMPA

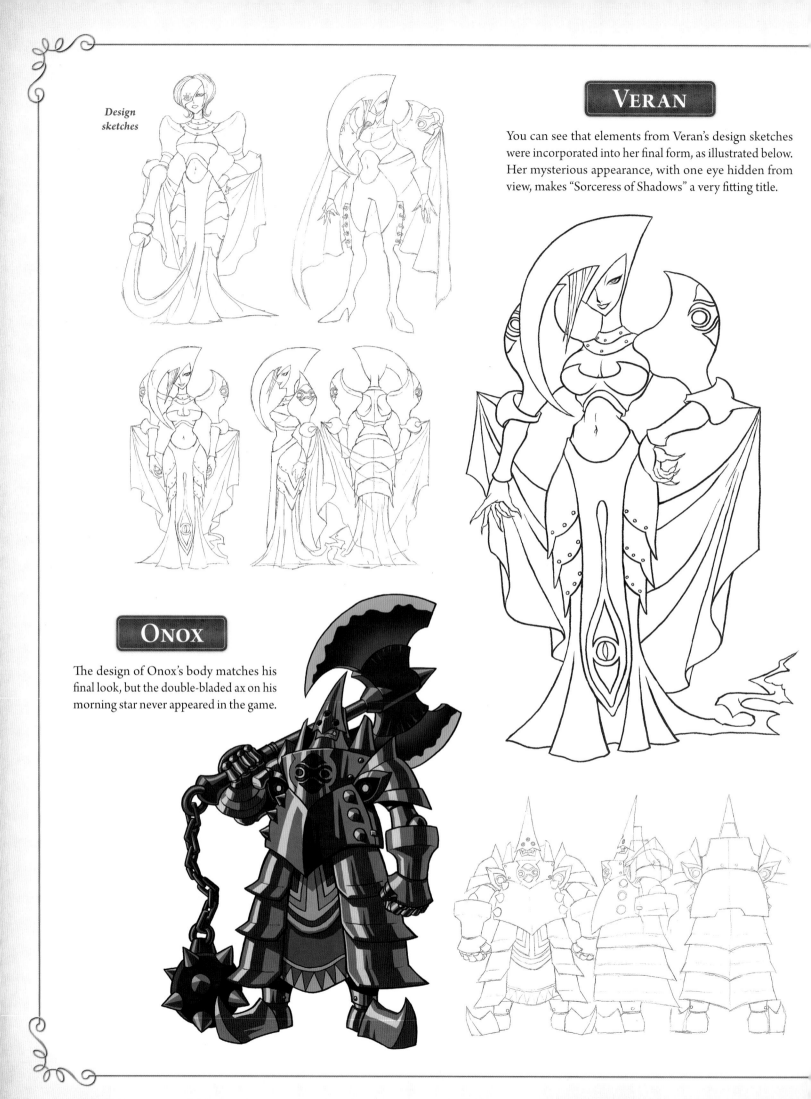

Design sketches

VERAN

You can see that elements from Veran's design sketches were incorporated into her final form, as illustrated below. Her mysterious appearance, with one eye hidden from view, makes "Sorceress of Shadows" a very fitting title.

ONOX

The design of Onox's body matches his final look, but the double-bladed ax on his morning star never appeared in the game.

GREAT MOBLIN

GANONDORF

A design sketch depicting Ganondorf's phantom. Ganondorf never appears in the *Oracle* series, however. Only his beast form, Ganon, is seen.

Oracle of Seasons

Oracle of Ages

CONCEPT ART

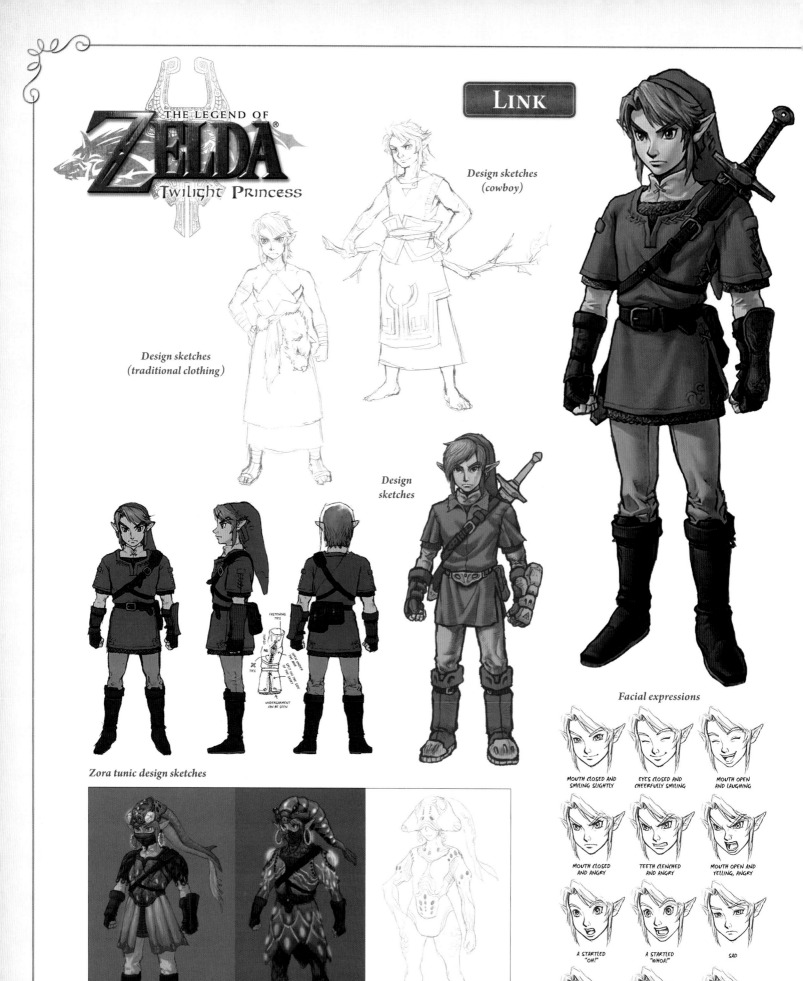

THE LEGEND OF ZELDA®
Twilight Princess

LINK

Design sketches (cowboy)

Design sketches (traditional clothing)

Design sketches

Facial expressions

MOUTH CLOSED AND SMILING SLIGHTLY

EYES CLOSED AND CHEERFULLY SMILING

MOUTH OPEN AND LAUGHING

MOUTH CLOSED AND ANGRY

TEETH CLENCHED AND ANGRY

MOUTH OPEN AND YELLING, ANGRY

A STARTLED "OH!"

A STARTLED "WHOA!"

SAD

TROUBLED

PLAYING THE OCARINA

DEFAULT EXPRESSION

Zora tunic design sketches

FASTENING TIES

TIES

UNDERGARMENT CAN BE SEEN

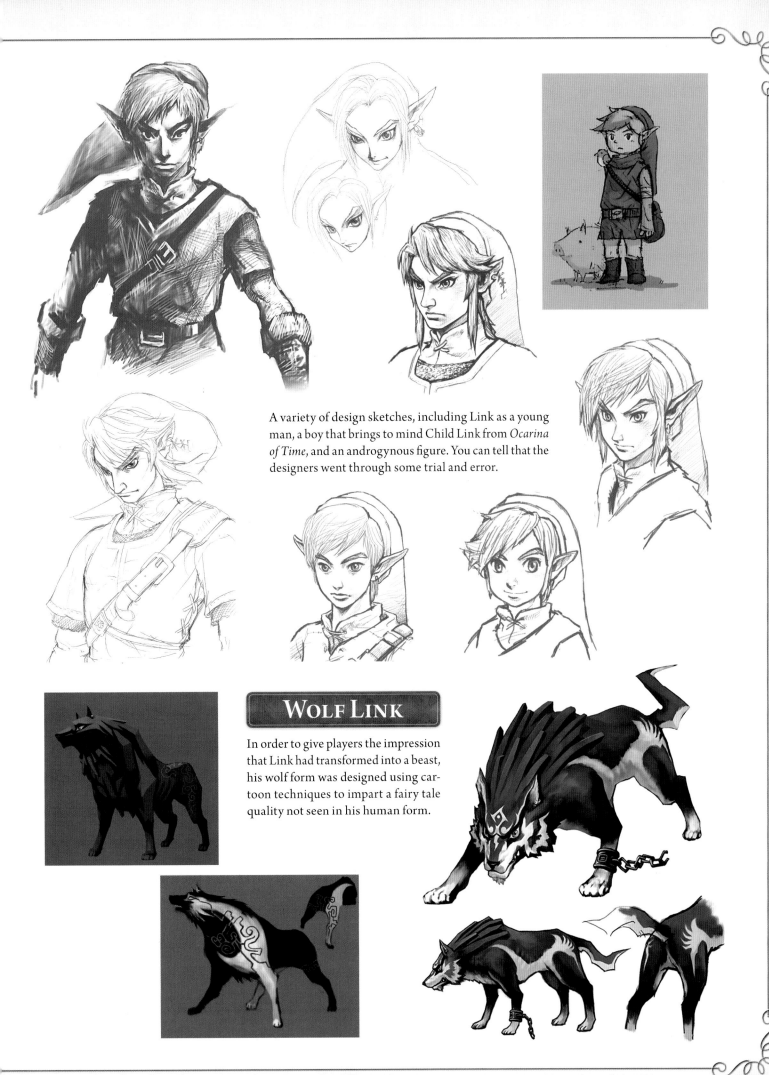

A variety of design sketches, including Link as a young man, a boy that brings to mind Child Link from *Ocarina of Time*, and an androgynous figure. You can tell that the designers went through some trial and error.

Wolf Link

In order to give players the impression that Link had transformed into a beast, his wolf form was designed using cartoon techniques to impart a fairy tale quality not seen in his human form.

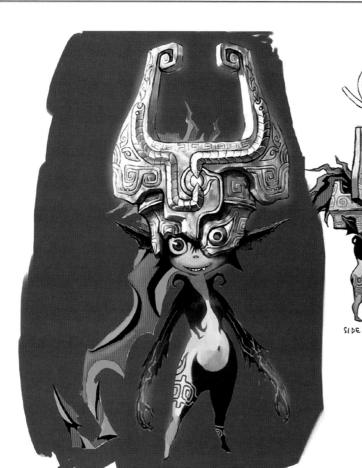

BACK CROWN, AS SEEN FROM ABOVE

FRONT

SIDE BACK

Facial expressions

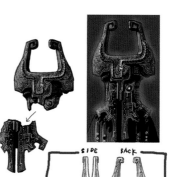

SIDE BACK

Fused Shadow

MIDNA'S TRUE FORM

Midna, as she appears after her true form is restored at the end of the game. If Zelda is a Western-style princess, Midna has the air of the Middle East about her.

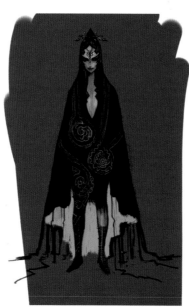

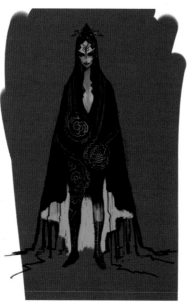

Design sketches (Midna's true form)

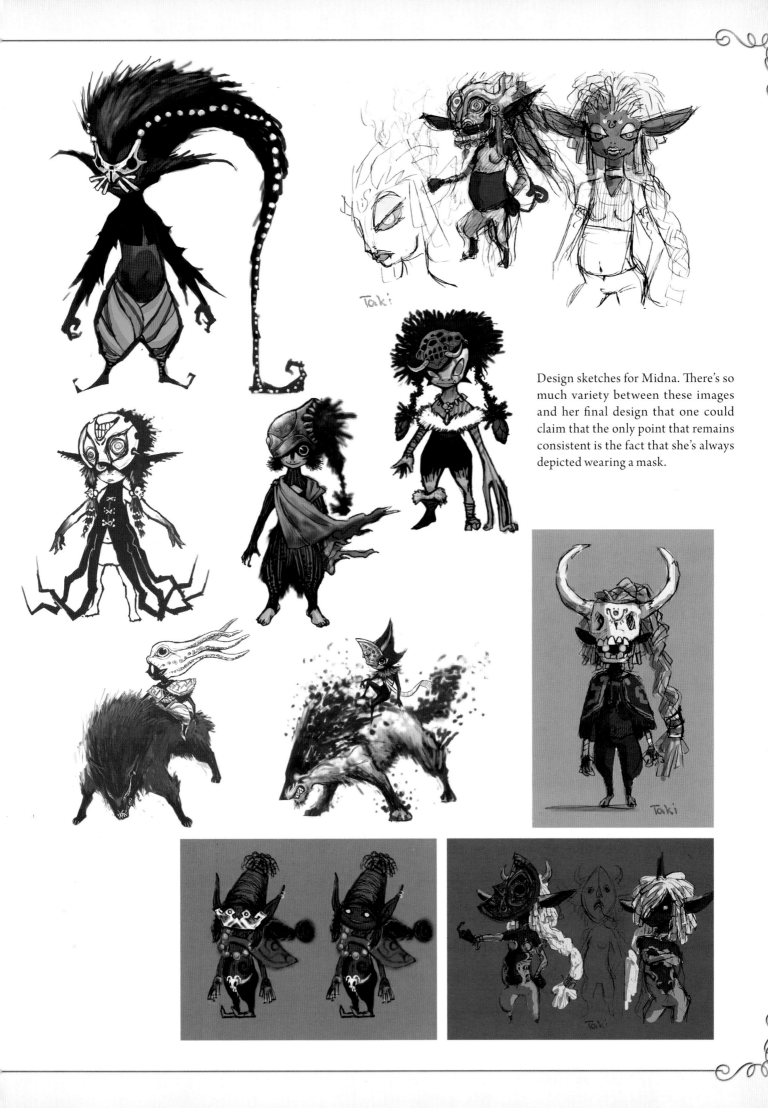

Design sketches for Midna. There's so much variety between these images and her final design that one could claim that the only point that remains consistent is the fact that she's always depicted wearing a mask.

ZELDA

Zelda was originally depicted wearing a robe that hid her expression. The pictures at the bottom right represent what Zelda from *Twilight Princess* would look like if she transformed into Sheik. They were drawn for *Super Smash Bros. Brawl*.

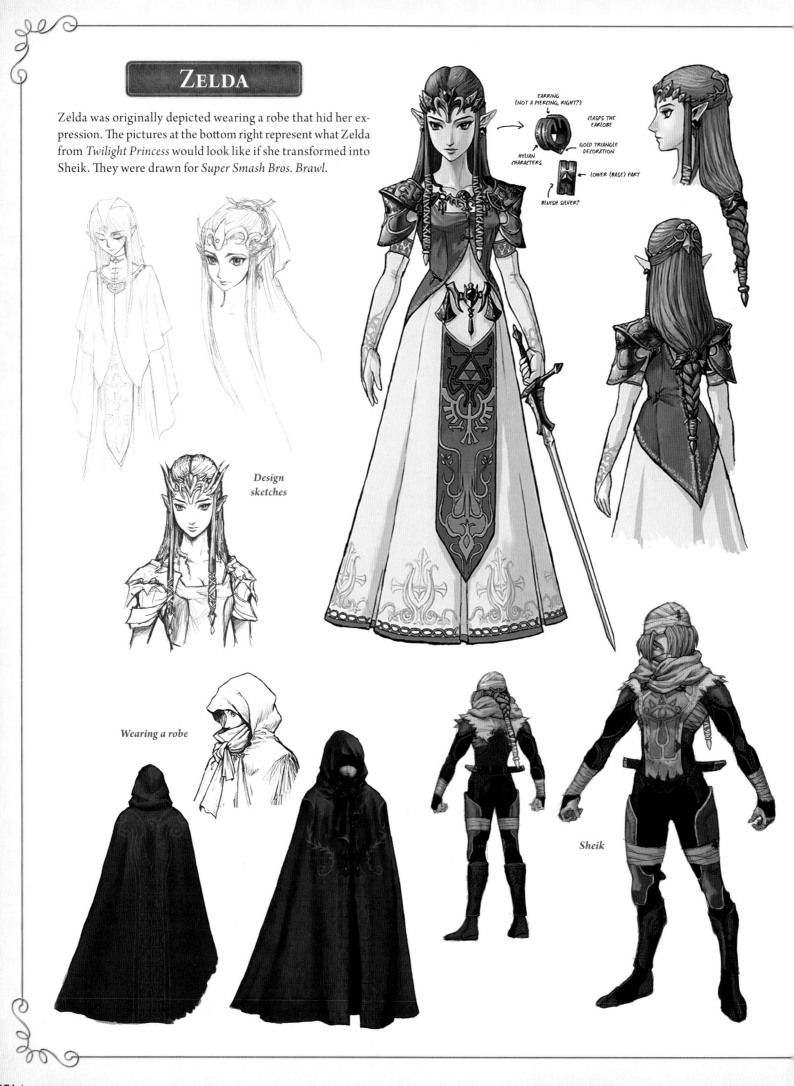

EARRING
(NOT A PIERCING, RIGHT?)

CLASPS THE
EARLOBE

GOLD TRIANGLE
DECORATION

HYLIAN
CHARACTERS

LOWER (BASE) PART

BLUISH SILVER?

Design sketches

Wearing a robe

Sheik

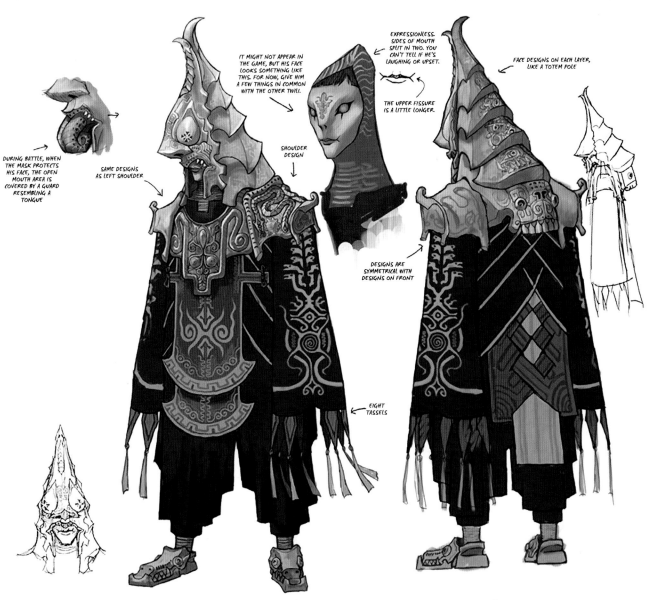

DURING BATTLE, WHEN THE MASK PROTECTS HIS FACE, THE OPEN MOUTH AREA IS COVERED BY A GUARD RESEMBLING A TONGUE

IT MIGHT NOT APPEAR IN THE GAME, BUT HIS FACE LOOKS SOMETHING LIKE THIS. FOR NOW, GIVE HIM A FEW THINGS IN COMMON WITH THE OTHER TWILI.

SAME DESIGNS AS LEFT SHOULDER

EXPRESSIONLESS. SIDES OF MOUTH SPLIT IN TWO. YOU CAN'T TELL IF HE'S LAUGHING OR UPSET.

THE UPPER FISSURE IS A LITTLE LONGER.

SHOULDER DESIGN

FACE DESIGNS ON EACH LAYER, LIKE A TOTEM POLE

DESIGNS ARE SYMMETRICAL WITH DESIGNS ON FRONT

EIGHT TASSELS

ZANT

During the early stages of the game, Zant appears as an unnerving persona encased in thick armor. When his true form is later unveiled, he gives off the strong impression of one whose cowardly ambition and madness have been exposed.

ZANT WITHOUT ARMOR

WHEN HE OPENS HIS MOUTH...

THE FISSURES ABOVE AND BELOW HIS MOUTH OPEN SUBTLY AS WELL

BAMBOO-SHOOT-STYLE COMBAT WEAPON
THE SS ZANT I

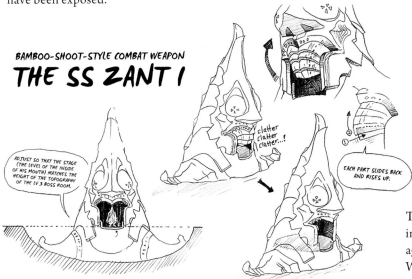

ADJUST SO THAT THE STAGE (THE LEVEL OF THE INSIDE OF HIS MOUTH) MATCHES THE HEIGHT OF THE TOPOGRAPHY OF THE LV 3 BOSS ROOM.

clatter clatter clatter....!

EACH PART SLIDES BACK AND RISES UP.

The illustration to the left is concept art for the shelter in the shape of Zant's face that appears during the battle against him. The moniker "Bamboo-Shoot-Style Combat Weapon," however . . .

GANONDORF

Though he was banished to the twilight by the sages in *Ocarina of Time*, Ganon lives again. Though the timeline he inhabits differs from that of *The Wind Waker*, he is drawn to be around the same age as the Ganondorf in that game.

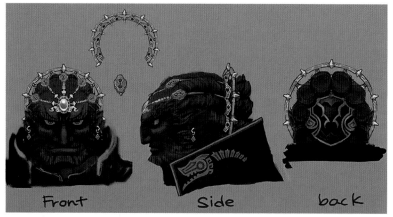

Front Side back

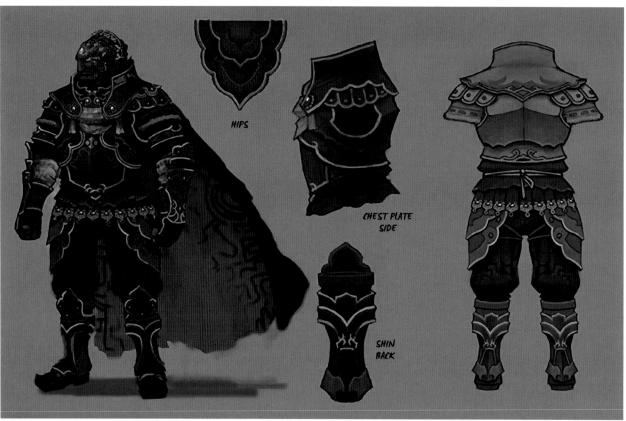

HIPS

CHEST PLATE SIDE

SHIN BACK

Ganondorf's horse

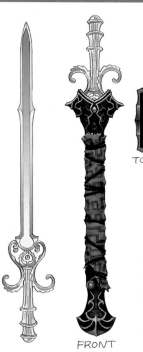

TOP

FRONT

GANONDORF'S SWORD
Ganondorf's sword is the same blade that was used by the sages in his own execution. In a flashback scene, it is seen to pierce right through him.

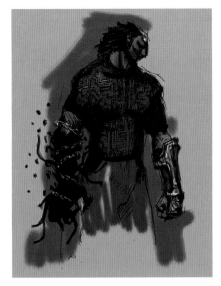

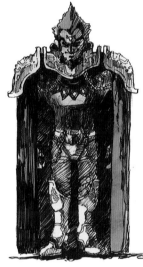

Design sketches

THE DEMONIC BEAST, GANON

The creature Ganondorf transforms into during the fight at Hyrule Castle. Perhaps the "Pig Ganon" caption on this piece of concept art was a nickname given to him by the staff?

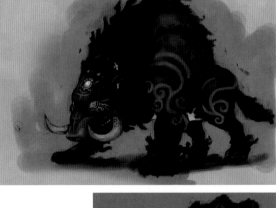

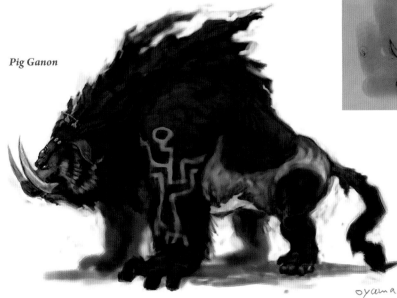

Pig Ganon

oyama

LIGHT SPIRITS

The spirits that watch over each corner of the land. In the game, they take on the form of animals, including deer and snakes. However, it seems as though the developers also considered making them humans with animal heads.

PATTERN RESEMBLES A PATH OF LIGHT. HAVE IT FLOW FROM THE TOP OF ITS HEAD TO THE TIP OF ITS TAIL

TAIL

LOOKS LIKE THIS WHEN SEEN FROM THE FRONT

SPIRIT - ORDON GOAT TYPE

FACE BROKEN LIKE A KINTARO CANDY

SPIRIT E IN KAKARIKO VILLAGE
BIRD

front face

perse partu

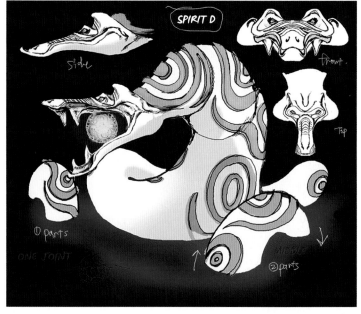

SPIRIT D

side

front

Top

① parts

ONE JOINT

MIDDLE
② parts

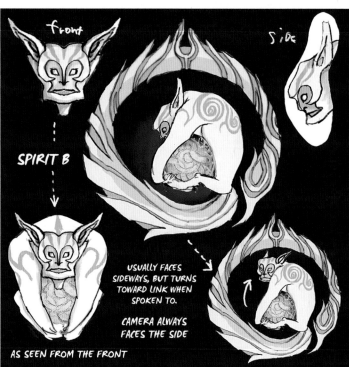

front

side

SPIRIT B

USUALLY FACES SIDEWAYS, BUT TURNS TOWARD LINK WHEN SPOKEN TO.

CAMERA ALWAYS FACES THE SIDE

AS SEEN FROM THE FRONT

SAGES

The design sketches seen at right were originally concept art for Rauru. Though his face is hidden behind a mask, his body retains vestiges of the sage.

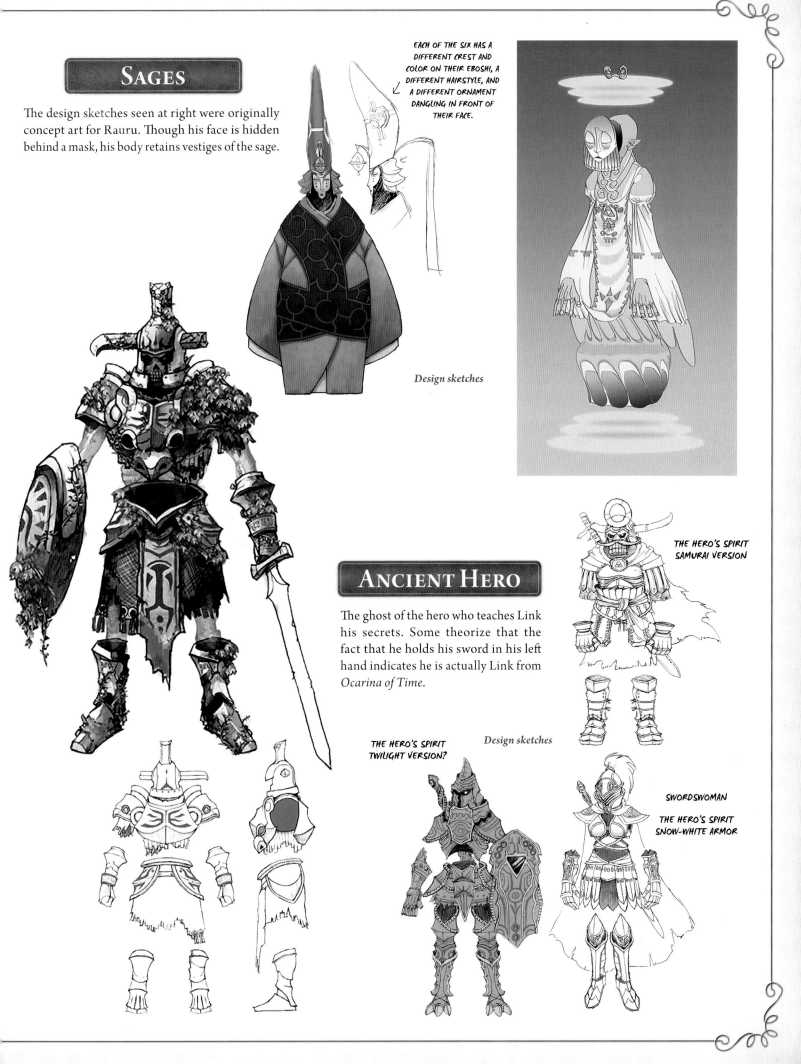

EACH OF THE SIX HAS A DIFFERENT CREST AND COLOR ON THEIR EBOSHI, A DIFFERENT HAIRSTYLE, AND A DIFFERENT ORNAMENT DANGLING IN FRONT OF THEIR FACE.

Design sketches

ANCIENT HERO

The ghost of the hero who teaches Link his secrets. Some theorize that the fact that he holds his sword in his left hand indicates he is actually Link from *Ocarina of Time*.

THE HERO'S SPIRIT SAMURAI VERSION

THE HERO'S SPIRIT TWILIGHT VERSION?

Design sketches

SWORDSWOMAN

THE HERO'S SPIRIT SNOW-WHITE ARMOR

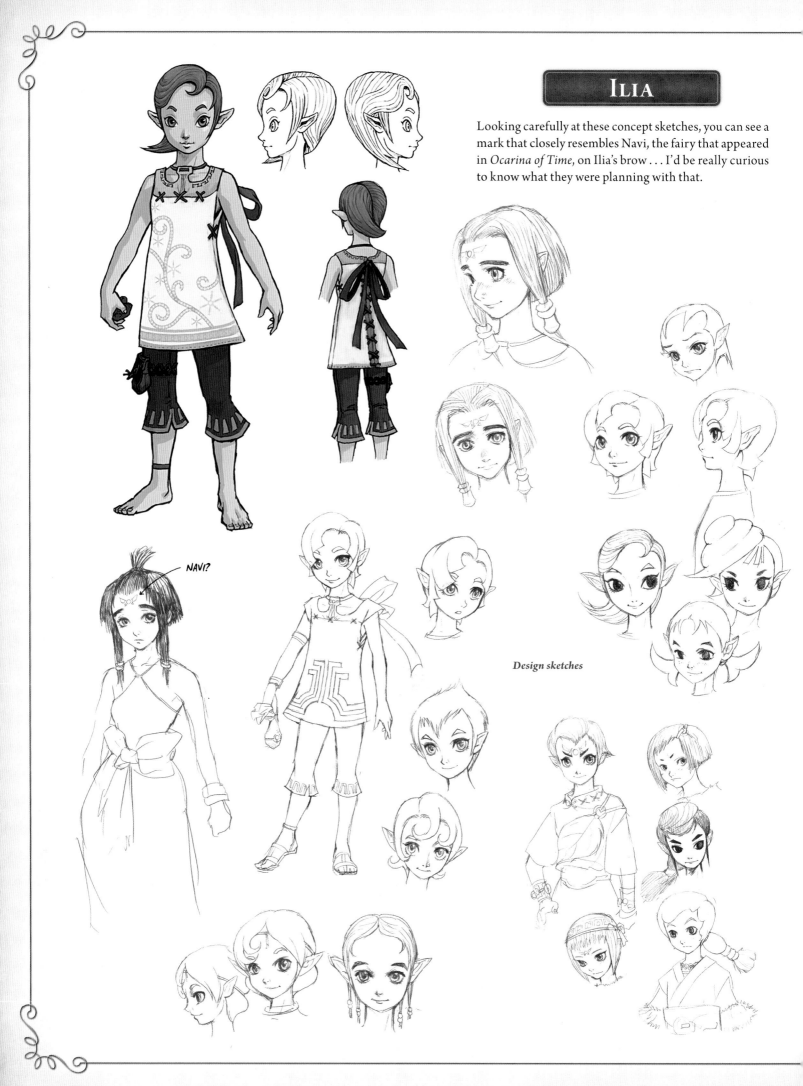

ILIA

Looking carefully at these concept sketches, you can see a mark that closely resembles Navi, the fairy that appeared in *Ocarina of Time*, on Ilia's brow . . . I'd be really curious to know what they were planning with that.

NAVI?

Design sketches

ORDON VILLAGERS

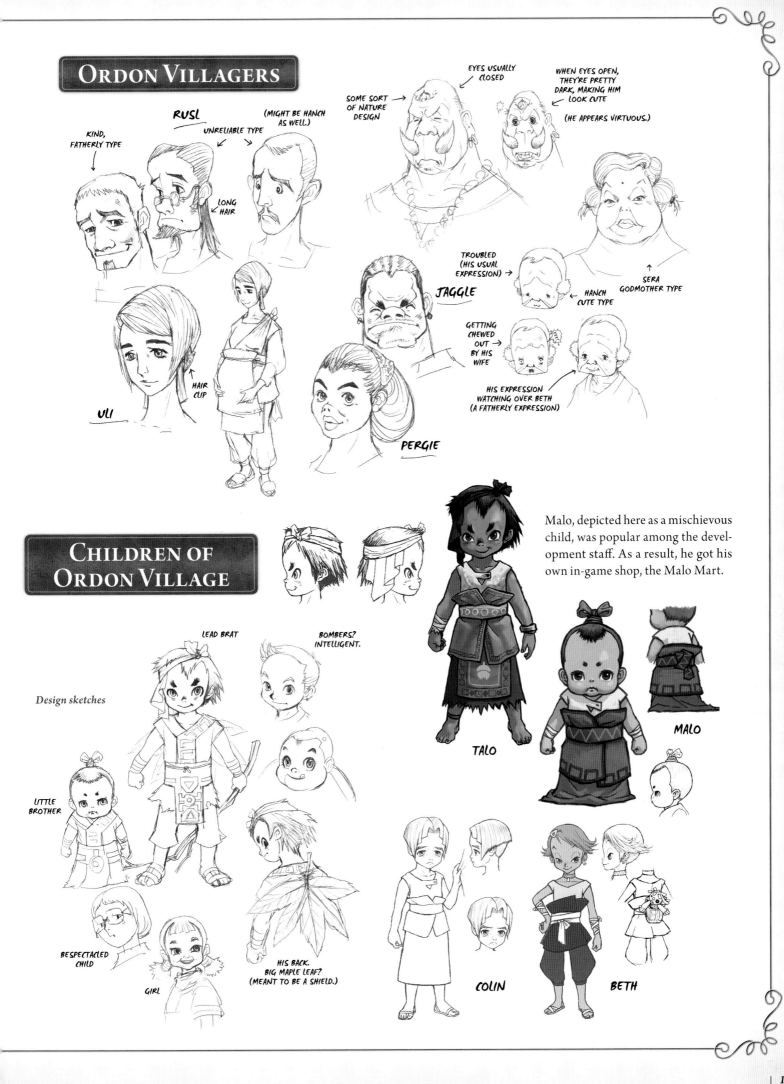

KIND,
FATHERLY TYPE

RUSL

UNRELIABLE TYPE

(MIGHT BE HANCH AS WELL.)

LONG
HAIR

HAIR
CLIP

ULI

EYES USUALLY
CLOSED

SOME SORT
OF NATURE
DESIGN

WHEN EYES OPEN,
THEY'RE PRETTY
DARK, MAKING HIM
LOOK CUTE

(HE APPEARS VIRTUOUS.)

TROUBLED
(HIS USUAL
EXPRESSION) →

JAGGLE

HANCH
CUTE TYPE

SERA
GODMOTHER TYPE

GETTING
CHEWED
OUT →
BY HIS
WIFE

HIS EXPRESSION
WATCHING OVER BETH
(A FATHERLY EXPRESSION)

PERGIE

CHILDREN OF ORDON VILLAGE

Malo, depicted here as a mischievous child, was popular among the development staff. As a result, he got his own in-game shop, the Malo Mart.

TALO

MALO

Design sketches

LEAD BRAT

BOMBERS?
INTELLIGENT.

LITTLE
BROTHER

BESPECTACLED
CHILD

GIRL

HIS BACK.
BIG MAPLE LEAF?
(MEANT TO BE A SHIELD.)

COLIN

BETH

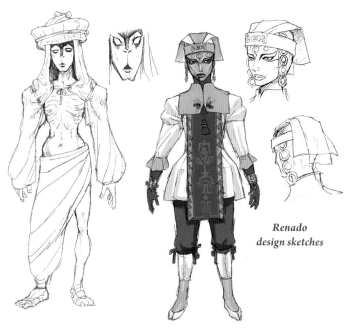

*Renado
design sketches*

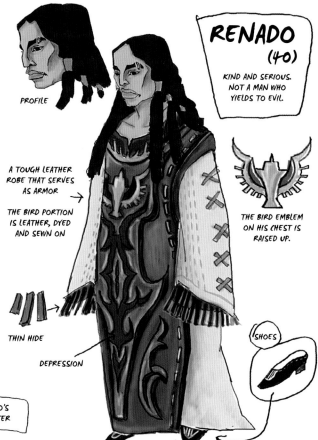

RENADO
(40)

KIND AND SERIOUS.
NOT A MAN WHO
YIELDS TO EVIL.

A TOUGH LEATHER
ROBE THAT SERVES
AS ARMOR →

THE BIRD PORTION
IS LEATHER, DYED
AND SEWN ON

THE BIRD EMBLEM
ON HIS CHEST IS
RAISED UP.

THIN HIDE

DEPRESSION

SHOES

PROFILE

LUDA (15) RENADO'S
DAUGHTER

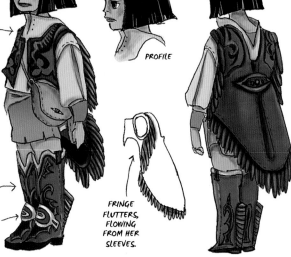

THE BAG IS SEWN ONTO
A SINGLE STRIP OF
LEATHER. IT CONTAINS
MEDICINE. IT'S LOW
QUALITY AND DIRTY.

WHITE
STONE

THE PATTERN IS
MADE OF DYED
LEATHER, SEWN ON. →

A THIN, ROLLED-UP
HANDKERCHIEF →

PROFILE

THESE ARE
HER KNEES →

MADE OF METAL →

FRINGE
FLUTTERS,
FLOWING
FROM HER
SLEEVES.

PARENT AND CHILD

Renado and his daughter, Luda. Their appearances,
reminiscent of Native Americans, are well suited to
the village of Kakariko, which wouldn't look out of
place in a western movie.

BARNES

There are many design sketches
of Barnes, who runs the Bomb
Shop. All of them depict a tired
old man.

Design sketches

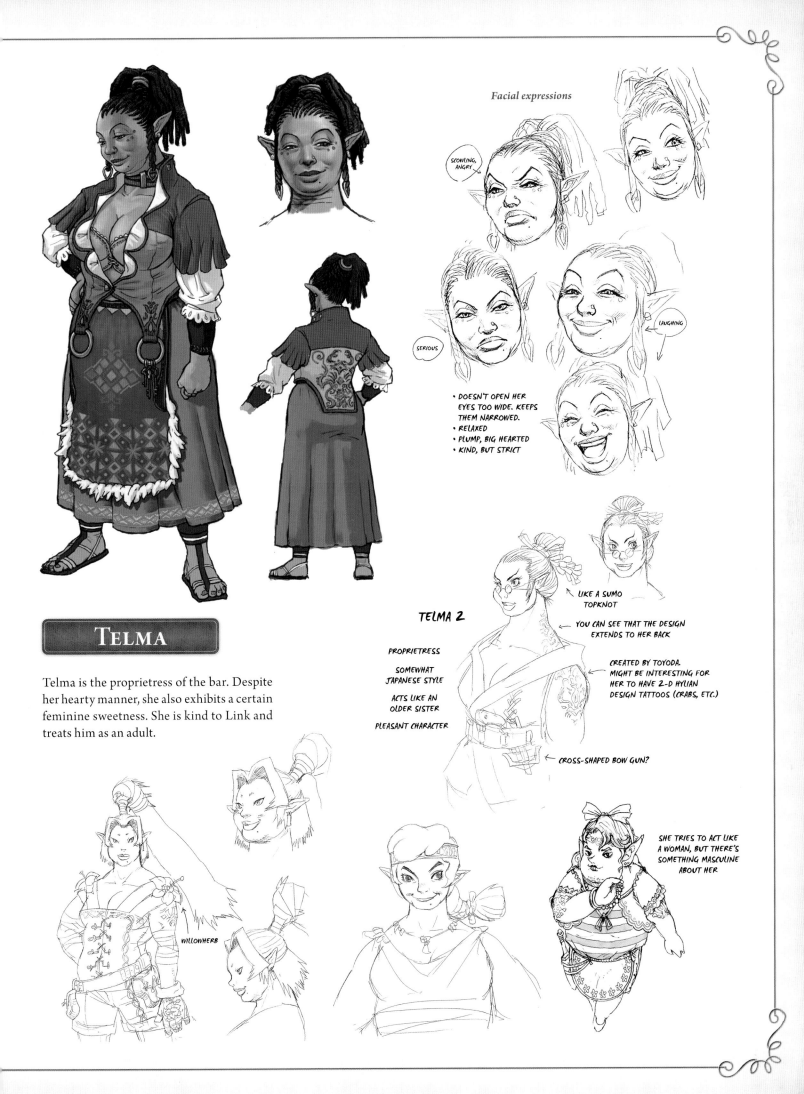

Facial expressions

SCOWLING, ANGRY

SERIOUS

LAUGHING

- DOESN'T OPEN HER EYES TOO WIDE. KEEPS THEM NARROWED.
- RELAXED
- PLUMP, BIG HEARTED
- KIND, BUT STRICT

TELMA

Telma is the proprietress of the bar. Despite her hearty manner, she also exhibits a certain feminine sweetness. She is kind to Link and treats him as an adult.

TELMA 2

PROPRIETRESS

SOMEWHAT JAPANESE STYLE

ACTS LIKE AN OLDER SISTER

PLEASANT CHARACTER

LIKE A SUMO TOPKNOT

YOU CAN SEE THAT THE DESIGN EXTENDS TO HER BACK

CREATED BY TOYODA. MIGHT BE INTERESTING FOR HER TO HAVE 2-D HYLIAN DESIGN TATTOOS (CRABS, ETC.)

CROSS-SHAPED BOW GUN?

WILLOWHERB

SHE TRIES TO ACT LIKE A WOMAN, BUT THERE'S SOMETHING MASCULINE ABOUT HER

AURU

Auru's cannon

← FUSE

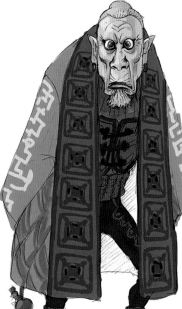

AURU

- KABUKI-STYLE GOGGLING, CROSSED EYES, LARGE FACIAL FEATURES

- COAT? HAORI? (PROTECTION FROM DUST CLOUDS?) TRAINS WITH A SHORT SWORD. AN IAIDO MASTER. STRONG.

- TURNS HIS HEAD QUICKLY. ONCE HE STARTS TALKING, HE NEVER STOPS

MIGHT BE GOOD TO HAVE HIM WEARING A CONICAL HAT AS PROTECTION FROM THE SAND

GLOVE

POUCH

BACK OF HAND

BACK

Rusl and his friends were called "The Resistance" by the developers. Of them, Auru was the character with the most concept art. It looks like they designed a macho version of Auru, as well.

AURU

NOW THEN, HERO...

A MACHO VERSION WAS ALSO DESIGNED...

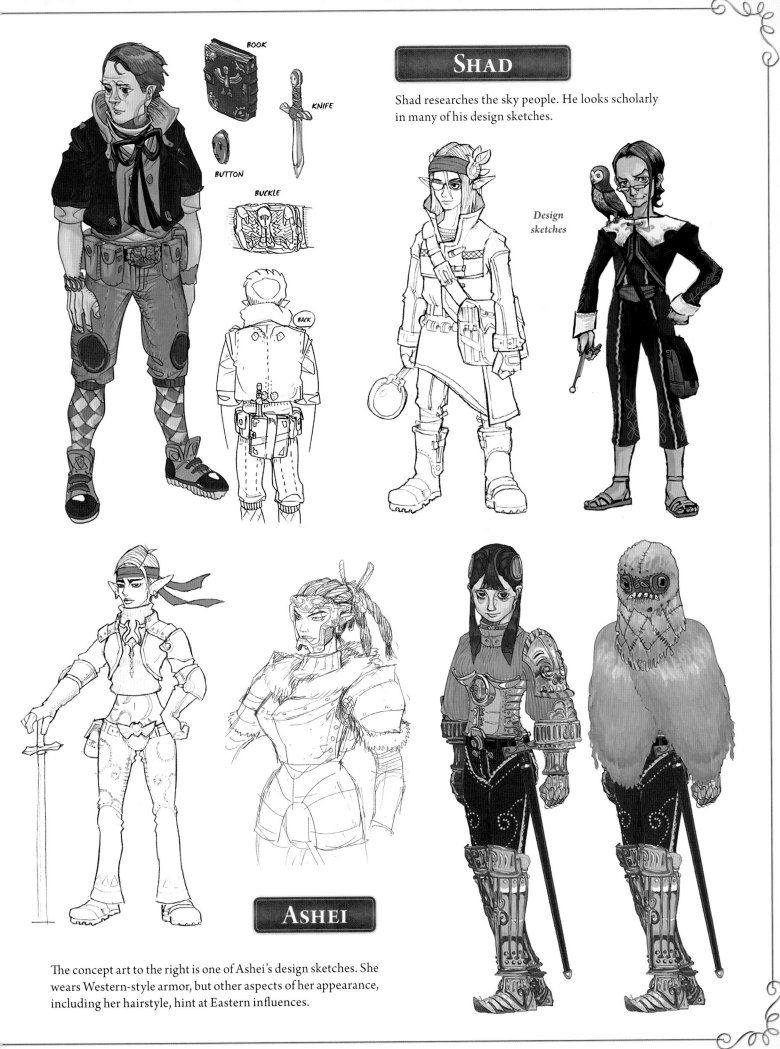

BOOK

KNIFE

BUTTON

BUCKLE

BACK

SHAD

Shad researches the sky people. He looks scholarly in many of his design sketches.

Design sketches

ASHEI

The concept art to the right is one of Ashei's design sketches. She wears Western-style armor, but other aspects of her appearance, including her hairstyle, hint at Eastern influences.

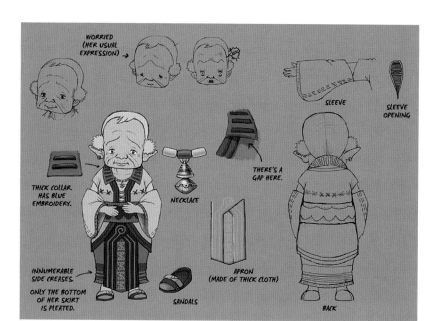

WORRIED (HER USUAL EXPRESSION) →

THICK COLLAR HAS BLUE EMBROIDERY.

NECKLACE

SLEEVE

SLEEVE OPENING

THERE'S A GAP HERE.

INNUMERABLE SIDE CREASES.

ONLY THE BOTTOM OF HER SKIRT IS PLEATED.

SANDALS

APRON (MADE OF THICK CLOTH)

BACK

IMPAZ

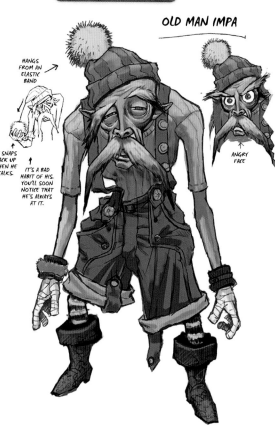

OLD MAN IMPA

HANGS FROM AN ELASTIC BAND →

IT SNAPS BACK UP WHEN HE TALKS.

IT'S A BAD HABIT OF HIS. YOU'LL SOON NOTICE THAT HE'S ALWAYS AT IT.

ANGRY FACE

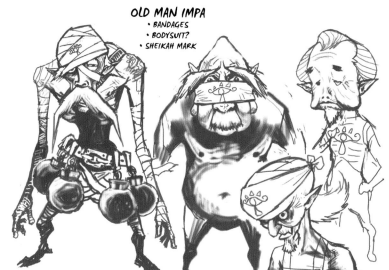

OLD MAN IMPA
• BANDAGES
• BODYSUIT?
• SHEIKAH MARK

Old Man Impa could be considered a male version of Impaz. If he'd been used, he would have been the series' first male Impa . . .

FYER

FALBI IS THIS OKAY?

FALBI & FYER

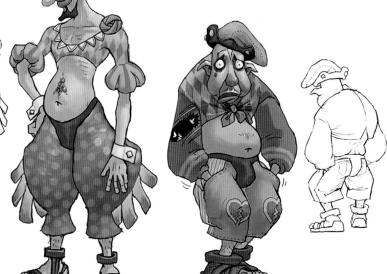

In the concept art shown here, Fyer is male, as he is in his final design. Falbi, however, is female. It is unclear if they were meant to be lovers or husband and wife.

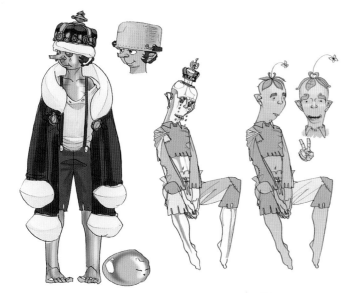

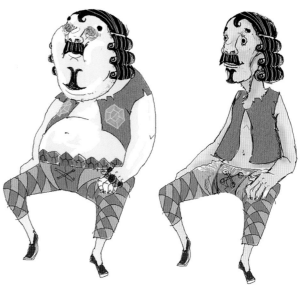

JOVANI

Jovani's body was turned into gold after he made a deal with demons. In his final design, he's depicted as round and fat, but his design sketches include a slender version.

Design sketches

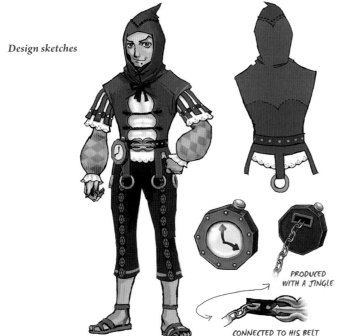

PRODUCED WITH A JINGLE

CONNECTED TO HIS BELT

PURLO

Purlo runs the STAR Game in Hyrule Castle Town. He was actually designed to be a more realistic version of Tingle.

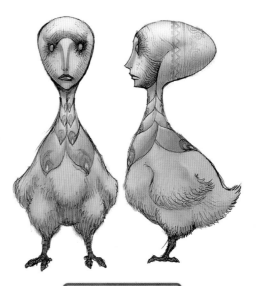

OOCCOO

Ooccoo's appearance is incredibly unique. Her design resembles the work of artist Amedeo Modigliani.

GREAT FAIRY
2006.5.23

• PALE WHITE SKIN

• MYSTERIOUSLY COLORED HAIR, A MIX OF YELLOW AND GREEN

RADIATES ALL THE COLORS OF THE RAINBOW WITH THE SAME EFFECT USED FOR THE ZORA PRINCE

MAKE THEM TRANSLUCENT USING THE ALPHA VERTEX

SIX WINGS

BONES IN EACH PAIR, CLEARLY SEPARATED BY COLOR.

ARMLET (METAL)

PLEASE MAKE IT THIS COLOR

LOINCLOTH—MADE OUT OF A SILKEN MATERIAL. NOT PATTERNED. IT'S TEXTURED WITH A VARIETY OF COLORS THAT SCROLL ACROSS IT. SIMILAR TO THE ZORA PRINCE.

GREAT FAIRY

BASIC GORON

Gorons first appear in the game as an enemy. Because of this, the gentleness that they had in *Ocarina of Time* has disappeared, replaced by a severe expression.

EACH GORON HAS A DESIGN PAINTED ON IT, SUCH AS THESE THREE LINES, WHICH CAN BE SEEN AS IT ROLLS.

THE ROCK NEAR THE TOP OF ITS HEAD SPLINTERS.

CURVATURE OF BACK

THE ROCK JUTS OUT A LITTLE

BOTTOM

ROLLED UP

LOINCLOTH?

HALF OF HIS FACE (FROM THE NOSE DOWN) IS HIDDEN AT THE ELBOW (?)

MOUTH

FOUR UPPER TEETH, TWO LOWER (ADULTS AND CHILDREN HAVE THE SAME NUMBER OF TEETH, ELDER GORONS HAVE ONE)

FROM BELOW ROLLED UP

HEAD

EYE HAND

BOTTOM SOLE OF FOOT

ROCK

BOTTOM

ROCK BOTTOM

SOLE OF FOOT

GORON CHILD

HAIRSTYLE VARIATIONS

BOTTOM HANGING HALF OUT

BACK

DANGLING NIPPLES

A LITTLE MOSSY

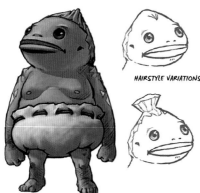

A LITTLE MOSSY

RICH

BABY

LEADER OF THE BRATS

MIDDLE CLASS

POOR

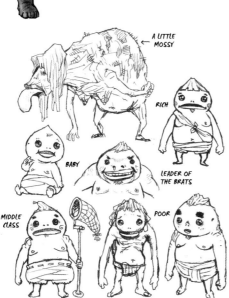

Design sketches

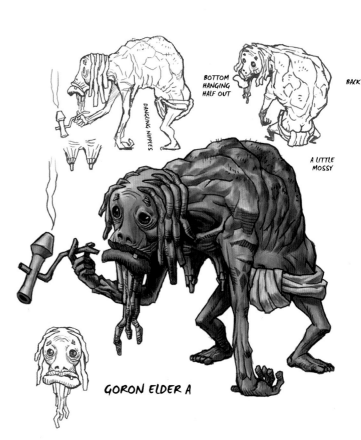

GORON ELDER A

Goron Elder A's design was used for Gor Ebizo, one of the four Goron Elders.

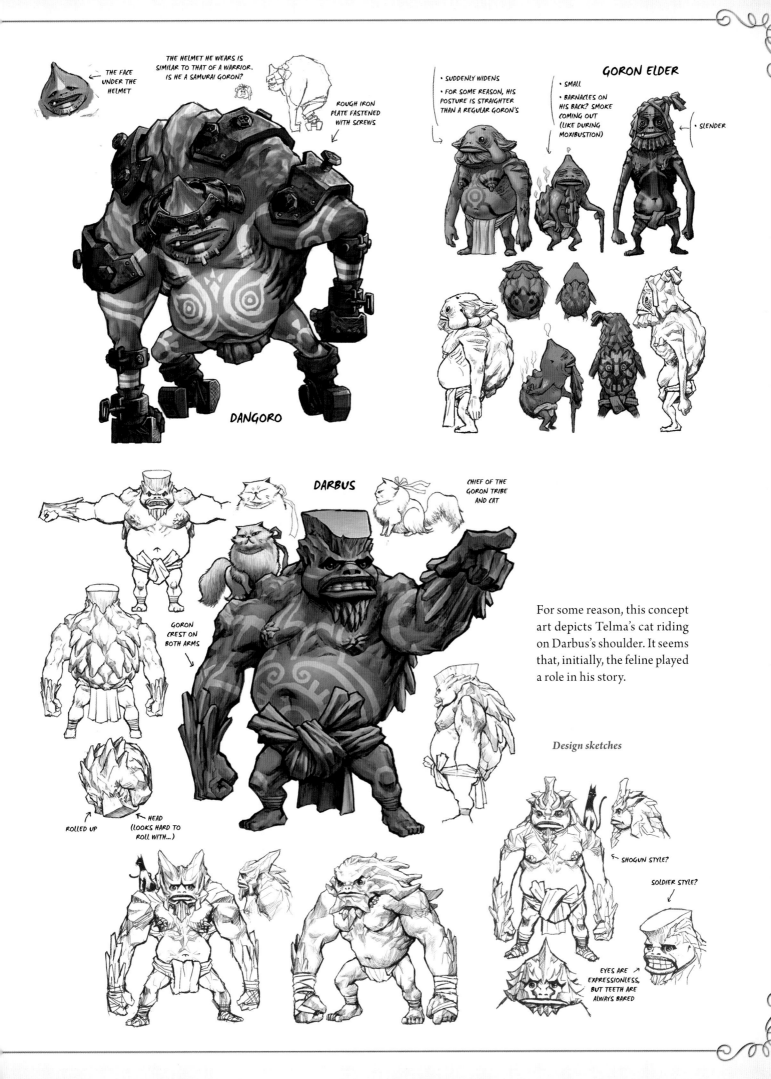

THE FACE UNDER THE HELMET

THE HELMET HE WEARS IS SIMILAR TO THAT OF A WARRIOR. IS HE A SAMURAI GORON?

ROUGH IRON PLATE FASTENED WITH SCREWS

DANGORO

• SUDDENLY WIDENS
• FOR SOME REASON, HIS POSTURE IS STRAIGHTER THAN A REGULAR GORON'S

• SMALL
• BARNACLES ON HIS BACK? SMOKE COMING OUT (LIKE DURING MOXIBUSTION)

GORON ELDER

• SLENDER

DARBUS

CHIEF OF THE GORON TRIBE AND CAT

GORON CREST ON BOTH ARMS

ROLLED UP

HEAD (LOOKS HARD TO ROLL WITH...)

For some reason, this concept art depicts Telma's cat riding on Darbus's shoulder. It seems that, initially, the feline played a role in his story.

Design sketches

SHOGUN STYLE?

SOLDIER STYLE?

EYES ARE EXPRESSIONLESS, BUT TEETH ARE ALWAYS BARED

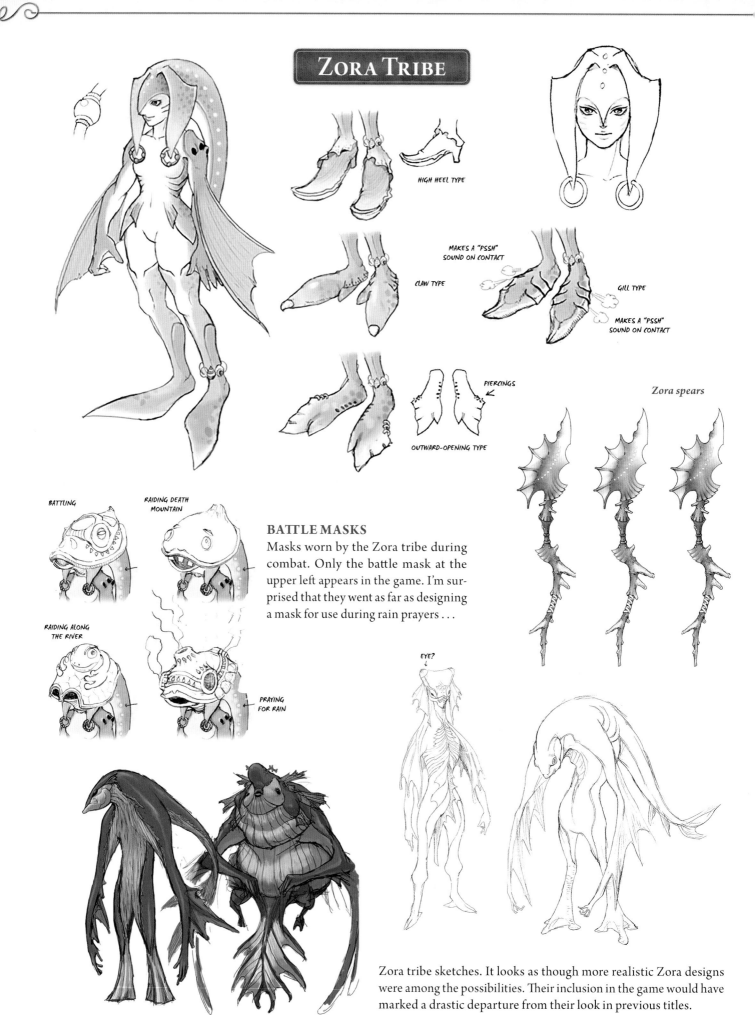

Zora Tribe

HIGH HEEL TYPE

MAKES A "PSSH" SOUND ON CONTACT

CLAW TYPE

GILL TYPE

MAKES A "PSSH" SOUND ON CONTACT

PIERCINGS

OUTWARD-OPENING TYPE

Zora spears

BATTLING

RAIDING DEATH MOUNTAIN

BATTLE MASKS

Masks worn by the Zora tribe during combat. Only the battle mask at the upper left appears in the game. I'm surprised that they went as far as designing a mask for use during rain prayers . . .

RAIDING ALONG THE RIVER

PRAYING FOR RAIN

EYE?

Zora tribe sketches. It looks as though more realistic Zora designs were among the possibilities. Their inclusion in the game would have marked a drastic departure from their look in previous titles.

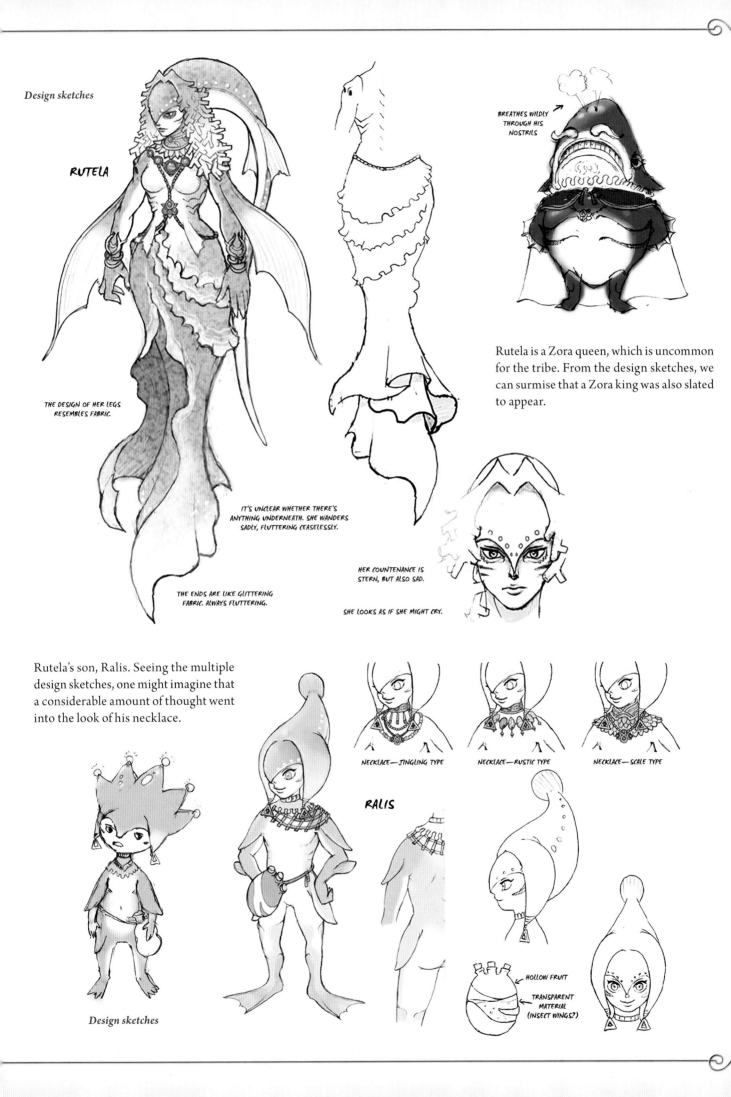

Design sketches

RUTELA

THE DESIGN OF HER LEGS RESEMBLES FABRIC.

IT'S UNCLEAR WHETHER THERE'S ANYTHING UNDERNEATH. SHE WANDERS SADLY, FLUTTERING CEASELESSLY.

THE ENDS ARE LIKE GLITTERING FABRIC. ALWAYS FLUTTERING.

HER COUNTENANCE IS STERN, BUT ALSO SAD.

SHE LOOKS AS IF SHE MIGHT CRY.

BREATHES WILDLY THROUGH HIS NOSTRILS

Rutela is a Zora queen, which is uncommon for the tribe. From the design sketches, we can surmise that a Zora king was also slated to appear.

Rutela's son, Ralis. Seeing the multiple design sketches, one might imagine that a considerable amount of thought went into the look of his necklace.

NECKLACE—JINGLING TYPE

NECKLACE—RUSTIC TYPE

NECKLACE—SCALE TYPE

RALIS

HOLLOW FRUIT

TRANSPARENT MATERIAL (INSECT WINGS?)

Design sketches

The illustration to the right is a design for what King Bulblin would be wearing during the second battle. The original plan was to have a piece of his armor fall off every time Link struck him with his sword. In the end, however, the king used two shields to defend himself.

Design sketches

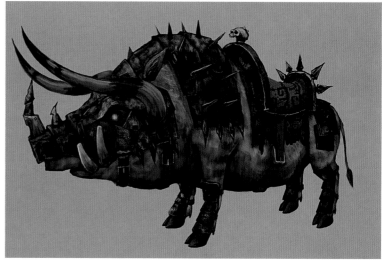

King Bulblin

Lord Bullbo

MONSTERS

When it comes to their designs, the Deku Toad and the Toadpoli have a few things in common. This is because the Deku Toad was meant to depict what a Toadpoli might look like a thousand years in the future.

Twilit Bloat

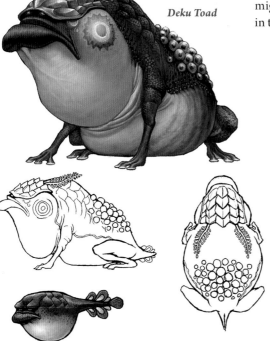

Deku Toad

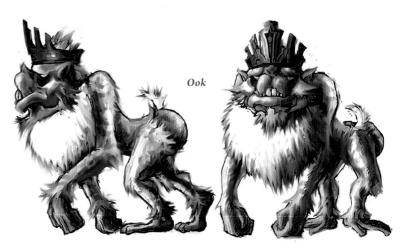

Ook

TOADPOLI

ITS FINS GLISTEN LIKE AN AMPHIBIAN'S.

THE PATTERNS ON ITS CHEEKS AREN'T EYES.

THE MASKLIKE THING THAT COVERS ITS FACE APPEARS METALLIC.

EYES →

ITS BODY RESEMBLES A GLISTENING AMPHIBIAN'S.

PULLS BACK

ITS CHEEKS AND CHIN INFLATE... →

PTOOIE!

BALL?

ITS FINS (?) ARE ALIGNED WITH ITS TAIL.

← FIN
← TAIL
← FIN

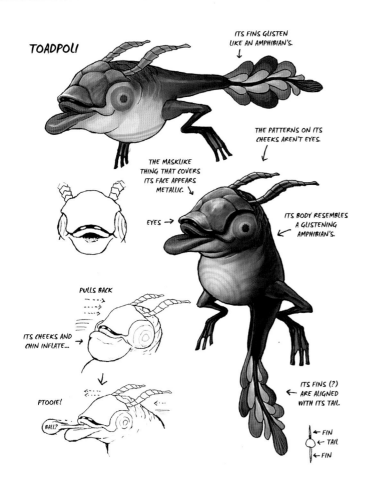

ABOUT THIS BIG.

Oyama

FIRE BUBBLE

WINGS SPROUT FROM THESE CREVICES, FLUTTERING THROUGH THE AIR WITH A RUSTLING NOISE.

BUBBLE

Puppet

Skull Kid

Death Sword

Darkhammer

Design sketches

TWILIGHT EMISSARIES

Citizens of the Twilight Realm, transformed into demons by Zant. As with Midna, they were designed from the mask down.

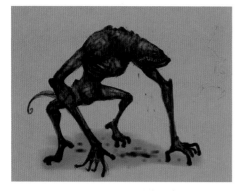

Design sketches

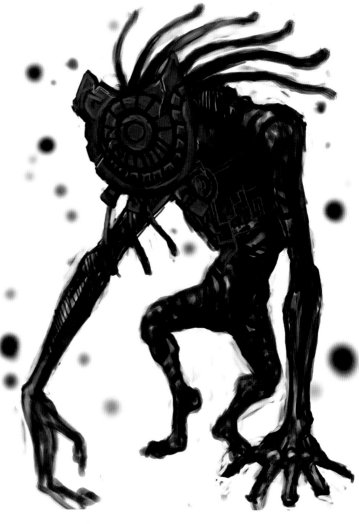

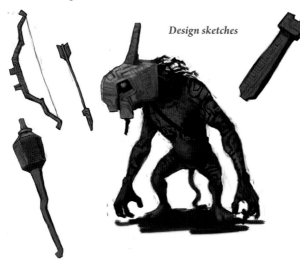

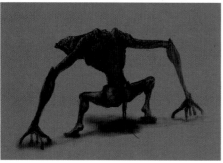

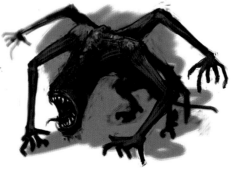

Shadow Kargarok

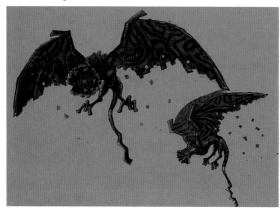

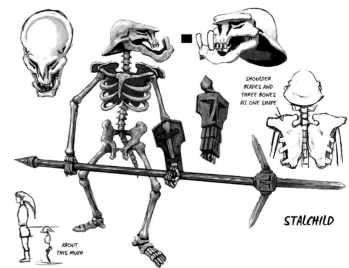

SHOULDER BLADES AND THREE BONES ALL ONE SHAPE

ABOUT THIS MUCH

HEIGHT DIFFERENCE

STALCHILD

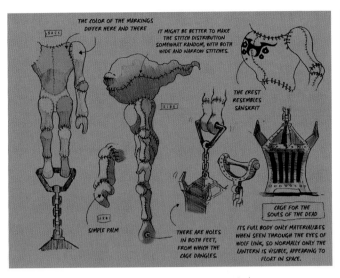

THE COLOR OF THE MARKINGS DIFFER HERE AND THERE

IT MIGHT BE BETTER TO MAKE THE STITCH DISTRIBUTION SOMEWHAT RANDOM, WITH BOTH WIDE AND NARROW STITCHES.

THE CREST RESEMBLES SANSKRIT

SIMPLE PALM

THERE ARE HOLES IN BOTH FEET, FROM WHICH THE CAGE DANGLES.

CAGE FOR THE SOULS OF THE DEAD

ITS FULL BODY ONLY MATERIALIZES WHEN SEEN THROUGH THE EYES OF WOLF LINK, SO NORMALLY ONLY THE LANTERN IS VISIBLE, APPEARING TO FLOAT IN SPACE.

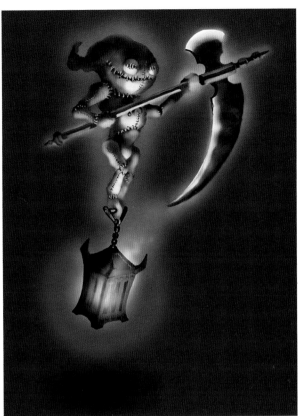

IMP POE

Upon defeat, Imp Poes leave behind Poe Souls. Because you're so busy trying to catch the Poes in the game, it's not often you get a chance to take a closer look.

AERALFOS

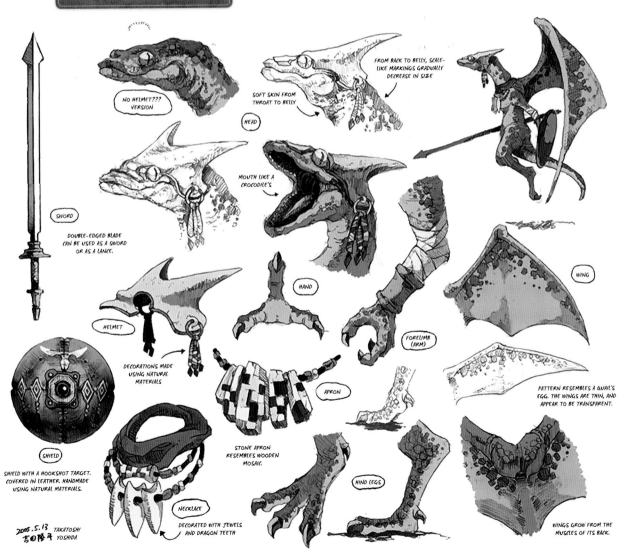

NO HELMET??? VERSION

HEAD

SOFT SKIN FROM THROAT TO BELLY

FROM BACK TO BELLY, SCALE-LIKE MARKINGS GRADUALLY DECREASE IN SIZE

MOUTH LIKE A CROCODILE'S

SWORD

DOUBLE-EDGED BLADE CAN BE USED AS A SWORD OR AS A LANCE.

HAND

WING

FORELIMB (ARM)

HELMET

DECORATIONS MADE USING NATURAL MATERIALS

APRON

PATTERN RESEMBLES A QUAIL'S EGG. THE WINGS ARE THIN, AND APPEAR TO BE TRANSPARENT.

SHIELD

SHIELD WITH A HOOKSHOT TARGET. COVERED IN LEATHER. HANDMADE USING NATURAL MATERIALS.

STONE APRON RESEMBLES WOODEN MOSAIC.

HIND LEGS

NECKLACE

DECORATED WITH JEWELS AND DRAGON TEETH

WINGS GROW FROM THE MUSCLES OF ITS BACK.

2005.5.13 TAKATOSHI YOSHIDA

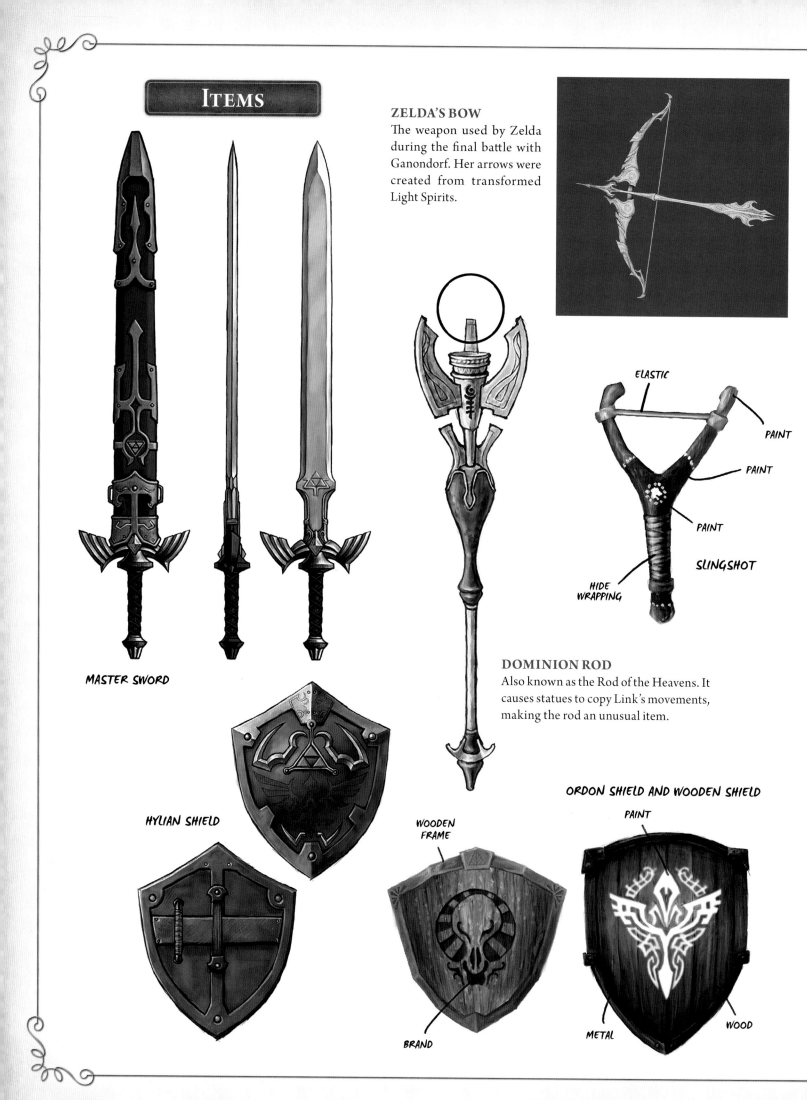

ITEMS

ZELDA'S BOW

The weapon used by Zelda during the final battle with Ganondorf. Her arrows were created from transformed Light Spirits.

ELASTIC

PAINT

PAINT

PAINT

HIDE WRAPPING

SLINGSHOT

MASTER SWORD

DOMINION ROD

Also known as the Rod of the Heavens. It causes statues to copy Link's movements, making the rod an unusual item.

HYLIAN SHIELD

ORDON SHIELD AND WOODEN SHIELD

PAINT

WOODEN FRAME

BRAND

METAL

WOOD

LOOKS LIKE
THIS FROM
THE FRONT?

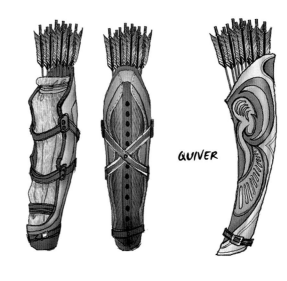

QUIVER

HERO'S BOW

SPINNER

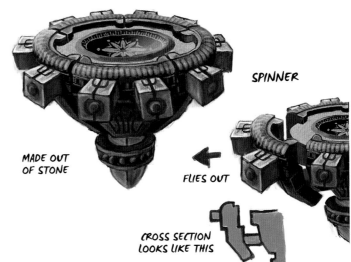

MADE OUT
OF STONE

FLIES OUT

CROSS SECTION
LOOKS LIKE THIS

LEATHER

IRON

IRON

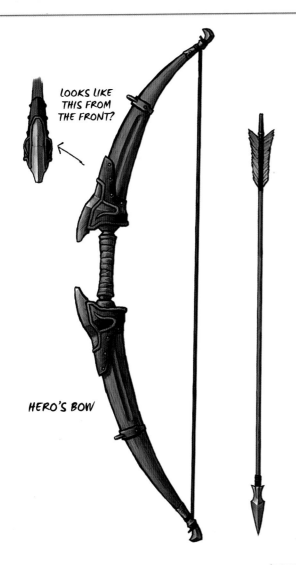

IRON BOOTS

LEATHER

IRON

IRON

IRON

HAWKEYE

MATERIAL SIMILAR TO
PORCELAIN, NOT METAL

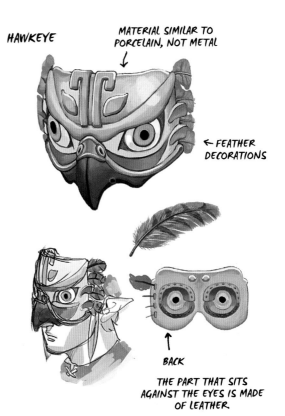

← FEATHER
DECORATIONS

ZORA TUNIC

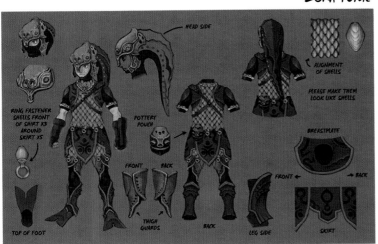

HEAD SIDE

ALIGNMENT
OF SHELLS

PLEASE MAKE THEM
LOOK LIKE SHELLS

RING FASTENER
SHELLS FRONT
OF SHIRT X3
AROUND
SKIRT X5

POTTERY
POUCH

FRONT BACK

BREASTPLATE

FRONT ← → BACK

TOP OF FOOT

THIGH
GUARDS

BACK

LEG SIDE

SKIRT

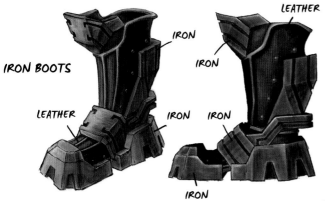

BACK

THE PART THAT SITS
AGAINST THE EYES IS MADE
OF LEATHER

The village was designed as a place attuned to nature, where the villagers lived happily, strongly rooted to the earth.

Ordon Village

SOMETHING STRANGE MUST HAVE HAPPENED TO PUT THIS HOUSE IN A TREE. A NEW CHASM HAS APPEARED IN THE EARTH.

ORDON VILLAGE
KAKARIKO VILLAGE

Lake Hylia

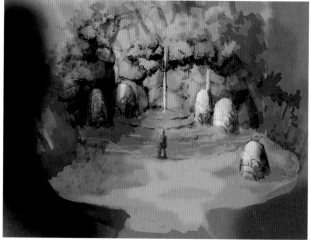

Forest spring

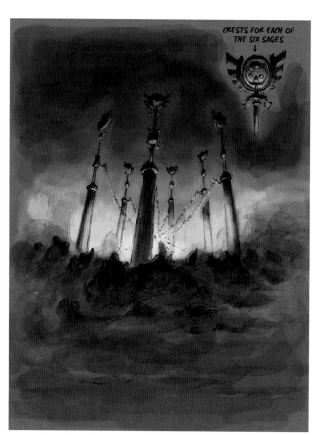

CRESTS FOR EACH OF THE SIX SAGES

Arbiter's Grounds

GOOD EFFECT!

RESEMBLES A BIRD'S NEST

CRACKS COVERED BY CLOTH

CORO'S LANTERN SHOP

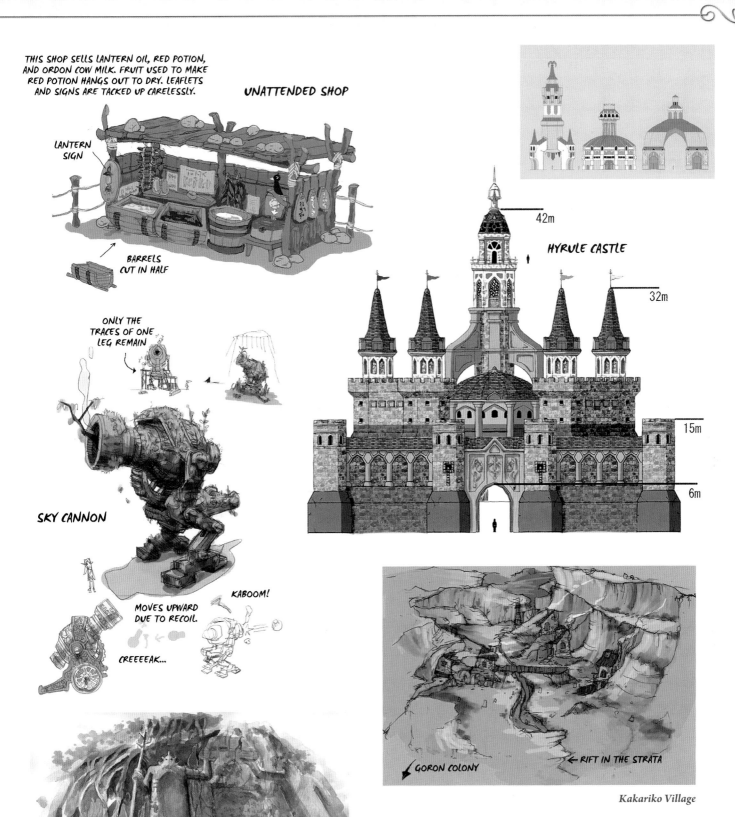

THIS SHOP SELLS LANTERN OIL, RED POTION, AND ORDON COW MILK. FRUIT USED TO MAKE RED POTION HANGS OUT TO DRY. LEAFLETS AND SIGNS ARE TACKED UP CARELESSLY.

UNATTENDED SHOP

LANTERN SIGN

BARRELS CUT IN HALF

ONLY THE TRACES OF ONE LEG REMAIN

SKY CANNON

MOVES UPWARD DUE TO RECOIL.

KABOOM!

CREEEEAK...

42m

HYRULE CASTLE

32m

15m

6m

← RIFT IN THE STRATA

GORON COLONY

Kakariko Village

Sacred Grove

Originally, Link would howl in his beast form to startle the statues into moving. In the final version of the game, however, players must solve a puzzle.

Bridge of Eldin

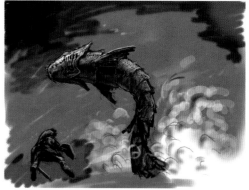

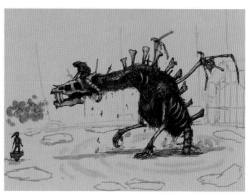

Boss fights

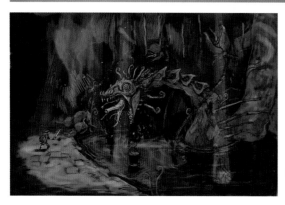

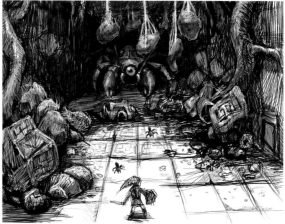

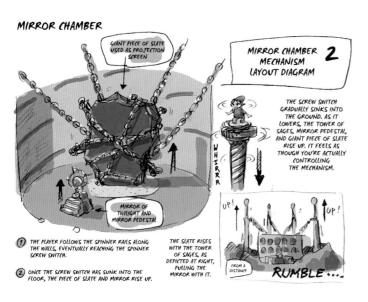

MIRROR CHAMBER

GIANT PIECE OF SLATE USED AS PROJECTION SCREEN

MIRROR CHAMBER **2** MECHANISM LAYOUT DIAGRAM

THE SCREW SWITCH GRADUALLY SINKS INTO THE GROUND. AS IT LOWERS, THE TOWER OF SAGES, MIRROR PEDESTAL, AND GIANT PIECE OF SLATE RISE UP. IT FEELS AS THOUGH YOU'RE ACTUALLY CONTROLLING THE MECHANISM.

WHIRRR

MIRROR OF TWILIGHT AND MIRROR PEDESTAL

① THE PLAYER FOLLOWS THE SPINNER RAILS ALONG THE WALLS, EVENTUALLY REACHING THE SPINNER SCREW SWITCH.

② ONCE THE SCREW SWITCH HAS SUNK INTO THE FLOOR, THE PIECE OF SLATE AND MIRROR RISE UP.

THE SLATE RISES THE TOWER OF SAGES, AS DEPICTED AT RIGHT, PULLING THE MIRROR WITH IT.

UP! UP!

FROM A DISTANCE

RUMBLE....

PORTAL

An initial concept sketch. The design for the rest of the Twilight Realm was based on its geometric patterns.

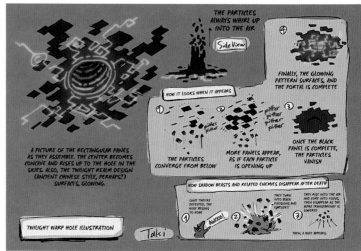

THE PARTICLES ALWAYS WHIRL UP INTO THE AIR

Side View

④

FINALLY, THE GLOWING PATTERN SURFACES, AND THE PORTAL IS COMPLETE

HOW IT LOOKS WHEN IT APPEARS

① ② ③

A PICTURE OF THE RECTANGULAR PANES AS THEY ASSEMBLE. THE CENTER BECOMES CONCAVE AND RISES UP TO THE HOLE IN THE SKIES. ALSO, THE TWILIGHT REALM DESIGN (ANCIENT CHINESE STYLE, PERHAPS?) SURFACES, GLOWING.

THE PARTICLES CONVERGE FROM BELOW

MORE PANELS APPEAR, AS IF EACH PARTICLE IS OPENING UP

ONCE THE BLACK PANEL IS COMPLETE, THE PARTICLES VANISH

HOW SHADOW BEASTS AND RELATED ENEMIES DISAPPEAR AFTER DEATH

① ② ③

TWILIGHT WARP HOLE ILLUSTRATION

Taki

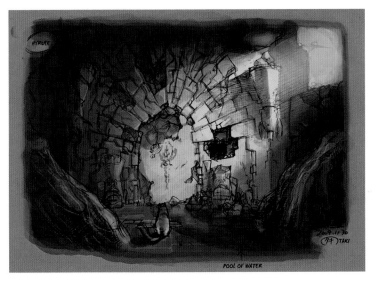

POOL OF WATER

HYRULE

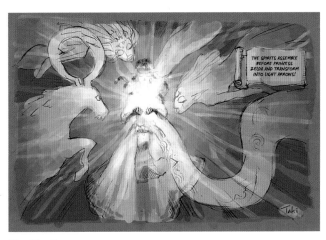

THE SPIRITS ASSEMBLE BEFORE PRINCESS ZELDA AND TRANSFORM INTO LIGHT ARROWS!

Final battle

SECRET ENTRANCE
A cat sits by a wall. Perhaps this is an illustration of Telma's cat, Louise, showing Link the secret passage into Hyrule Castle.

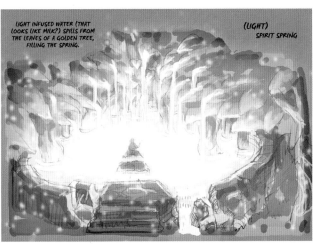

LIGHT INFUSED WATER (THAT LOOKS LIKE MILK?) SPILLS FROM THE LEAVES OF A GOLDEN TREE, FILLING THE SPRING.

(LIGHT) SPIRIT SPRING

Spirit spring 1

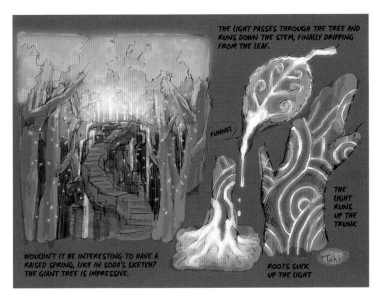

THE LIGHT PASSES THROUGH THE TREE AND RUNS DOWN THE STEM, FINALLY DRIPPING FROM THE LEAF.

FUNNEL

THE LIGHT RUNS UP THE TRUNK

WOULDN'T IT BE INTERESTING TO HAVE A RAISED SPRING, LIKE IN SODA'S SKETCH? THE GIANT TREE IS IMPRESSIVE.

ROOTS SUCK UP THE LIGHT

Spirit spring 2

Main visual sketch

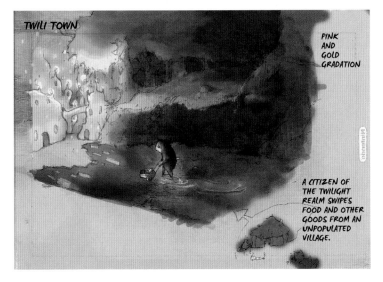

TWILI TOWN

PINK AND GOLD GRADATION

A CITIZEN OF THE TWILIGHT REALM SWIPES FOOD AND OTHER GOODS FROM AN UNPOPULATED VILLAGE.

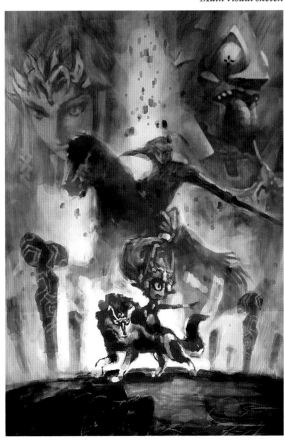

TWILI
An illustration depicting the daily life of a citizen of the Twilight Realm. This one is stealthily stealing food from an abandoned village.

EFFECT → CREST

OCEAN KING

An illustration of the Ocean King, the true form of Oshus. He appears in his whale form at the end of the game.

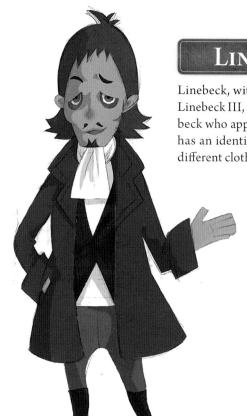

LINEBECK

Linebeck, with his dashing smile. Linebeck III, a descendent of Linebeck who appears in *Spirit Tracks*, has an identical face, but slightly different clothing.

MUTOH & THE COBBLE KNIGHTS

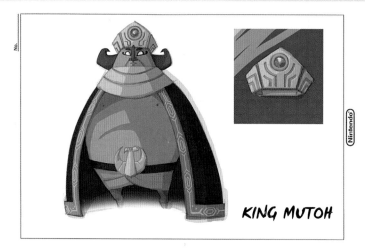

KING MUTOH

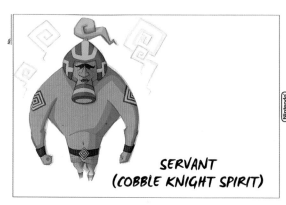

SERVANT
(COBBLE KNIGHT SPIRIT)

To the left is a picture of King Mutoh, who dwells on the Isle of Ruins. To the right is the spirit of a Cobble Knight commander, who works in the king's service. There are three commanders in all, each clad in a different color. The first wears red, the second green, and the third yellow.

ASTRID & KAYO

Astrid, the fortuneteller, and her servant, Kayo. Kayo's initial design was more or less identical to his appearance in the final game, but Astrid's appearance was later altered, including the color of her hair.

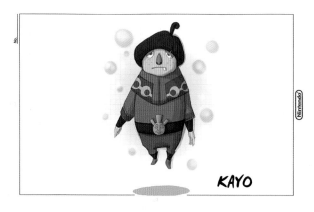

KAYO

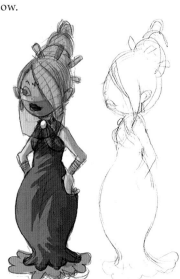

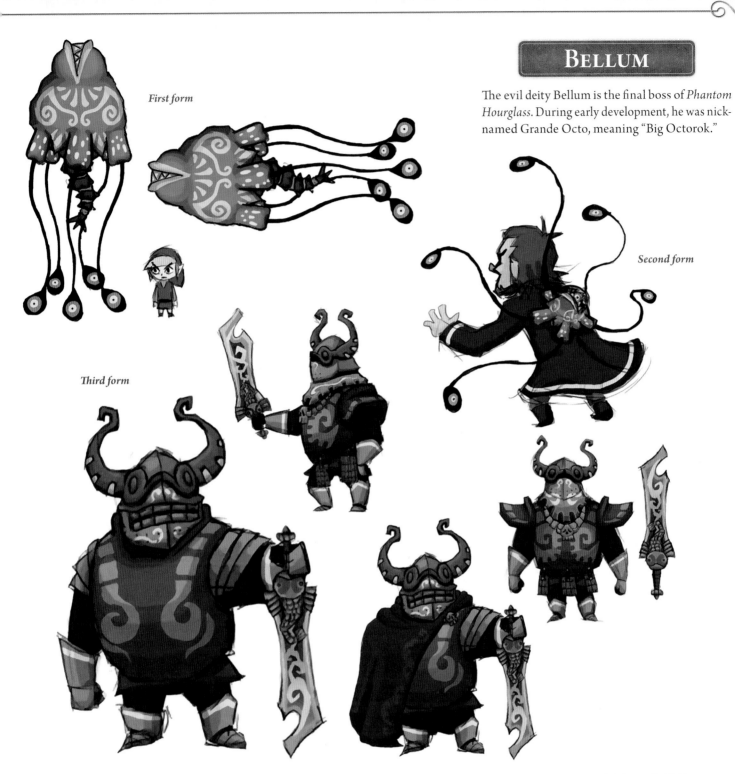

First form

BELLUM

The evil deity Bellum is the final boss of *Phantom Hourglass*. During early development, he was nicknamed Grande Octo, meaning "Big Octorok."

Second form

Third form

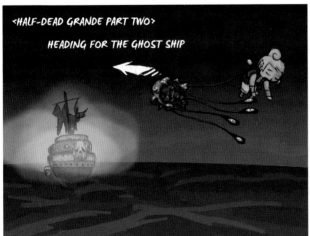

<HALF-DEAD GRANDE PART TWO>

HEADING FOR THE GHOST SHIP

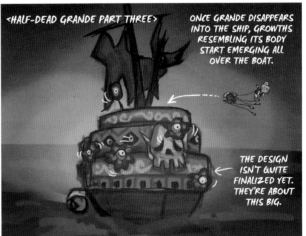

<HALF-DEAD GRANDE PART THREE>

ONCE GRANDE DISAPPEARS INTO THE SHIP, GROWTHS RESEMBLING ITS BODY START EMERGING ALL OVER THE BOAT.

THE DESIGN ISN'T QUITE FINALIZED YET. THEY'RE ABOUT THIS BIG.

OCTOMINE

These members of the Octorok family were designed to be Bellum's henchmen.

Gleeok

Octorok

Yook

Ink Octo

Stalfos

CONCEPT ART

Ghost Ship

ISLAND DESIGNS

Design sketches for a variety of islands. The island to the right was originally going to have a new addition each time Link visited, gradually growing larger and larger.

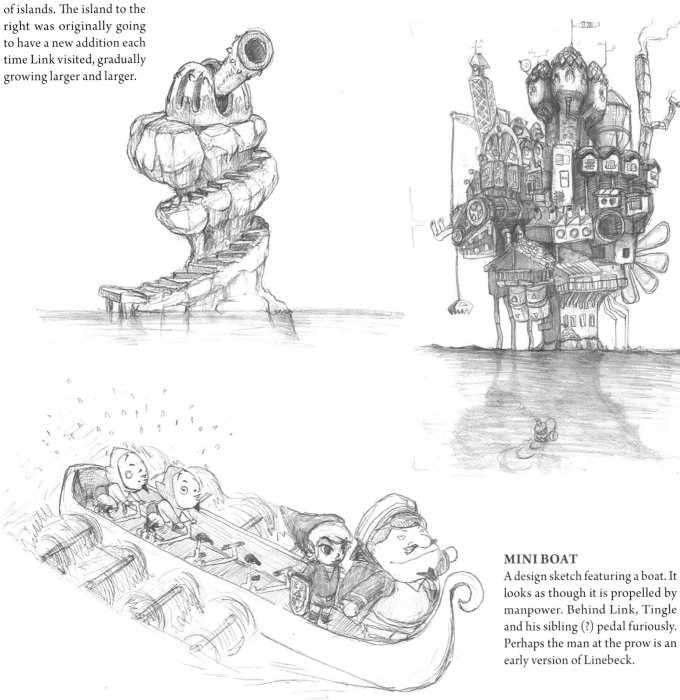

MINI BOAT

A design sketch featuring a boat. It looks as though it is propelled by manpower. Behind Link, Tingle and his sibling (?) pedal furiously. Perhaps the man at the prow is an early version of Linebeck.

LINK

Design sketches of the uniform Link wears during his time as an apprentice train engineer. This was the first Zelda game to depict Link wearing a uniform. Perhaps the large number of design sketches is proof of the staff's efforts. The final design was chosen based on whether or not it made him look like an engineer.

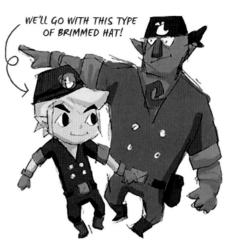

WE'LL GO WITH THIS TYPE OF BRIMMED HAT!

IT WOULD BE BETTER TO AVOID HAVING HIM DRESSED IN GREEN WHILE RIDING THE TRAIN.

I WANT THE ROLLED-UP SLEEVES AND OPEN CHEST TO MAKE HIM LOOK MISCHIEVOUS, WITH ONLY THE HAT GIVING HIM A SHARP LOOK.

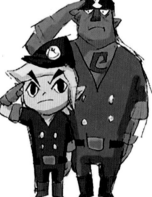

THE COLOR CONTRAST BETWEEN LINK AND ALFONZO. EVEN THOUGH THEIR OUTFITS AREN'T THE SAME COLOR, I'D LIKE THEM TO USE A MATCHING DESIGN.

TOO FORMAL.

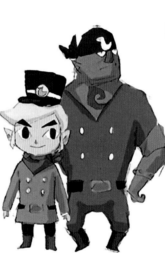

LINK MIGHT LOOK TOO FORMAL...

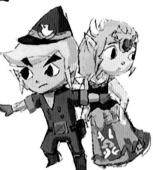

LINK AND ZELDA. PLEASE AVOID HAVING THEM BOTH WEARING PINK.

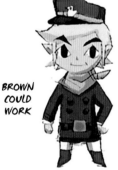

BROWN COULD WORK

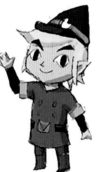

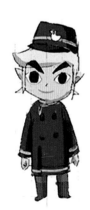

DULL, BUT ALSO INTERESTING.

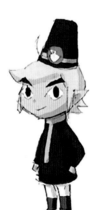

BLACK LOOKS SHARP

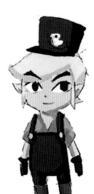

OVERALLS MIGHT BE TOO SIMPLE...

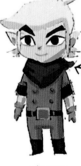

THE BANDANNA MIGHT OVERLAP WITH TETRA'S DESIGN...

NO HAT.

ZELDA

Zelda calls to Byrne from within the possessed phantom. To the bottom right, Byrne is depicted kneeling before Zelda in the manner of a royal retainer. In the final game, you see them meet for the first time, but perhaps it was originally intended that they would be old friends.

TRANSPARENT

BYRNE!!

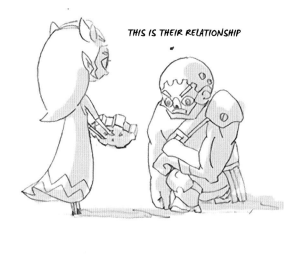

THIS IS THEIR RELATIONSHIP

ALFONZO

Alfonzo is a descendant of Gonzo, who appears in *The Wind Waker* and *Phantom Hourglass*. In these design sketches, however, the resemblance to his ancestor is not as clear.

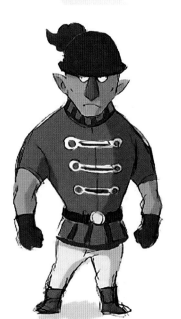

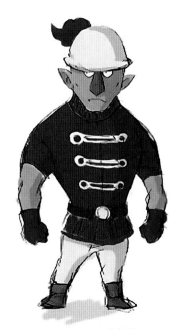

CHANCELLOR COLE

Cole takes on the form of the chancellor of Hyrule Castle. As far as I can tell from the design sketches, it appears that, even in the early stages of development, he was intended to be a man of small stature who would undergo a complete transformation.

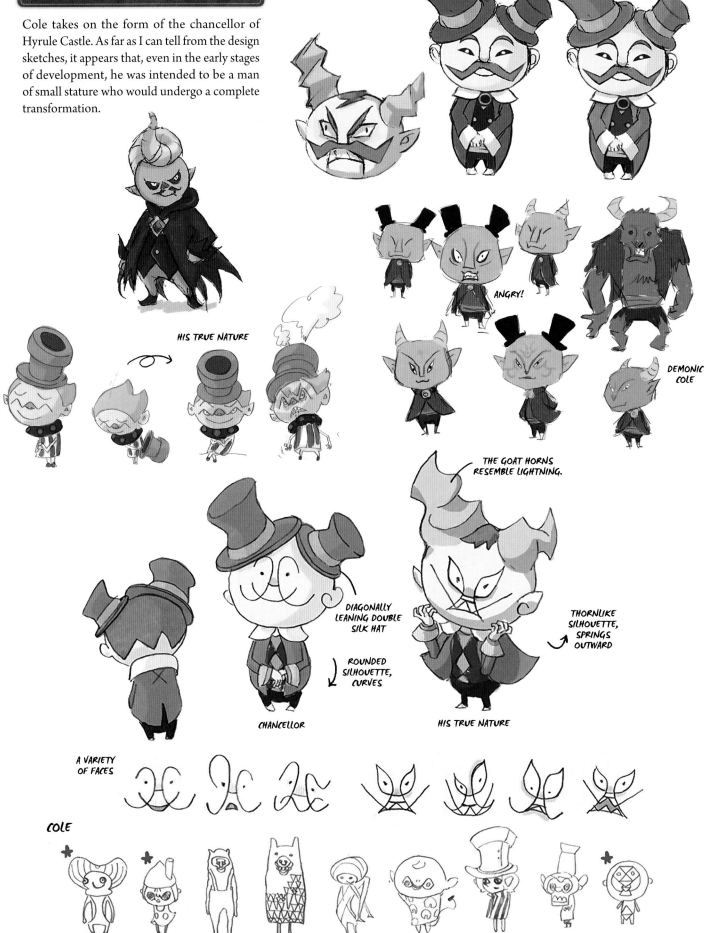

HIS TRUE NATURE

ANGRY!

DEMONIC COLE

THE GOAT HORNS RESEMBLE LIGHTNING.

DIAGONALLY LEANING DOUBLE SILK HAT

ROUNDED SILHOUETTE, CURVES

THORNLIKE SILHOUETTE, SPRINGS OUTWARD

CHANCELLOR

HIS TRUE NATURE

A VARIETY OF FACES

COLE

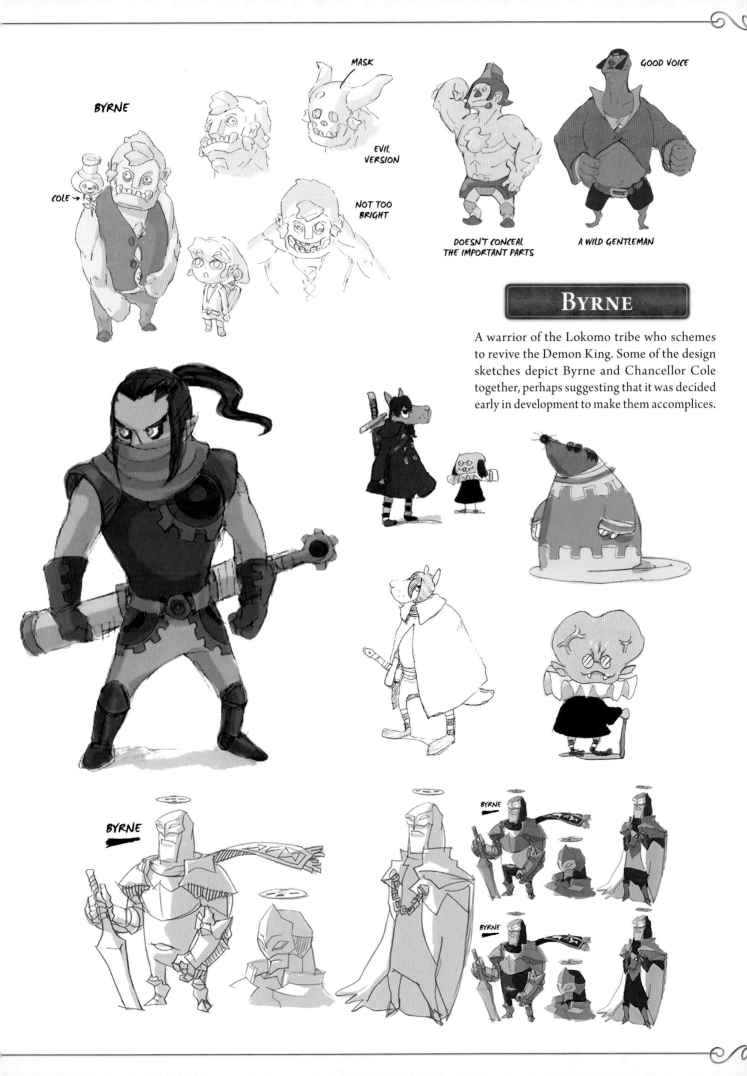

BYRNE

MASK

EVIL VERSION

NOT TOO BRIGHT

COLE →

GOOD VOICE

DOESN'T CONCEAL THE IMPORTANT PARTS

A WILD GENTLEMAN

BYRNE

A warrior of the Lokomo tribe who schemes to revive the Demon King. Some of the design sketches depict Byrne and Chancellor Cole together, perhaps suggesting that it was decided early in development to make them accomplices.

BYRNE

BYRNE

BYRNE

Design sketches

Malladus

Malladus after losing his hold on the body he occupied. Some of his design sketches have two horns, which are one of the characteristics of his final form.

Malladus (Final Form)

Malladus, as he appears after possessing Cole during the final battle, allowing him to obtain a body. In the final game, he is a four-legged demonic beast, but it seems that there were designs for a humanoid form as well.

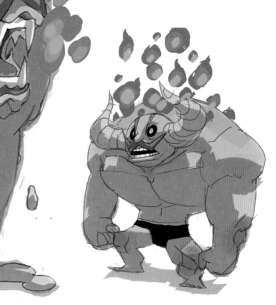

Malladus in his death throes, wailing in agony after losing the battle. He never appears like this in the game. You can't help but feel a little sorry for him . . .

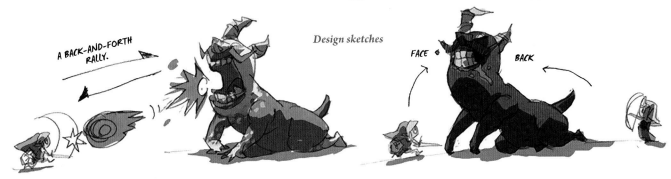

Design sketches

A BACK-AND-FORTH RALLY.

FACE BACK

Illustrations depicting ideas for the fight with Malladus. This idea was used in the final battle.

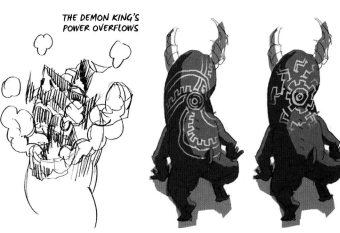

THE DEMON KING'S POWER OVERFLOWS

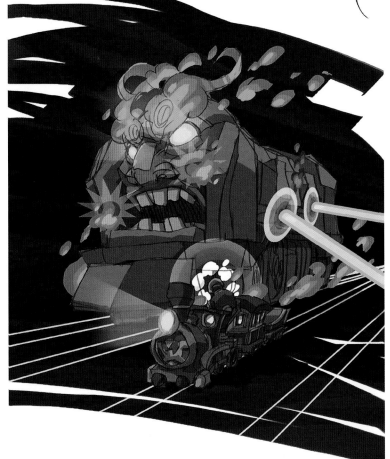

DREAM TRAIN

Design sketches

SAGES

Anjean, who protects the Tower of Spirits, and the sages of the Lokomo tribe, who appear in shrines all over the world and aid Link in his quest. In the final game, Anjean is an old woman, but there are also design sketches in which she is drawn as a man.

VARIATION

Design sketches

TILTED

KAH!

SCARY?

GRANDMA

SPIRITUAL MEDIUM

SENDS WHEELS FLYING USING A ROD
(NAME UNKNOWN)

SYSO FOREST	**SYSN** SNOW	**SYWA** WATER	**SYFI** FIRE	**SYDE** DESERT	**SYDA** SHADOW
VIOLIN	BIWA	CONCH (HARP) (FIFE)	DRUM	CHARUMERA	GAMELAN

Design sketches featuring the various sages, their attributes, and the instruments they play.
The Sage of Shadow, on the right, doesn't appear in the game.

Design sketches of the Lokomo tribe. It seems that their vehicles, which are integral to their characters in the final game, didn't exist in early development. The picture of Byrne with the pompadour is quite cute.

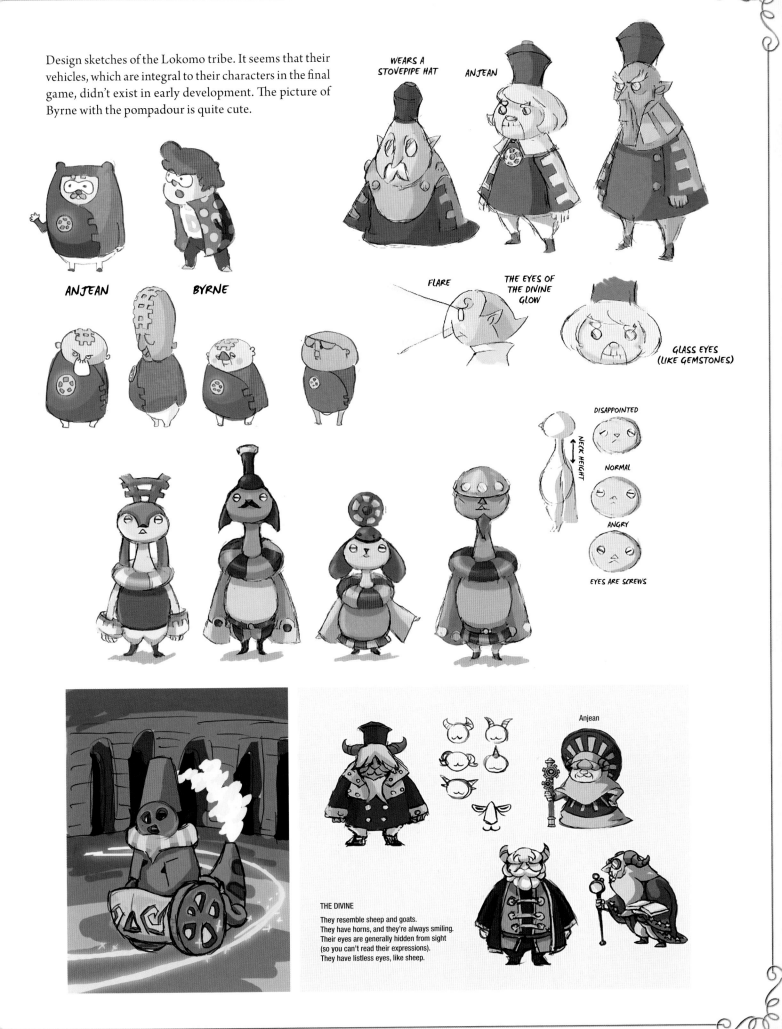

WEARS A STOVEPIPE HAT

ANJEAN

ANJEAN

BYRNE

FLARE

THE EYES OF THE DIVINE GLOW

GLASS EYES (LIKE GEMSTONES)

NECK HEIGHT

DISAPPOINTED

NORMAL

ANGRY

EYES ARE SCREWS

Anjean

THE DIVINE

They resemble sheep and goats.
They have horns, and they're always smiling.
Their eyes are generally hidden from sight
(so you can't read their expressions).
They have listless eyes, like sheep.

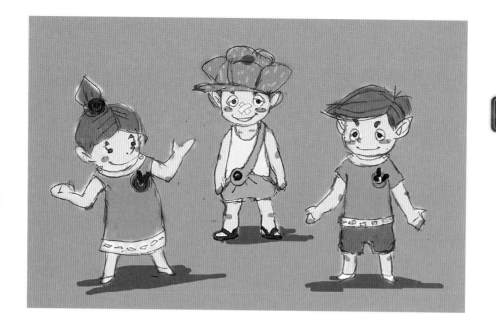

ABODA VILLAGERS

The children of Link's hometown, Aboda Village. In the middle is the mischief-loving Joe. To the left, his little sister, Rei. The boy on the right was cut and never appeared in the game.

CITIZENS OF HYRULE CASTLE & HYRULE CASTLE TOWN

Joynas

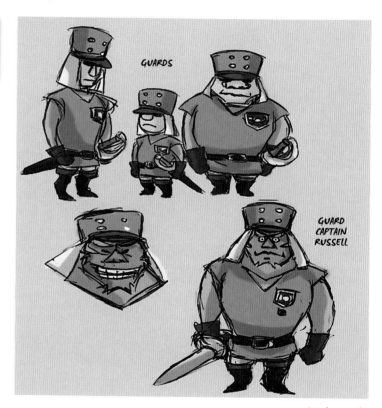

GUARDS

GUARD CAPTAIN RUSSELL

Castle guards

Shitate

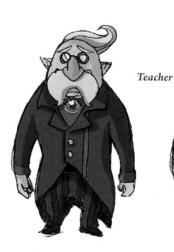

Teacher

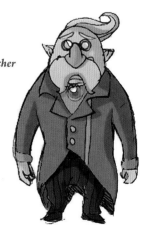

WHITTLETON VILLAGERS

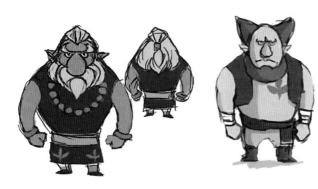
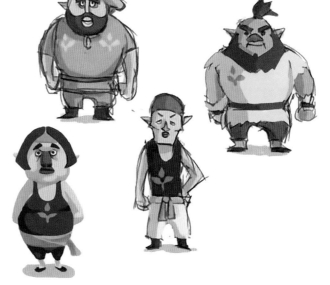

PAPUCHIA VILLAGERS

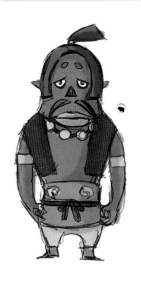
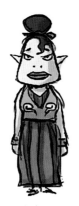
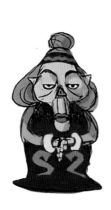
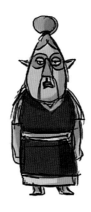

GORON TRIBE

BUNNIO

FERRUS

MONSTERS

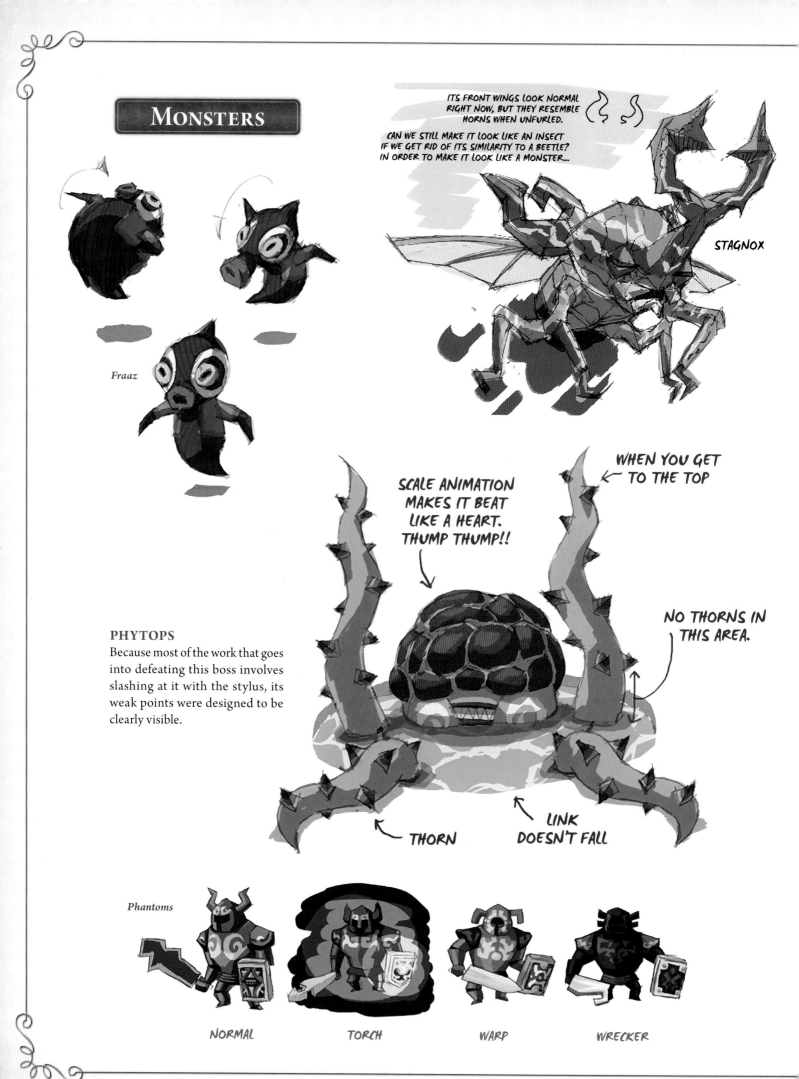

ITS FRONT WINGS LOOK NORMAL RIGHT NOW, BUT THEY RESEMBLE HORNS WHEN UNFURLED.

CAN WE STILL MAKE IT LOOK LIKE AN INSECT IF WE GET RID OF ITS SIMILARITY TO A BEETLE? IN ORDER TO MAKE IT LOOK LIKE A MONSTER...

STAGNOX

Fraaz

SCALE ANIMATION MAKES IT BEAT LIKE A HEART. THUMP THUMP!!

WHEN YOU GET TO THE TOP

NO THORNS IN THIS AREA.

PHYTOPS
Because most of the work that goes into defeating this boss involves slashing at it with the stylus, its weak points were designed to be clearly visible.

THORN

LINK DOESN'T FALL

Phantoms

NORMAL

TORCH

WARP

WRECKER

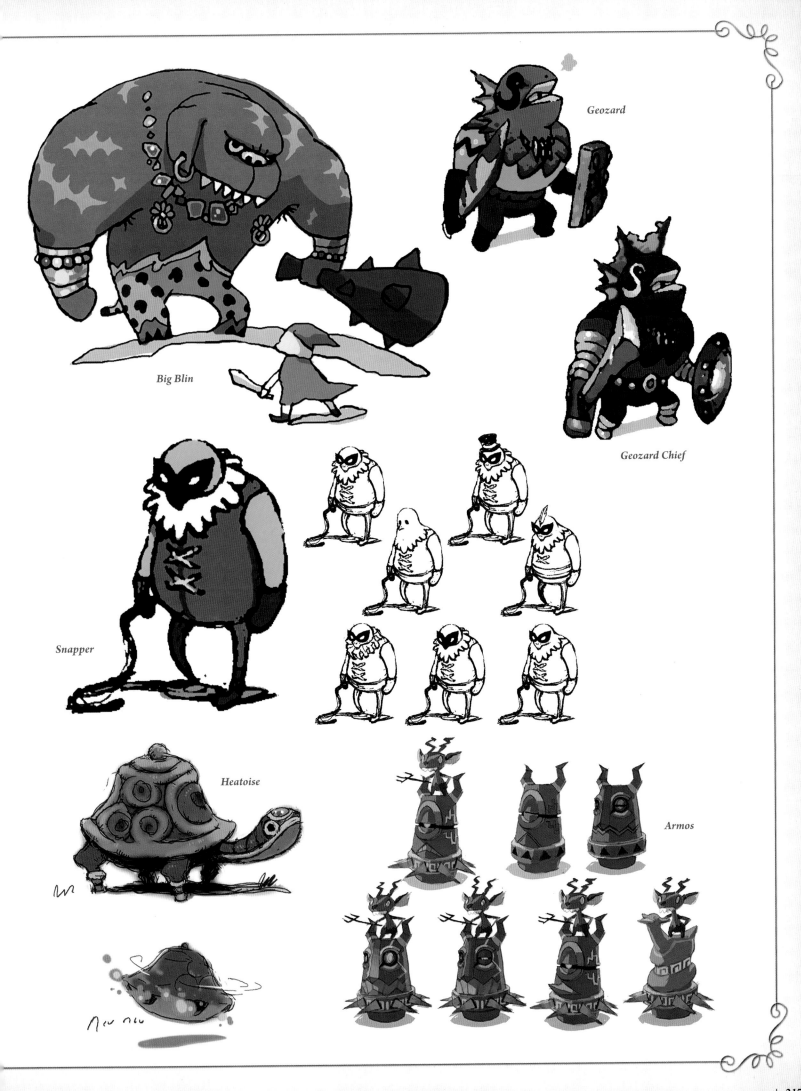

Geozard

Big Blin

Geozard Chief

Snapper

Heatoise

Armos

Key Master

METALLIC

RESEMBLES YELLOW RUBBER LOOKS LIKE IT CAN BE DEFEATED WITH A SWORD.

NORMAL

IN PURSUIT

Nocturn

Lobarrier

Spinut

Armored Train

Snurgle

Sir Frosty

Octorok

SMOKE POURS
FROM ITS NOSE

PIG TRAIN

Dark Train

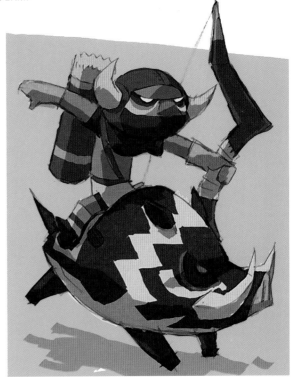

Bulblin and Bullbo

TRAINS

The Spirit Train, which ferries Link and his friends across the land. The design on the train is a modified Hylian crest. The triangle is upside down because it's not associated with the story of the Triforce.

SPIRIT TRAIN

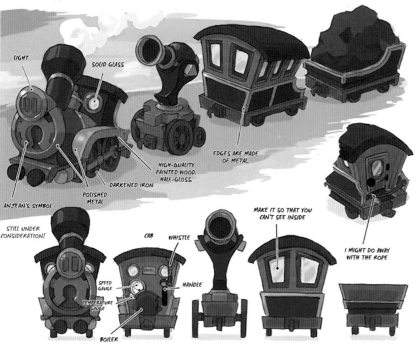

LIGHT

SOLID GLASS

ANJEAN'S SYMBOL

POLISHED METAL

DARKENED IRON

HIGH-QUALITY PAINTED WOOD. HALF-GLOSS.

EDGES ARE MADE OF METAL.

MAKE IT SO THAT YOU CAN'T SEE INSIDE

I MIGHT DO AWAY WITH THE ROPE

STILL UNDER CONSIDERATION!

CAB

WHISTLE

SPEED GAUGE

TEMPERATURE GAUGE

HANDLE

BOILER

HOW HE LOOKS WHILE RIDING IT STANDING UP.

FRONT CAR

CANNON

PASSENGER CAR

FREIGHT CAR (CARRIES MATERIALS)

ROTATION OF SHAFT MATCHES PISTON MOVEMENTS

MAIN TOWER SYMBOL

GLOWS THE COLOR OF FORE ONCE IT STARTS RUNNING

WOODEN TRAIN

CANNON

PASSENGER CAR

UNNECESSARY, BUT I'D BE HAPPY IF IT WAS THERE.

CURTAIN

PLATFORM HEIGHT

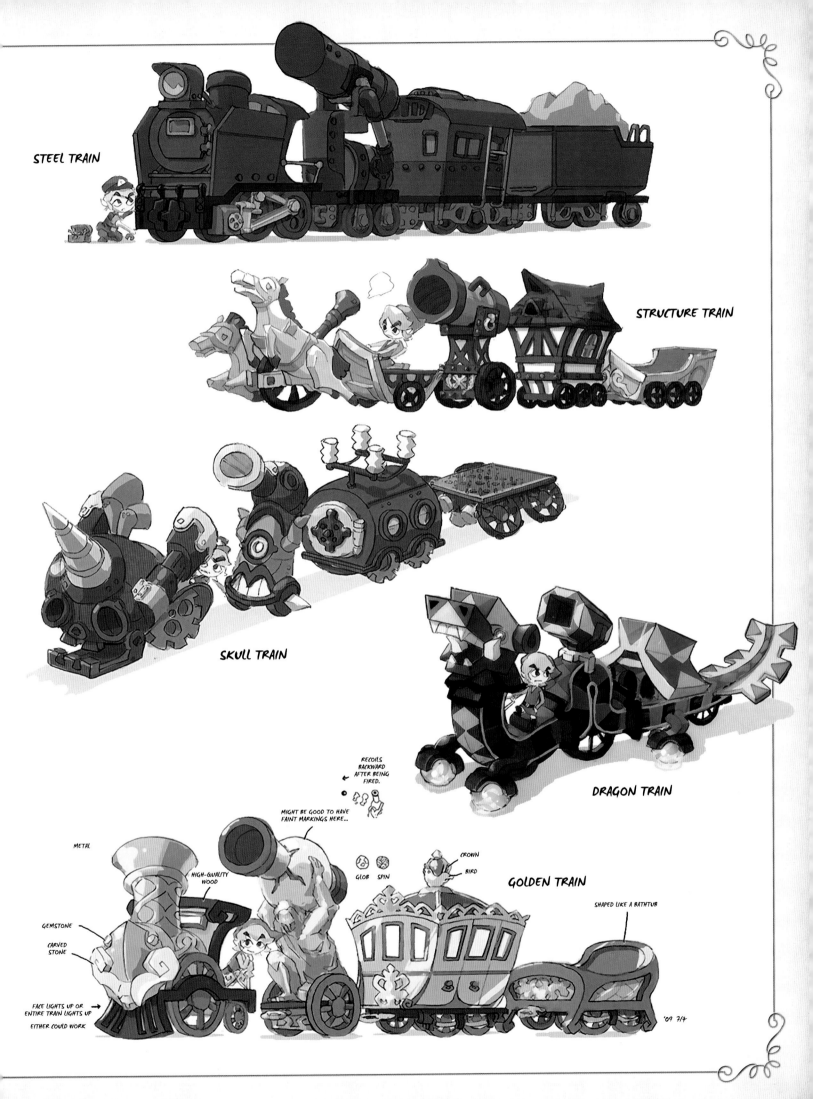

STEEL TRAIN

STRUCTURE TRAIN

SKULL TRAIN

DRAGON TRAIN

RECOILS
BACKWARD
AFTER BEING
FIRED.

MIGHT BE GOOD TO HAVE
FAINT MARKINGS HERE...

GLOB SPIN

CROWN

BIRD

GOLDEN TRAIN

METAL

HIGH-QUALITY
WOOD

SHAPED LIKE A BATHTUB

GEMSTONE

CARVED
STONE

FACE LIGHTS UP OR
ENTIRE TRAIN LIGHTS UP
EITHER COULD WORK

'09 7/4

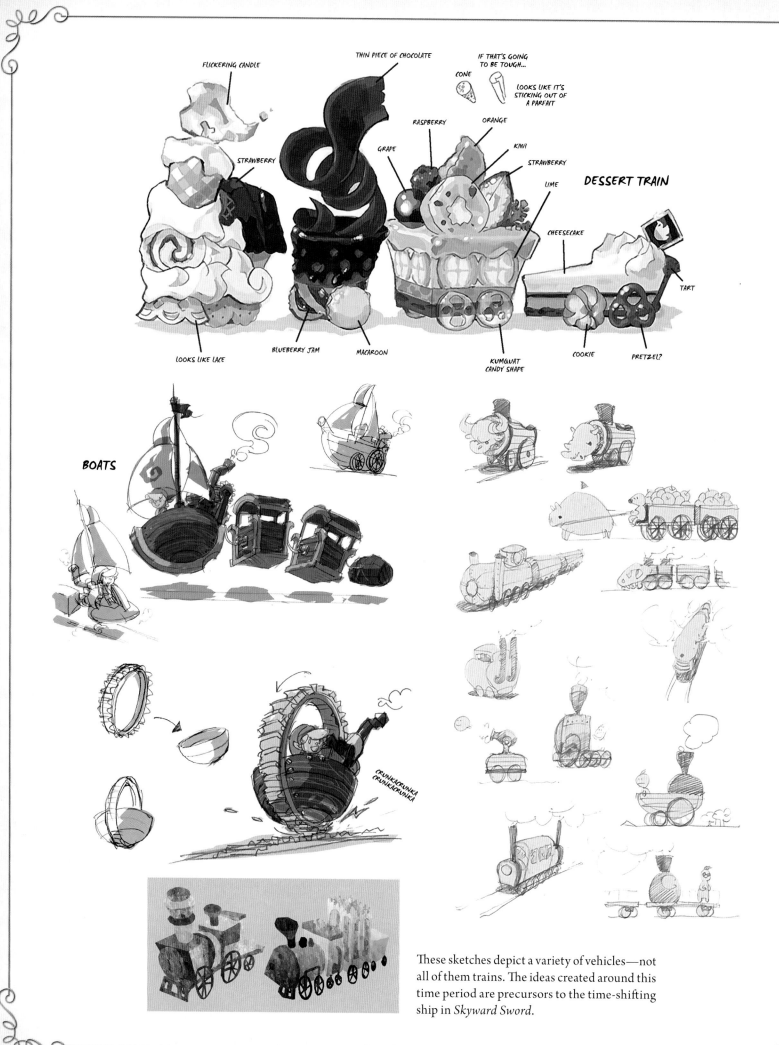

FLICKERING CANDLE

THIN PIECE OF CHOCOLATE

IF THAT'S GOING TO BE TOUGH...

CONE

LOOKS LIKE IT'S STICKING OUT OF A PARFAIT

RASPBERRY

ORANGE

STRAWBERRY

GRAPE

KIWI

STRAWBERRY

LIME

DESSERT TRAIN

CHEESECAKE

TART

LOOKS LIKE LACE

BLUEBERRY JAM

MACAROON

KUMQUAT CANDY SHAPE

COOKIE

PRETZEL?

BOATS

CRUNKACRUNKA CRUNKACRUNKA

These sketches depict a variety of vehicles—not all of them trains. The ideas created around this time period are precursors to the time-shifting ship in *Skyward Sword*.

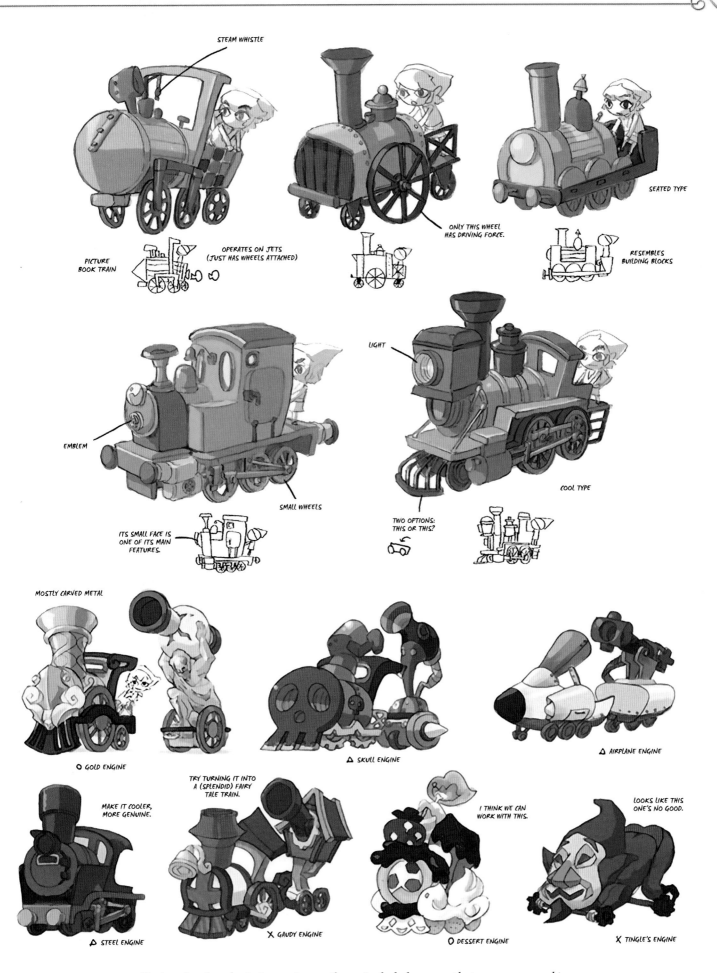

STEAM WHISTLE

OPERATES ON JETS
(JUST HAS WHEELS ATTACHED)

PICTURE
BOOK TRAIN

ONLY THIS WHEEL
HAS DRIVING FORCE.

SEATED TYPE

RESEMBLES
BUILDING BLOCKS

EMBLEM

SMALL WHEELS

ITS SMALL FACE IS
ONE OF ITS MAIN
FEATURES.

LIGHT

COOL TYPE

TWO OPTIONS:
THIS OR THIS?

MOSTLY CARVED METAL

O GOLD ENGINE

△ SKULL ENGINE

△ AIRPLANE ENGINE

MAKE IT COOLER,
MORE GENUINE.

△ STEEL ENGINE

TRY TURNING IT INTO
A (SPLENDID) FAIRY
TALE TRAIN.

X GAUDY ENGINE

I THINK WE CAN
WORK WITH THIS.

O DESSERT ENGINE

LOOKS LIKE THIS
ONE'S NO GOOD.

X TINGLE'S ENGINE

Design sketches depicting various railcars. Included are cars that never appeared in
the game, including an imitation of an airplane, and another in the shape of Tingle.

Et Cetera

To the right, design sketches for the Spirit Flute. Below, concept art for various items, including illustrations of Link using them.

SPIRIT FLUTE

BOW OF LIGHT

SHINING

WIND

BLOW

THIS DESIGN MIGHT BETTER RESEMBLE A TORNADO.

WHIRLWIND

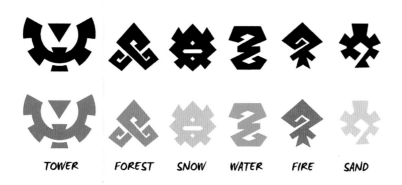

TOWER	FOREST	SNOW	WATER	FIRE	SAND

CRESTS

Above, the symbol of the Tower of Spirits and those of the temples found across the land. To the right, concept art depicting the crest and banner of Hyrule's royal family, as well as a shield carried by the Phantoms.

CONCEPT ART

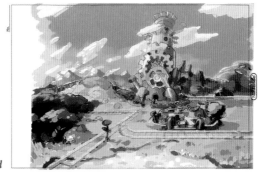

Field

STATION

OFFERINGS

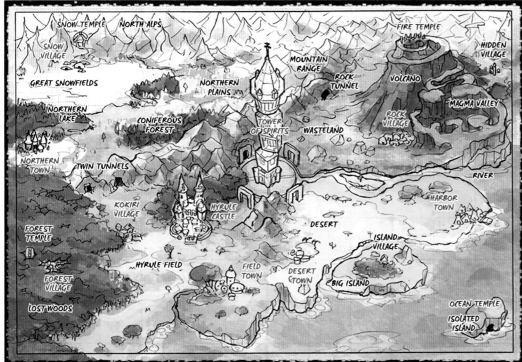

WORLD MAP

A world map drawn in early development. The designers consulted the world map throughout the game's development, ensuring that, no matter where the train went, players would always be able to see the Tower of Spirits located at the heart of the realm.

Force

RABBIT GATE

RABBITLAND RESCUE

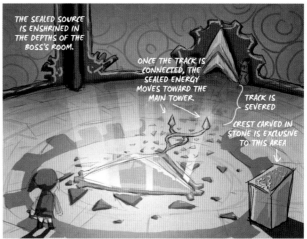

THE SEALED SOURCE IS ENSHRINED IN THE DEPTHS OF THE BOSS'S ROOM.

ONCE THE TRACK IS CONNECTED, THE SEALED ENERGY MOVES TOWARD THE MAIN TOWER

TRACK IS SEVERED

CREST CARVED IN STONE IS EXCLUSIVE TO THIS AREA

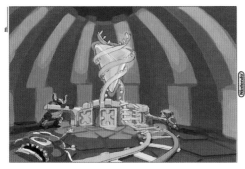

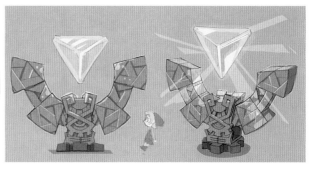

TOWER OF SPIRITS

The Tower of Spirits is a very important place in the story, and Link visits it many times during his adventure. Perhaps the fact that such a large number of design sketches were under consideration is a reflection of its importance.

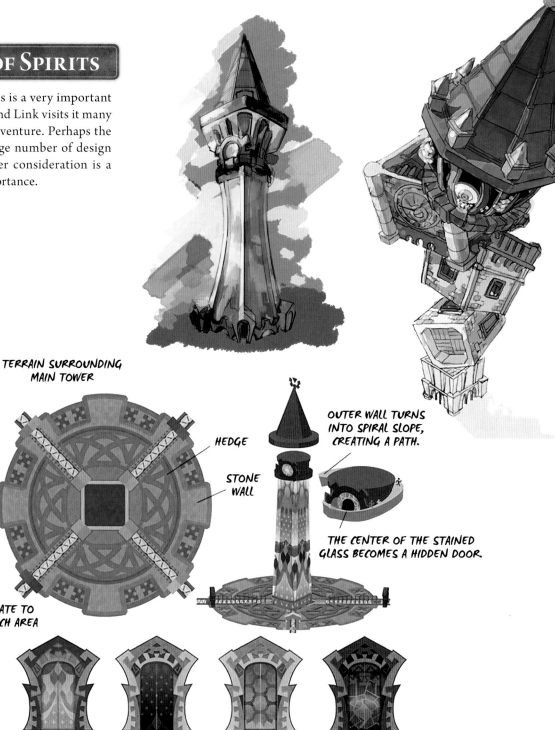

MAIN TOWER

TERRAIN SURROUNDING MAIN TOWER

FIRE
········
WATER
········
SNOW
········
FOREST
········

HEDGE

STONE WALL

GATE TO EACH AREA

OUTER WALL TURNS INTO SPIRAL SLOPE, CREATING A PATH.

THE CENTER OF THE STAINED GLASS BECOMES A HIDDEN DOOR.

FOREST SNOW WATER FIRE

↙ YGGDRASIL

CASTLE IN THE SKY

SOURCE OF THE MONSTERS

↑ MAGIC SQUARE CAUSES IT TO APPEAR!!

↑ LV2 DUNGEON CLEARED

↑ LV1 DUNGEON CLEARED

UP, UP, AND AWAY!!

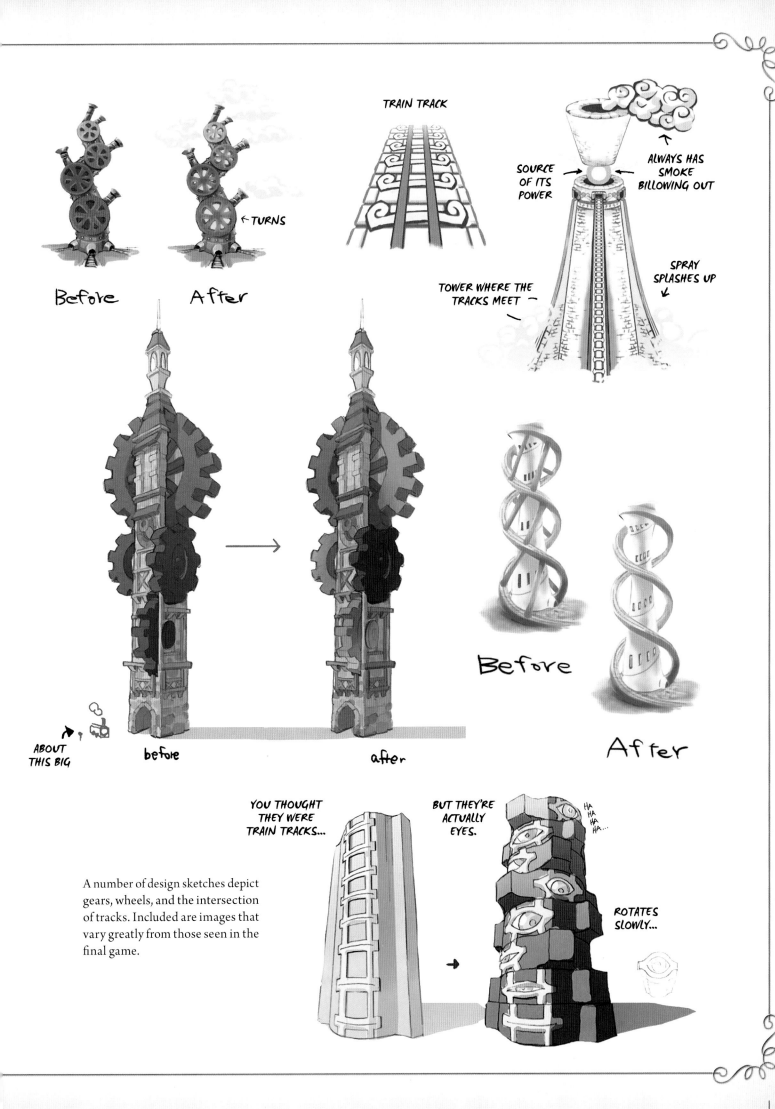

Before

After

← TURNS

TRAIN TRACK

SOURCE OF ITS POWER →

← ALWAYS HAS SMOKE BILLOWING OUT

TOWER WHERE THE TRACKS MEET →

SPRAY SPLASHES UP ↓

ABOUT THIS BIG

before

after

Before

After

YOU THOUGHT THEY WERE TRAIN TRACKS...

BUT THEY'RE ACTUALLY EYES.

HA HA HA HA...

ROTATES SLOWLY...

A number of design sketches depict gears, wheels, and the intersection of tracks. Included are images that vary greatly from those seen in the final game.

CHANGES IN CHARACTER DESIGN

With each incarnation of the series, the appearances of the characters have evolved. Here, we take a look at the changes in the order in which they appeared.

LINK

1986

THE LEGEND OF ZELDA

The original *Zelda* established Link's now-familiar style: a sword, a shield, and green garb.

1987

THE ADVENTURE OF LINK

In *The Adventure of Link*, our hero is now sixteen years old. As a result, he appears more mature than in the first title.

1991

A LINK TO THE PAST

The Triforce and a bird appear on Link's shield for the first time. The design of the shield was carried over to other games in the series, though it underwent many variations.

1993

LINK'S AWAKENING

1998

OCARINA OF TIME

Two generations of Links appear in this time-traveling adventure. Their appearance had a great influence on the protagonist's design in later games of the series.

2000

MAJORA'S MASK

Though the Link from *Majora's Mask* is the same as the Link from *Ocarina of Time*, he looks a bit more adventurous. Perhaps he has matured following his battle against Ganondorf.

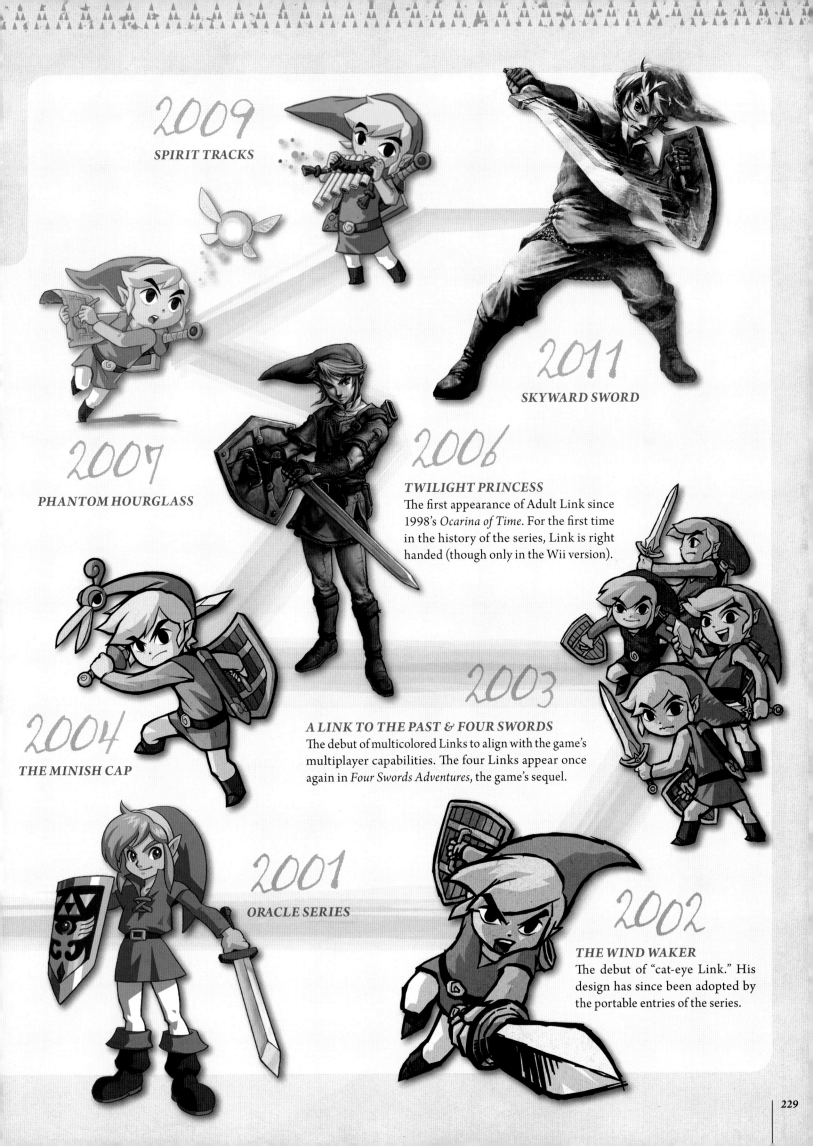

2009

SPIRIT TRACKS

2011

SKYWARD SWORD

2007

PHANTOM HOURGLASS

2006

TWILIGHT PRINCESS

The first appearance of Adult Link since 1998's *Ocarina of Time*. For the first time in the history of the series, Link is right handed (though only in the Wii version).

2004

THE MINISH CAP

2003

A LINK TO THE PAST & FOUR SWORDS

The debut of multicolored Links to align with the game's multiplayer capabilities. The four Links appear once again in *Four Swords Adventures*, the game's sequel.

2001

ORACLE SERIES

2002

THE WIND WAKER

The debut of "cat-eye Link." His design has since been adopted by the portable entries of the series.

ZELDA

THE LEGEND OF ZELDA

An illustration of Princess Zelda. Her outfit is very simple, compared to the Princess Zeldas from *A Link to the Past* onward. Her hair color in this game is red, rather than the gold that fans are familiar with.

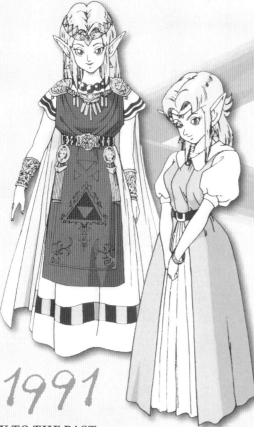

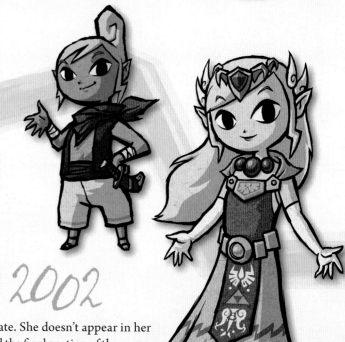

1991

A LINK TO THE PAST

The first Princess Zelda to have golden hair. Her design determined the look of the Princess Zeldas that followed.

1998

OCARINA OF TIME

As with Link, two generations of Zeldas appear in the game. It also marks the introduction of her alter ego, Sheik.

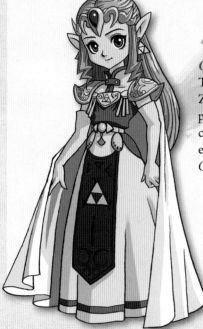

2001

ORACLE SERIES

This incarnation of Princess Zelda has more exaggerated proportions, making her appear cutesy. The design of her outfit emulates Adult Zelda's from *Ocarina of Time*.

2002

THE WIND WAKER

The debut of Tetra the pirate. She doesn't appear in her familiar princess form until the final portion of the game.

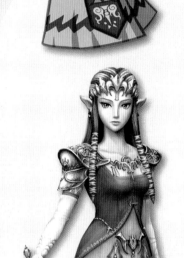

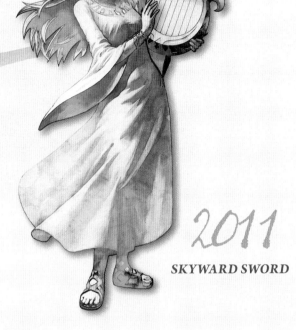

2009

SPIRIT TRACKS

Because she is intended to be a descendant of Tetra, her look is similar to Tetra's appearance as a princess in *The Wind Waker*. On the left, she is nothing more than a spirit after losing possession of her body.

2011

SKYWARD SWORD

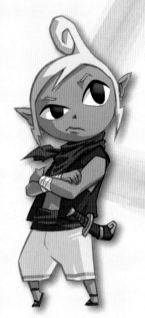

2006

TWILIGHT PRINCESS

This incarnation of Princess Zelda is the most mature of any Zelda in the series so far. She takes on a frightening form when she is possessed by Ganondorf in the final portion of the game.

2007

PHANTOM HOURGLASS

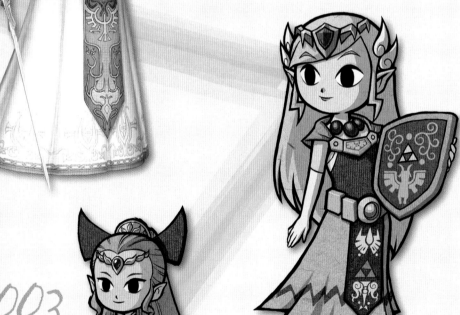

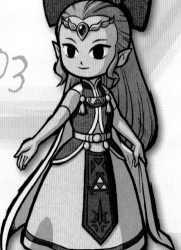

2003

A LINK TO THE PAST & FOUR SWORDS

Princess Zelda as she appears in *Four Swords*. The large ribbon adorning her head is one of her hallmarks.

2004

THE MINISH CAP

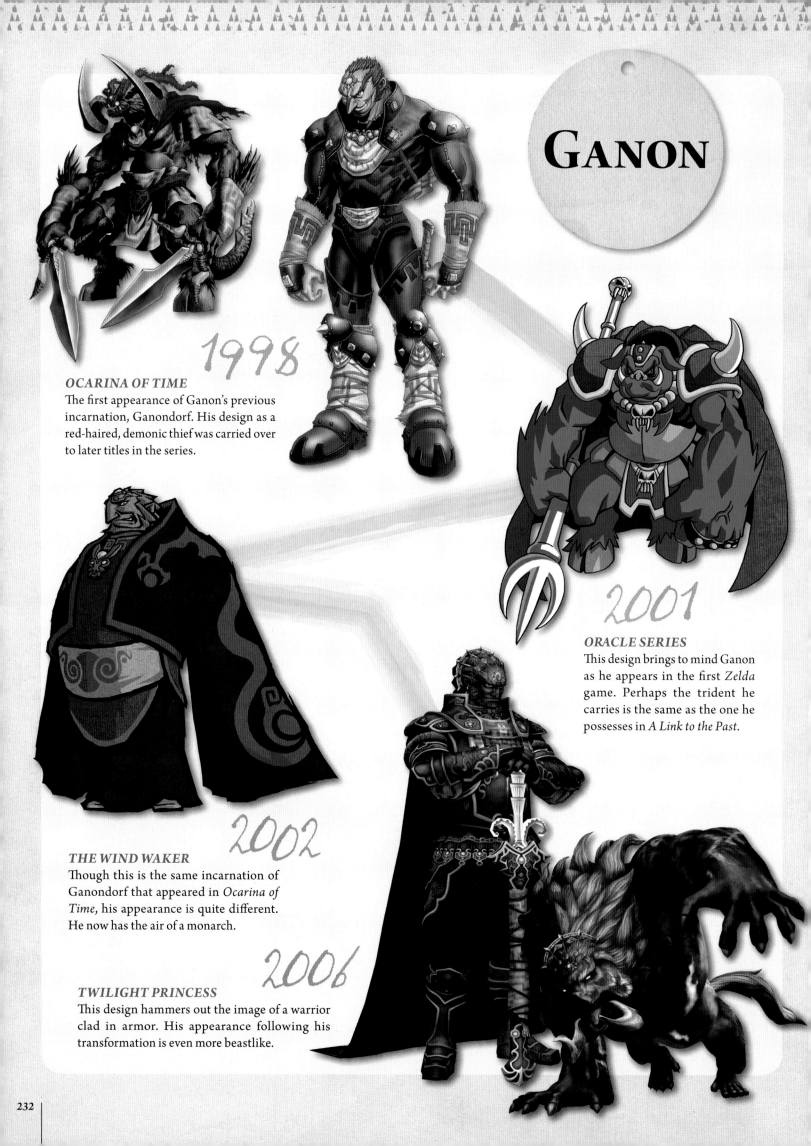

GANON

1998

OCARINA OF TIME
The first appearance of Ganon's previous incarnation, Ganondorf. His design as a red-haired, demonic thief was carried over to later titles in the series.

2001

ORACLE SERIES
This design brings to mind Ganon as he appears in the first *Zelda* game. Perhaps the trident he carries is the same as the one he possesses in *A Link to the Past*.

2002

THE WIND WAKER
Though this is the same incarnation of Ganondorf that appeared in *Ocarina of Time*, his appearance is quite different. He now has the air of a monarch.

2006

TWILIGHT PRINCESS
This design hammers out the image of a warrior clad in armor. His appearance following his transformation is even more beastlike.

Game Catalog

The *Legend of Zelda* series has spawned numerous sequels and spinoffs. Here, you'll find a collection of all the titles that have been released to date. Let's take a look back at how far the series has come.

THE LEGEND OF ZELDA

- Famicom Disk System • Released February 21, 1986

< Ports >
- Famicom • Released February 19, 1994
- Famicom Mini 05 (Game Boy Advance) • Released February 14, 2004
- Virtual Console (Wii) • Released December 2, 2006

THE FIRST GAME IN THE SERIES

This launch title for the Famicom Disk System marked the first game in the series. It also established a system of using items to solve puzzles, which went on to become a mainstay of the *Zelda* series. The game included a second quest, which could be enjoyed after completing the main story line.

European version

ZELDA II: THE ADVENTURE OF LINK

- Famicom Disk System • Released January 14, 1987

< Ports >
- Famicom Mini 25 (Game Boy Advance) • Released August 10, 2004
- Virtual Console (Wii) • Released January 23, 2007

A UNIQUE SIDE SCROLLER

The second game in the series adopted a side-scrolling perspective when players maneuvered through towns and palaces, as well as during enemy battles. It incorporated more action than the first *Zelda*. A leveling system, rare for the series, was also introduced. This allowed players to choose which abilities to augment when leveling up.

European version

THE LEGEND OF ZELDA: A LINK TO THE PAST

- Super Nintendo • Released November 21, 1991

< Ports >
- Virtual Console (Wii) • Released December 2, 2006

AN ADVENTUROUS JOURNEY ACROSS TWO WORLDS

The third game in the series was the first to be released on the Super Nintendo. Its basic game play followed in the footsteps of the original *Legend of Zelda*. However, players were now capable of traveling between the Light World and the Dark World, and as a result, the game's size drastically increased. In addition, the ability to grab and throw objects was introduced to the series.

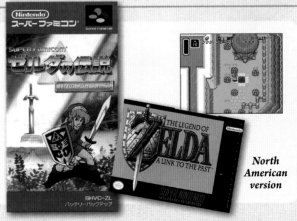

North American version

THE LEGEND OF ZELDA: LINK'S AWAKENING / LINK'S AWAKENING DX

- *Link's Awakening*: Game Boy • Released June 6, 1993
- *Link's Awakening DX*: Game Boy Color • Released December 12, 1998
- < Ports >
- Virtual Console (Nintendo 3DS) • Released June 8, 2011

THE FIRST *ZELDA* RELEASED ON A PORTABLE SYSTEM

Link's Awakening was the first title in the series to be released on a portable game system. Though Zelda and Ganon are nowhere to be seen, personalities resembling historic Nintendo characters such as Mario, Yoshi, and Chain Chomp appear in supporting roles. *Link's Awakening DX*, which contained new puzzles and dungeons, was released later.

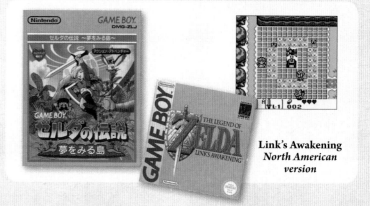

*Link's Awakening
North American
version*

THE LEGEND OF ZELDA: OCARINA OF TIME

- Nintendo 64 • Released November 21, 1998
- < Ports >
- Virtual Console (Wii) • Released February 27, 2007

THE GAME THAT MADE *ZELDA* WORLD FAMOUS

Ocarina of Time was the first installment in the series to make use of the Nintendo 64's 3-D graphics. The game's puzzle solving and detailed world, rendered in 3-D, charmed gamers the world over and boosted *Zelda*'s popularity. Players were able to switch between Child Link and Adult Link at will, adventuring in the eras of past and present.

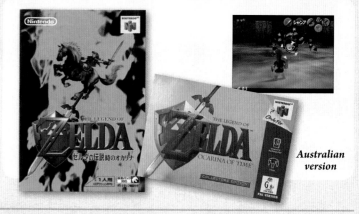

*Australian
version*

THE LEGEND OF ZELDA: MAJORA'S MASK

- Nintendo 64 • Released April 27, 2000
- < Ports >
- Virtual Console (Wii) • Released April 7, 2009

THE DARK SEQUEL TO *OCARINA OF TIME*

In a continuation of the story of *Ocarina of Time*, Link had three days to stop the moon from falling and destroying everything. Players unlocked new puzzles and changed the flow of time by playing the ocarina, continuously reliving the three days leading up to the lunar body's impact. The game was characterized, in part, by Link's ability to transform using the power of masks.

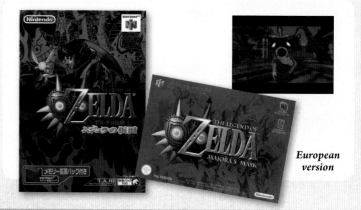

*European
version*

THE LEGEND OF ZELDA: ORACLE OF SEASONS / ORACLE OF AGES

- Game Boy Color • Released February 27, 2001

**A GAME BY THE DREAM TEAM OF
NINTENDO AND CAPCOM**

Oracle of Seasons and *Oracle of Ages* were released simultaneously. The fact that Nintendo and Capcom united to develop the new installments in the *Zelda* series stirred up the excitement of the fans.

It was possible to connect *Seasons* and *Ages* via a linking system. Players could unlock new dungeons and items by inputting passwords obtained during their adventures into the companion game.

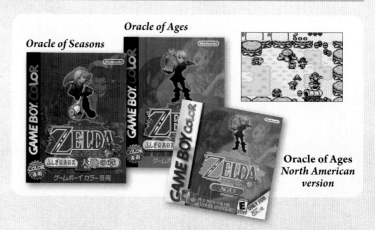

Oracle of Ages

Oracle of Seasons

*Oracle of Ages
North American
version*

THE LEGEND OF ZELDA: THE WIND WAKER

• Nintendo GameCube • Released December 13, 2002

THE DEBUT OF "CAT-EYE LINK"

This game adopted a technique known as cel shading. The animated 3-D graphics fully rendered Link's facial expressions, breathing new life into the series.

In contrast to the landlocked settings of the previous games, *The Wind Waker* took place on the ocean. Players controlled a boat, traveling between islands in order to solve puzzles. The game could also be connected to the Game Boy Advance, making cooperative play possible for the first time in the history of the series.

Australian version

Limited-edition English version

THE LEGEND OF ZELDA: OCARINA OF TIME MASTER QUEST

This limited-edition disk was distributed as a bonus for preordering *The Wind Waker*. The disk included two games: a reissue of *Ocarina of Time* for the GameCube, and *Ocarina of Time Master Quest*, a more difficult version of the original title. The latter was a rare, previously unreleased game initially developed for the Nintendo 64 peripheral known as the 64DD or 64 Disk Drive. Fans flooded to preorder *The Wind Waker* in an attempt to obtain the limited-edition disk.

THE LEGEND OF ZELDA: A LINK TO THE PAST & FOUR SWORDS

• Game Boy Advance • Released March 14, 2003

< Ports >
• *The Legend of Zelda: Four Swords Anniversary Edition*:
DSiWare (Nintendo DSi/DS XL/3DS) • Distributed free from September 28, 2011 to February 20, 2012

A REISSUE THAT ADDED NEW CONTENT

This game was a reissue of *A Link to the Past* for the Game Boy Advance. Players could connect with *Four Swords* in order to enjoy cooperative play. A new version of the game was distributed in 2011 to commemorate the series' twenty-fifth anniversary.

European version

THE LEGEND OF ZELDA: FOUR SWORDS ADVENTURES

• Nintendo GameCube • Released March 18, 2004

FOUR SWORDS POWERS UP

The sequel to *Four Swords*, a game that was bundled with the reissue of *A Link to the Past*. It included three modes: Hyrulean Adventure, a single-player campaign, Shadow Battle, a battle royale that could be enjoyed by up to four players, and Navi Trackers, a game that involved collecting medallions. In multiplayer mode, players could connect the Game Boy Advance to the GameCube and use the system as a controller.

North American version

THE LEGEND OF ZELDA: THE MINISH CAP

• Game Boy Advance • Released November 4, 2004

SHRINK DOWN AND JOURNEY INTO A NEW WORLD!
Following the release of the *Oracle* series and *Four Swords*, Nintendo and Capcom teamed up once again. In this game, Link was able to shrink himself at will using portals between the macro world and the tiny Minish world. The game was packed with things to do, from fusing Kinstones to using Mysterious Shells to collect figurines.

North American
version

THE LEGEND OF ZELDA: TWILIGHT PRINCESS

• Wii and Nintendo GameCube • Released December 2, 2006
(GameCube version sold online for a limited time)

**INTUITIVE CONTROLS NOW POSSIBLE
WITH THE WII REMOTE!**
Twilight Princess made its debut as a Wii launch title. Fans were captivated by the intuitive controls, a hallmark of the Wii, and Link's realistic proportions. Players shape shifted between man and beast, cooperating with Midna to save Hyrule from danger. The Nintendo GameCube version, with its mirrored screen, was released at the same time.

North
American
Wii version

European
GameCube
version

LINK'S CROSSBOW TRAINING

A shooting game that came bundled with a peripheral known as the Wii Zapper. By placing the Wii Remote and Nunchuk in the Zapper, players were able to use their controller like a crossbow. The game was set in the world of *Twilight Princess*. Link, equipped with the Crossbow, shot down targets and balloons in addition to established *Zelda* baddies such as Keese and Bokoblins.

THE LEGEND OF ZELDA: PHANTOM HOURGLASS

• Nintendo DS • Released June 23, 2007

WINNING OVER NEW FANS WITH SIMPLE CONTROLS
This Nintendo DS title served as the sequel to *The Wind Waker*. All major actions, such as moving and attacking, could be performed with the stylus, and the simplistic controls earned the series new fans. In addition, the game came equipped with the capability to write notes on the bottom touchscreen, a hallmark of the DS. A two-player battle mode was also included, which could be accessed via the DS Wi-Fi or wireless connections.

North
American
version

THE LEGEND OF ZELDA: SPIRIT TRACKS

• Nintendo DS • Released December 23, 2009

PRINCESS ZELDA TEAMS UP WITH LINK!

In the sequel to *Phantom Hourglass*, the basic system of game play was identical to its predecessor, but the setting was switched from sea to land. Link's means of transportation underwent the biggest change, with Link traveling by train rather than by boat. *Spirit Tracks* also marked the first time in the series that Princess Zelda partnered up with Link on his adventure as a playable character. The princess's body was possessed by a Phantom in a dungeon, and her spirit cooperated with Link to solve puzzles and progress through the game.

North American version

THE LEGEND OF ZELDA: OCARINA OF TIME 3D

• Nintendo 3DS • Released June 16, 2011

THE NEXT EVOLUTION OF THE MASTERPIECE, NOW ON 3DS!

This update of *Ocarina of Time* was released on the 3DS. The game was more than a reissue; it featured a number of improvements to the original, such as beautiful 3-D graphics, the convenience of storing and using items via the bottom touchscreen, and a viewing mode making use of the gyroscope. Players could also try their hand at the more challenging *Ocarina of Time 3D Master Quest* after clearing the game.

Australian version

ELUSIVE AND RARE ZELDA TITLES

HERE, WE INTRODUCE SOME RARE *ZELDA* TITLES THAT ARE NOW DIFFICULT TO OBTAIN OR CAN NO LONGER BE PLAYED.

THE LEGEND OF ZELDA: COLLECTOR'S EDITION

This compilation was distributed via Club Nintendo in 2004 and could be obtained by trading in points. In addition to the games listed below, the compilation also included a collection of famous scenes from past titles, enticing the fans. Because the disk is no longer being distributed, it has become difficult to obtain.

< Titles included >

• *The Legend of Zelda*
• *The Adventure of Link*
• *Ocarina of Time*
• *Majora's Mask*
• *The Wind Waker* (demo version)

European version

BS THE LEGEND OF ZELDA

These games were broadcast via the Satellaview, a satellite modem for the Super Nintendo. Two titles were created for the system: *BS The Legend of Zelda*, based on the first *Zelda* game, and *BS The Legend of Zelda: Ancient Stone Tablets*, based on *A Link to the Past*. Because Satellaview broadcasts ended in 2000, the games are unplayable today.

WRAPPING THINGS UP

Eiji Aonuma, director and producer at Nintendo Corporation and series producer of the *Legend of Zelda* series

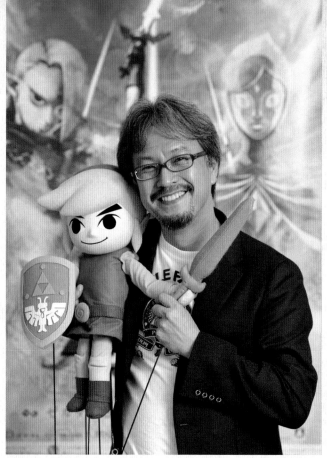

Photos: Shoji Chudo

This year, we've been able to welcome the twenty-fifth anniversary of *The Legend of Zelda*, and it's all thanks to you. We've launched a number of campaigns to show our appreciation for the fan support the series has received, including holding a symphony orchestra concert in three major cities around the world and distributing *Four Swords Anniversary Edition* for free via DSiWare. After all this, I found myself wondering whether there wasn't anything left over that we would be able to compile into a book. That's how *The Legend of Zelda: Hyrule Historia* came to be.

This book is divided into four sections. The first section, "The Legend Begins," tells the story of *Skyward Sword*, the latest entry in the series. The second, "The History of Hyrule," is organized chronologically according to the eras of the *Zelda* series. The third is known as "Creative Footprints," where we introduce artwork from the games, including rough sketches from past releases. Finally, the fourth section features a special comic from comic-book queens Akira Himekawa.

"Creative Footprints" contains a large amount of material that has never before left the halls of Nintendo. In order to help us compile this section, staff members were kind enough to go hunting through stacks of ancient documents, an experience akin to losing themselves in the depths of a dungeon.

"The History of Hyrule" allows players to determine where each *Zelda* game is positioned in the chronology of the series. One thing to bear in mind, however, is that the question the developers of the *Legend of Zelda* series asked themselves before starting on a game was, "What kind of game play should we focus on?" rather than "What kind of story should we write?" For example, the theme of *Ocarina of Time*, the first *Zelda* game I was involved with, was, "What kind of responsive game play will we be able to create in a 3-D environment?" The theme of *Phantom Hourglass*, which I helped develop for the Nintendo DS, was, "How can we make the game comfortable to control using the stylus?" Lastly, the theme of *Skyward Sword*, the latest entry in the series, was, "How can we use the Wii Remote Plus to allow players to freely manipulate the sword?"

Because the games were developed in such a manner, it could be said that *Zelda*'s story lines were afterthoughts.

Eiji Aonuma's HYRULE HISTORY

1998	*The Legend of Zelda: Ocarina of Time* (Nintendo 64): Game System Director
2000	*The Legend of Zelda: Majora's Mask* (Nintendo 64): Game System Director
2002	*The Legend of Zelda: The Wind Waker* (Nintendo GameCube): Director
2003	*The Legend of Zelda: A Link to the Past & Four Swords* (Game Boy Advance): Producer
2004	*The Legend of Zelda: Four Swords Adventures* (Nintendo GameCube): Producer
2004	*The Legend of Zelda: The Minish Cap* (Game Boy Advance): Supervising Director
2006	*The Legend of Zelda: Twilight Princess* (Wii and Nintendo GameCube): Director
2007	*The Legend of Zelda: Phantom Hourglass* (Nintendo DS): Producer
2008	Official Wii Zapper with *Link's Crossbow Training* (Wii): Producer
2009	*The Legend of Zelda: Spirit Tracks* (Nintendo DS): Producer
2011	*The Legend of Zelda: Ocarina of Time 3D* (Nintendo 3DS): Producer
2011	*The Legend of Zelda: Four Swords Anniversary Edition* (DSiWare): Producer
2011	*The Legend of Zelda: Skyward Sword* (Wii): Producer

As a result, I feel that even the story of "The Legend Begins" in *Skyward Sword* was something that simply came about by chance.

Flipping through the pages of "The History of Hyrule," you may even find a few inconsistencies. However, peoples such as the Mogma tribe and items such as the Beetle that appear in *Skyward Sword* may show up again in other eras. Thus, it is my hope that the fans will be broad minded enough to take into consideration that this is simply how *Zelda* is made.

I may be exaggerating a little, but I feel like developing a large-scale video game like *The Legend of Zelda* is similar to setting out on a voyage across the ocean in the distant past. I've said that each installment in the series has a theme. For me, that involves coming up with a system that I've not yet had the opportunity to explore. It's similar to seeking a new continent that no one on Earth has visited before.

We set out from the harbor without a single sea chart. We start out not knowing what direction we're heading in, and the small crew argues back and forth about where to go and what to do. Sometimes, we find ourselves adrift. Other times, we're buffeted by storms and end up becoming shipwrecked. Still others, we cry that we've discovered new land, but when we make for shore, we end up at a loss when we find that it was nothing but a tiny, barren island.

However, we never remain in the same place for long, and as we keep moving forward, we eventually catch sight of the new continent we've been seeking just beyond the horizon. The crew gets bigger, and we all band together to make a push for the new world.

It's a lot of fun, enough to make me completely forget about the times that I felt like abandoning ship when storms crashed down around us. If we manage to make it safely to the opposite

shore, then I know that fans around the world will enjoy what we've achieved. That's the greatest gratification of making *Zelda*.

With the completion of *Skyward Sword* in time for *Zelda*'s twenty-fifth anniversary, our long voyage is only just now complete. We're starting to hear feedback from people all over the world who have been kind enough to play our game. This feedback includes both praise and criticism. However, the voices of the fans provide us with energy for our next voyage. To be honest with you, the new voyage has already begun.

I extend my sincerest gratitude and appreciation for your continued support of *The Legend of Zelda*.

Never stop playing *Zelda*!
Eiji Aonuma

これからも
ゼルダをヨロシク！
青沼英二

STOP! This is the back of the manga section!

This comic is translated into English, but arranged in right-to-left reading format to maintain the artwork's visual orientation as originally drawn and published in Japan. If you've never read comics this way before, take a look at the diagram below to give yourself an idea of how to go about it. You'll start in the upper right-hand corner and will read each word balloon and panel moving right to left. It may take a little getting used to, but you should get the hang of it very quickly. Have fun! (And if this is the millionth manga you've read this way, never mind!)

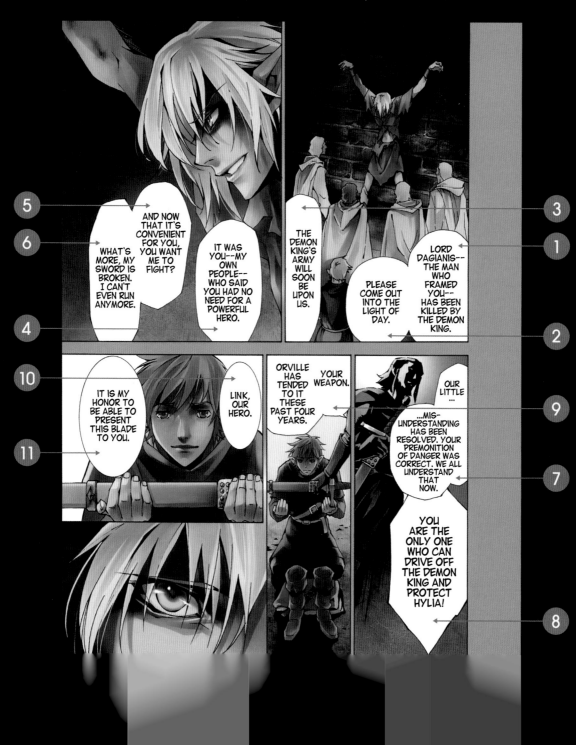

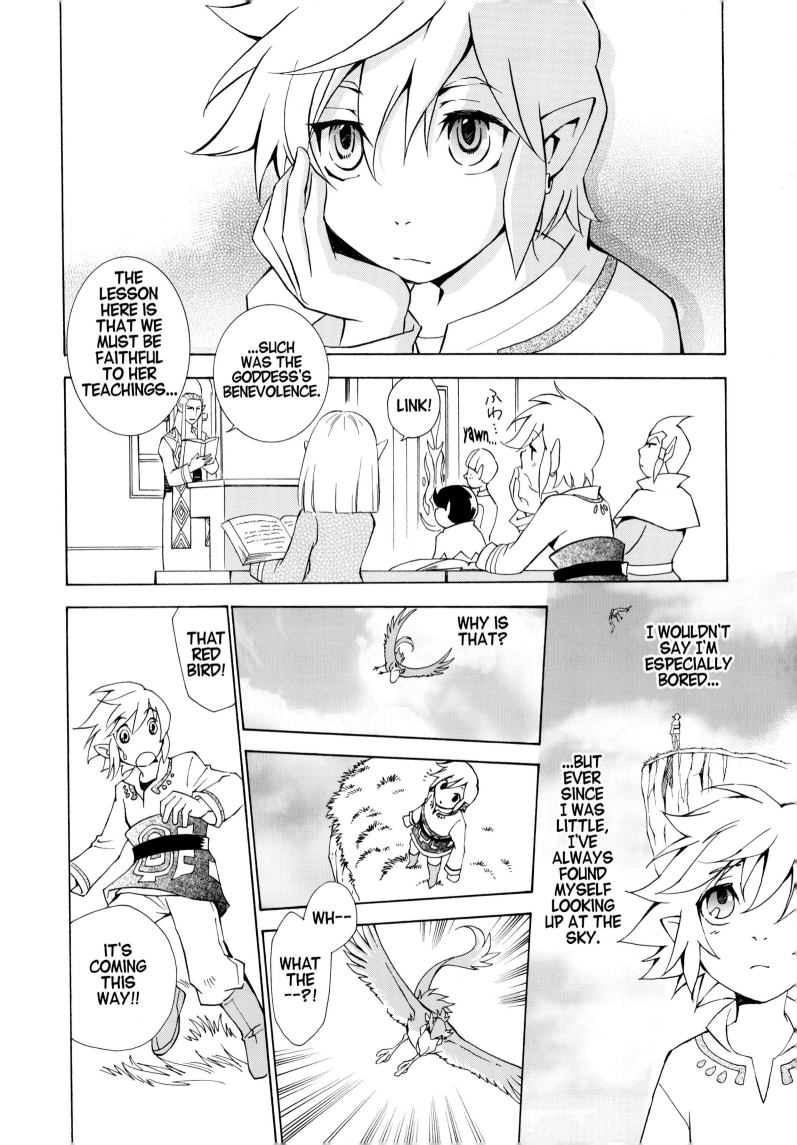

THE SWORD WAS TEMPERED BY YOUR SPIRIT.

YOU WOKE IT...

...AND WILL SERVE AS ITS MASTER FOR ALL ETERNITY...

LIKE A SWORD HAMMERED AND HONED SO THAT IT WOULD NEVER BREAK.

YOUR IMPRISONMENT WAS WILLED BY THE HEAVENS. IT WAS MEANT TO MAKE YOU STRONG.

IT WAS NECESSARY TO TRANSFORM YOU INTO ONE FIT TO WIELD THE MASTER SWORD...

THIS IS BECAUSE YOU DEEPLY LOVE THE LAND OF HYLIA...

...AND ALL ITS PEOPLE...

...AS I DO.

I HAVE WATCHED YOU...

...AND FELT YOUR PAIN LIKE A KNIFE THROUGH MY BODY.

BUT BECAUSE OF THIS, YOUR LIFE HAS BEEN FULL OF SUFFERING.

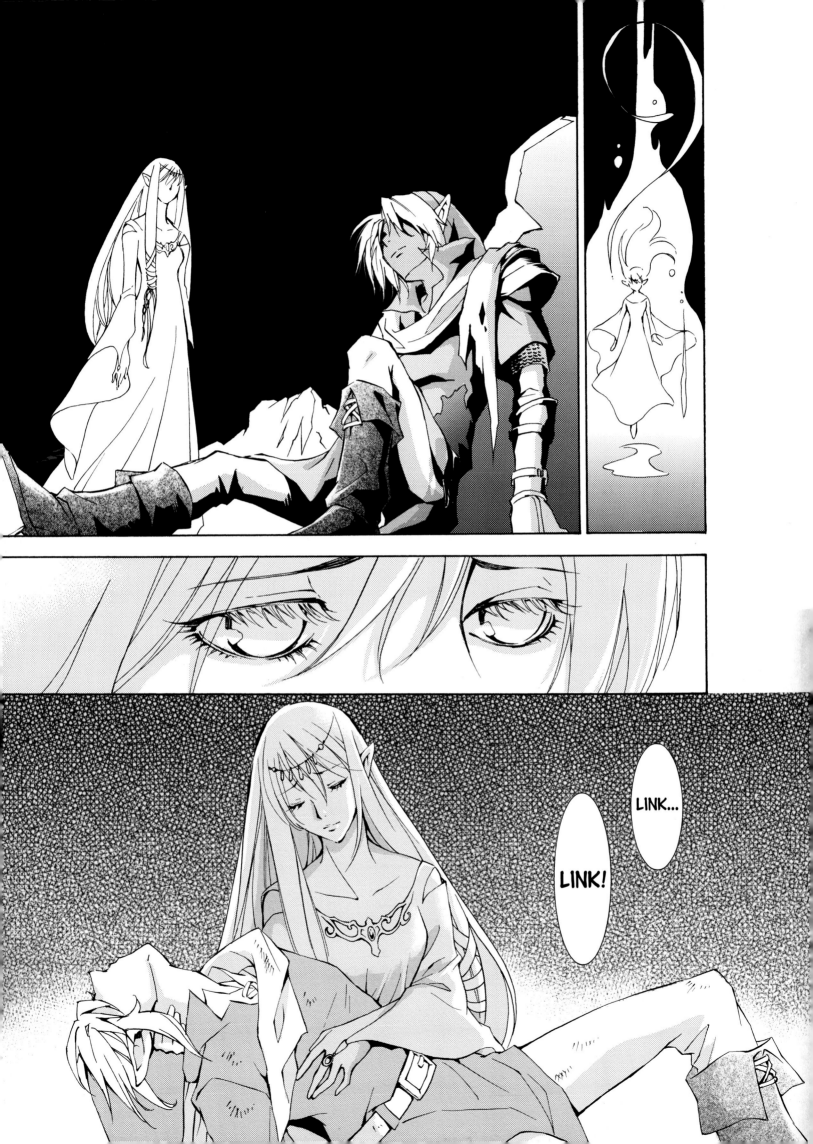

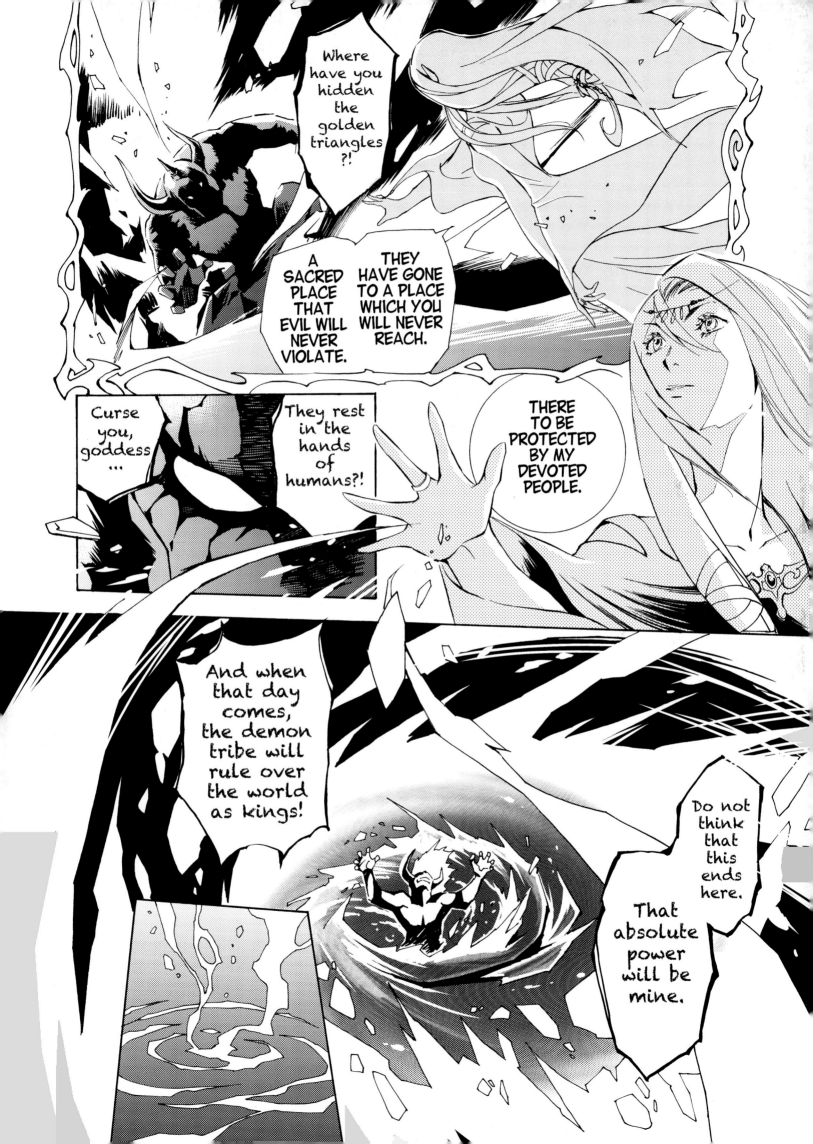

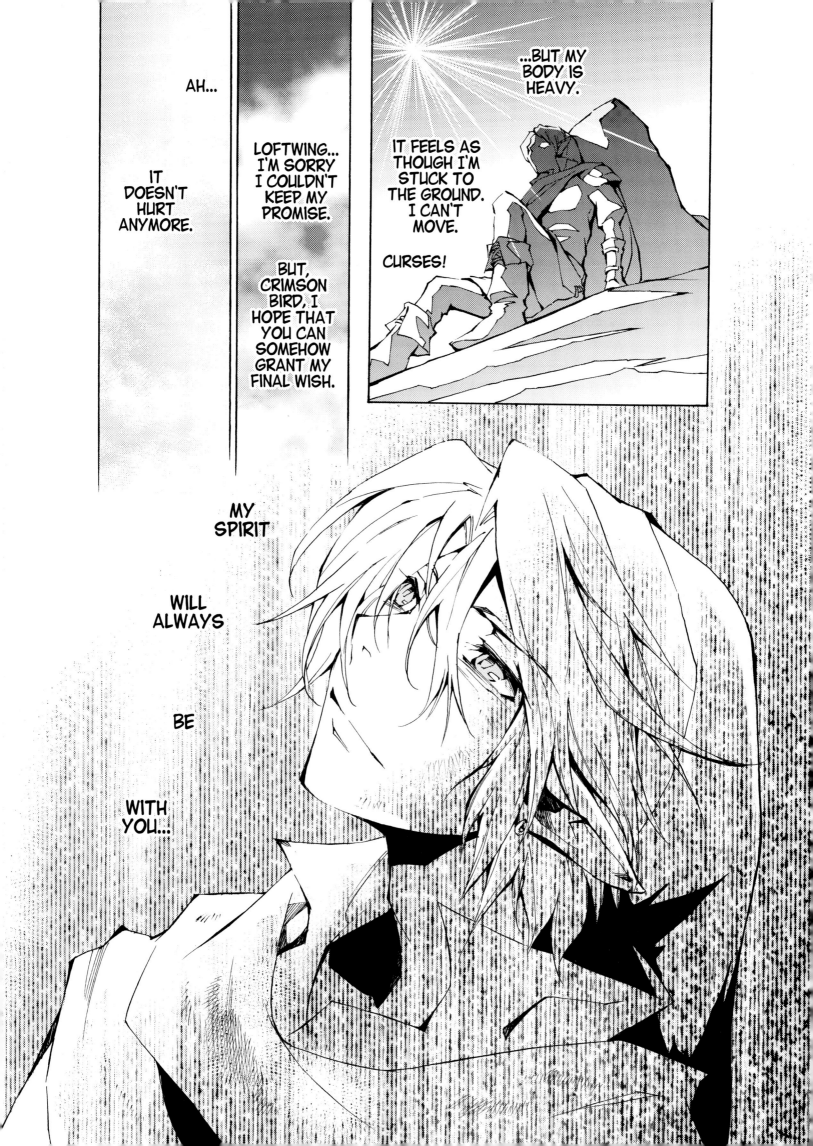

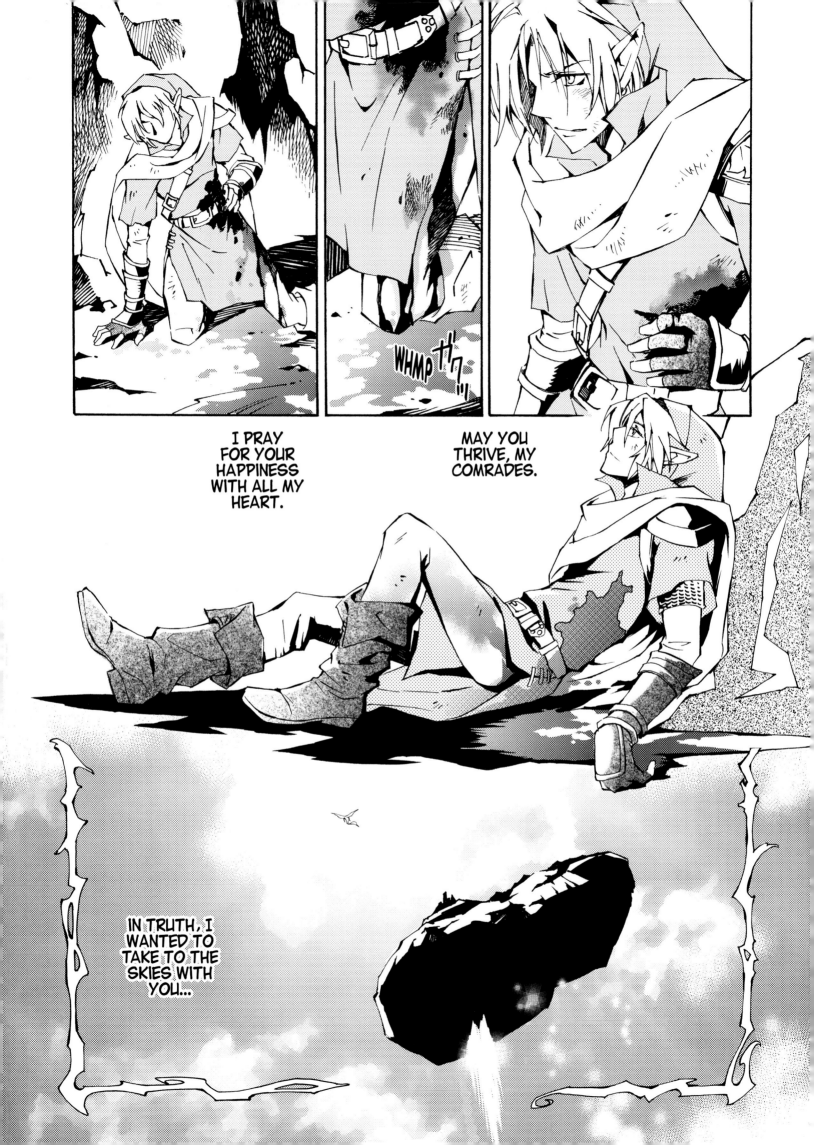

I PRAY FOR YOUR HAPPINESS WITH ALL MY HEART.

MAY YOU THRIVE, MY COMRADES.

WHMP

IN TRUTH, I WANTED TO TAKE TO THE SKIES WITH YOU...

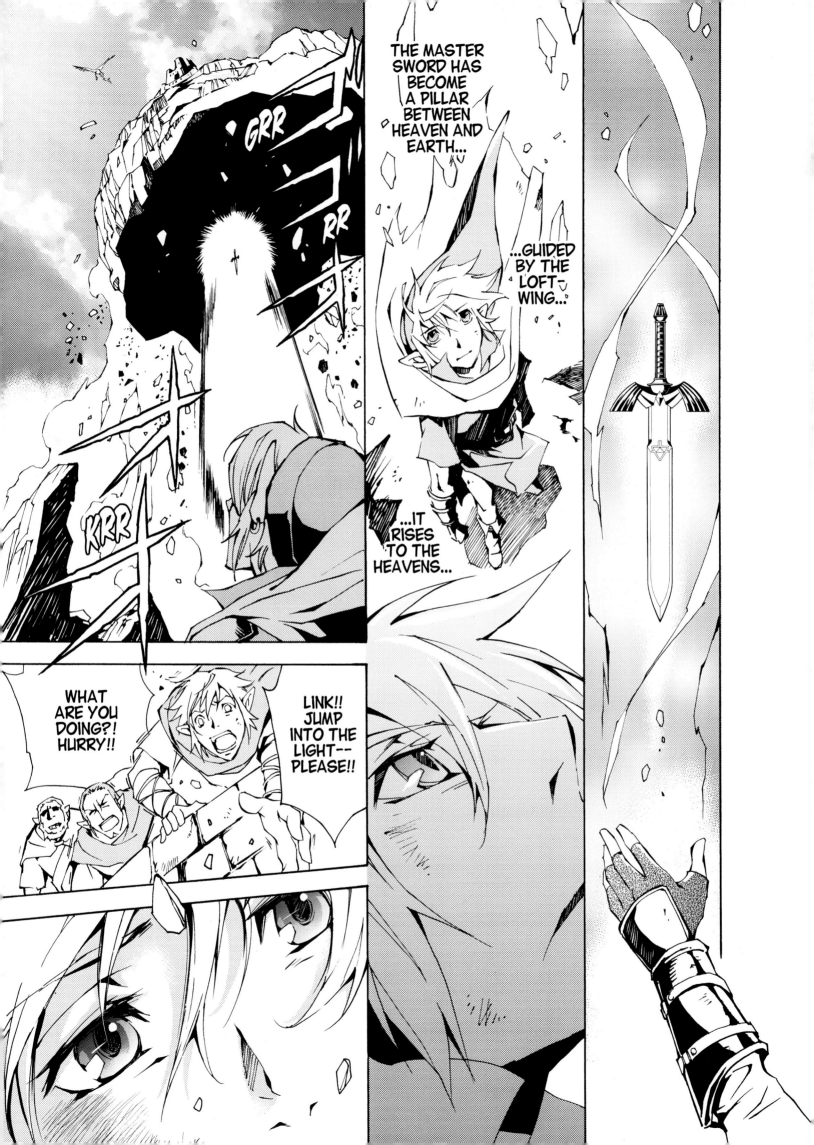

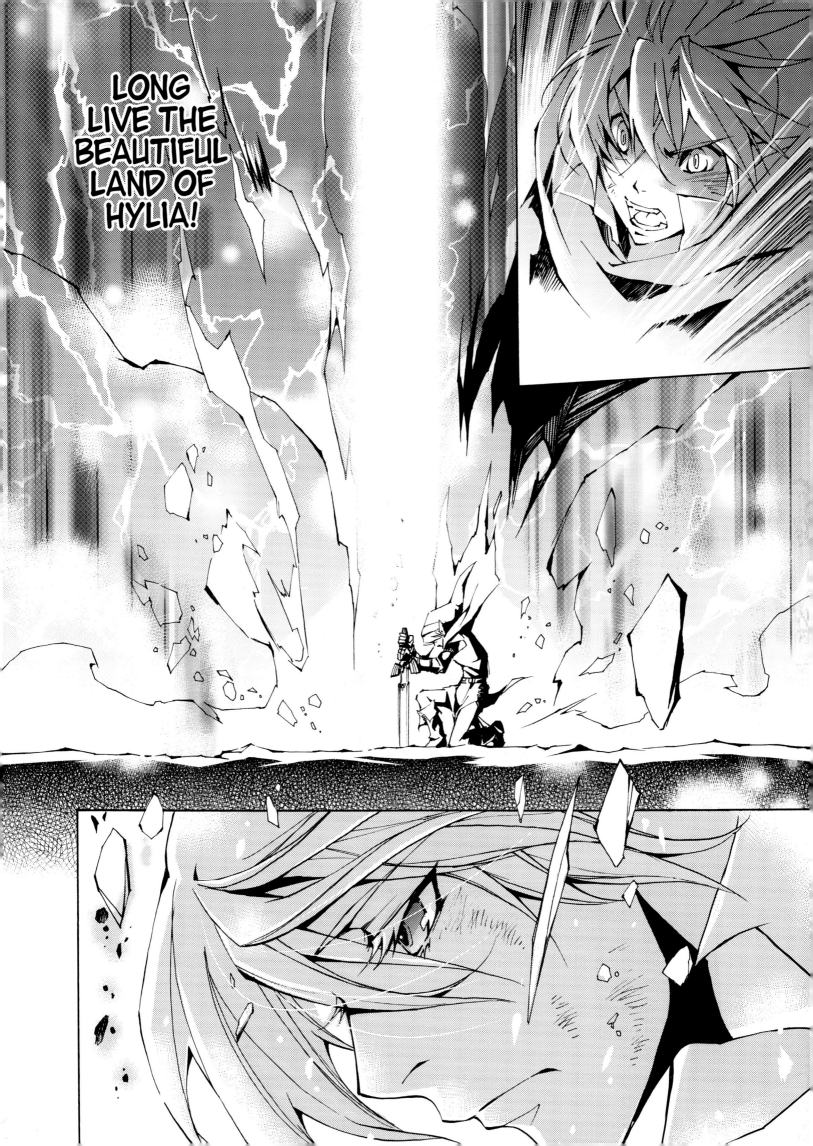

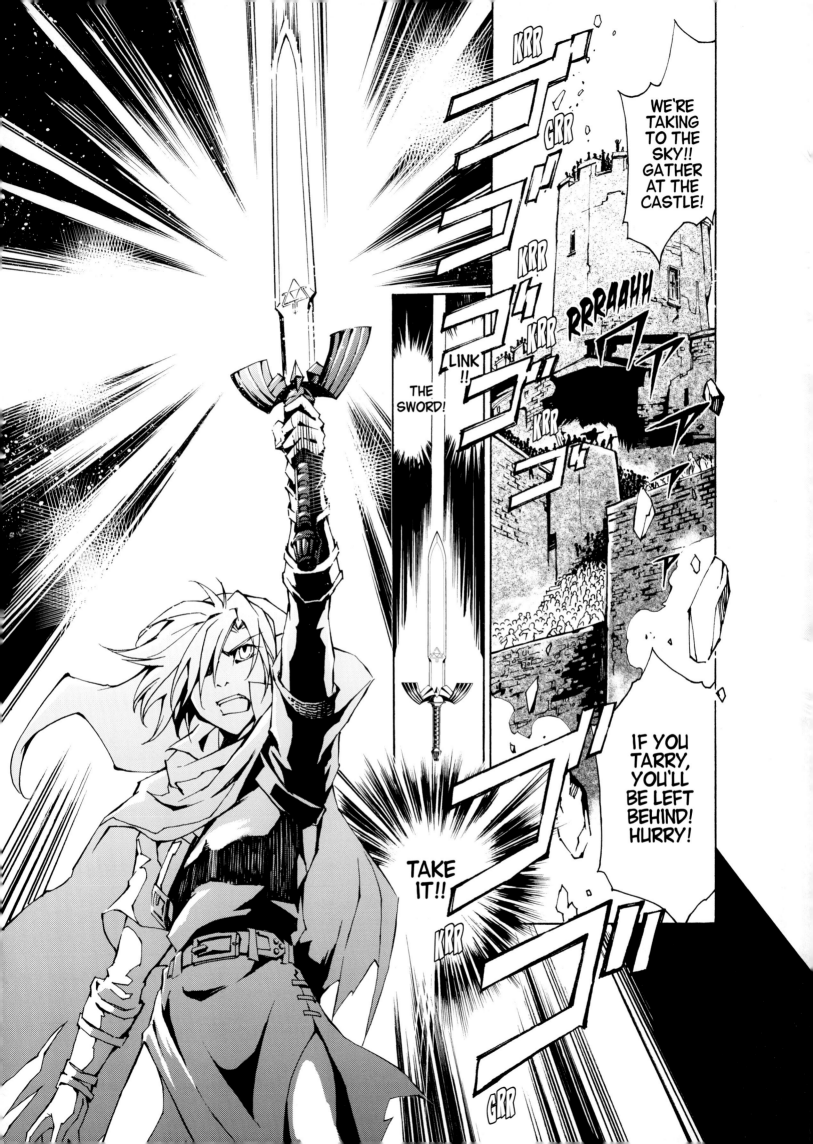

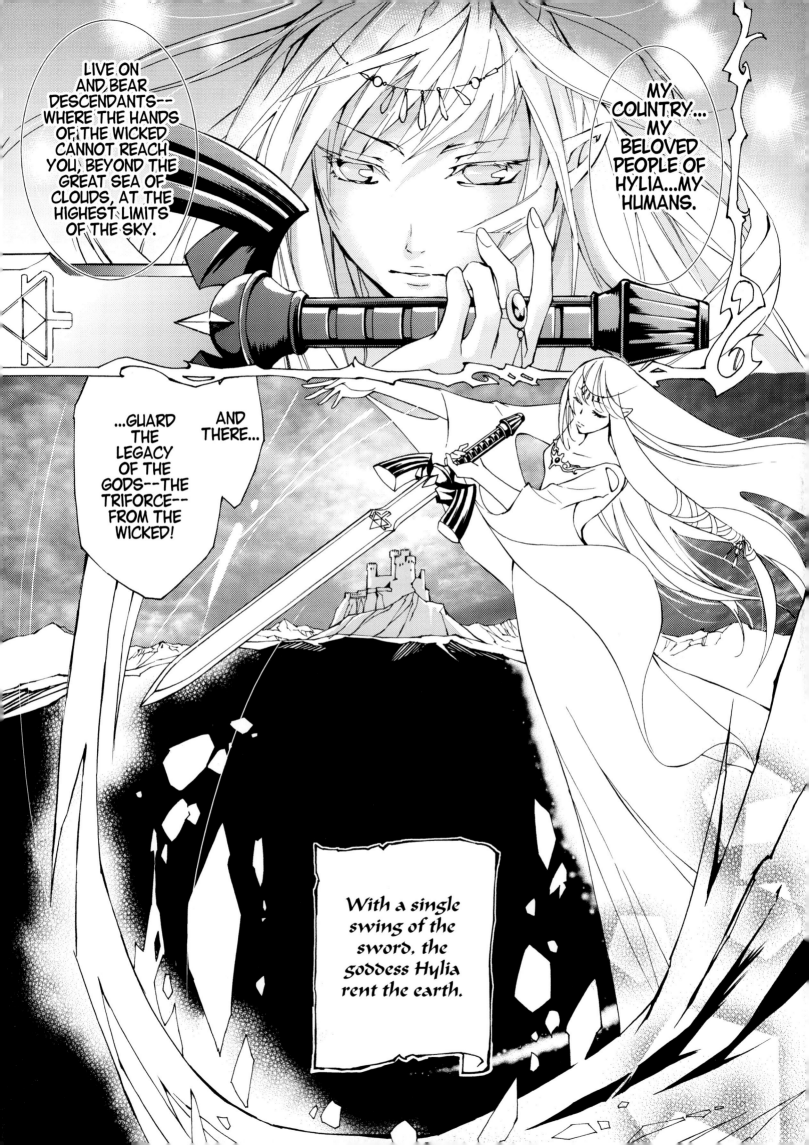

With a single swing of the sword, the goddess Hylia rent the earth.

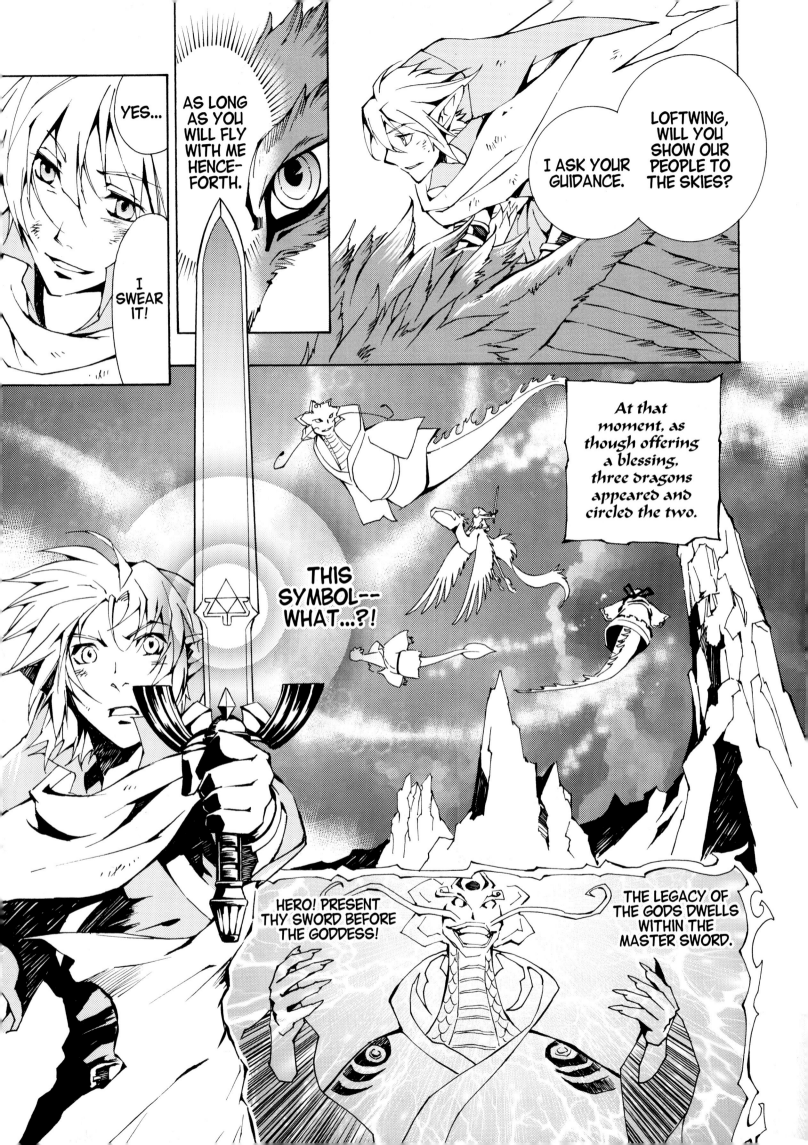

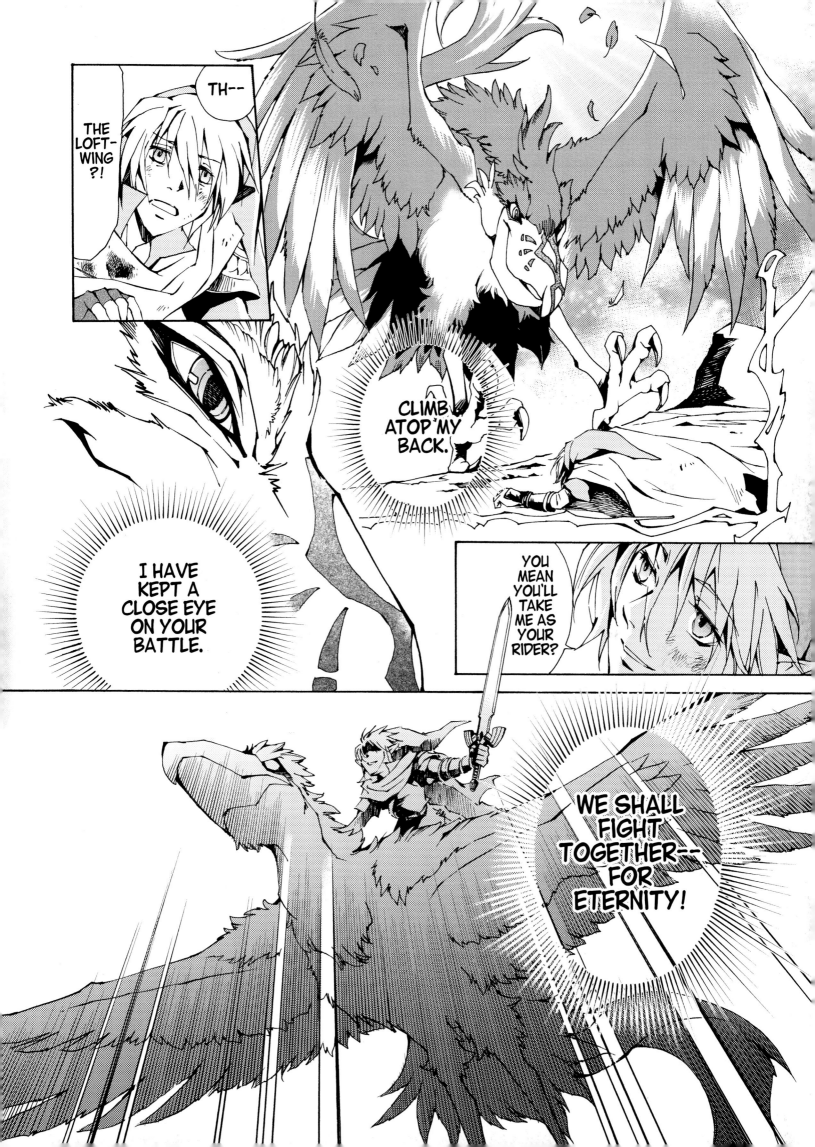

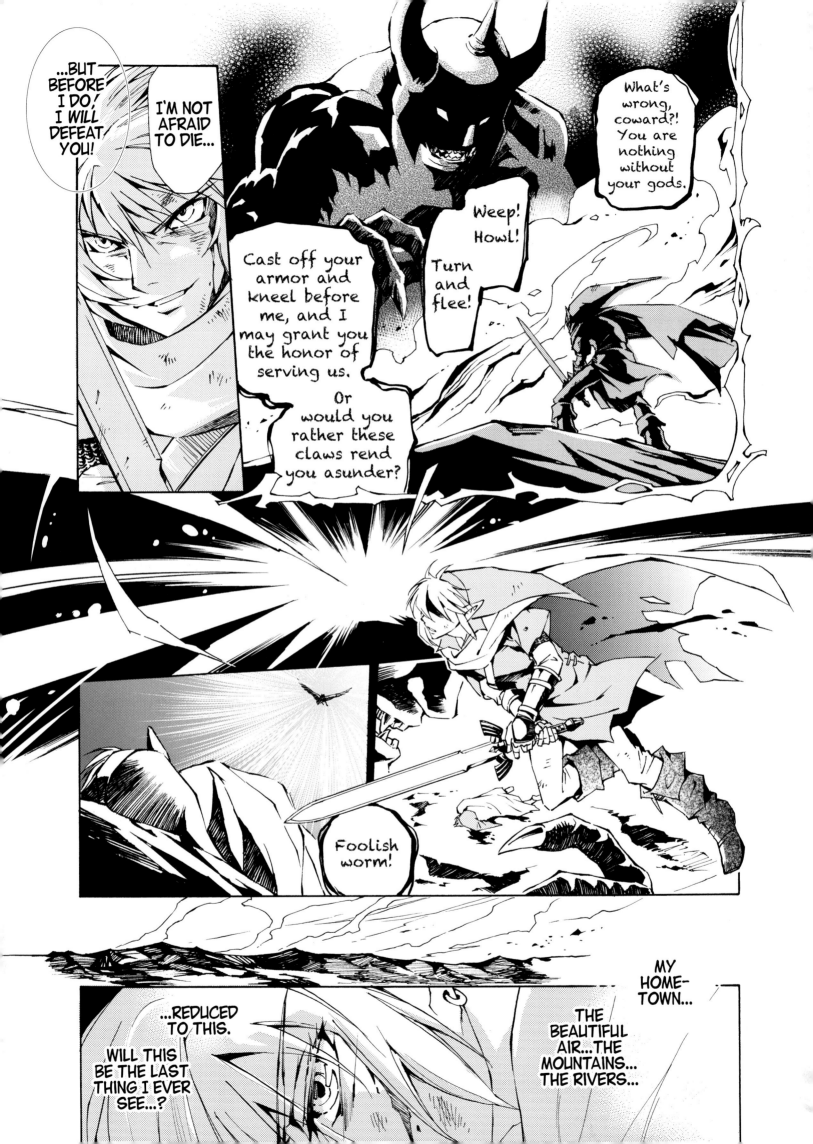

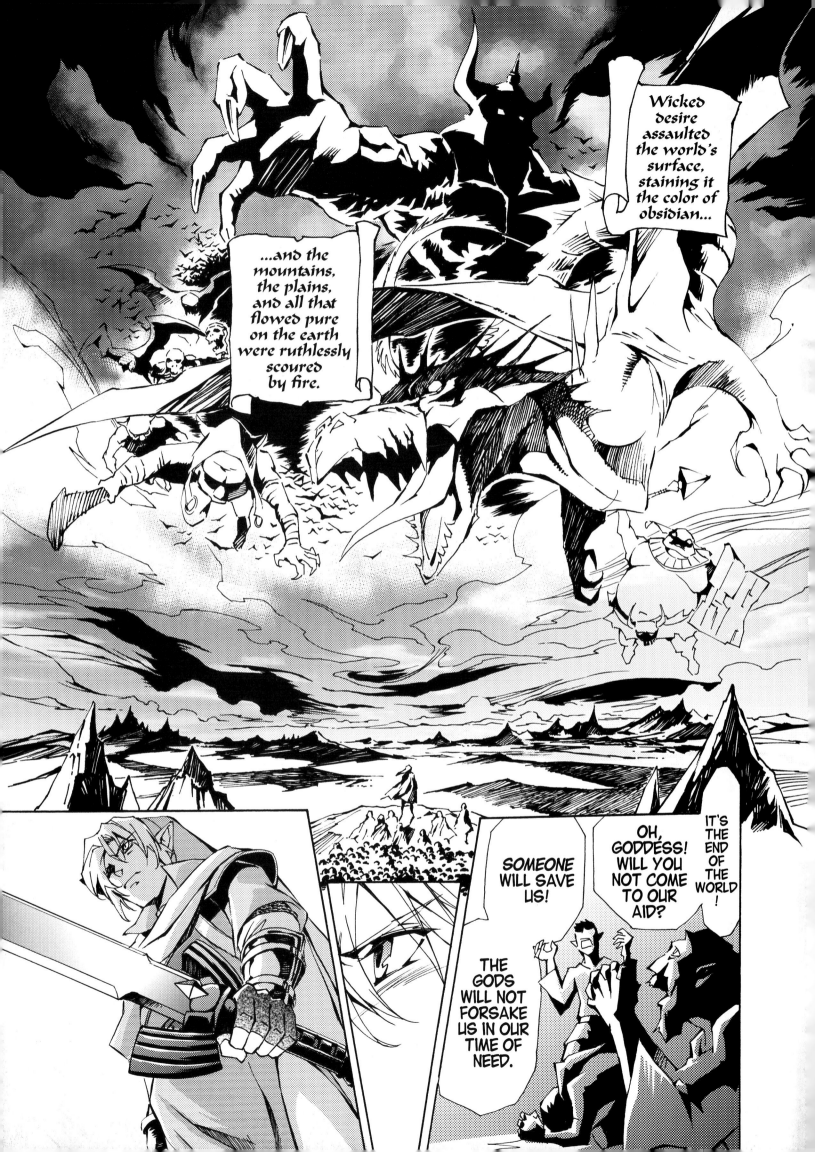

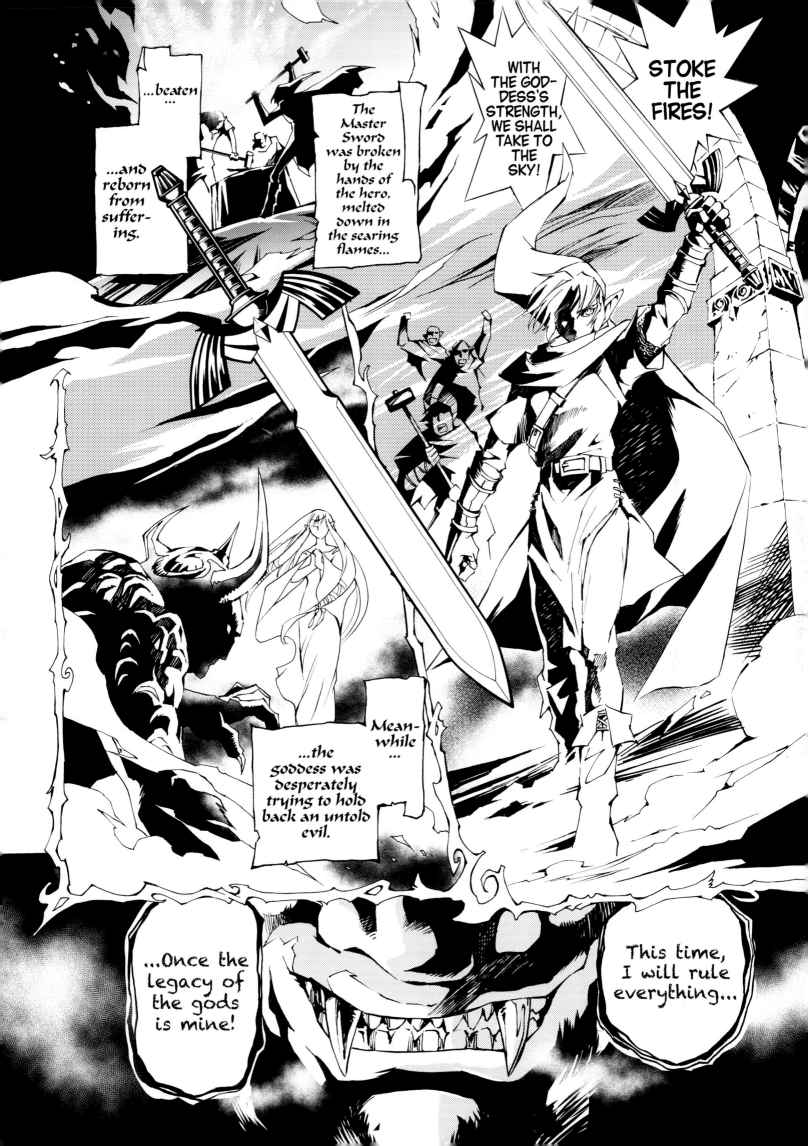

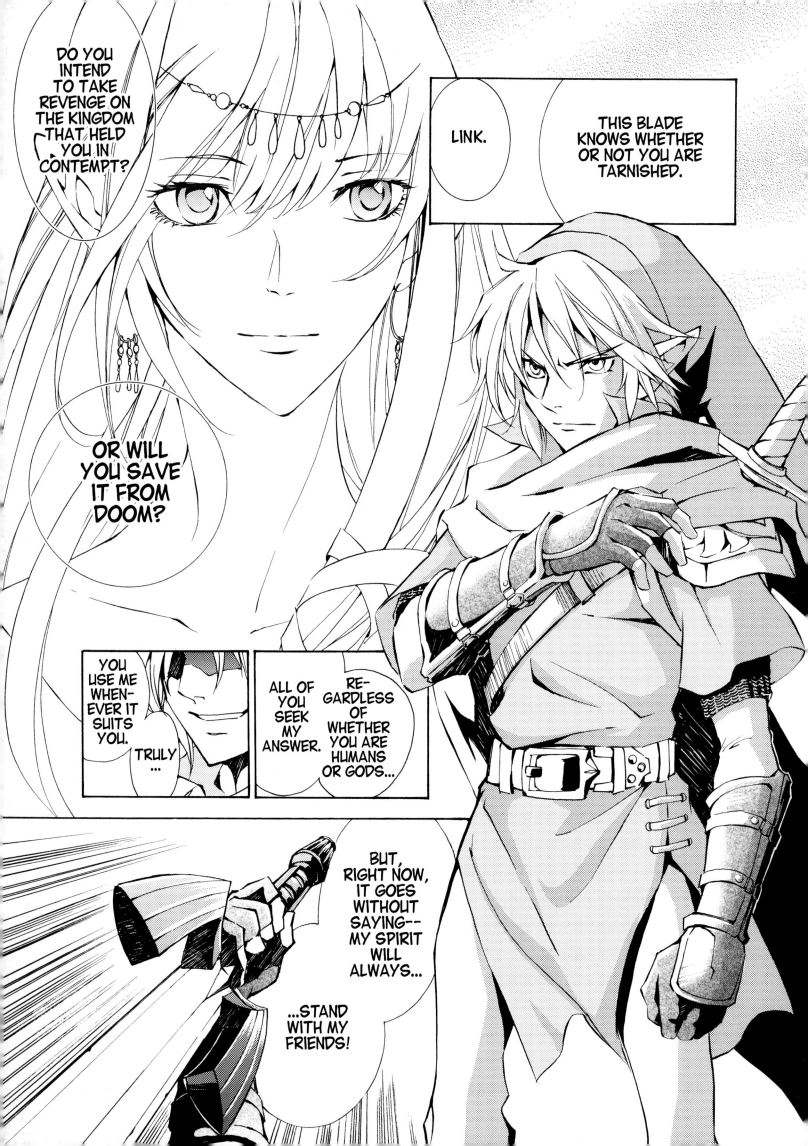

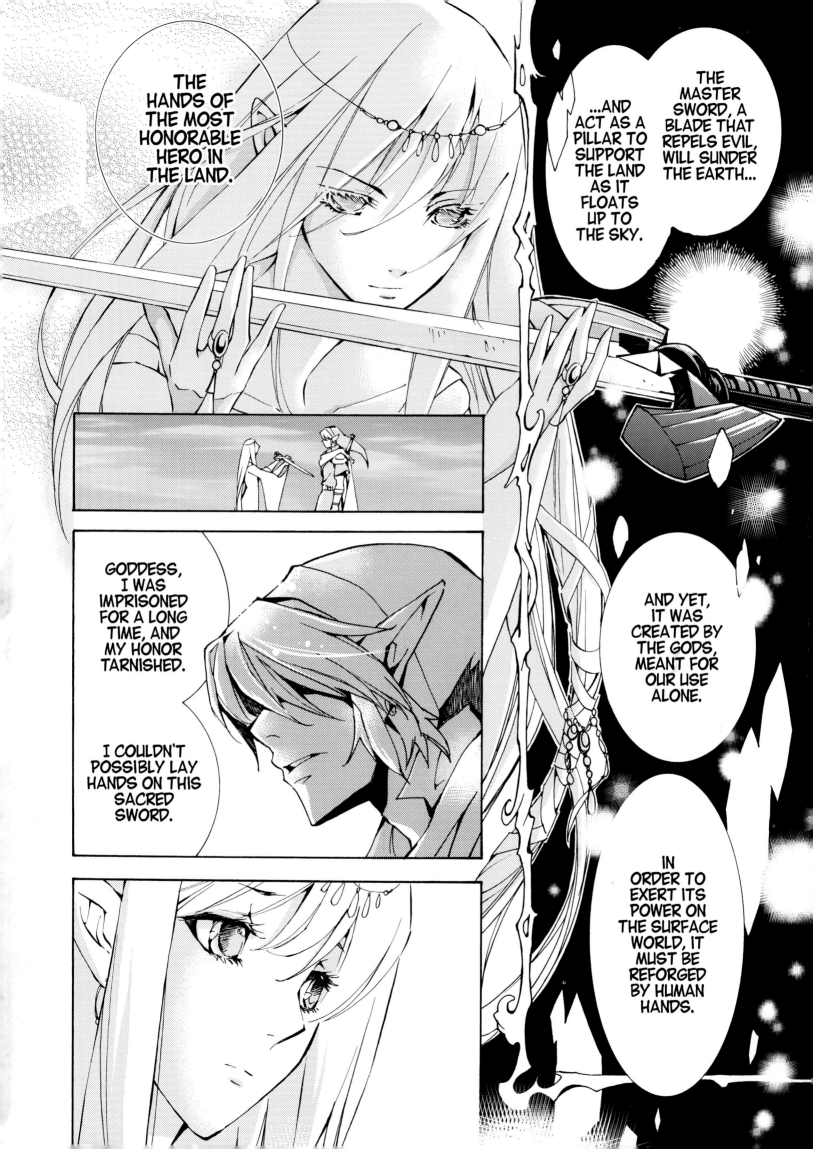

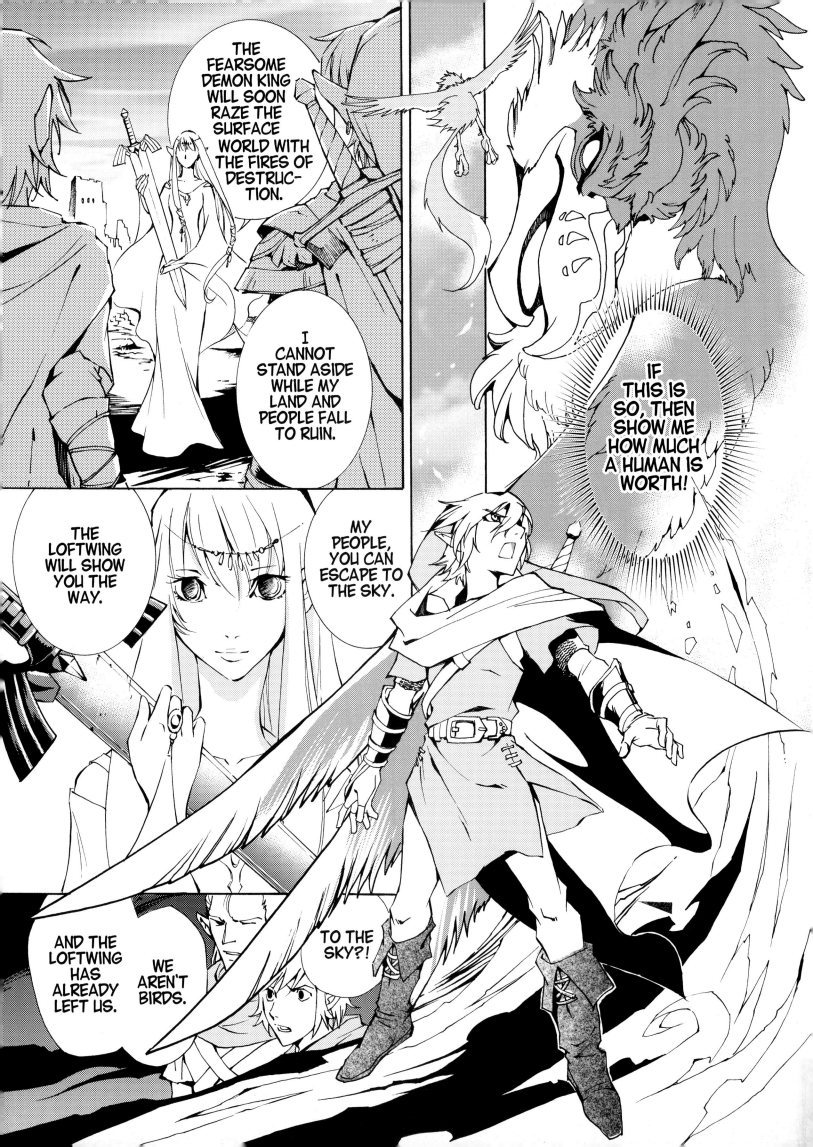

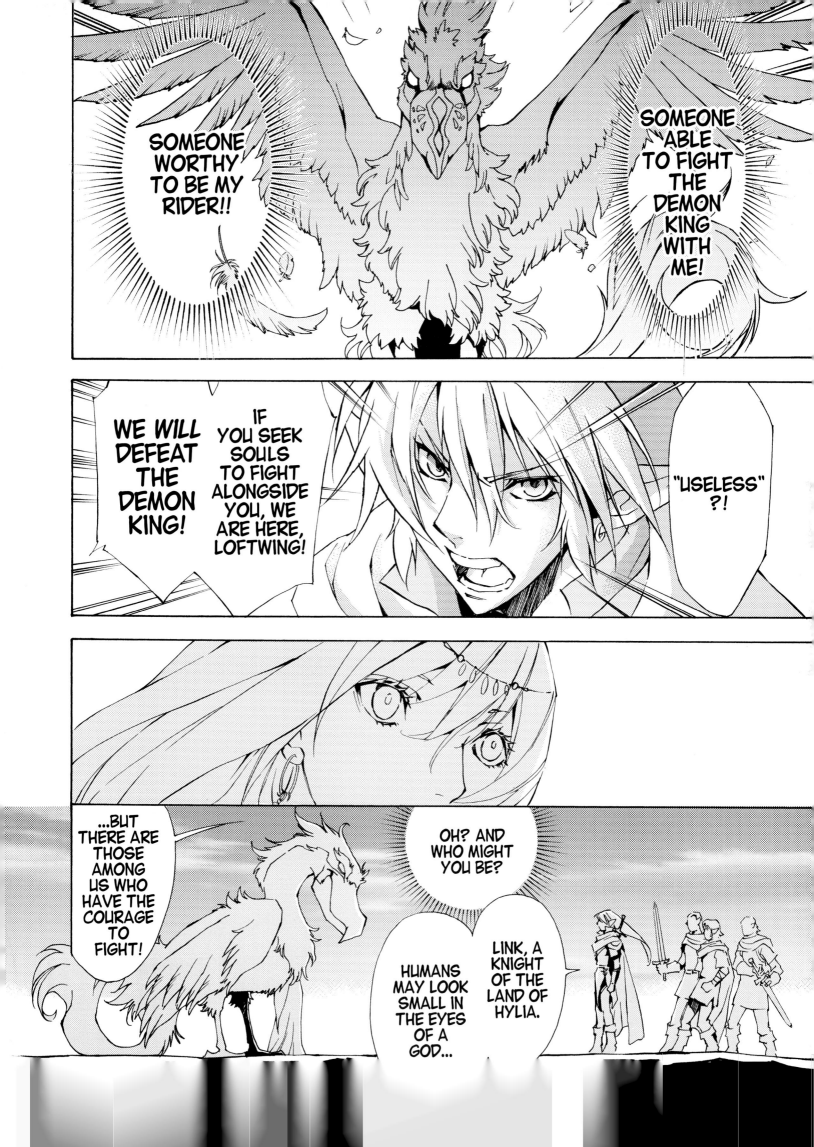

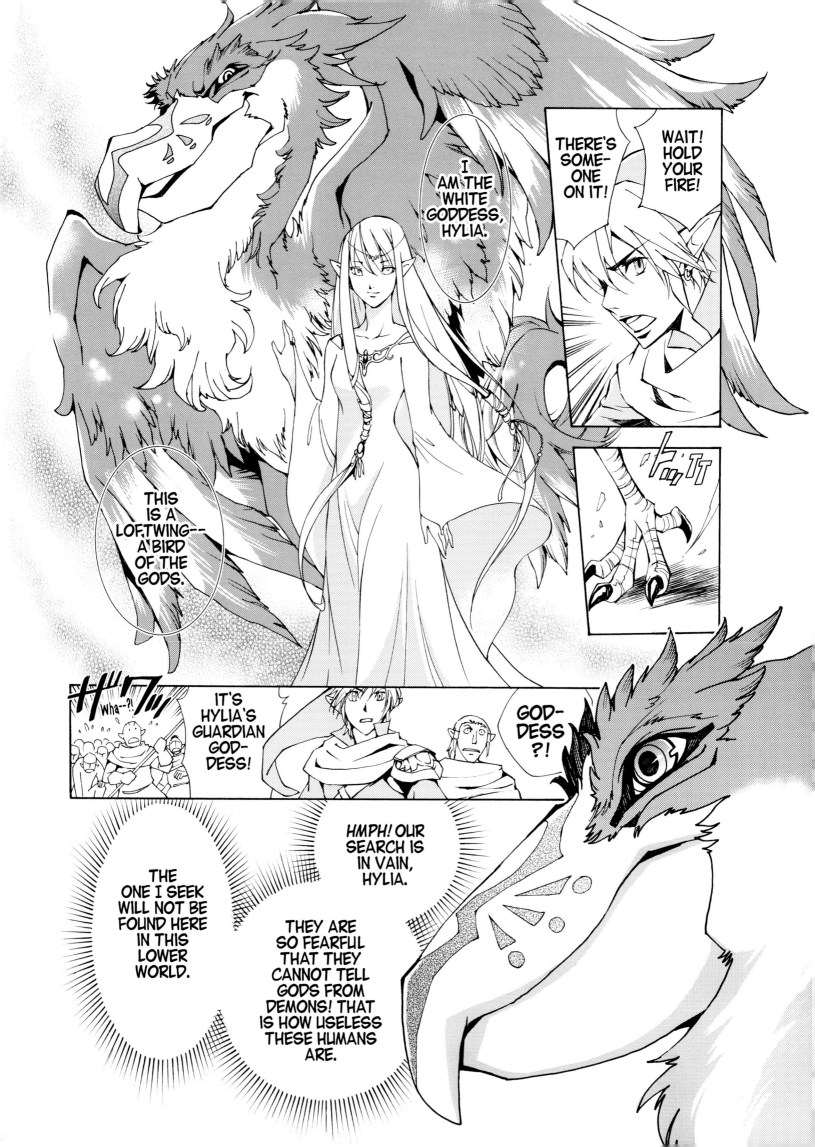

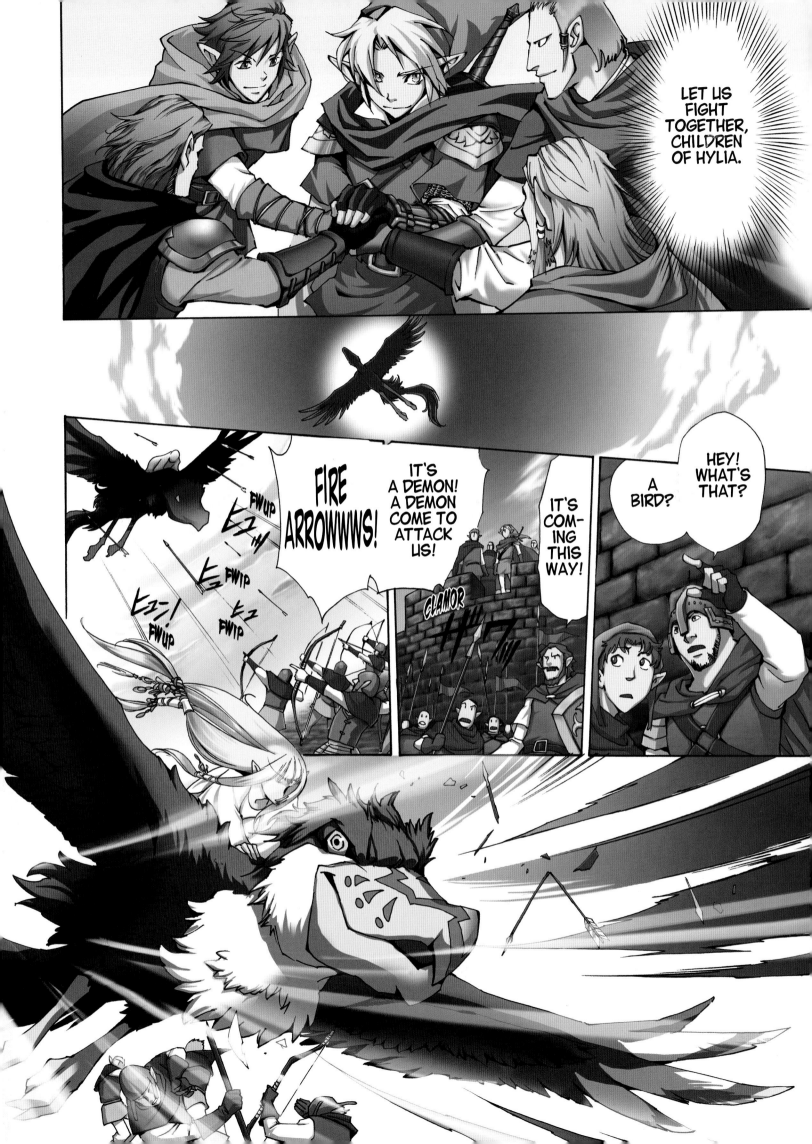

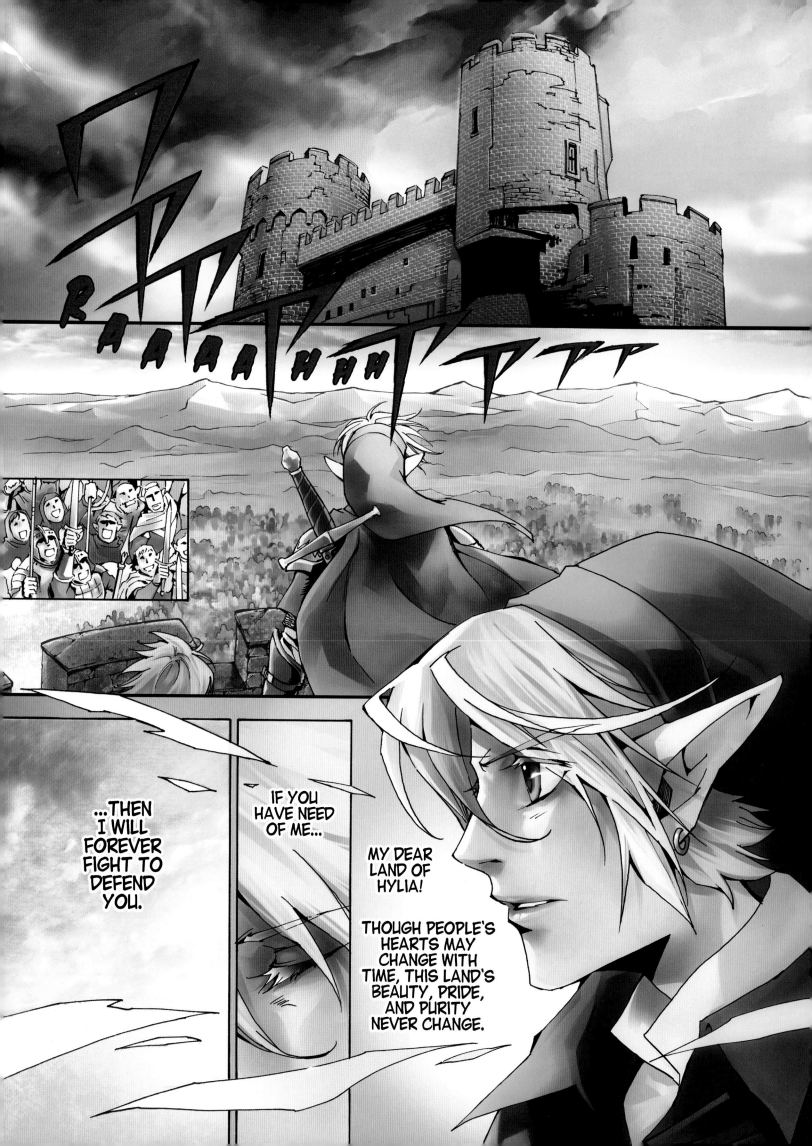

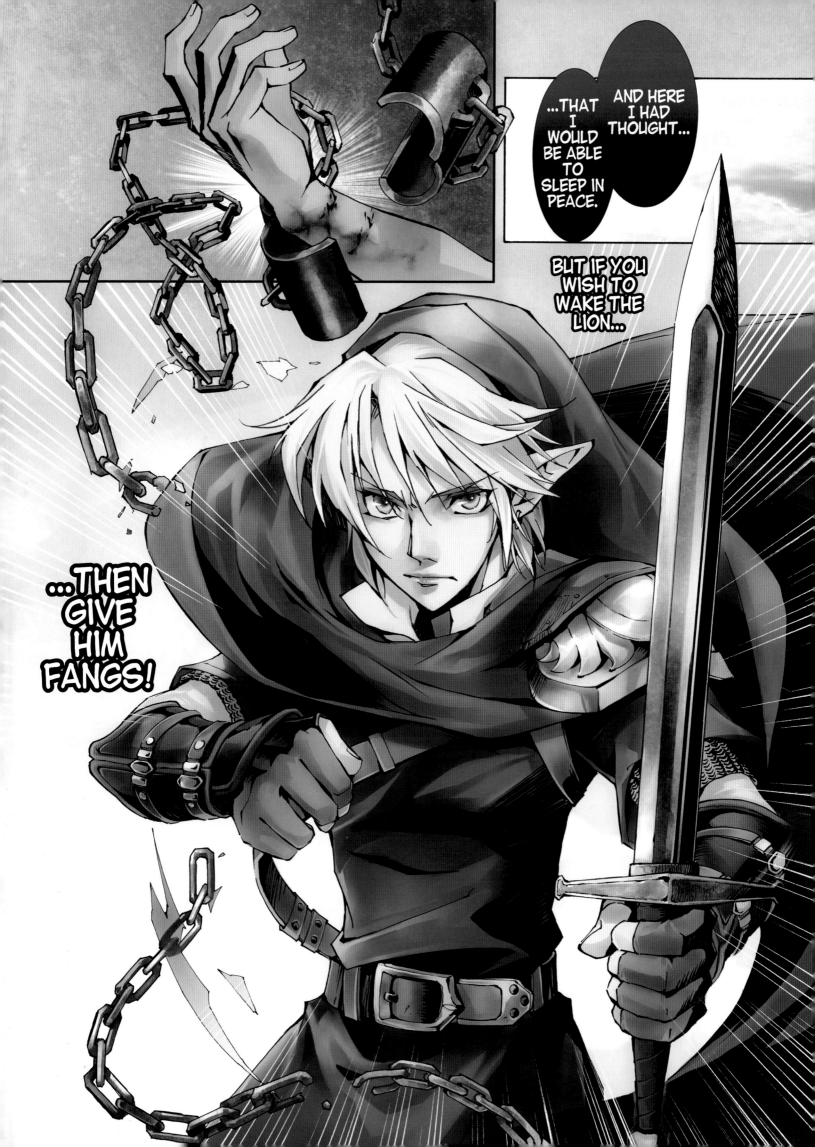

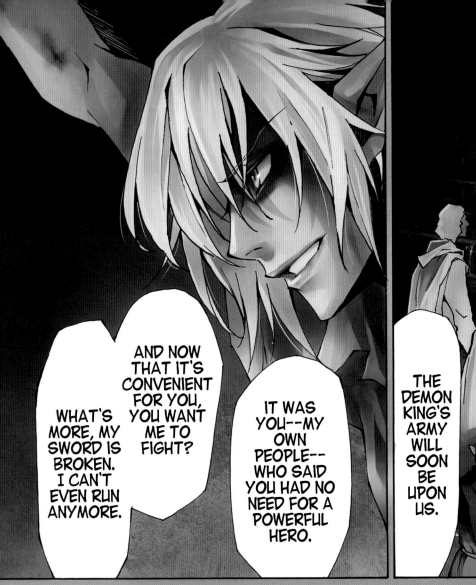

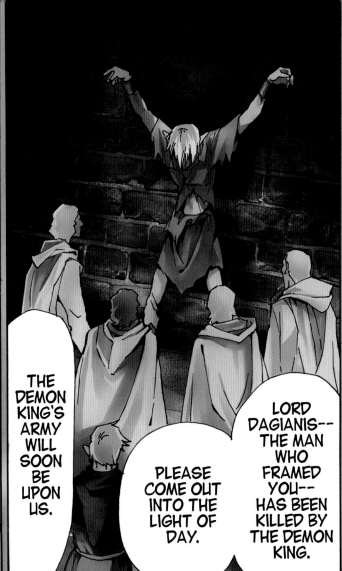

AND NOW THAT IT'S CONVENIENT FOR YOU, YOU WANT ME TO FIGHT?

WHAT'S MORE, MY SWORD IS BROKEN. I CAN'T EVEN RUN ANYMORE.

IT WAS YOU--MY OWN PEOPLE--WHO SAID YOU HAD NO NEED FOR A POWERFUL HERO.

THE DEMON KING'S ARMY WILL SOON BE UPON US.

PLEASE COME OUT INTO THE LIGHT OF DAY.

LORD DAGIANIS-- THE MAN WHO FRAMED YOU-- HAS BEEN KILLED BY THE DEMON KING.

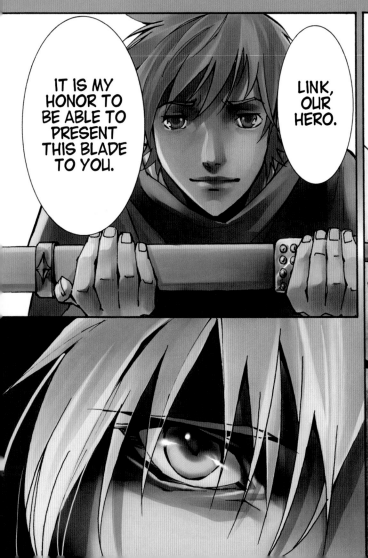

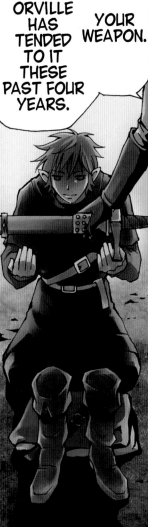

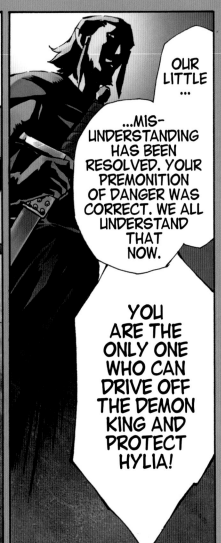

IT IS MY HONOR TO BE ABLE TO PRESENT THIS BLADE TO YOU.

LINK, OUR HERO.

ORVILLE HAS TENDED TO IT THESE PAST FOUR YEARS.

YOUR WEAPON.

OUR LITTLE ...

...MIS- UNDERSTANDING HAS BEEN RESOLVED. YOUR PREMONITION OF DANGER WAS CORRECT. WE ALL UNDERSTAND THAT NOW.

YOU ARE THE ONLY ONE WHO CAN DRIVE OFF THE DEMON KING AND PROTECT HYLIA!

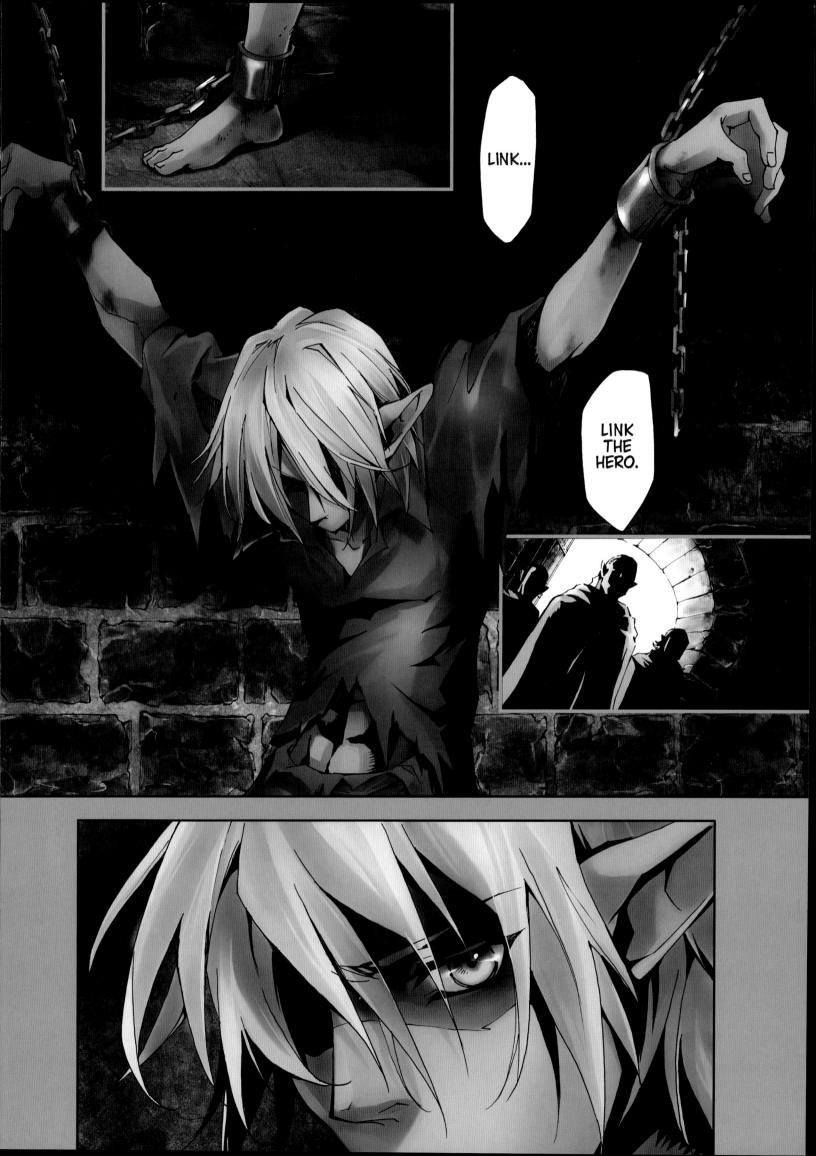

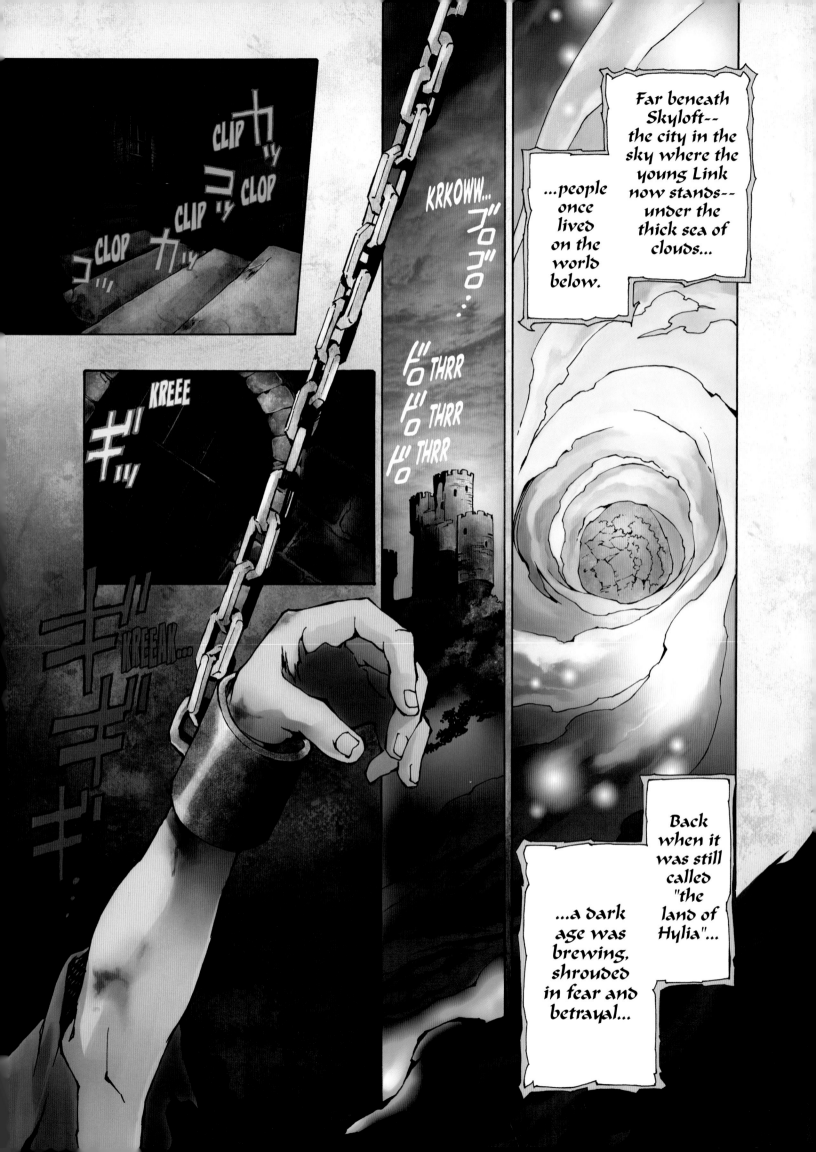

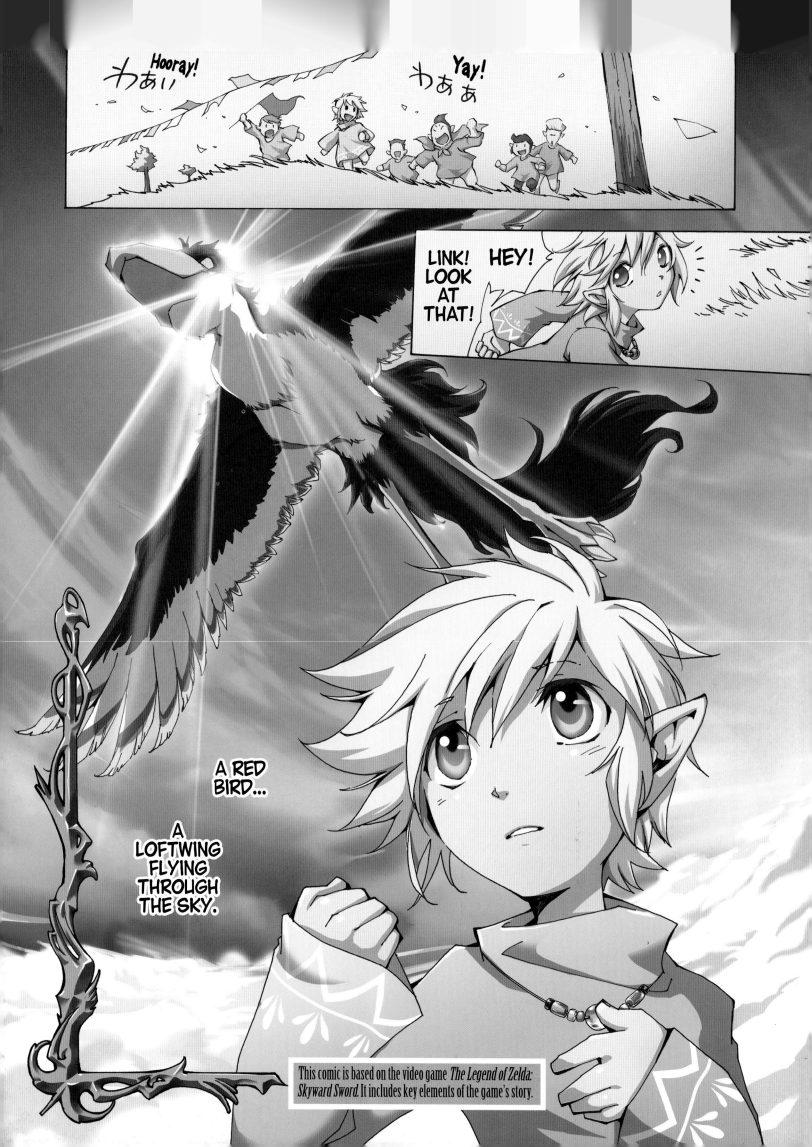

Message from
Akira Himekawa

Congratulations on the twenty-fifth anniversary of the birth of *The Legend of Zelda*!! And congratulations also on the eagerly anticipated release of the latest in the series—*Skyward Sword*. We've been given the task of creating the comic versions of *Zelda* games since 1999. We are thankful that people enjoy the manga as much as the games. We've been able to produce multiple volumes, and in 2010 we were chosen by readers for a manga award in Germany. Thank you kindly! So, it's been twelve years since we last drew a grown-up Link in a manga, huh? We really wracked our brains even more than we usually do for the comic versions, trying to come up with something that was worthy of the twenty-fifth anniversary and connected to *Skyward Sword* but would be all settled in thirty-two pages. We think we've turned out a special short piece that

concludes the "very first *Zelda* tale." Ever since Nintendo first started making video games, they've birthed a lot of games and fans, but we feel *Zelda* in particular is a rare game series that has tons of fans across the world who love it passionately. We created this manga with all those many adoring *Zelda* fans in mind. We hope you enjoy it!

Akira Himekawa is the pseudonym, or "unit name," of the female manga artist pair A. Honda and S. Nagano (self-portraits below). They debuted in Weekly Shonen Sunday *in 1991. In 1999 they began serializing* The Legend of Zelda: Ocarina of Time *in* Shogaku gonensei *(Fifth-grade student) and* Shogaku rokunensei *(Sixth-grade student). Ten volumes of their* Legend of Zelda *manga have been published by Shogakukan.*

THE LEGEND IS BORN!!

An exclusive Zelda comic for the
25th anniversary of The Legend of Zelda

SPECIAL
32-PAGE
BONUS!!

Manga by
AKIRA HIMEKAWA

THE LEGEND OF ZELDA
Skyward Sword